序

《Hit101西洋流行鋼琴百大首選》是繼《Hit101中文流行鋼琴百大首選》後，麥書出版社的年度力作，我們挑選了西洋歌曲中，非常經典與好聽的歌曲，將這些歌曲精心編成鋼琴演奏曲，在編曲的過程中，我們考慮了初學與進階的兩種程度，讓曲子的難易度落在適中，並減化繁複的反覆，讓整個譜面看起來更簡單易彈，這是本書的設計理念。

如果您手邊的西洋歌曲鋼琴樂譜資料已經老舊，別忘了帶一本回家彈彈新的編曲、新的詮釋；擔任教學工作的鋼琴老師們不必再為了不曉得要舉什麼曲例給學生練習而傷破腦筋，本書不但將每首好歌與經典曲目的雙手各別彈奏方法清楚編曲，更讓您在教學的過程中輕鬆引領學生演奏世界級的金曲。

自習的同學們更不必為了收集標準曲目而翻遍各大書店的書架，如果您已經有《Hit101中文流行鋼琴百大首選》，那麼《Hit101西洋流行鋼琴百大首選》你絕對不能錯過，祝大家演奏愉快、琴藝精進！

作者　邱哲豐

目錄
CONTENTS

Always On My Mind

詞／曲：Wayne Thompson／Mark James／Johnny Christopher　演唱：Willie Nelson

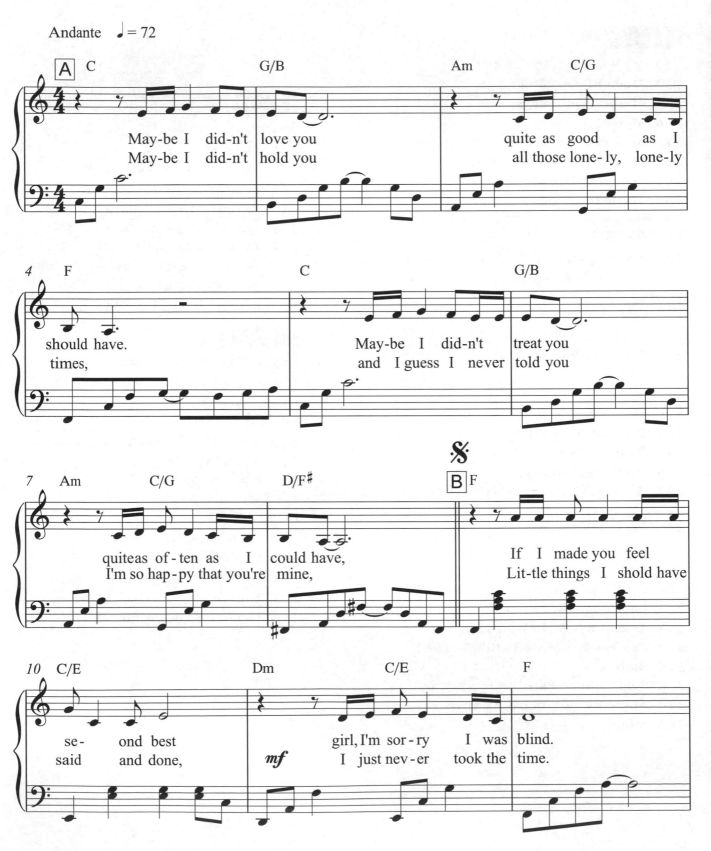

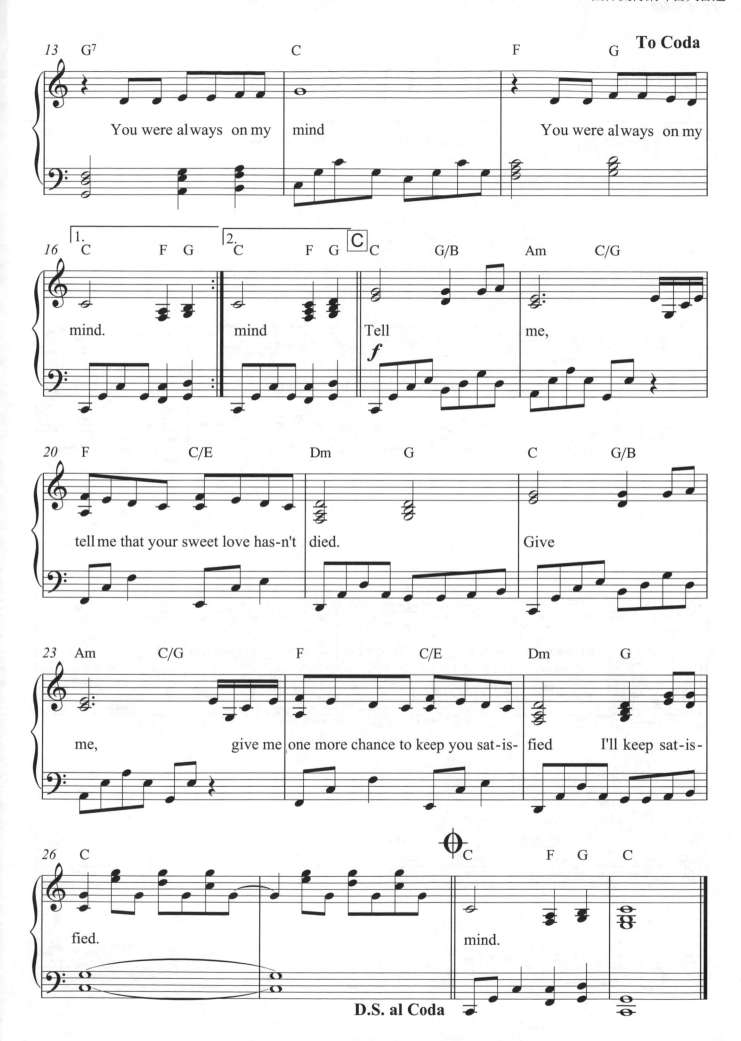

A Time For Us

（電影《殉情記》主題曲）

詞／曲：Nino Rotar　演唱：Andy Williams

Andantino ♩ = 90

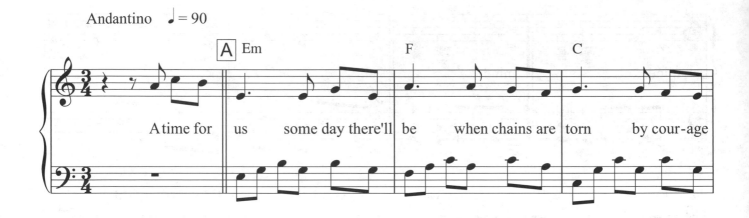

A time for us some day there'll be when chains are torn by cour-age

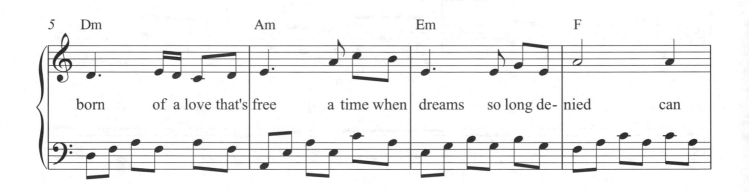

born of a love that's free a time when dreams so long de-nied can

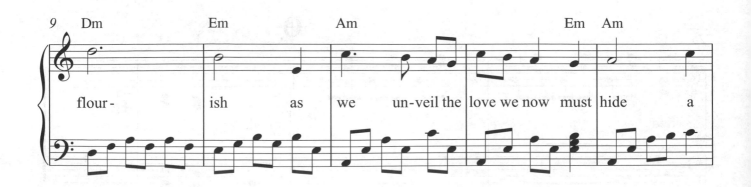

flour-ish as we un-veil the love we now must hide a

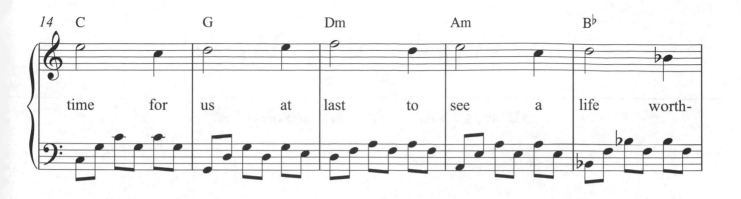

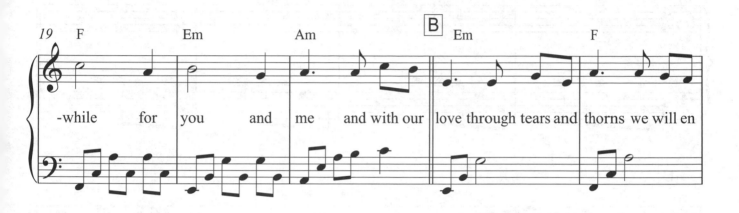

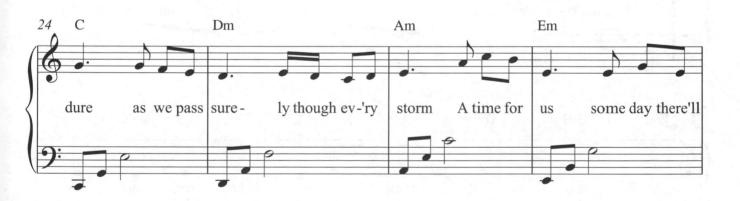

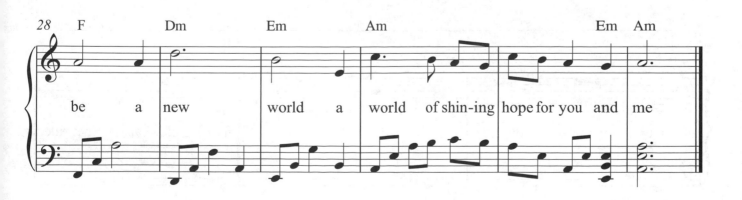

A Whole New World

（動畫《阿拉丁》主題曲）

詞 / 曲：Tim Rice / Alan Menken　演唱：Barbara Hendricks

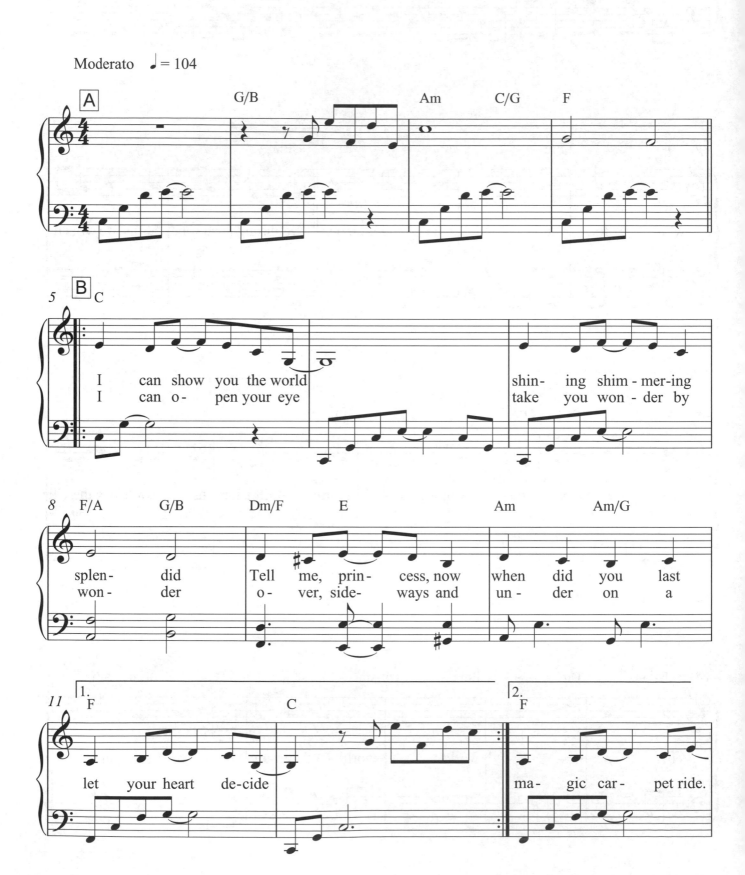

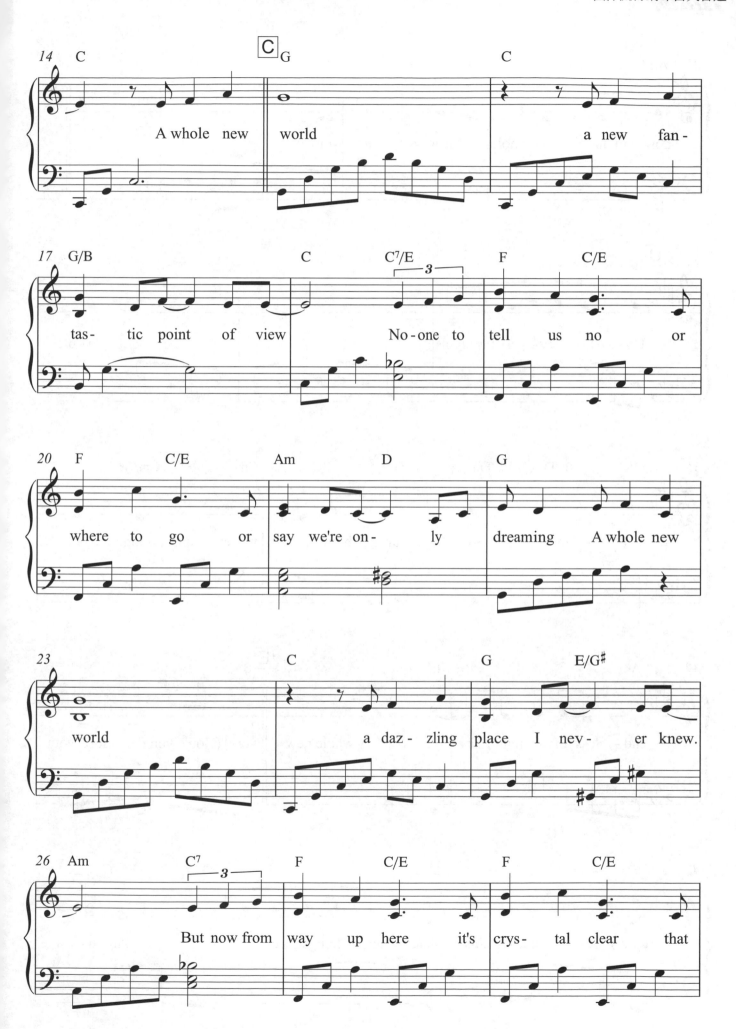

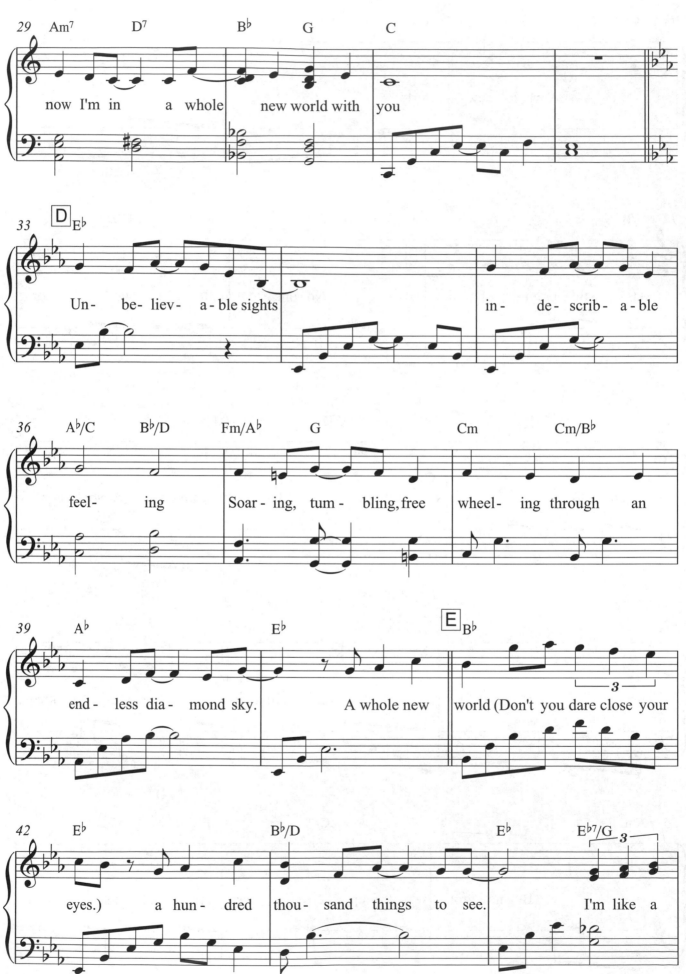

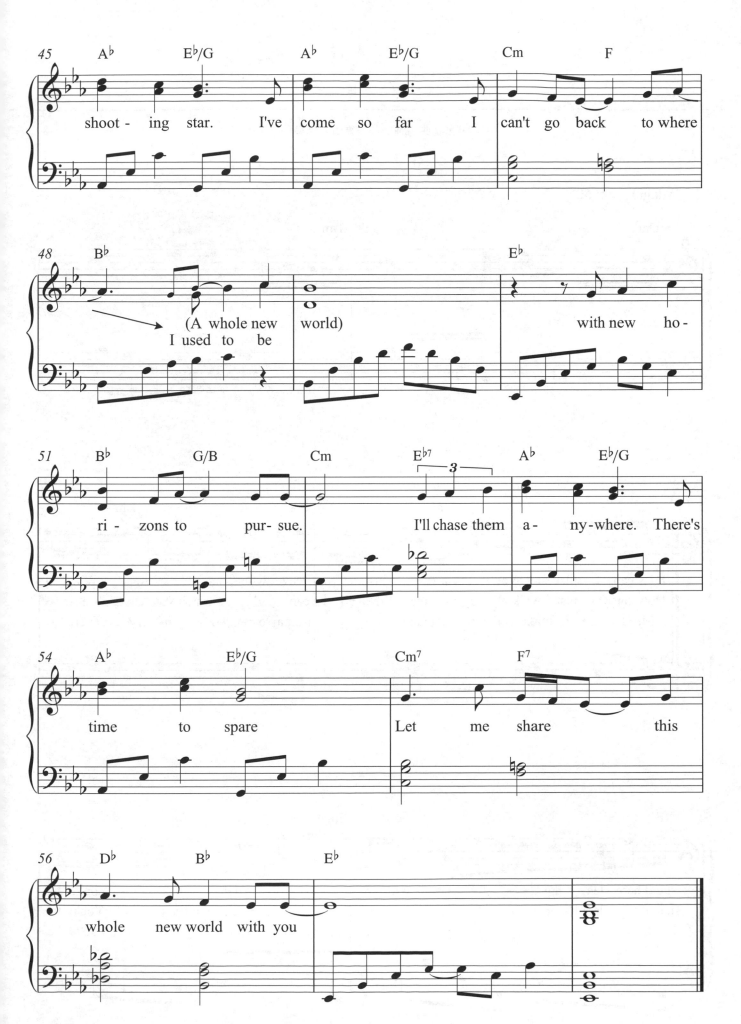

Against All Odds

（電影《再看我一眼》主題曲）

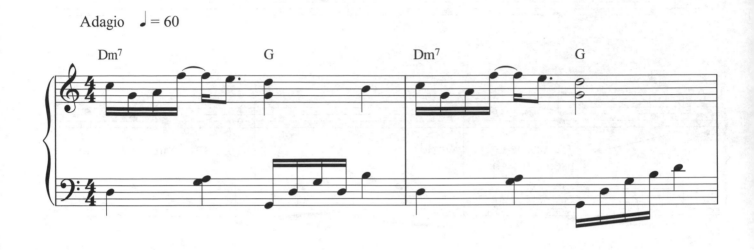

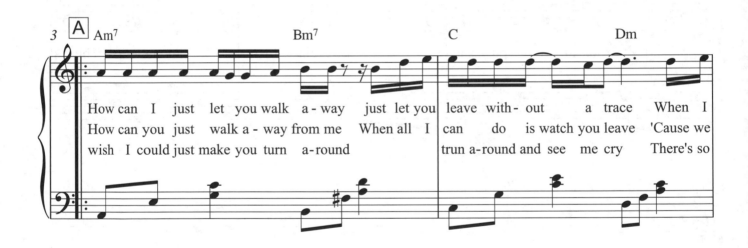

How can I just let you walk a-way just let you leave with-out a trace When I
How can you just walk a-way from me When all I can do is watch you leave 'Cause we
wish I could just make you turn a-round trun a-round and see me cry There's so

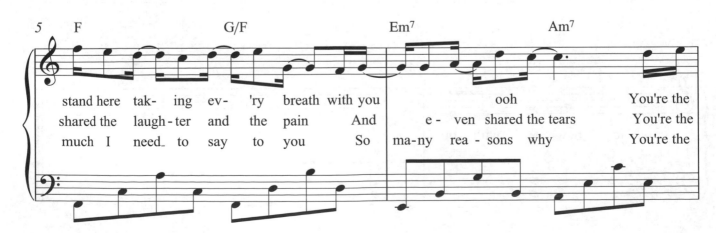

stand here tak-ing ev-'ry breath with you ooh You're the
shared the laugh-ter and the pain And e-ven shared the tears You're the
much I need to say to you So ma-ny rea-sons why You're the

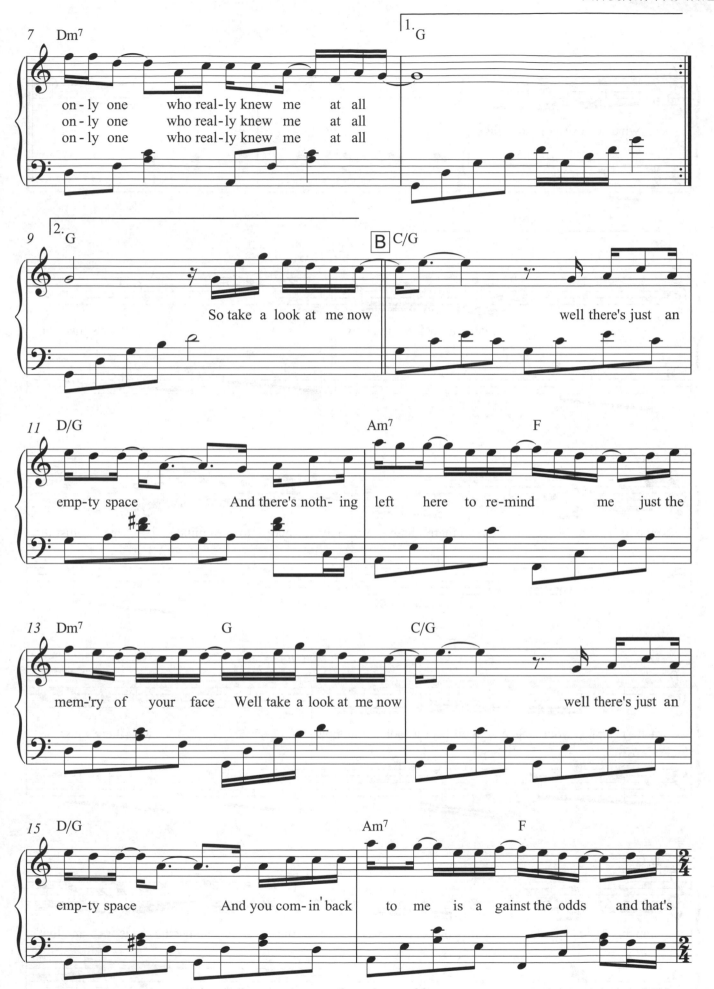

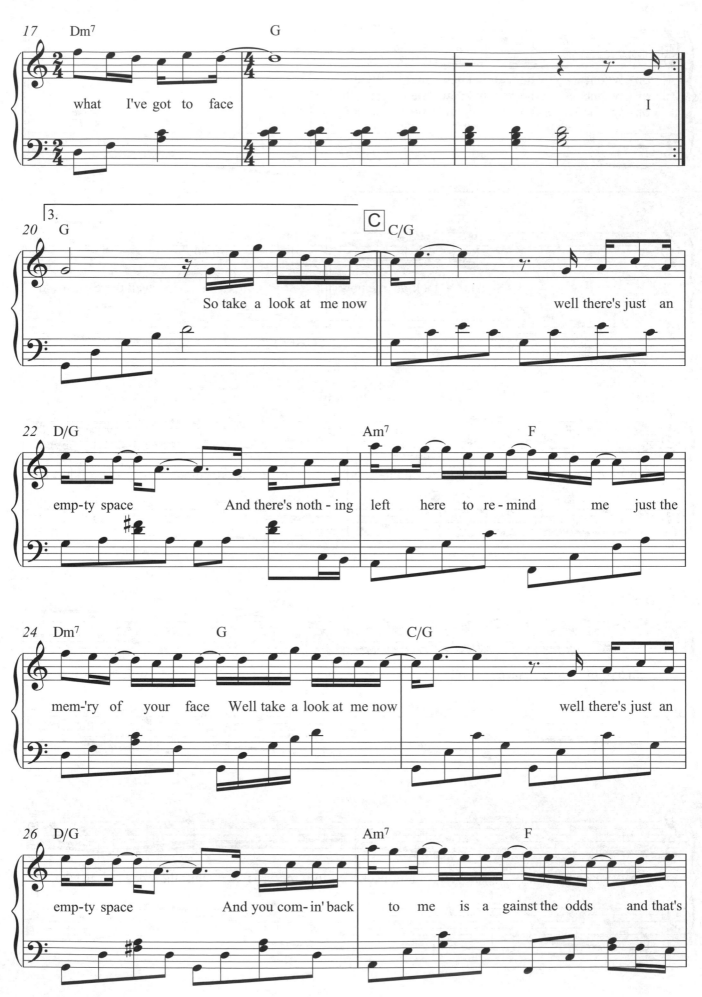

Hitron

14

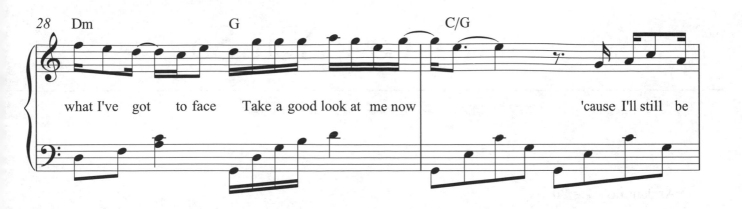

what I've got to face Take a good look at me now 'cause I'll still be

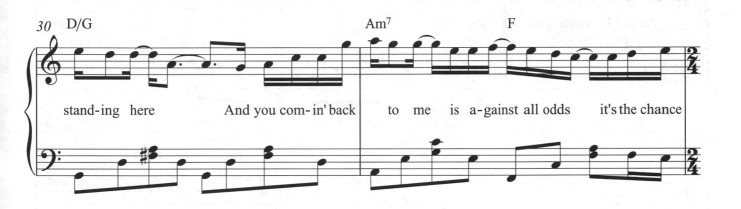

stand-ing here And you com-in' back to me is a-gainst all odds it's the chance

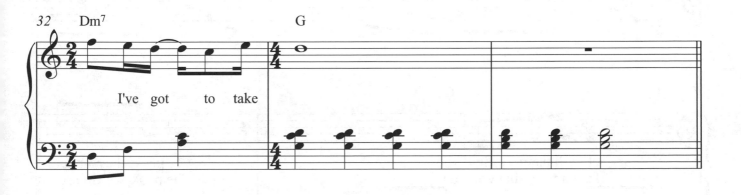

I've got to take

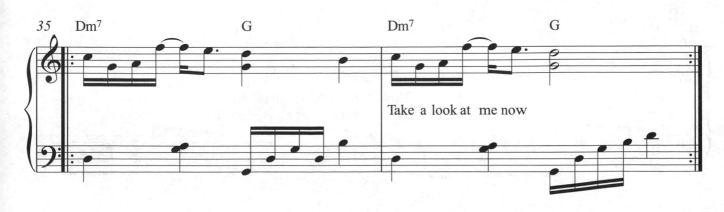

Take a look at me now

And I Love You So

詞 / 曲：Don Mclean　演唱：Elvis Presley

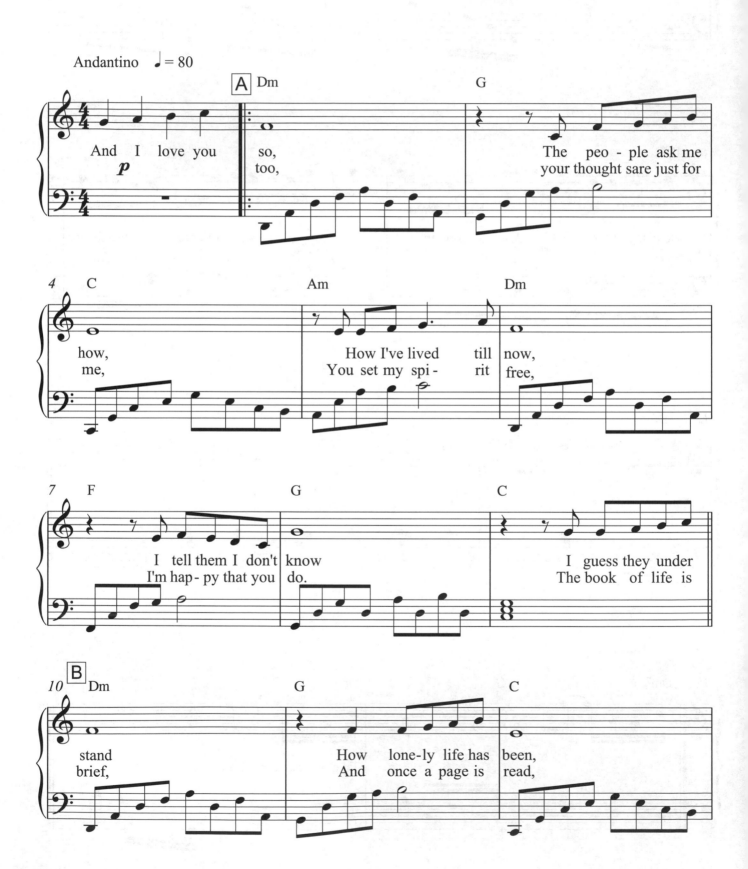

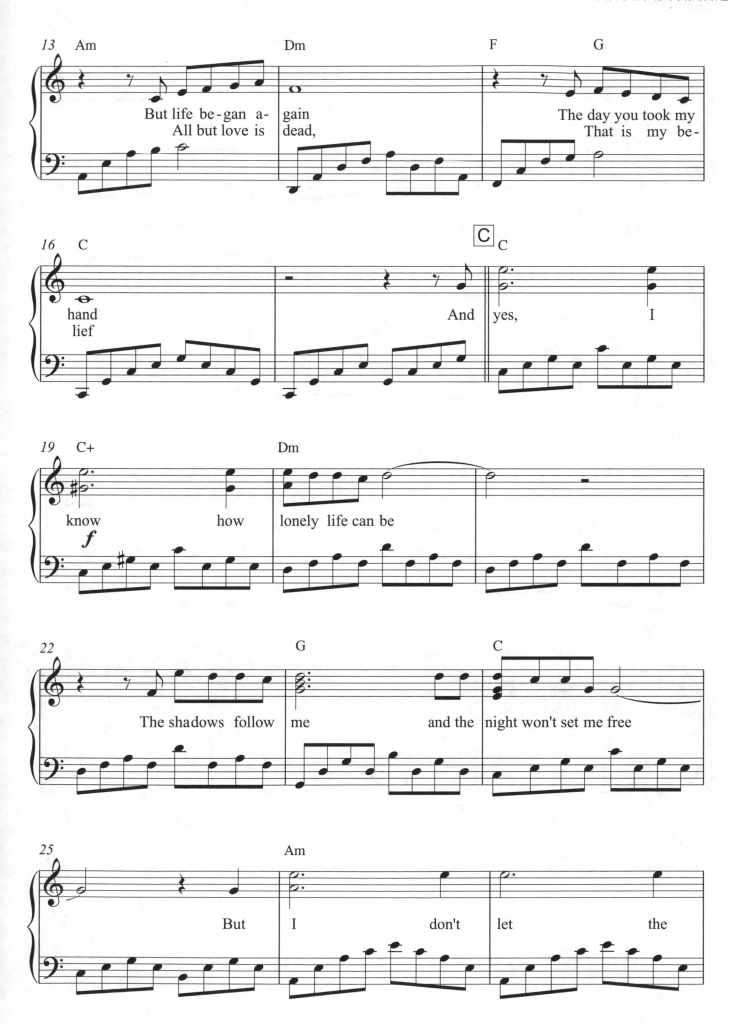

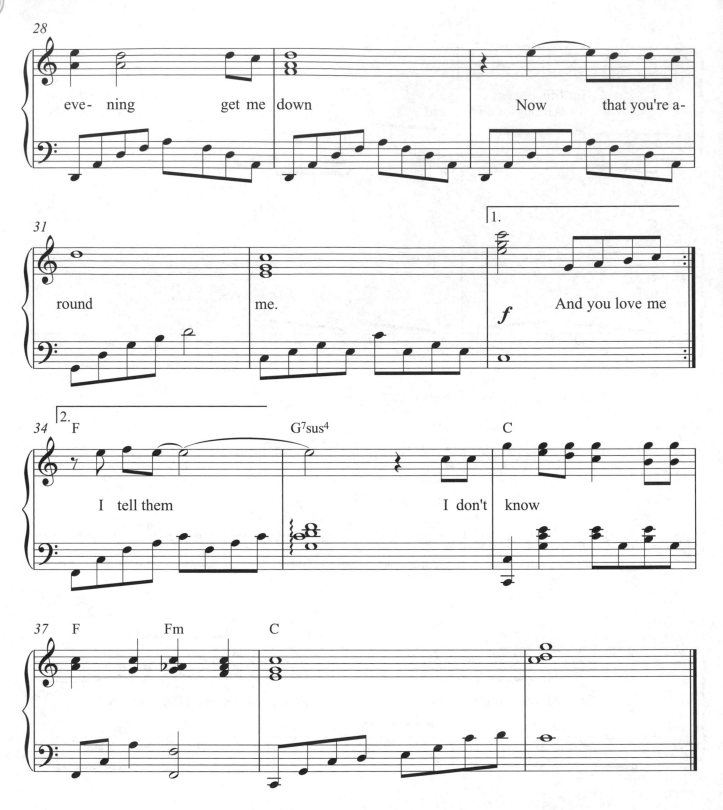

eve- ning　　　get me down　　　Now　　that you're a-

round　　　　　me.　　　　And you love me

f

I　tell them　　　　　I don't　know

Arthur's Theme

（電影《二八佳人花公子》主題曲）

詞 / 曲：Burt Bacharach / Carole Bayer Sager / Christopher Cross / Peter Allen　演唱：Christopher Cross

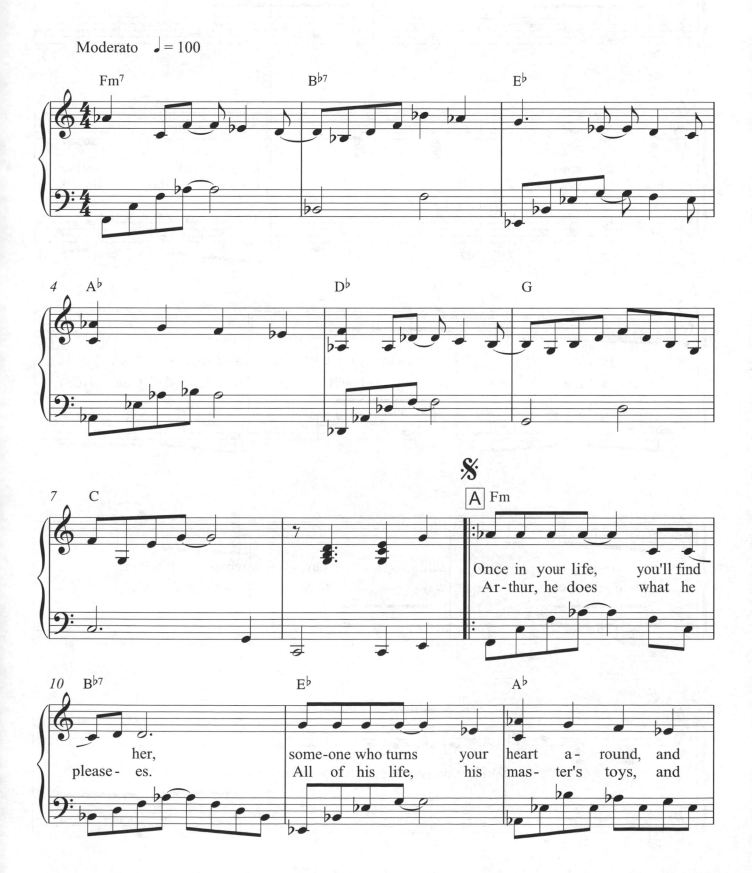

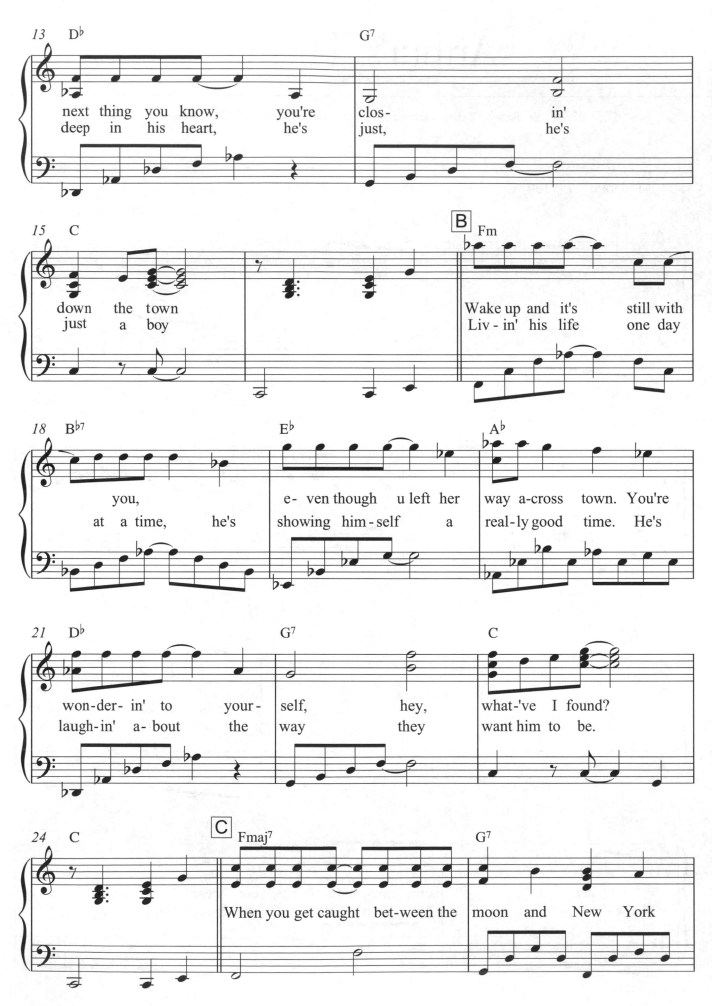

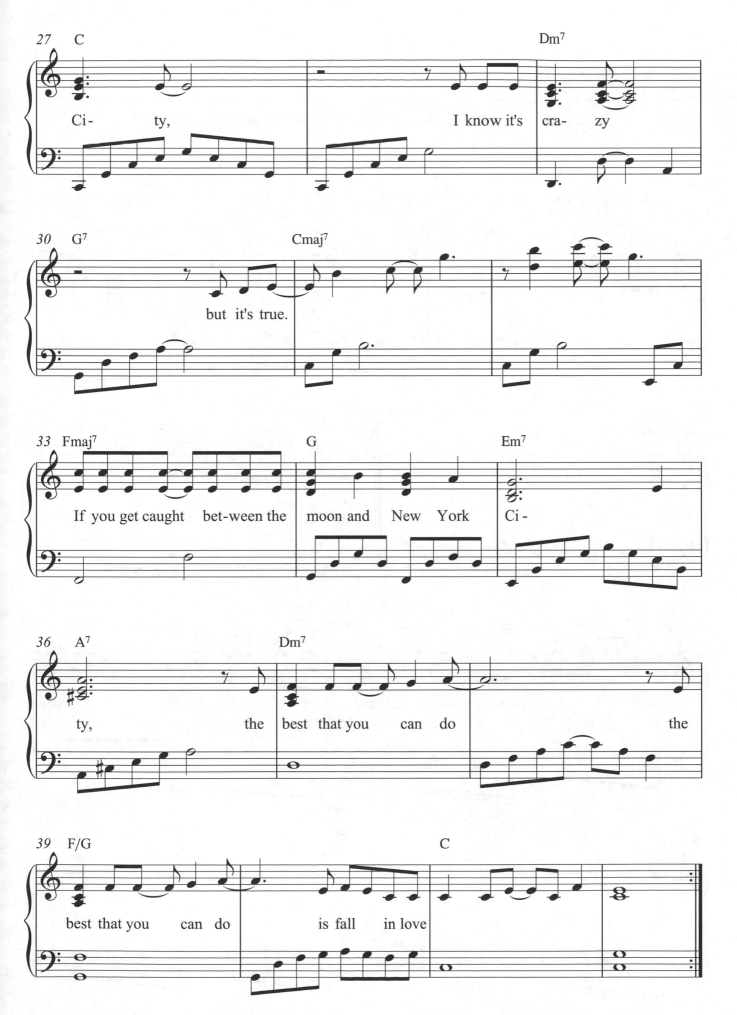

Always

詞 / 曲：Jonathan Lewis / David Lewis / David Lewis / Wayne Lewis 演唱：Atlantic Starr

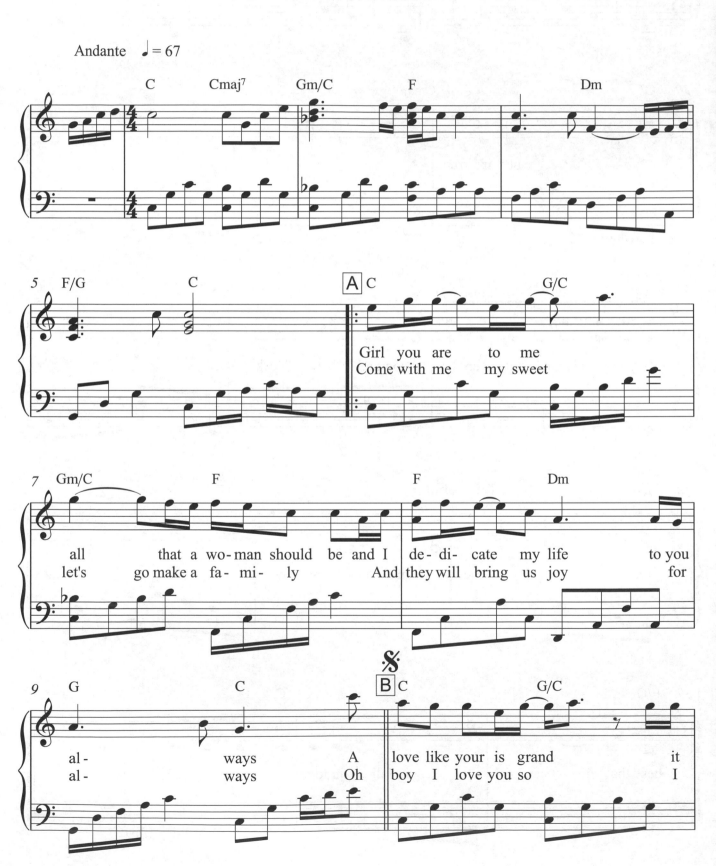

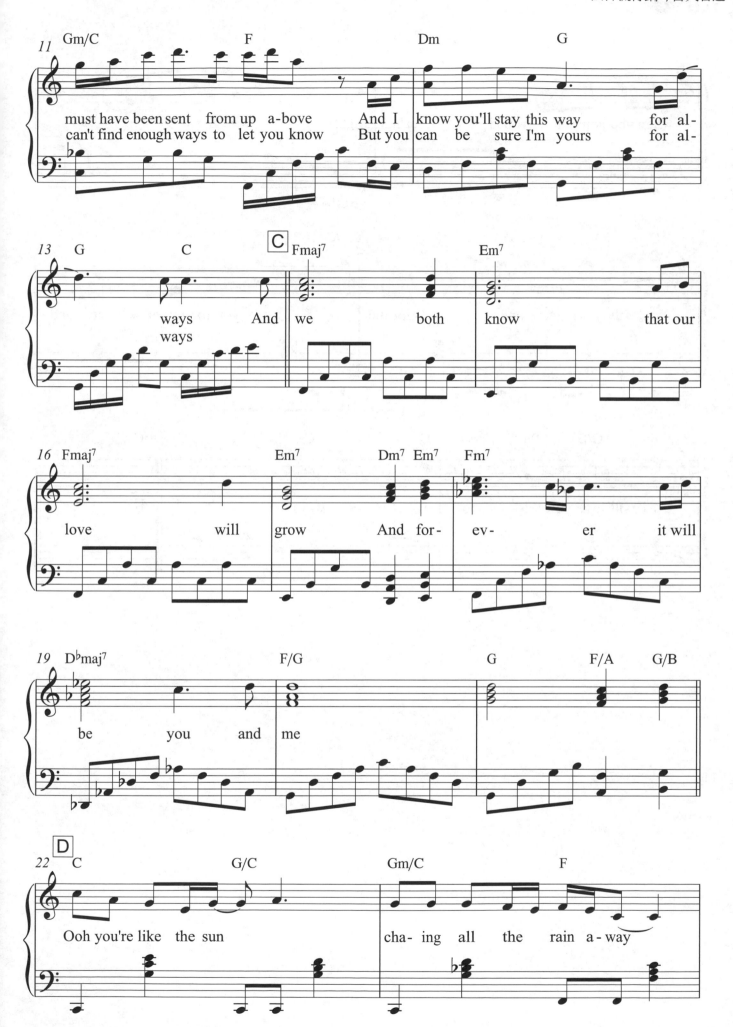

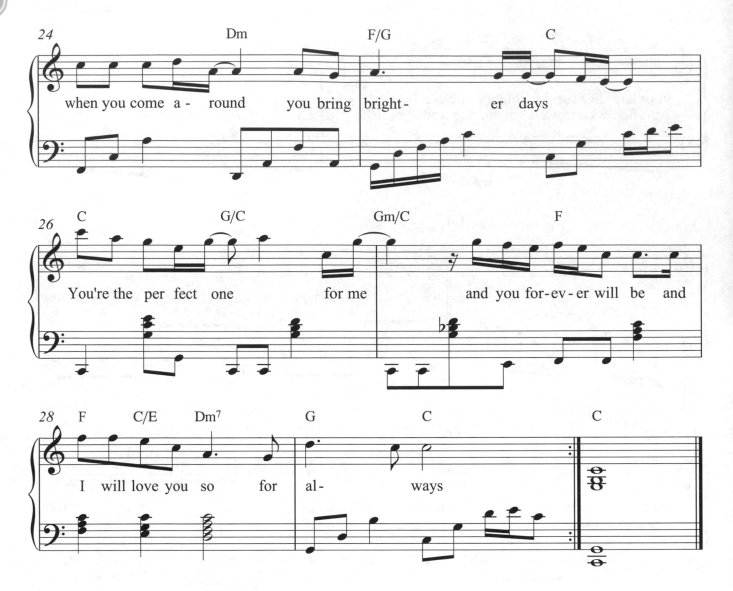

Beauty And The Beast

（動畫《美女與野獸》主題曲）

詞 / 曲：Howard Ashman / Alan Menken　　演唱：Celine Dion

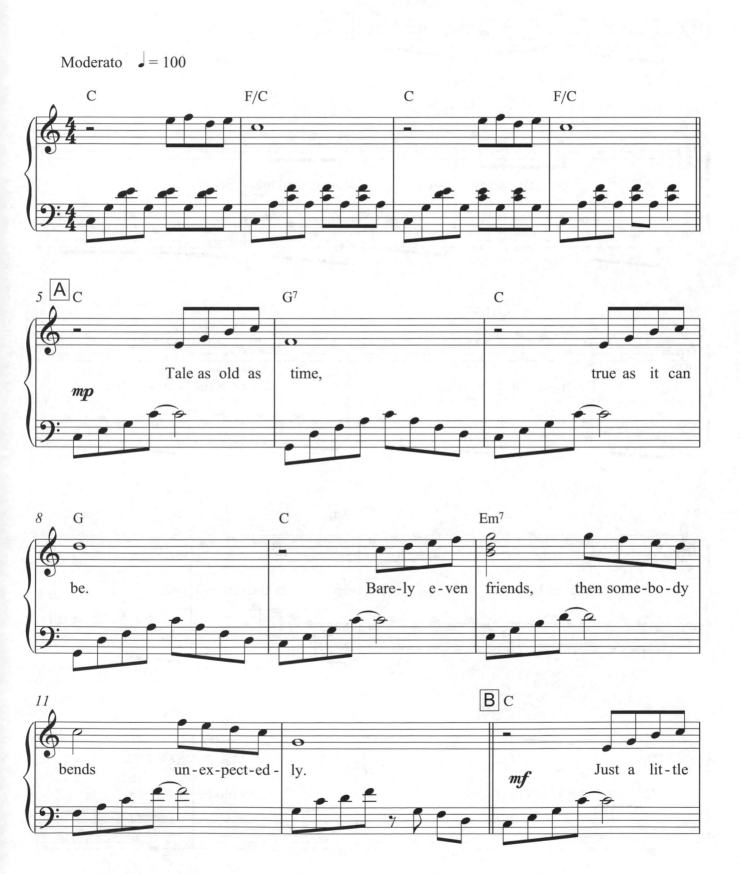

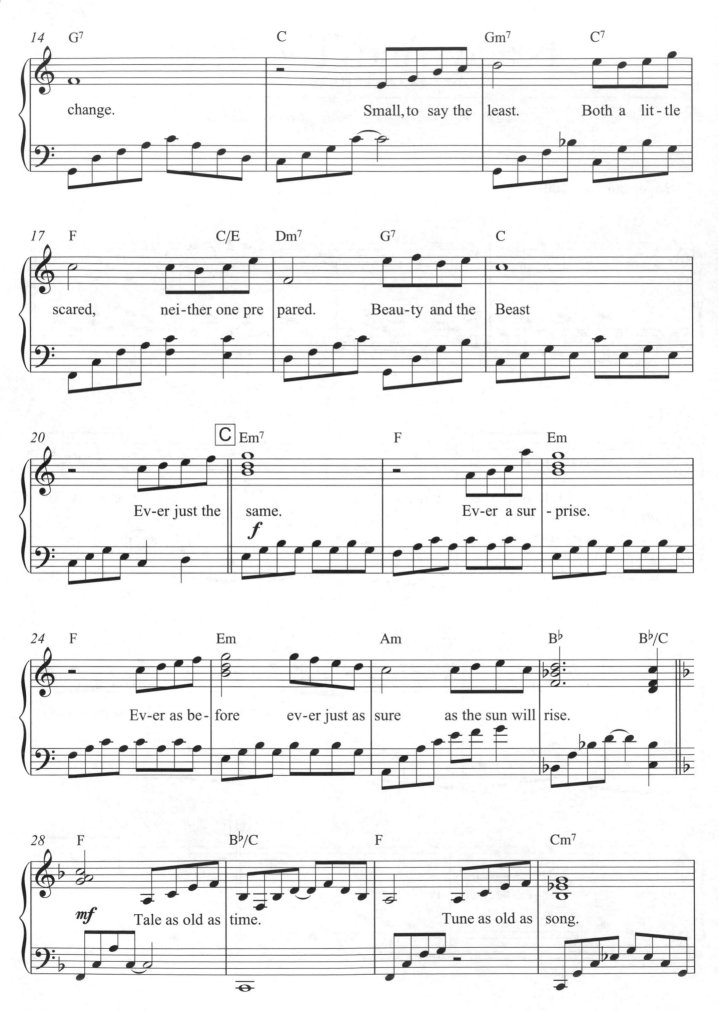

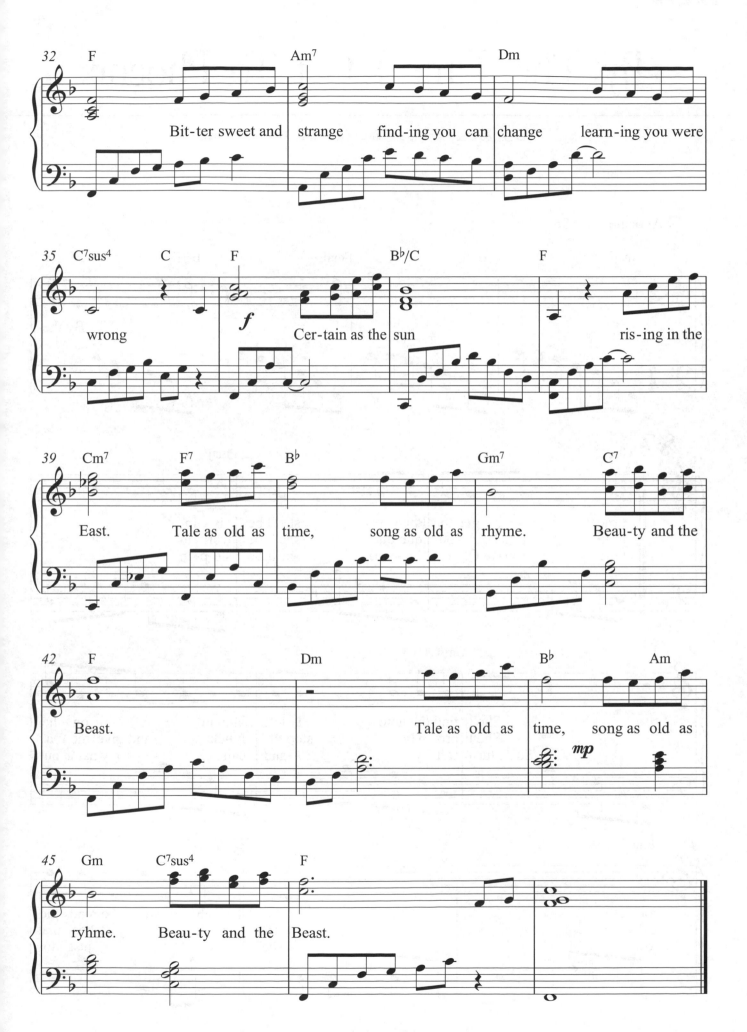

By The Time I Get To Phoenix

詞 / 曲：Jimmy Webb / Glen Campbell　演唱：Glen Campbell

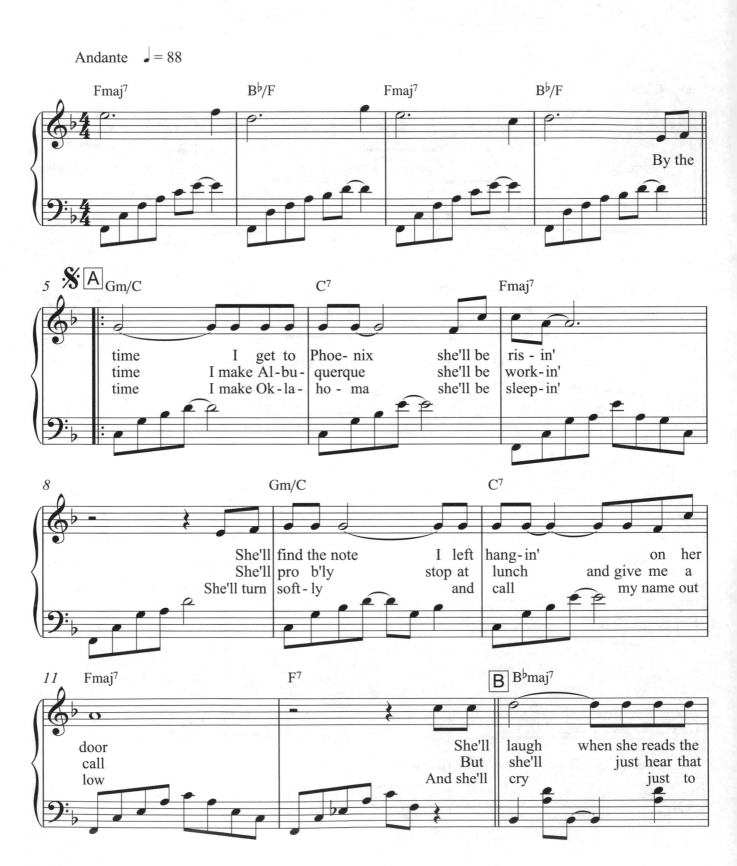

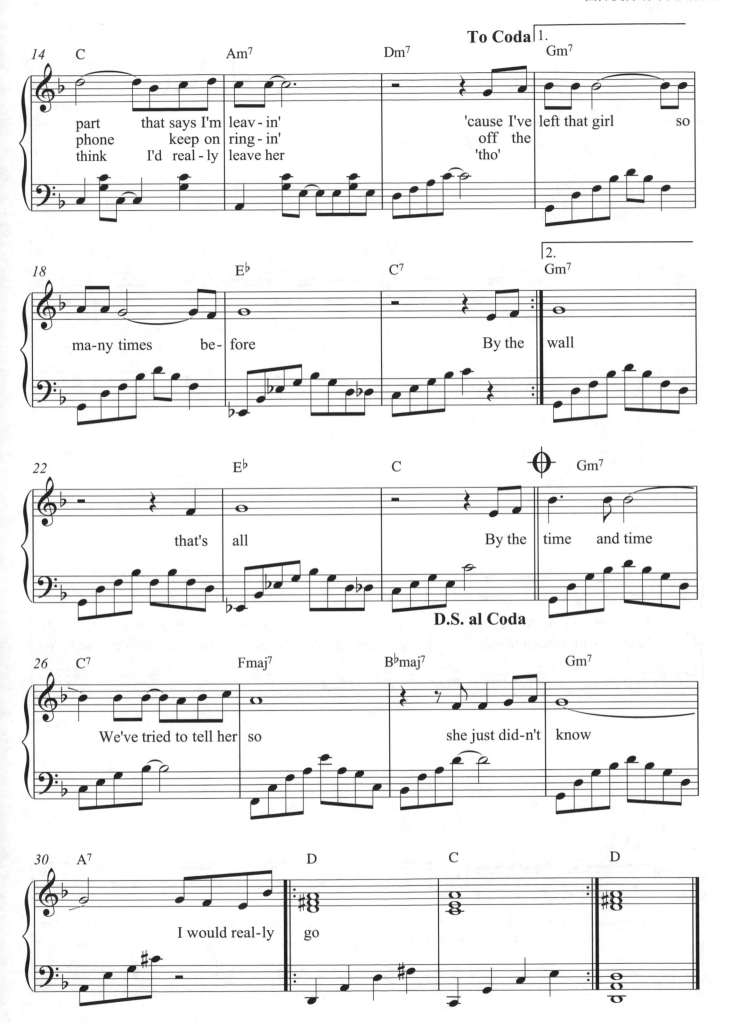

Because You Loved Me

（電影《因為你愛過我》主題曲）

詞／曲：Shaking Steven　　演唱：Celine Dion

Andante ♩ = 88

For all those times you stood by me for all the
wings and made me fly You touched my

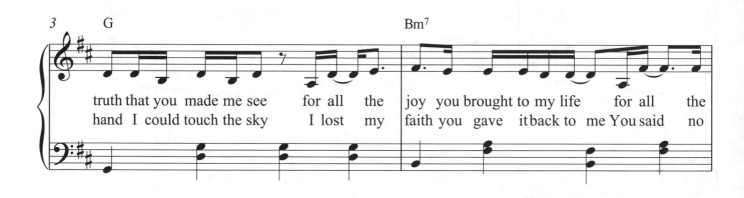

truth that you made me see for all the joy you brought to my life for all the
hand I could touch the sky I lost my faith you gave it back to me You said no

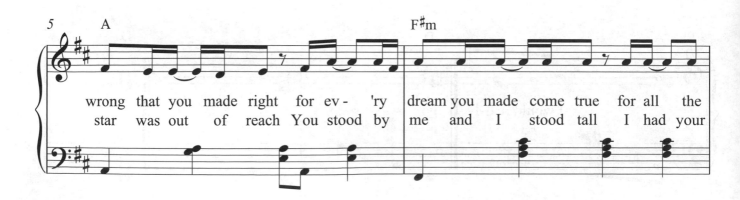

wrong that you made right for ev - 'ry dream you made come true for all the
star was out of reach You stood by me and I stood tall I had your

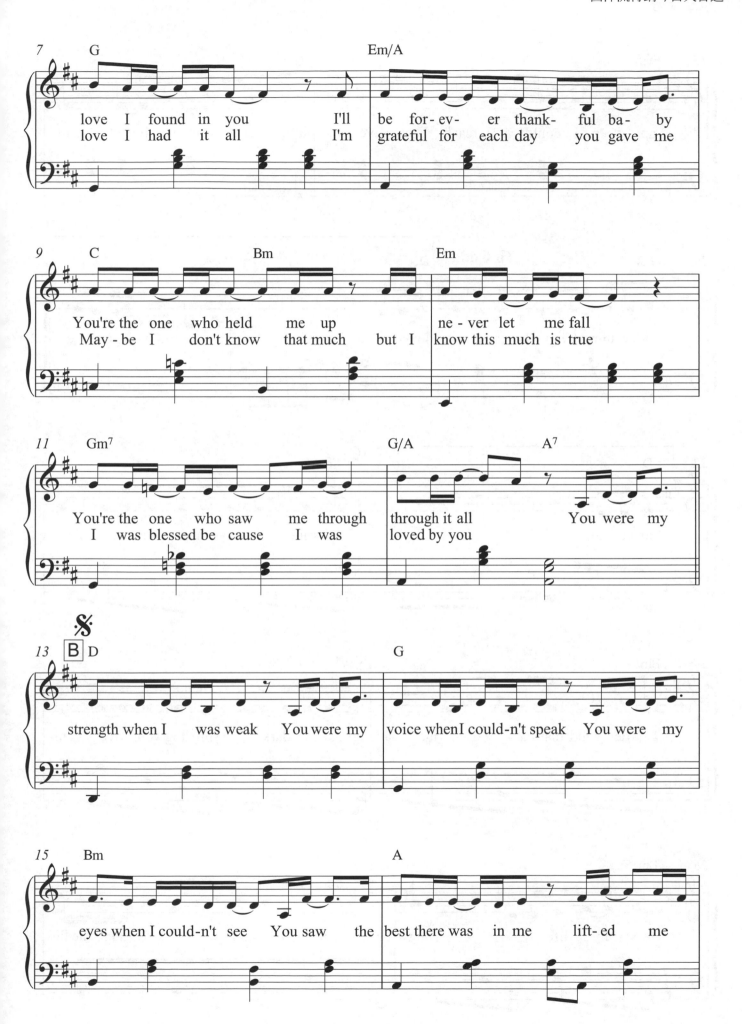

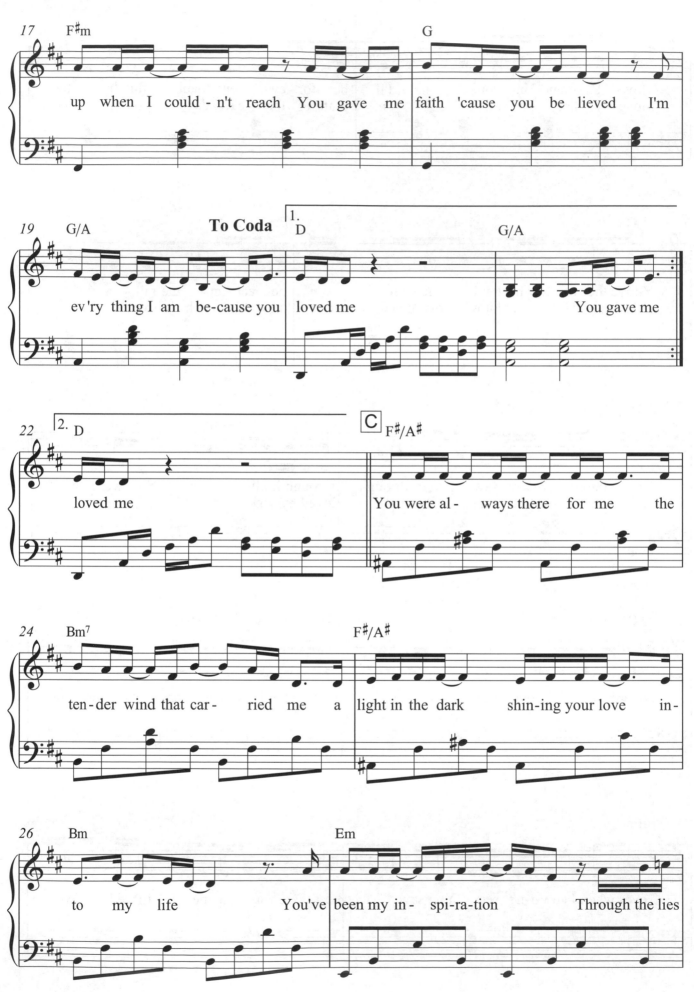

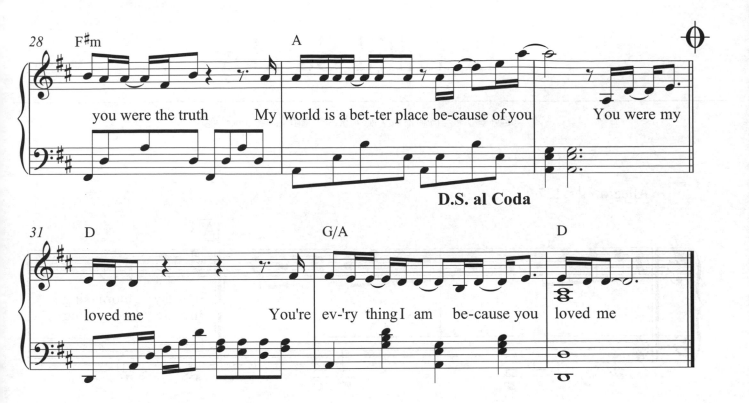

28 F#m A

you were the truth My world is a bet-ter place be-cause of you You were my

D.S. al Coda

31 D G/A D

loved me You're ev-'ry thing I am be-cause you loved me

Beautiful Sunday

詞／曲：Daniel Boone / Rod McQueen　演唱：Daniel Boone

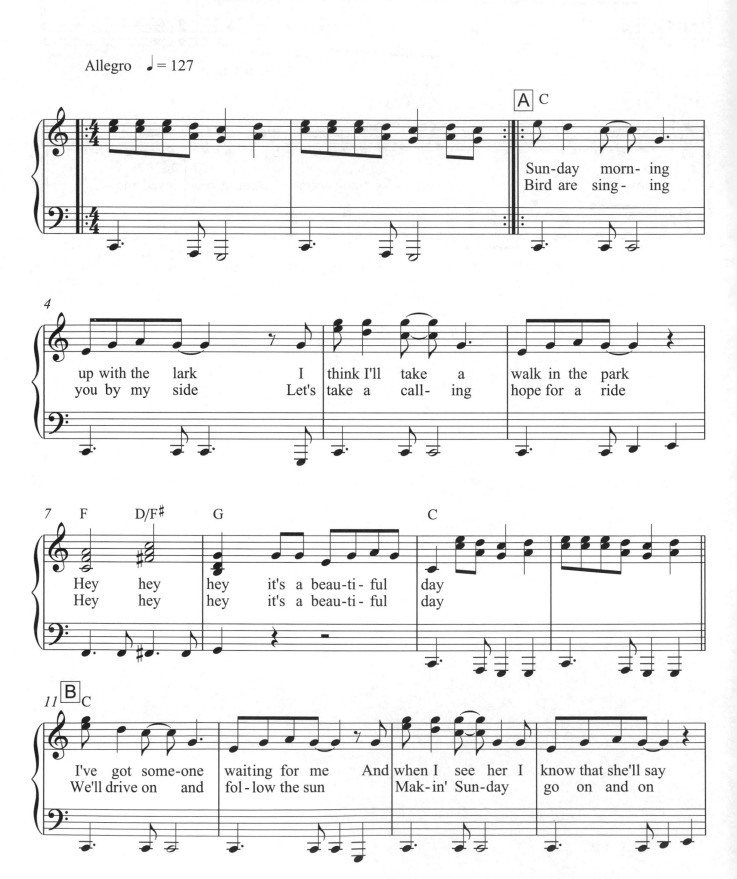

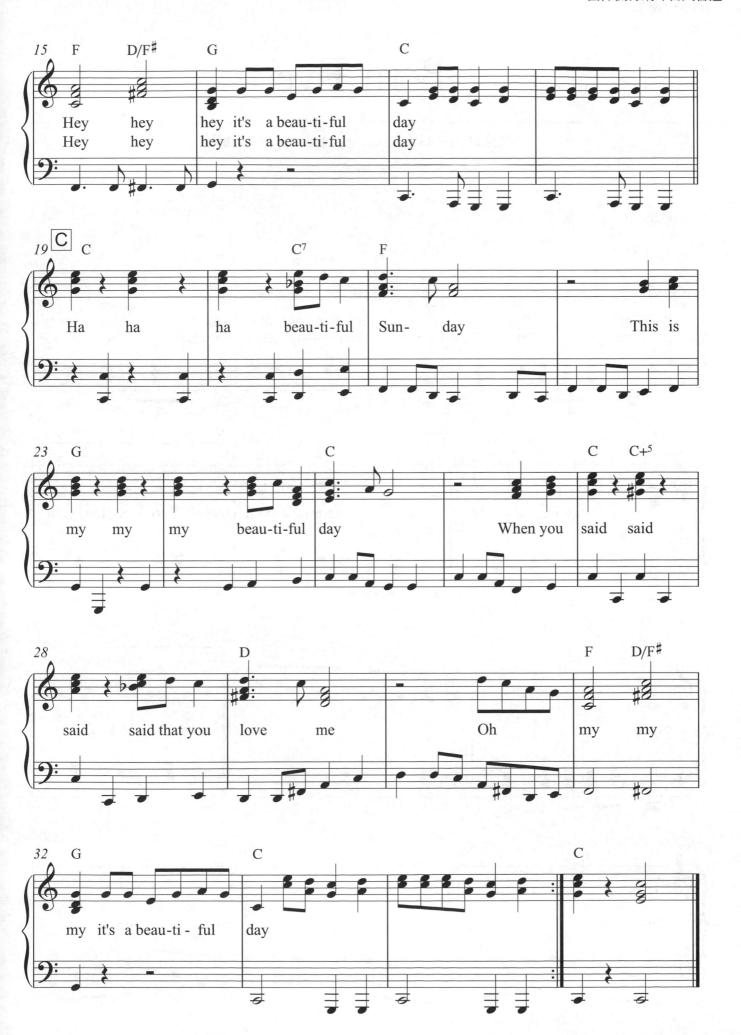

Born Free

詞 / 曲：Don Black / John Barry　演唱：Andy Williams

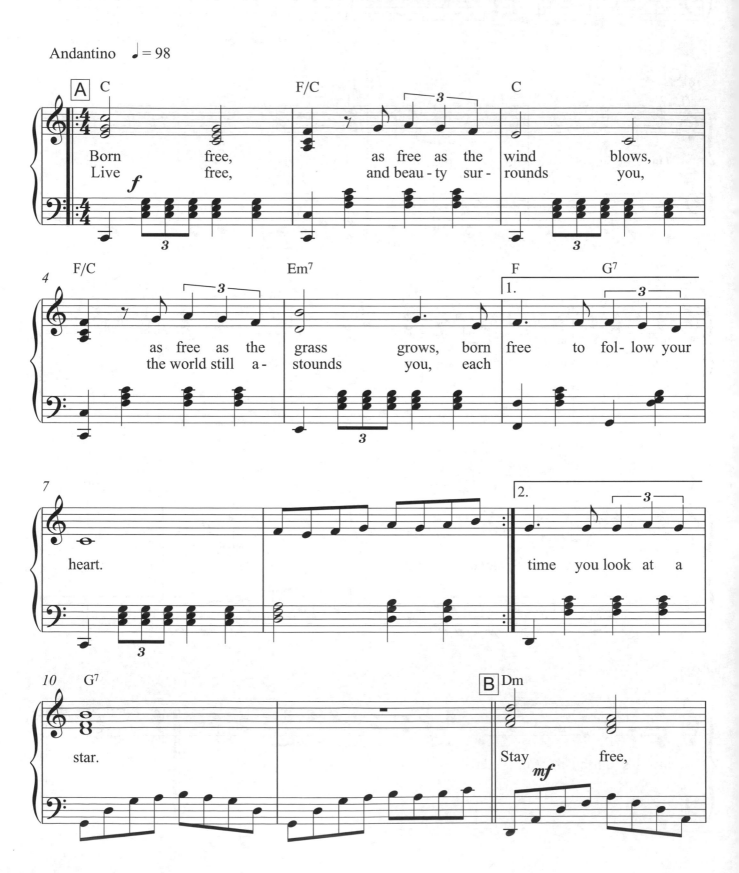

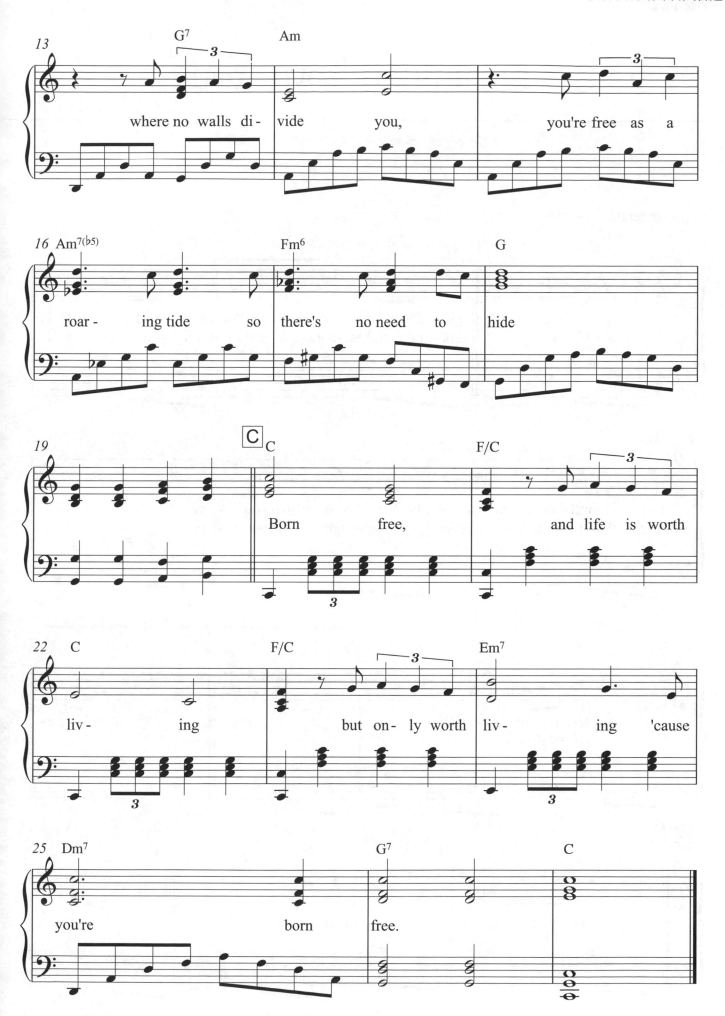

Because I Love You

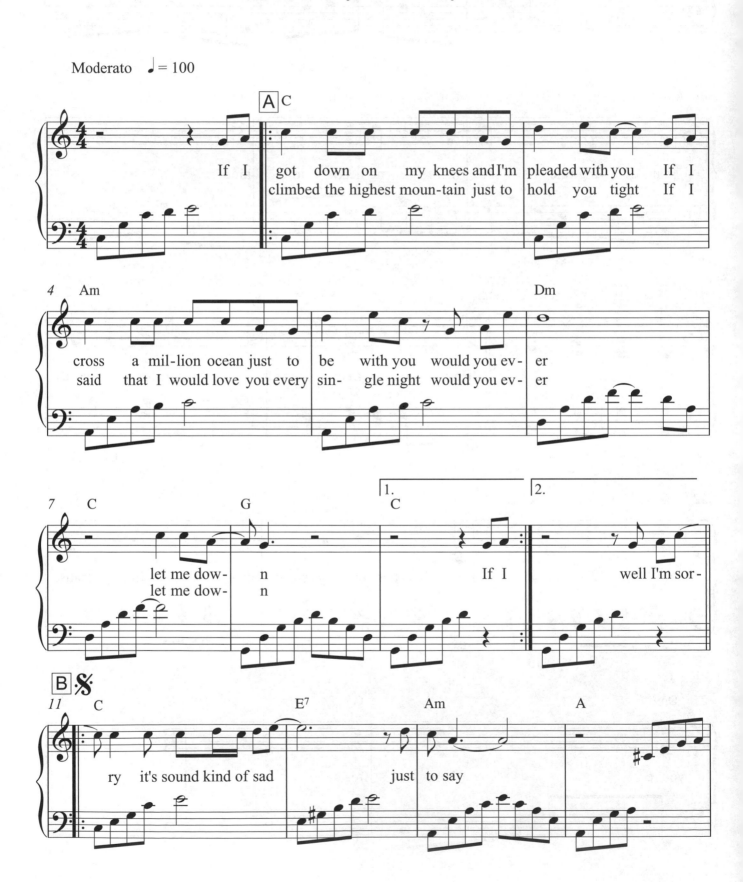

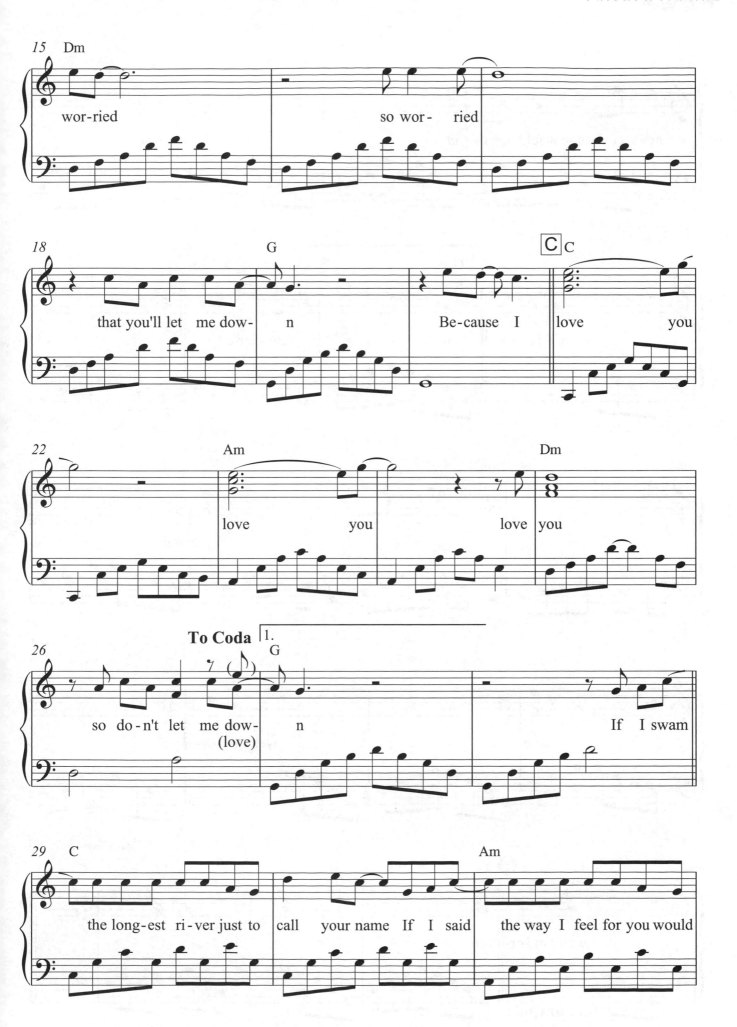

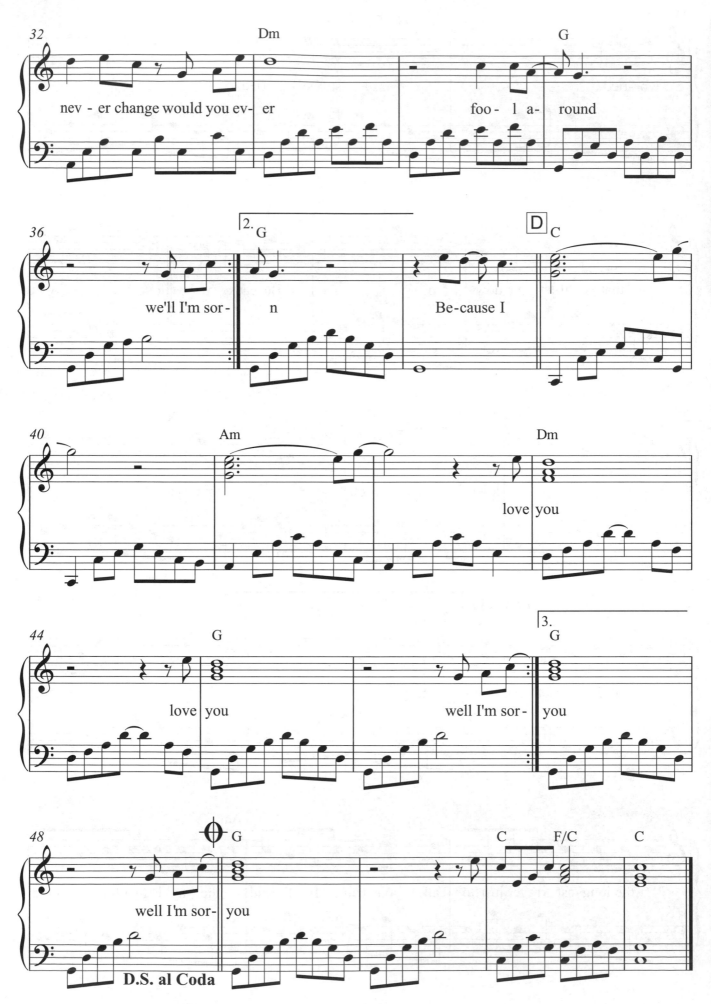

Bridge Over Troubled Water

詞 / 曲：Paul Simon　演唱：Simon & Garfunkel

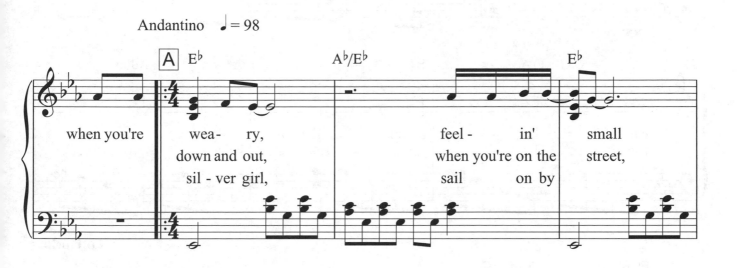

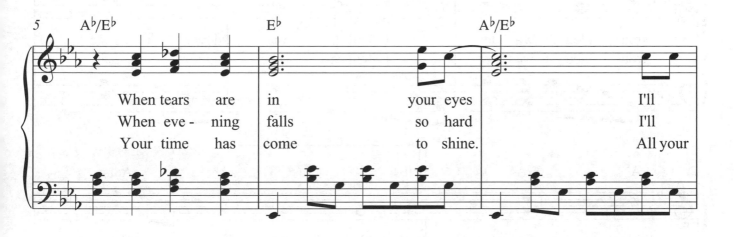

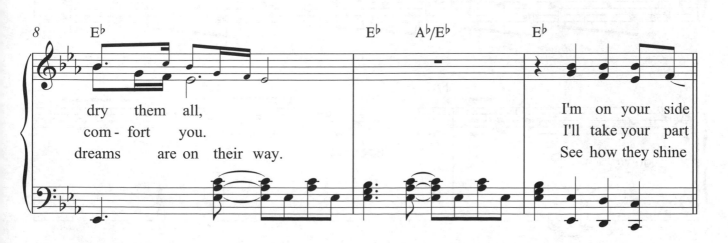

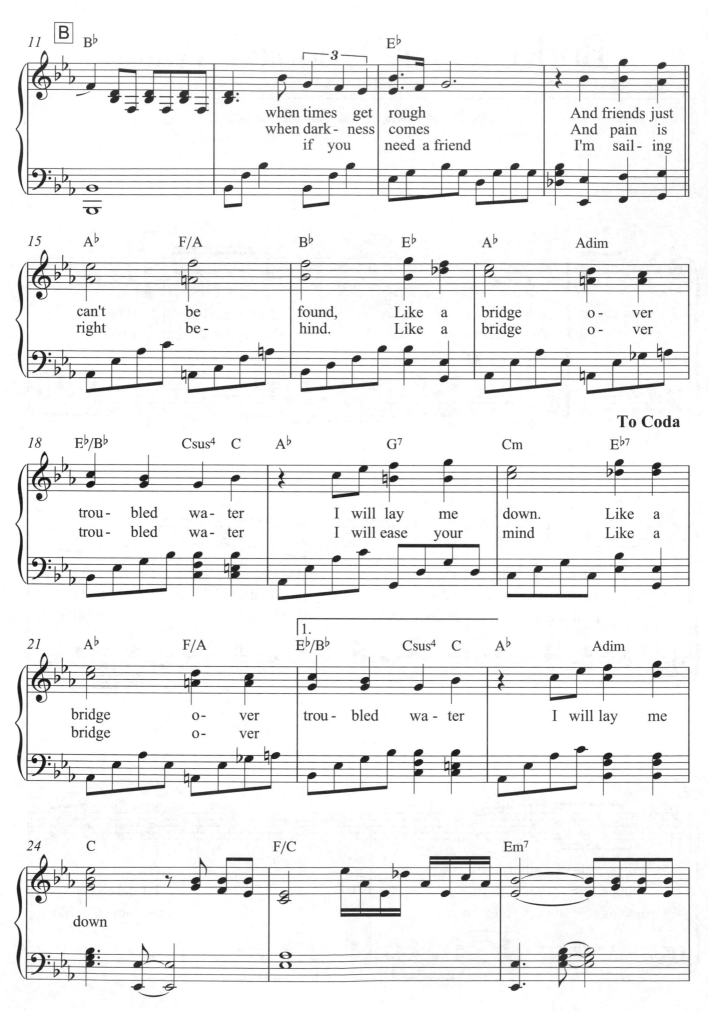

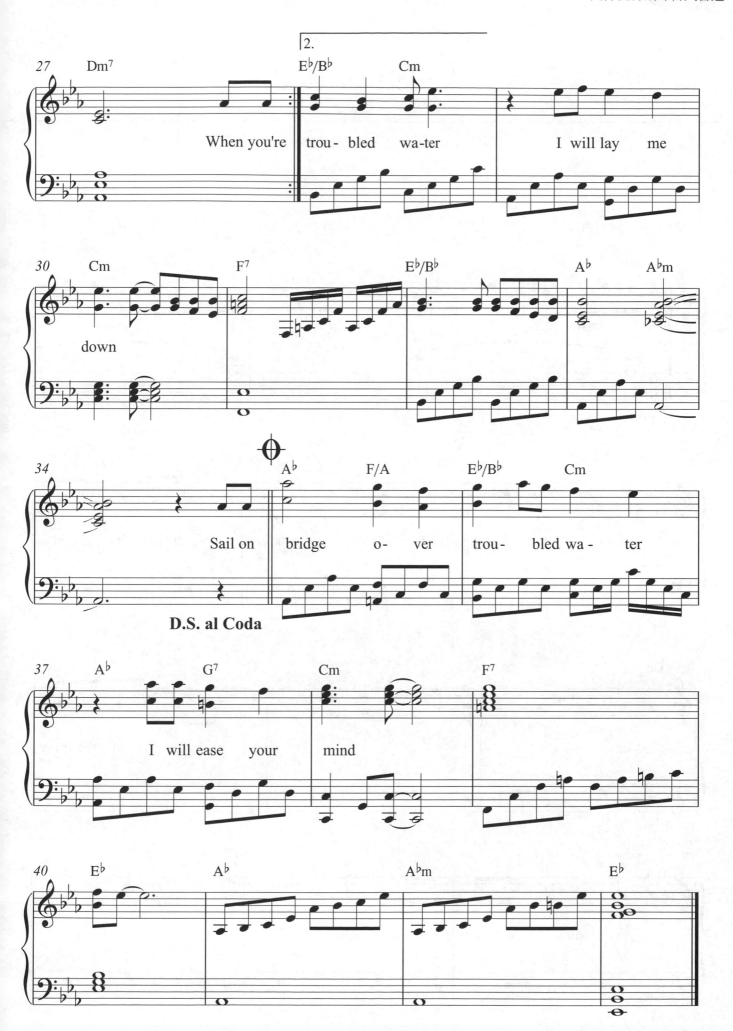

Casablanca

（電影《北非諜影》主題音樂）

詞／曲：B.Higgins／J.Healy　演唱：Bertie Higgins

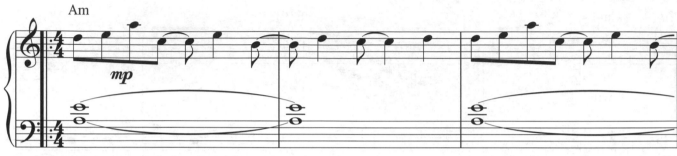

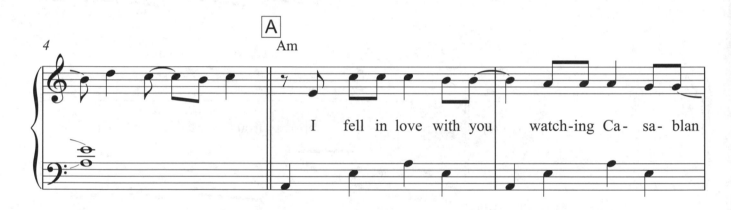

I fell in love with you watch-ing Ca- sa- blan

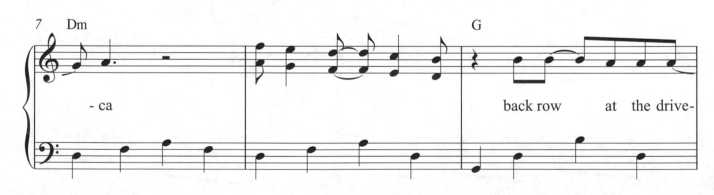

-ca　　　　　　　　　　　back row　at the drive-

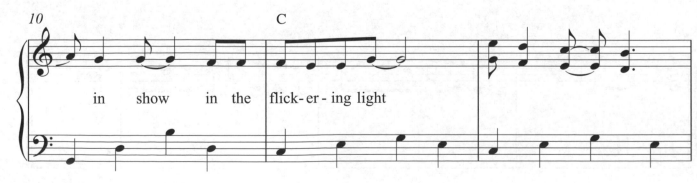

in show in the flick-er-ing light

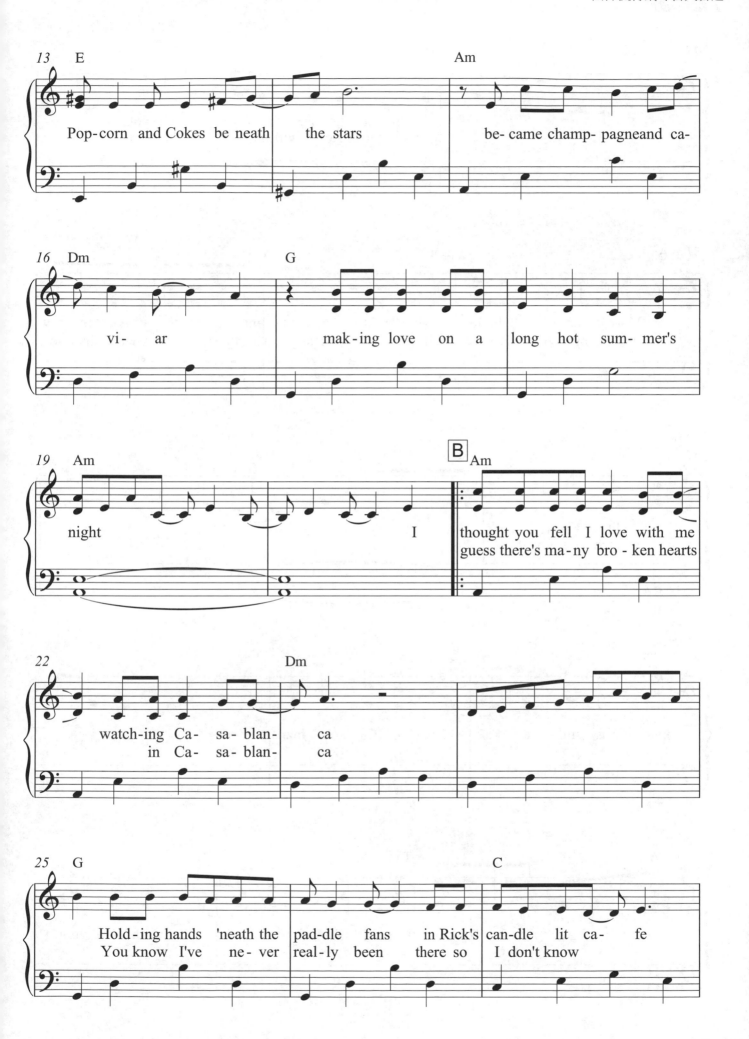

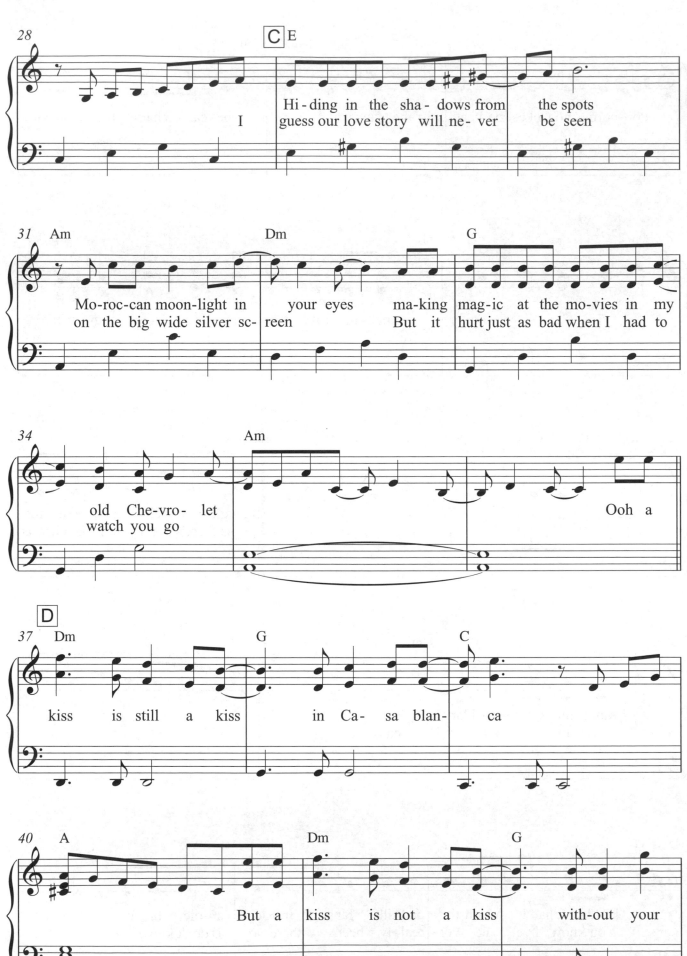

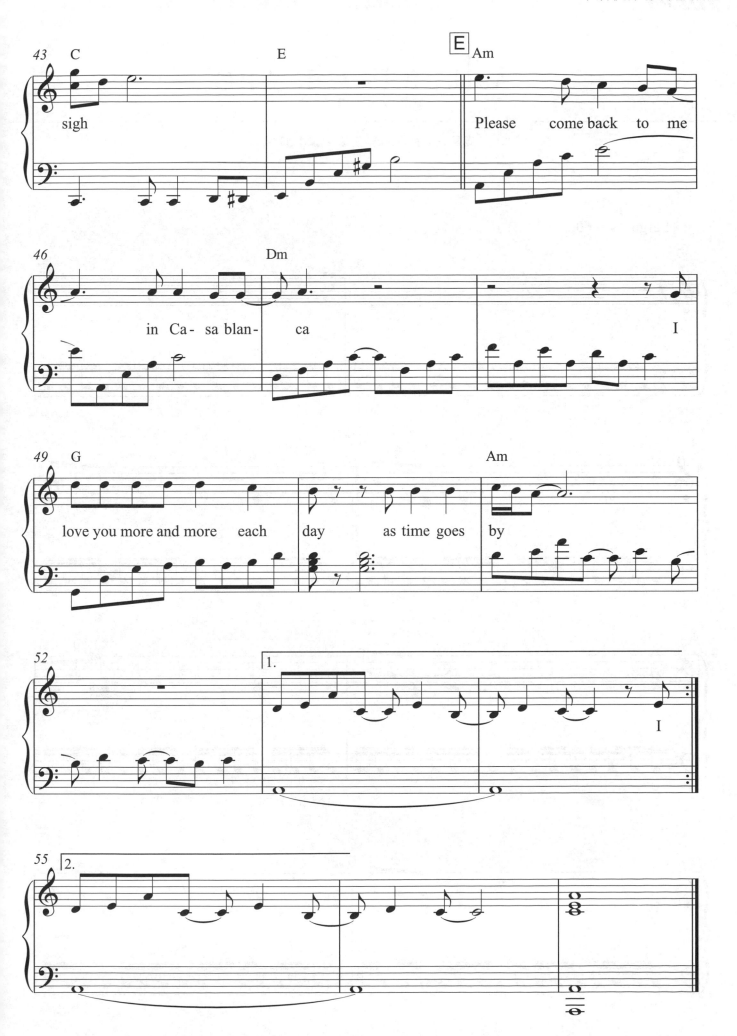

Chariots Of Fire

（電影《火戰車》主題音樂）

詞／曲：Vangelis 演唱：（演奏曲）

Largo　♩ = 60

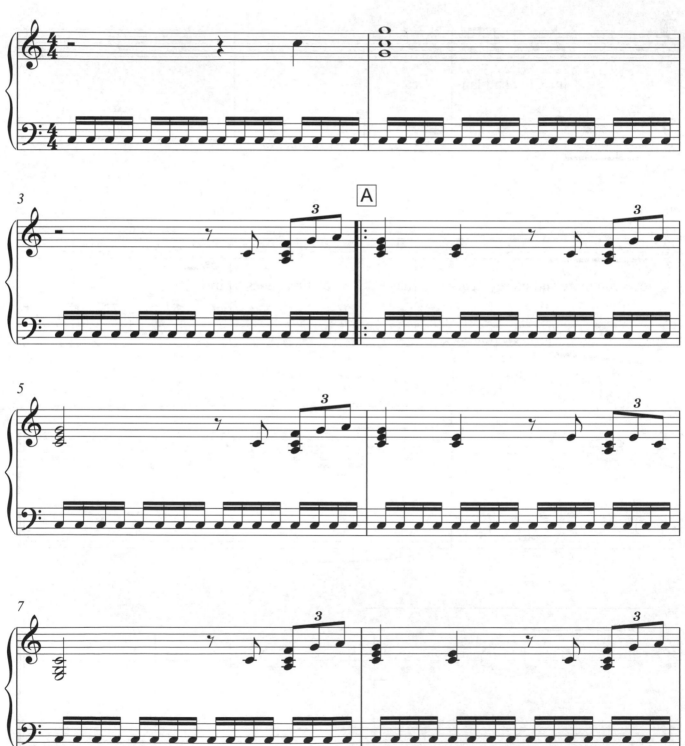

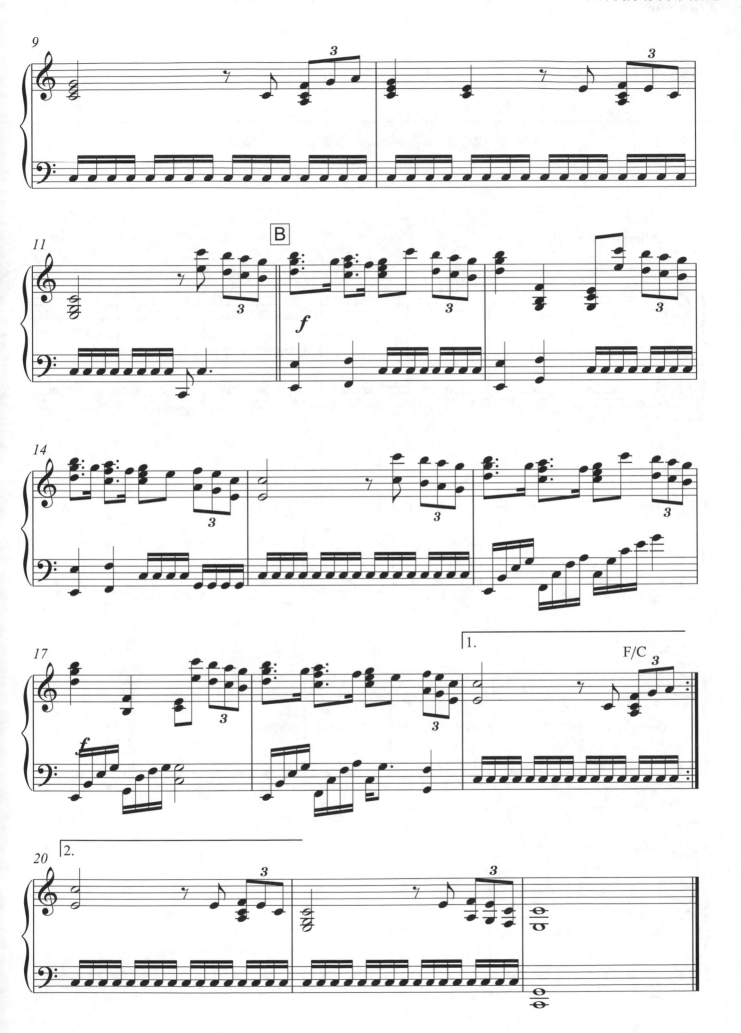

Charade

詞／曲：Henry Mancini　演唱：Andy Williams

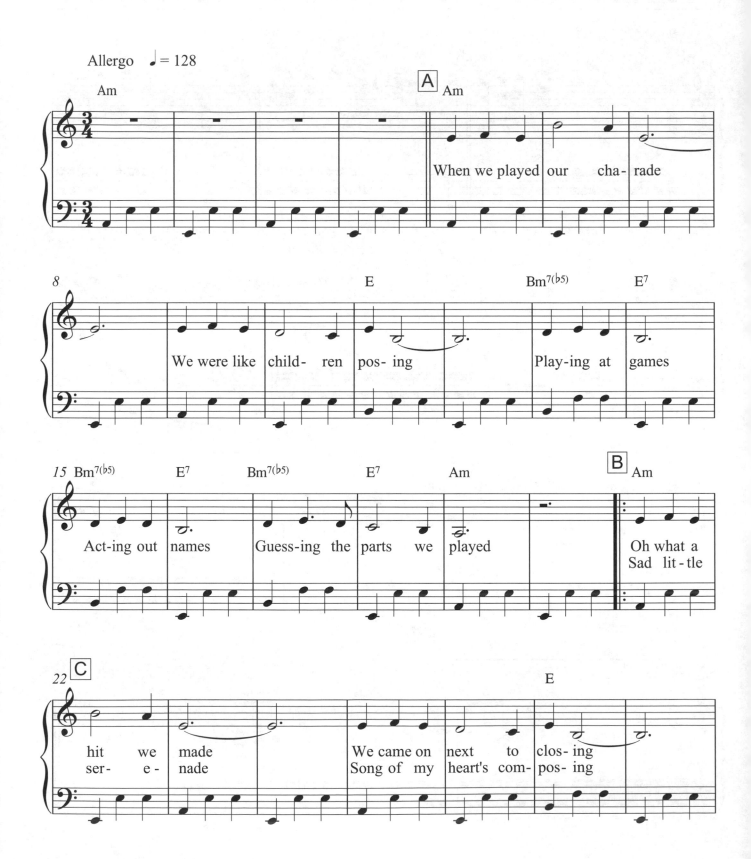

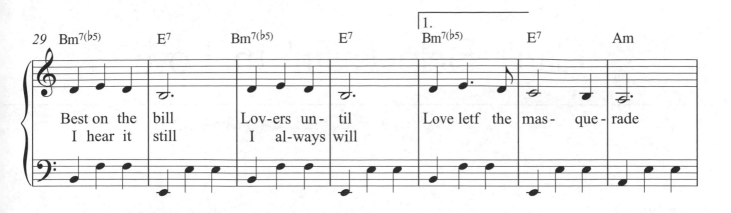

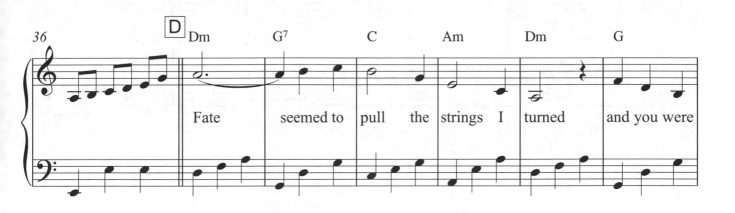

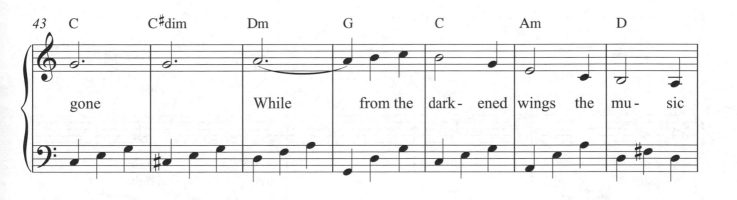

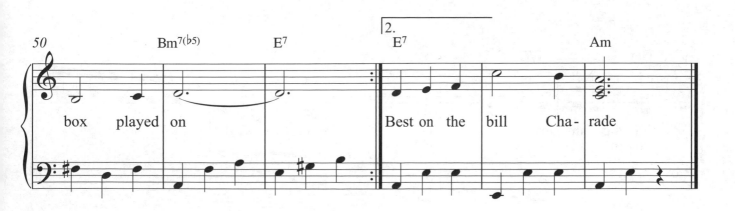

Can't Help Fallin' In Love

詞／曲：George Weiss / Hugo Perett / Luigi Creatore　演唱：Elvis Presley

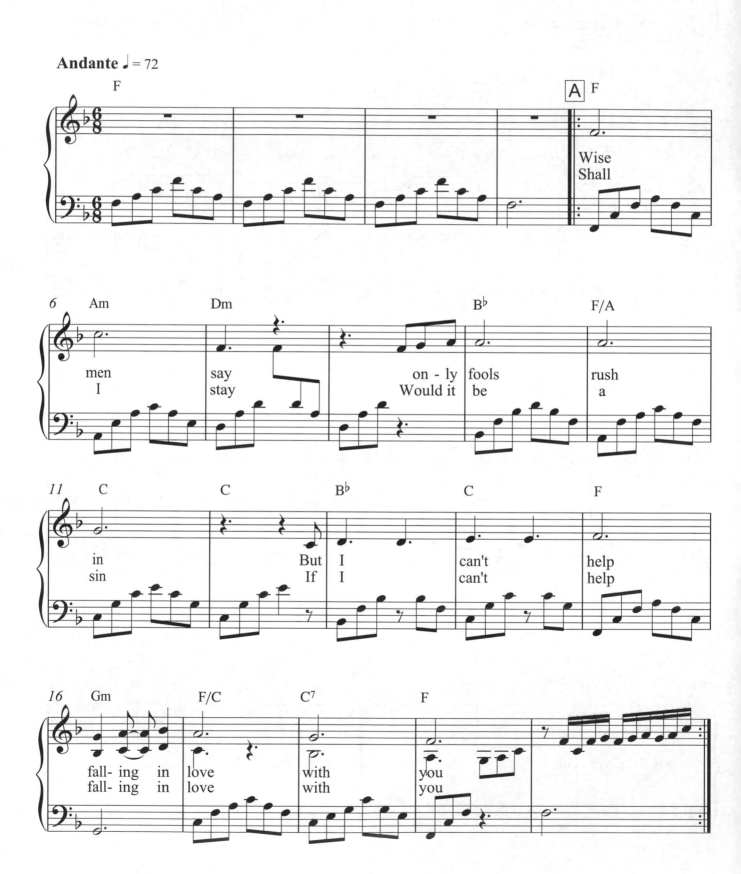

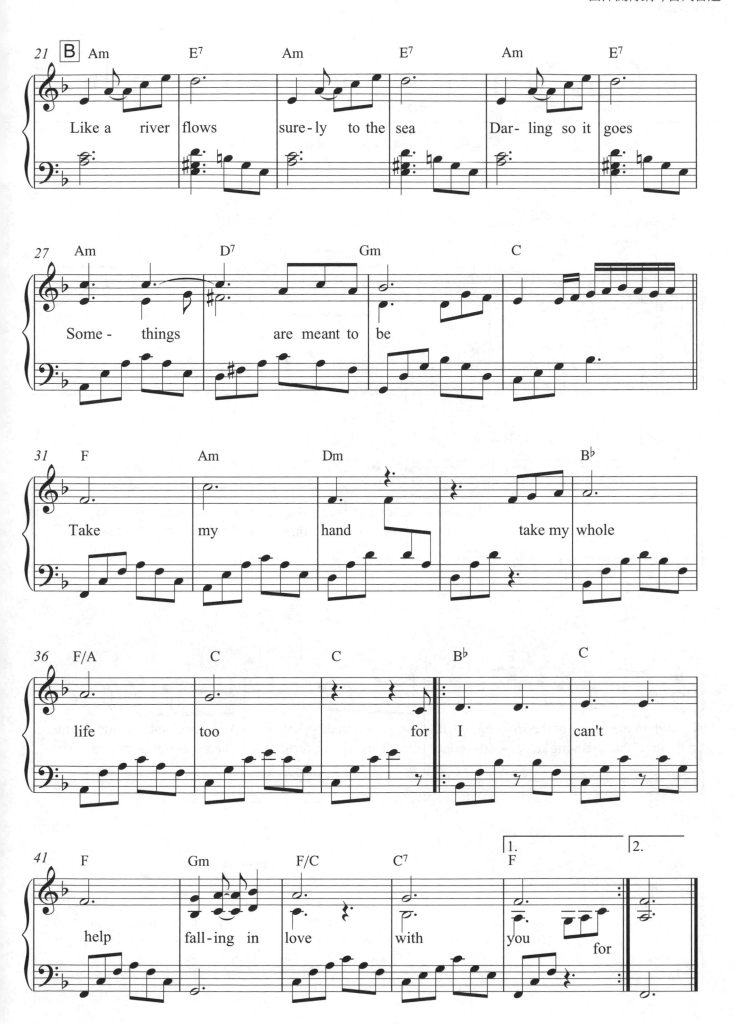

Can You Feel The Love Tonight

（動畫《獅子王》主題曲）

詞 / 曲：Tim Rice / Elton John　演唱：Elton John

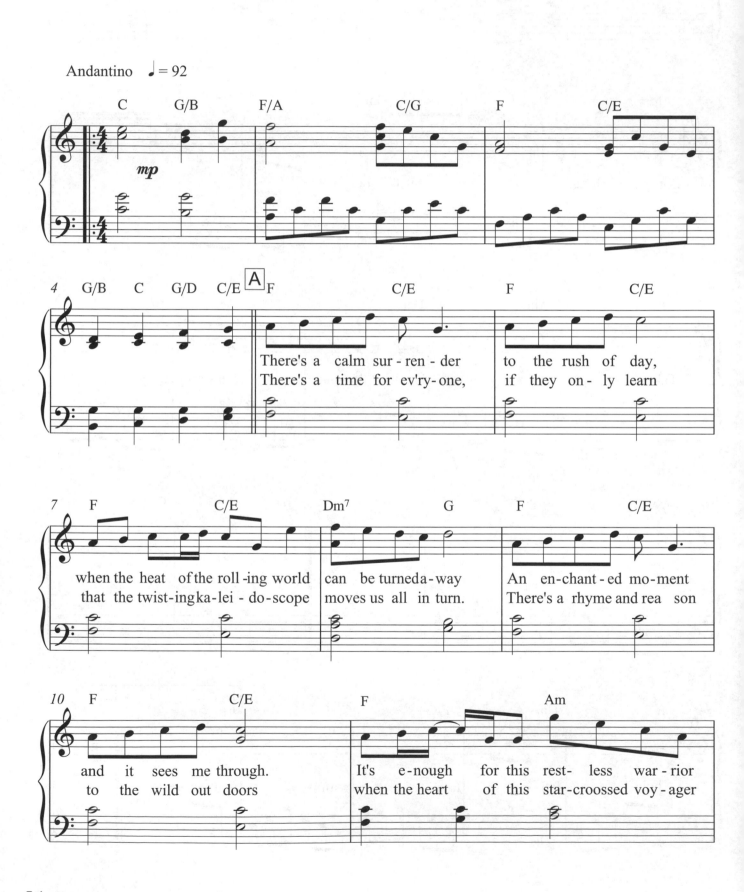

Andantino ♩ = 92

There's a calm sur-ren-der to the rush of day,
There's a time for ev'ry-one, if they on-ly learn

when the heat of the roll-ing world can be turned a-way
that the twist-ing ka-lei-do-scope moves us all in turn.

An en-chant-ed mo-ment
There's a rhyme and rea son

and it sees me through.
to the wild out doors

It's e-nough for this rest-less war-rior
when the heart of this star-croossed voy-ager

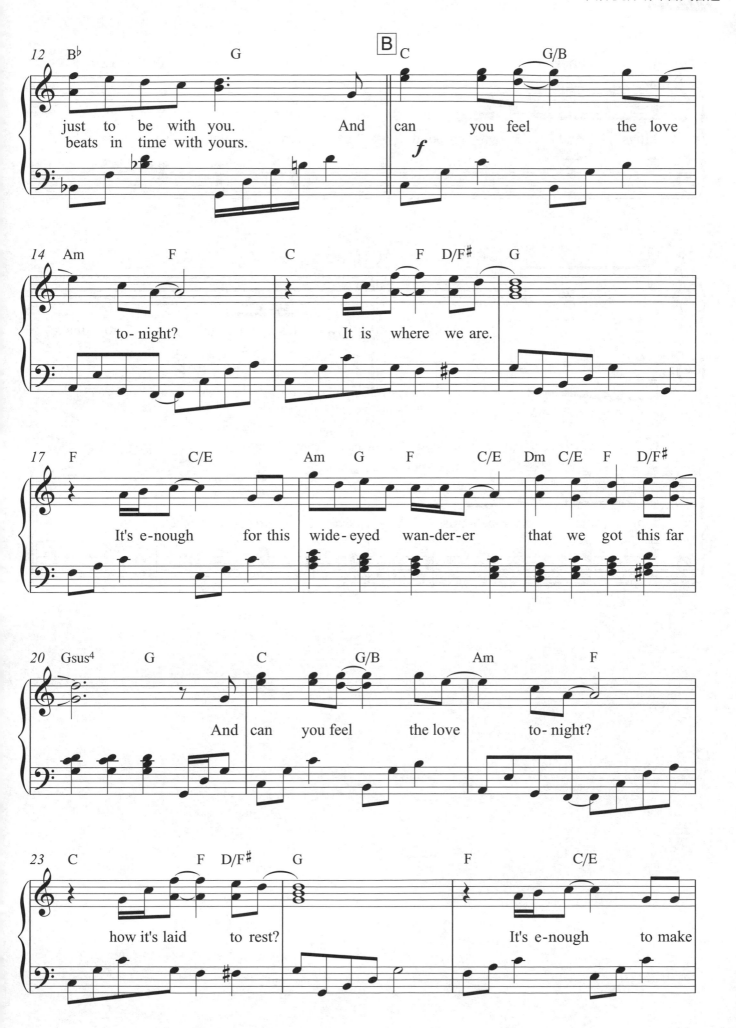

Careless Whisper

詞／曲：George Michael / Andrew Ridgeley　演唱：Wham

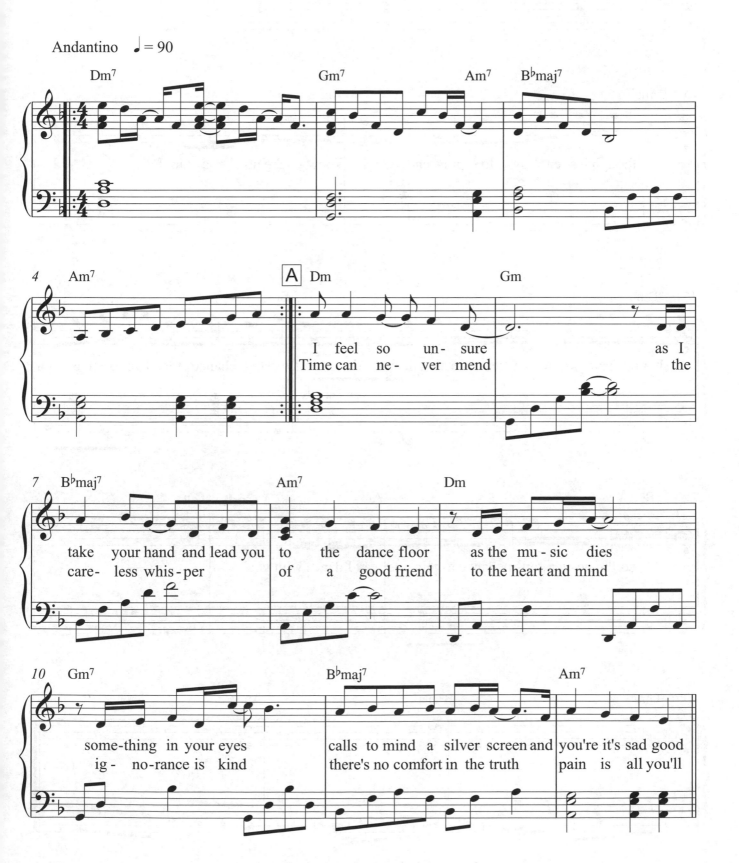

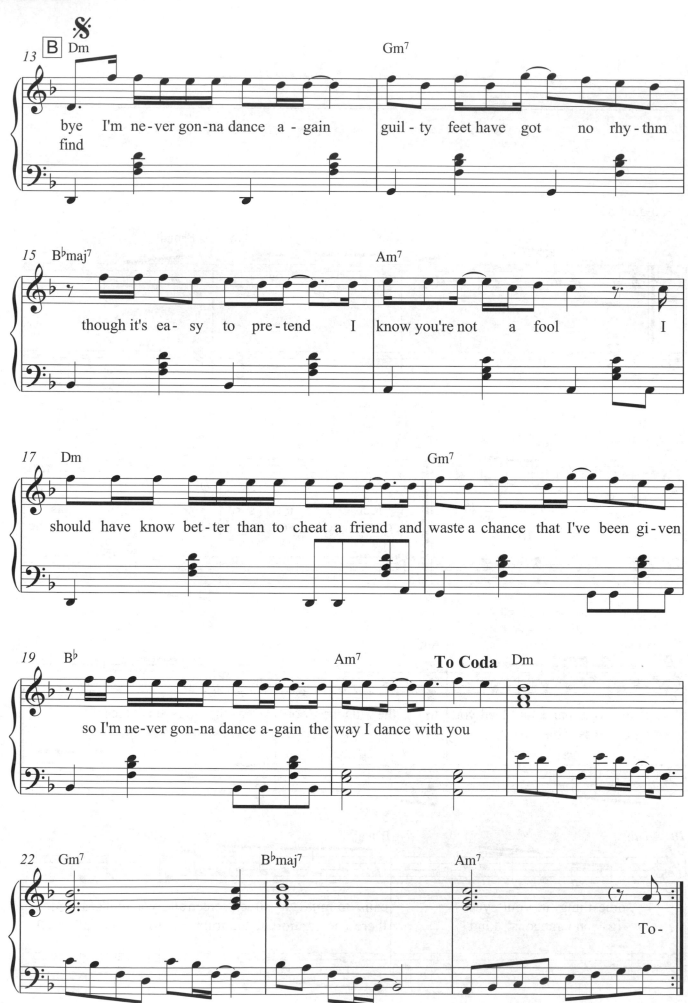

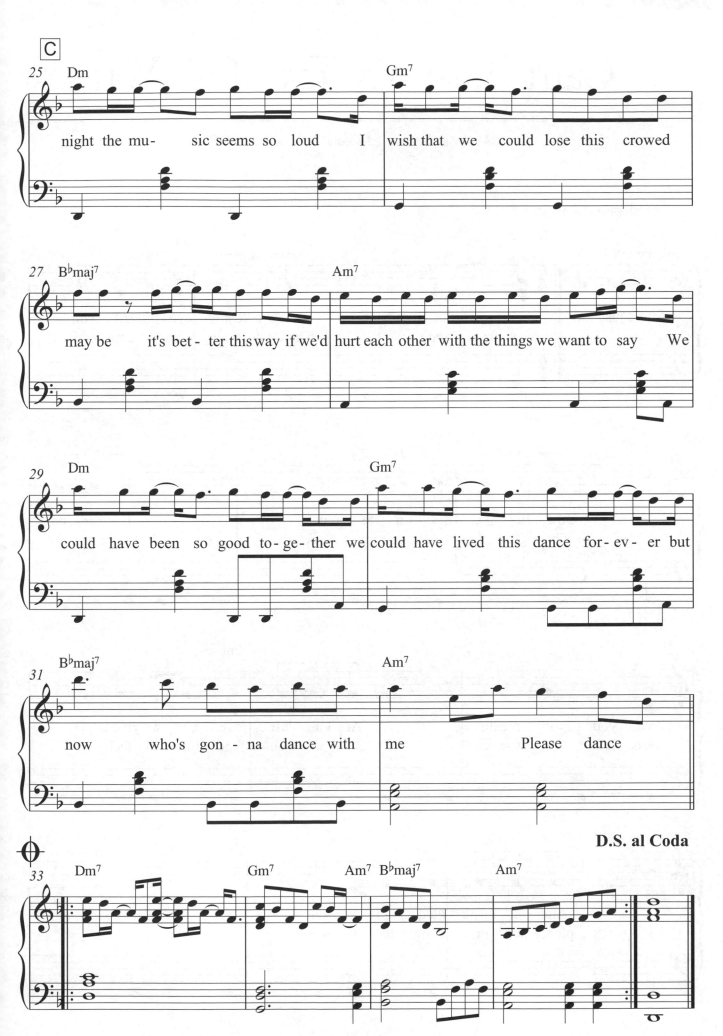

Can't Take My Eyes Off You

詞 / 曲：Bob Crewe / Bob Gaudio 演唱：Frankie Valli

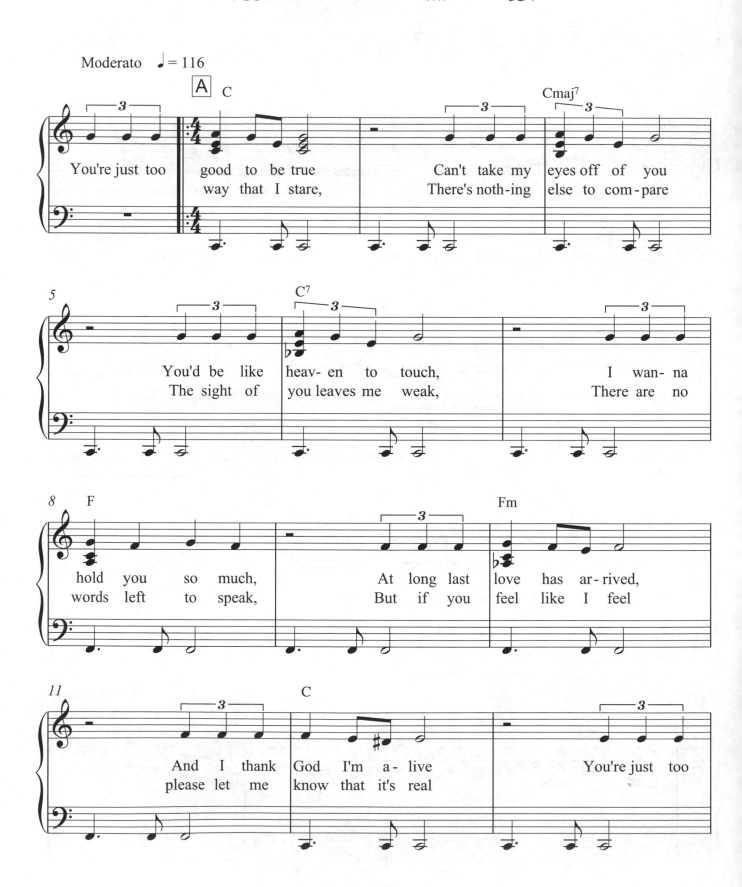

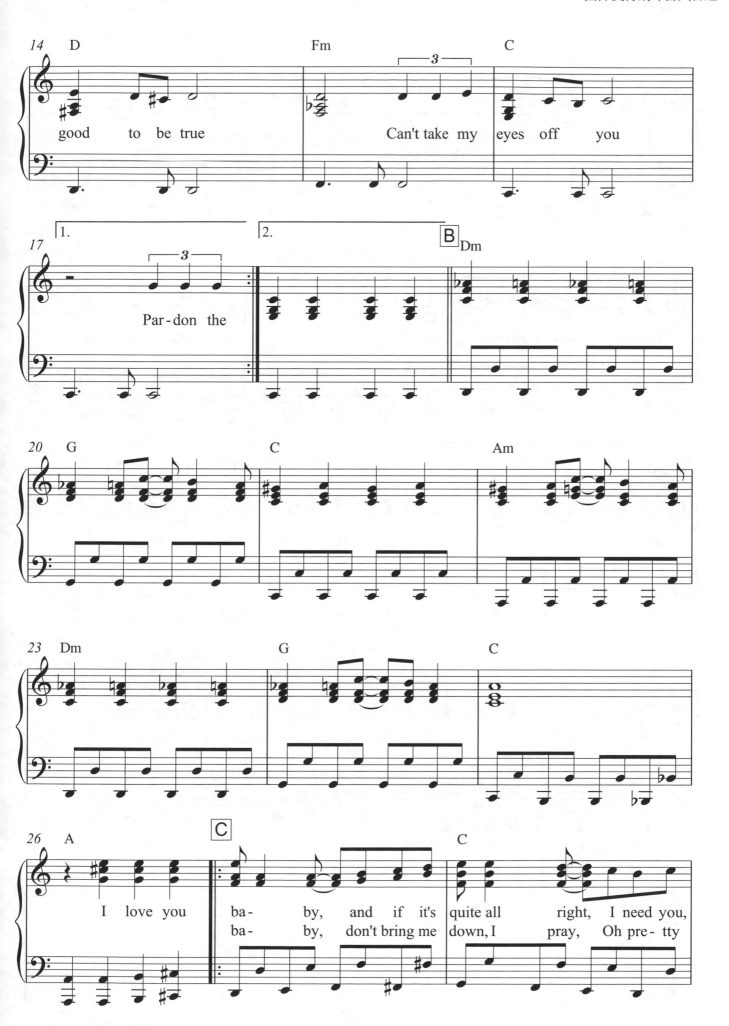

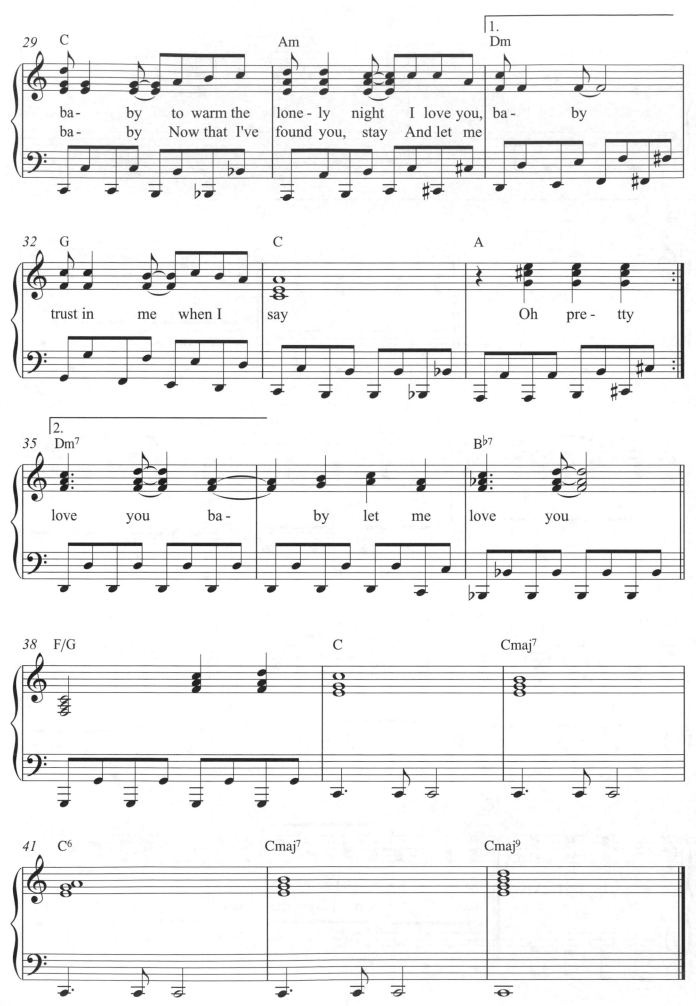

Colors Of The Wind

（動畫《風中奇緣》主題曲）

詞／曲：Stephen Schwartz / Alan Menken　演唱：Vanessa Williams

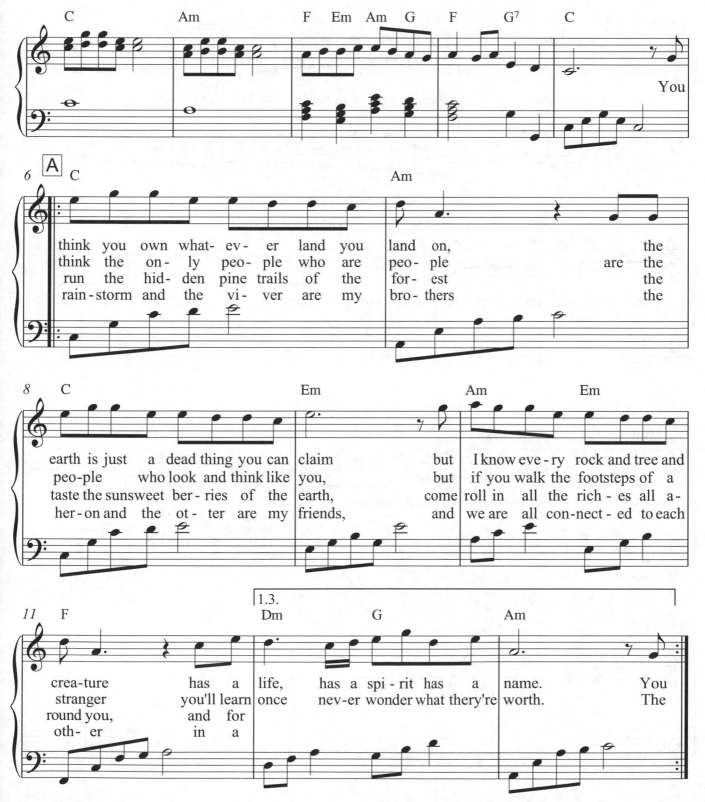

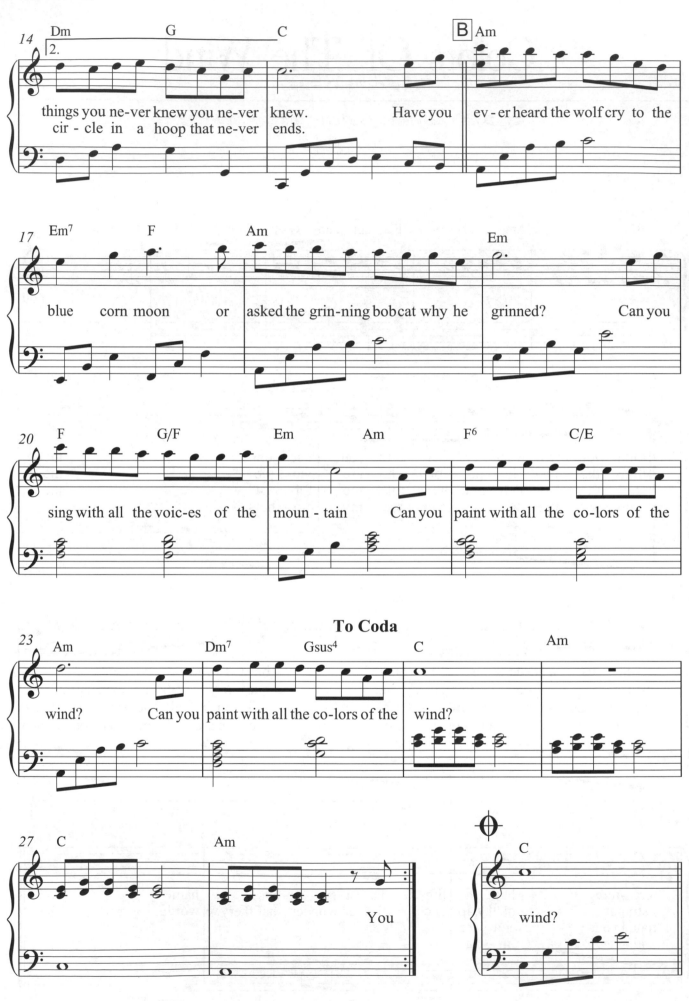

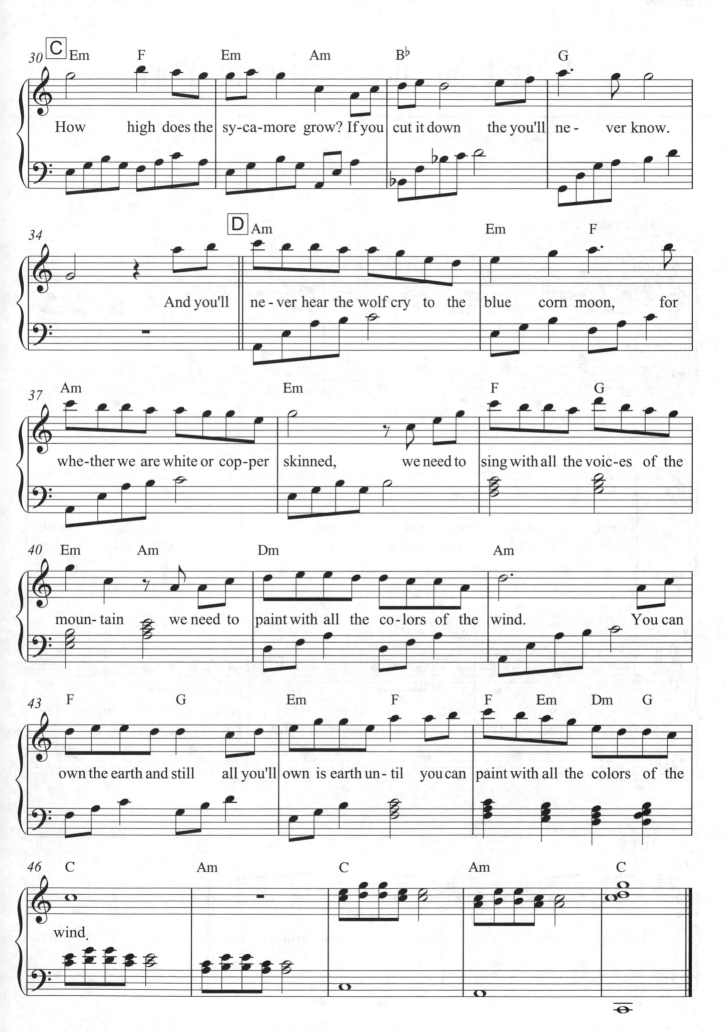

Can't Smile Without You

詞／曲：Chris Arnold／David Martin／Geoff Morrow　演唱：The Carpenters

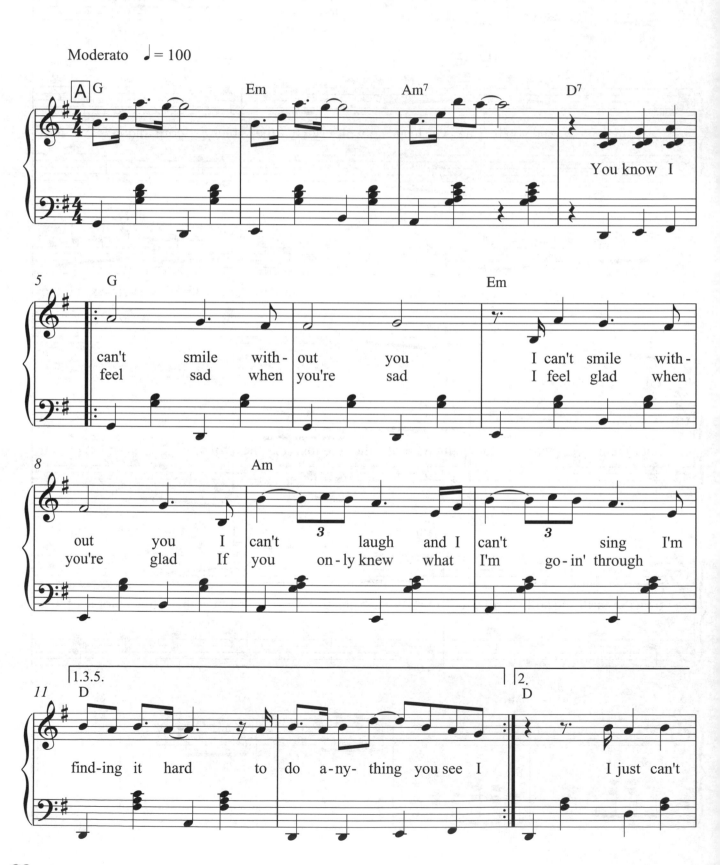

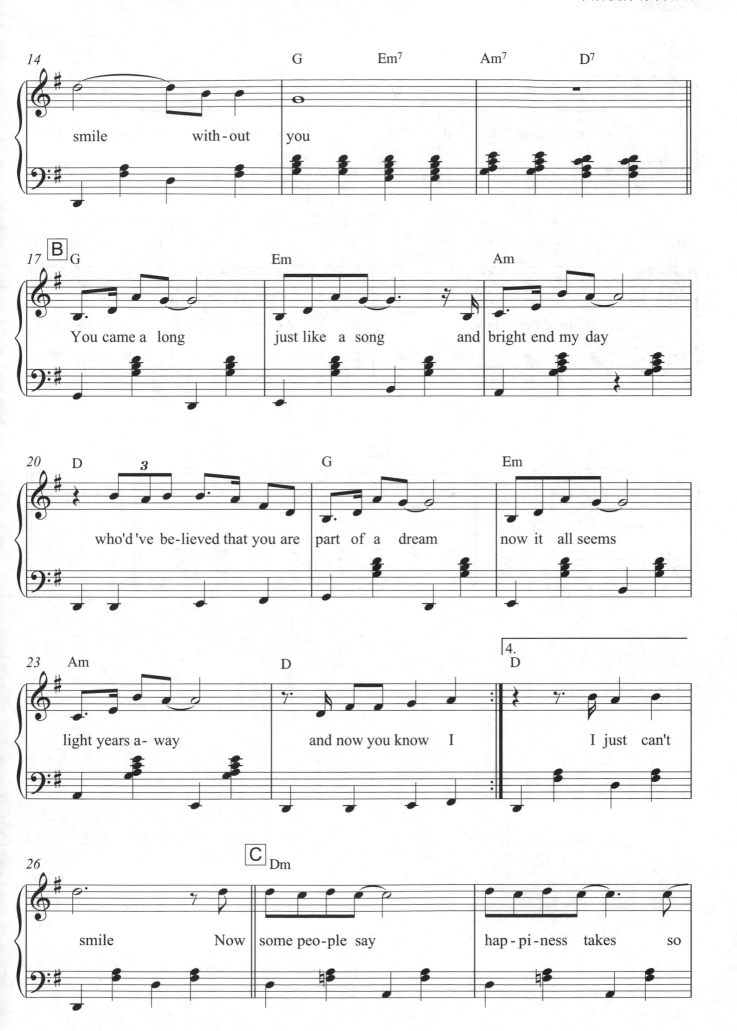

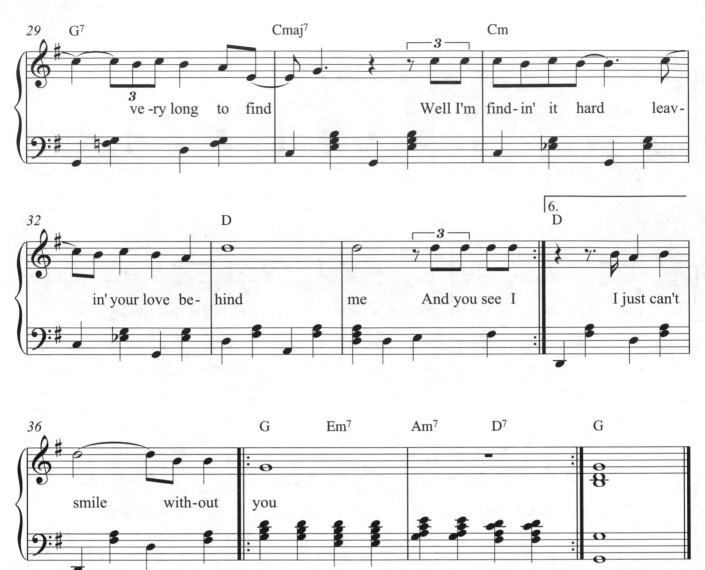

Danny Boy

西洋流行鋼琴百大首選

詞／曲：Frederic E.Weatherly　演唱：Elvis Presley

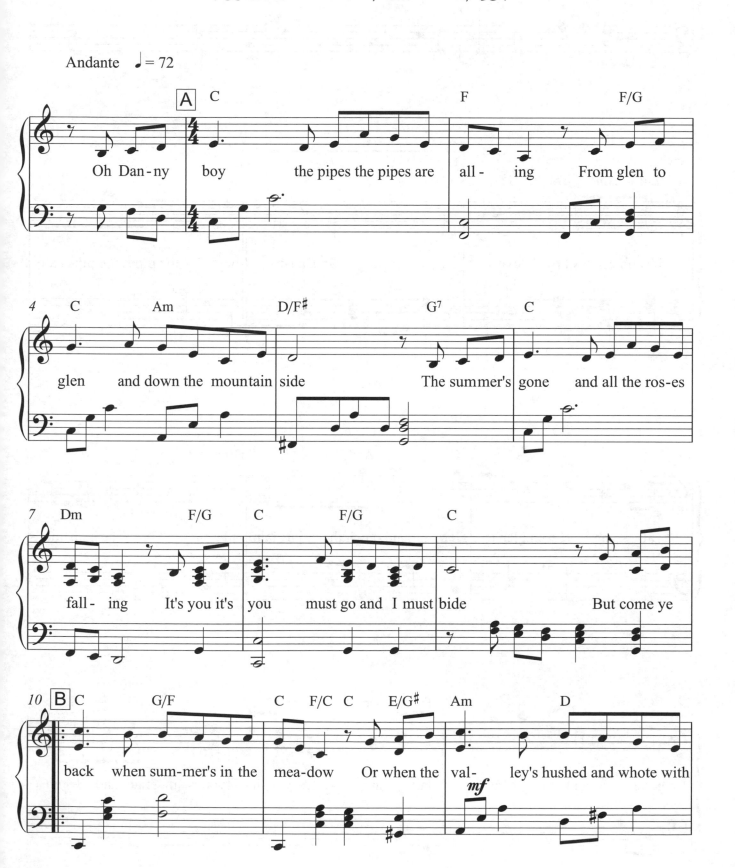

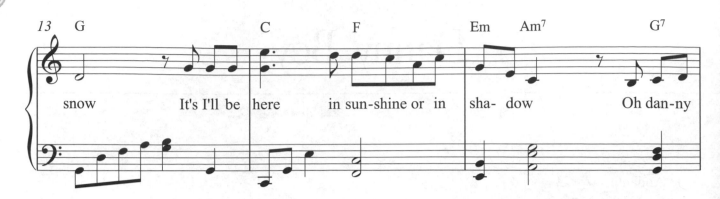

snow It's I'll be here in sun-shine or in sha- dow Oh dan-ny

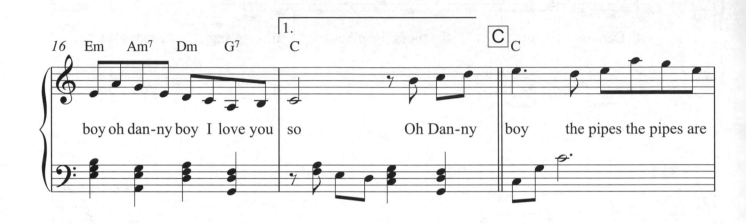

boy oh dan-ny boy I love you so Oh Dan-ny boy the pipes the pipes are

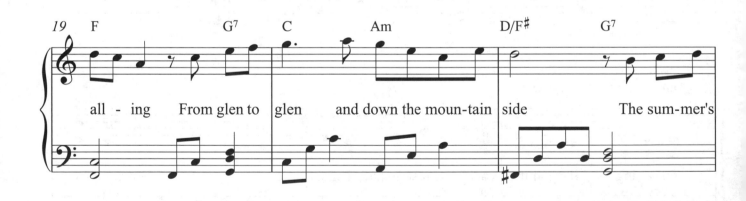

all - ing From glen to glen and down the moun-tain side The sum-mer's

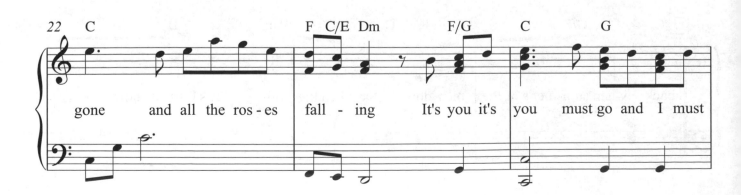

gone and all the ros - es fall - ing It's you it's you must go and I must

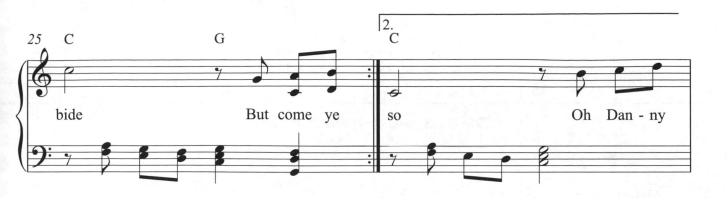

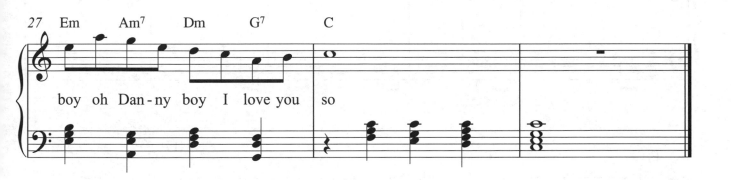

Dying Young

詞／曲：James Newton Howard　演奏：Kenny.G

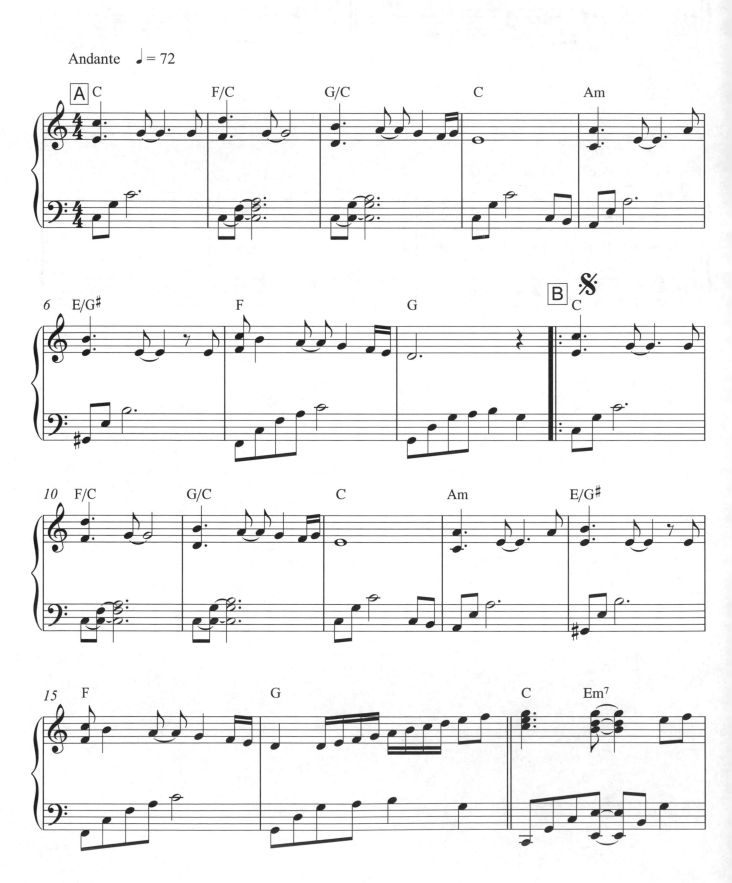

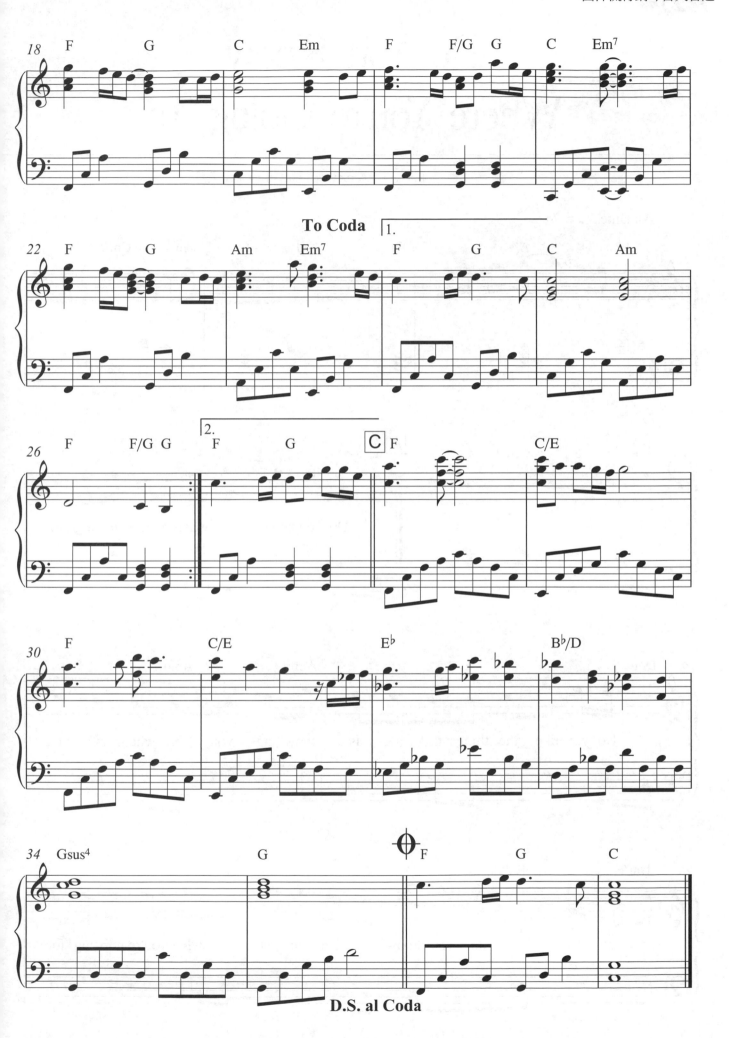

Do You Know
Where You're Going To

詞／曲：Michael Masser／Gerald Goffin　演唱：Diana Ross

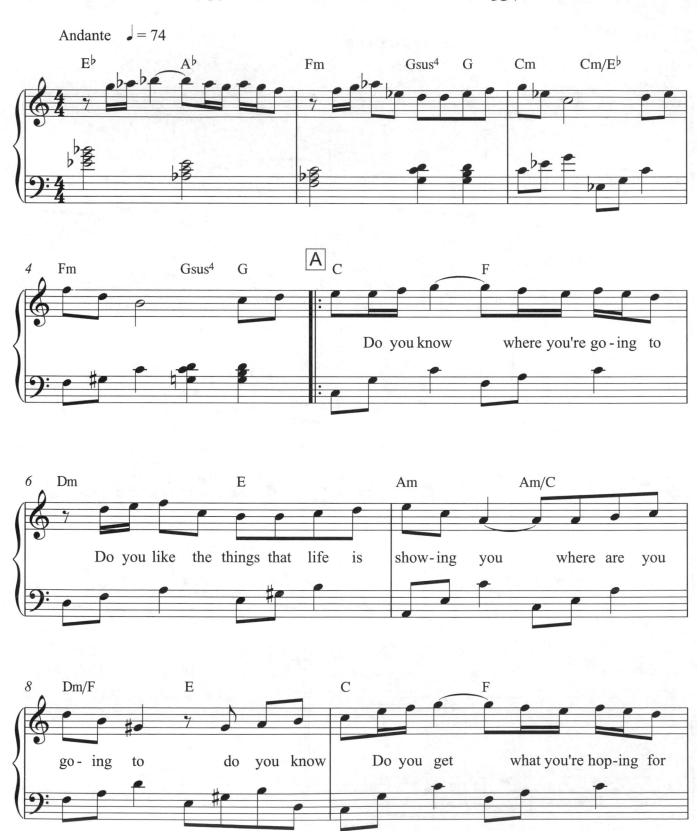

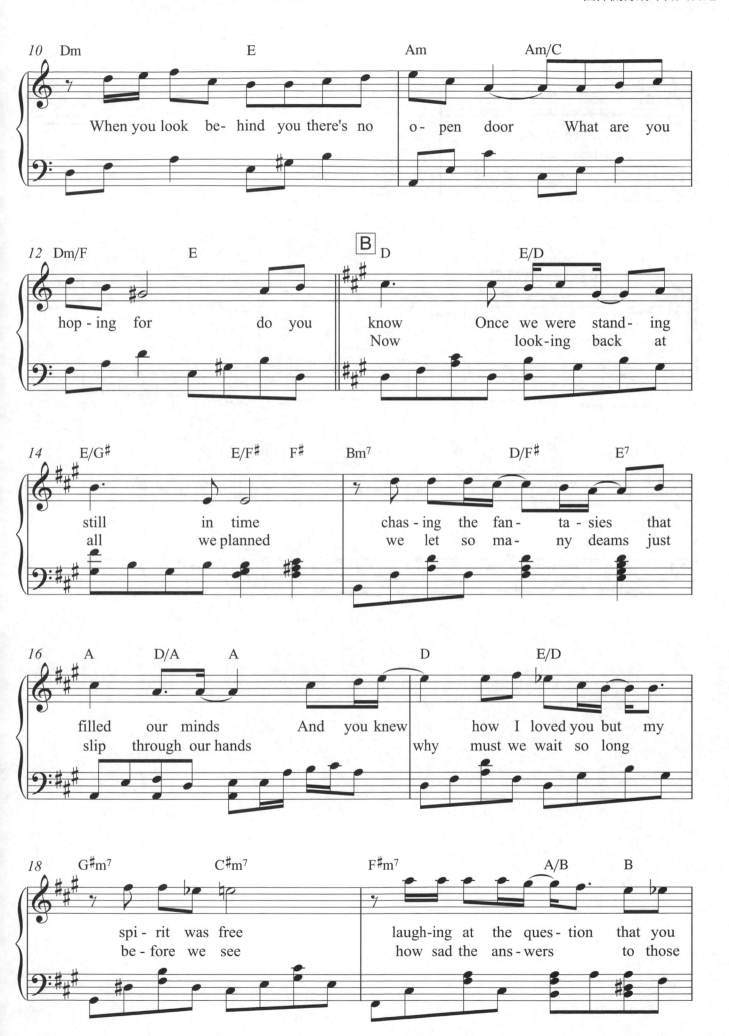

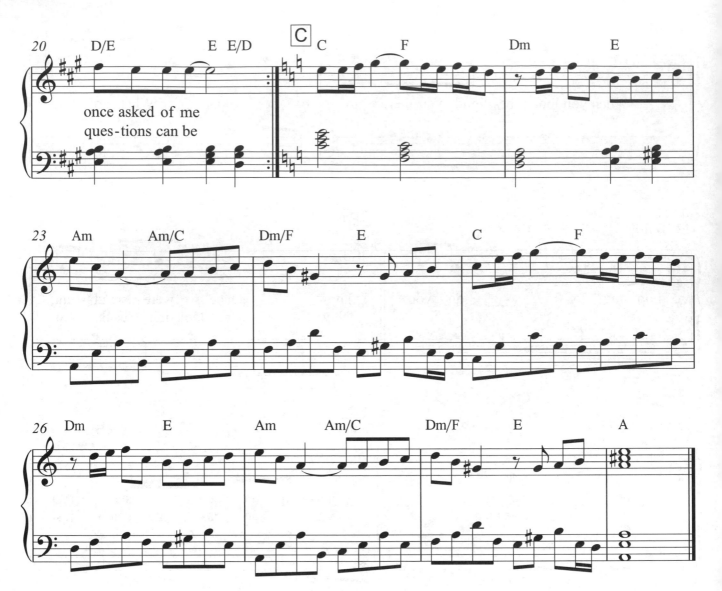

once asked of me
ques-tions can be

Don't Cry For Me Argentina

（電影《阿根廷，別為我哭泣》主題曲）

詞／曲：Andrew Lloyd Webber / Tim Rice　演唱：Madonna

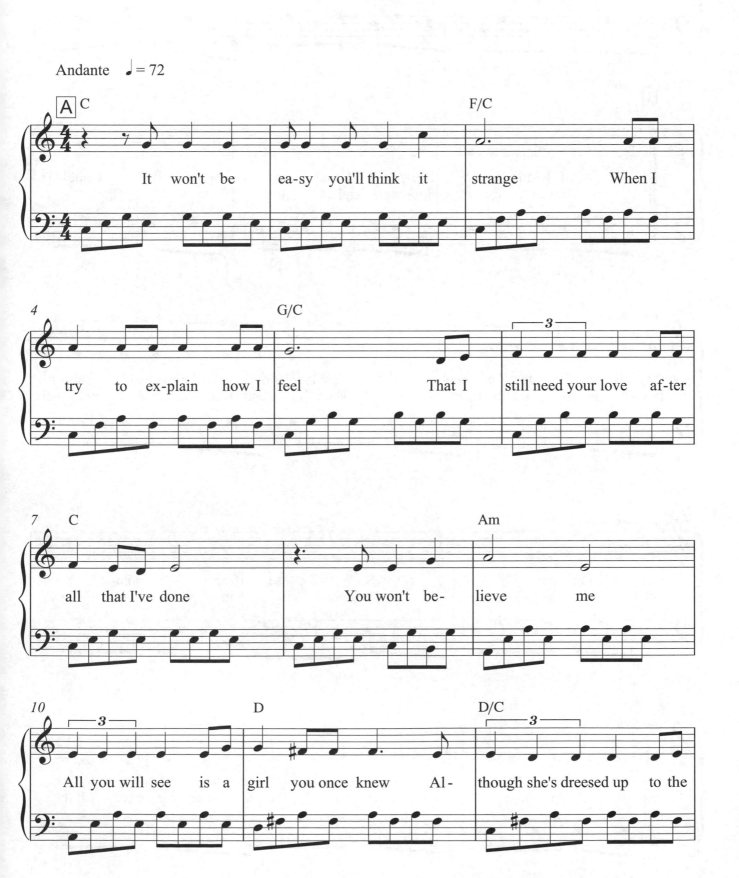

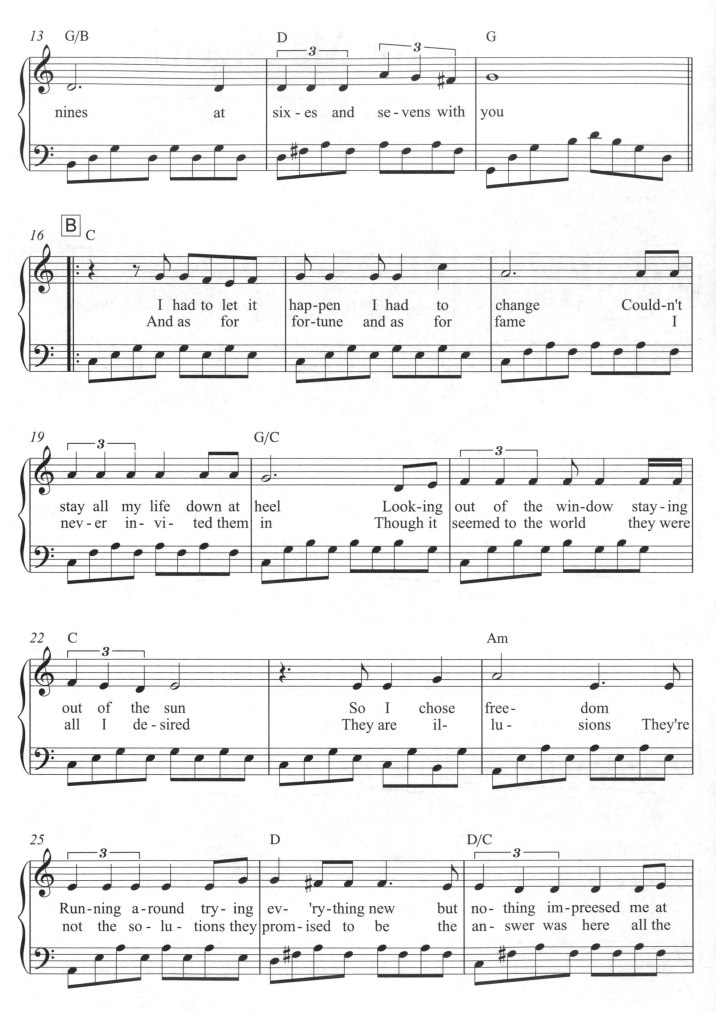

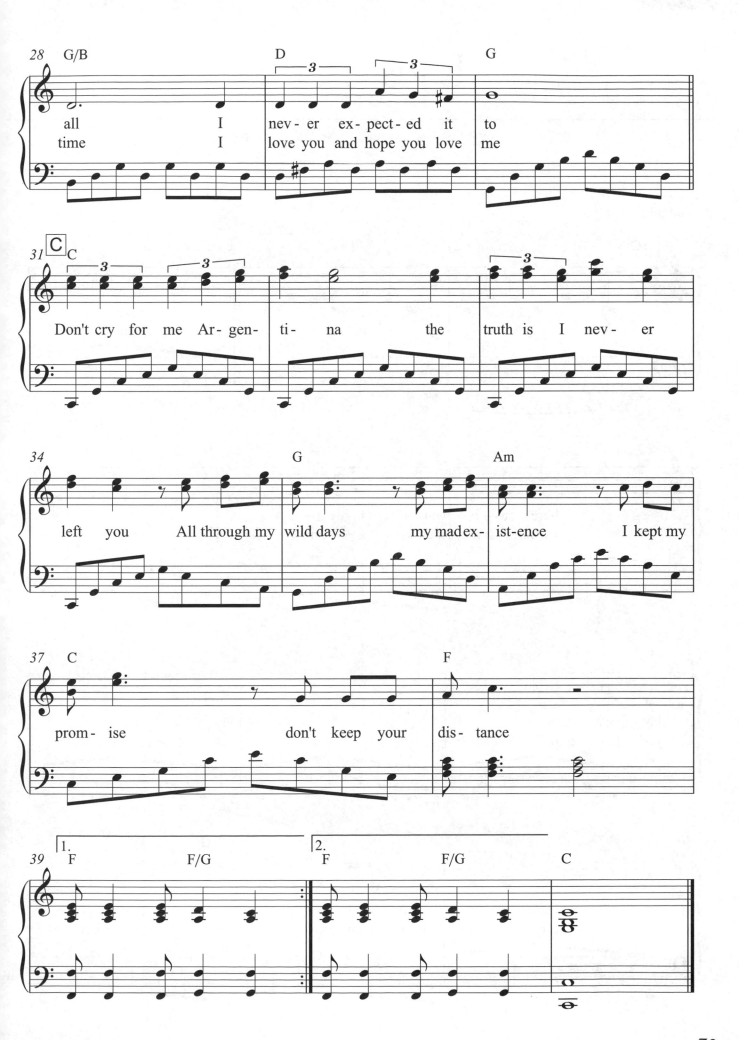

Endless Love

（電影《無盡的愛》主題曲）

詞／曲：Lionel Richie　演唱：Lionel Richie

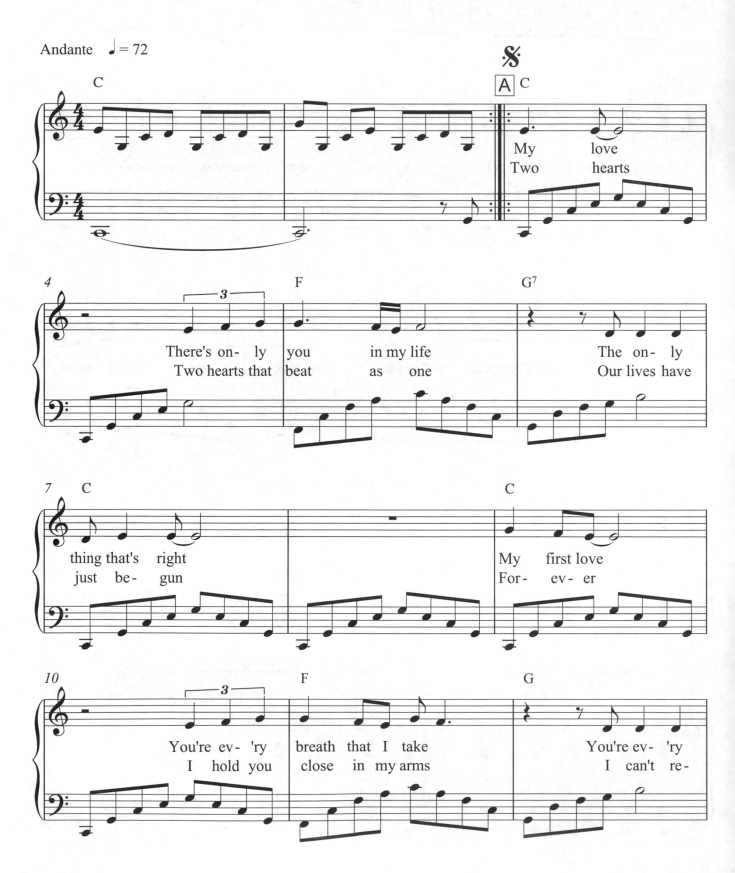

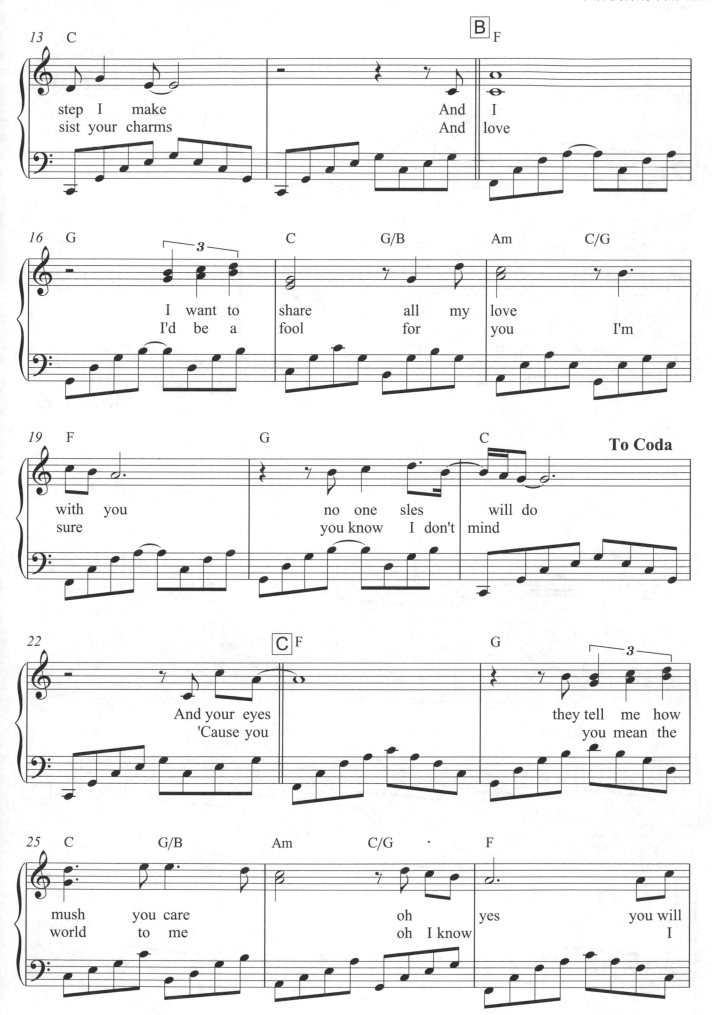

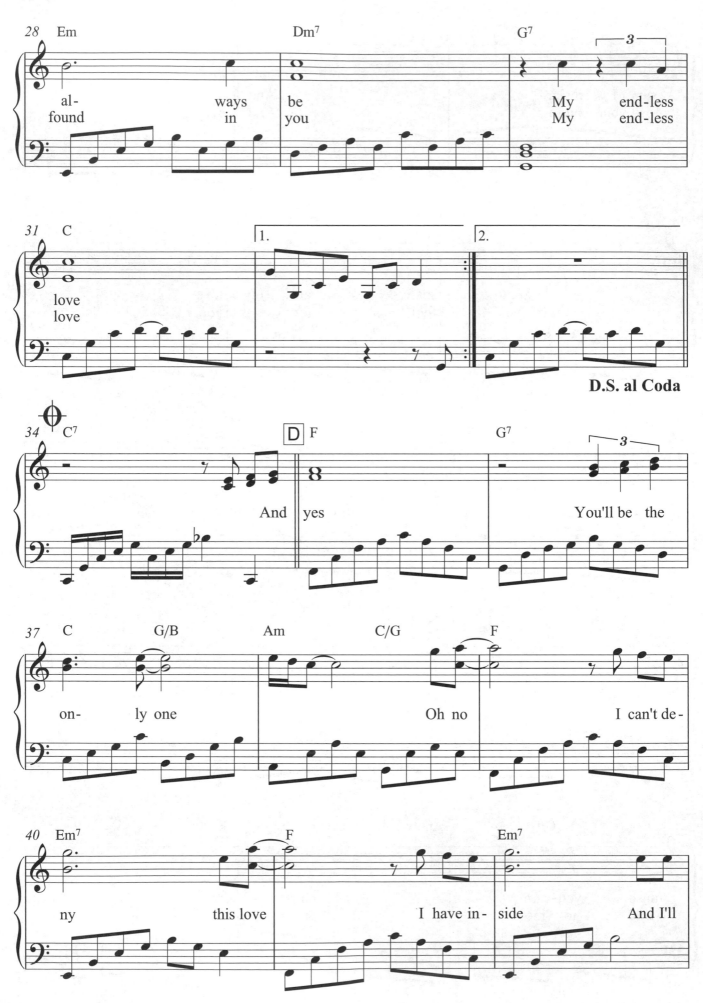

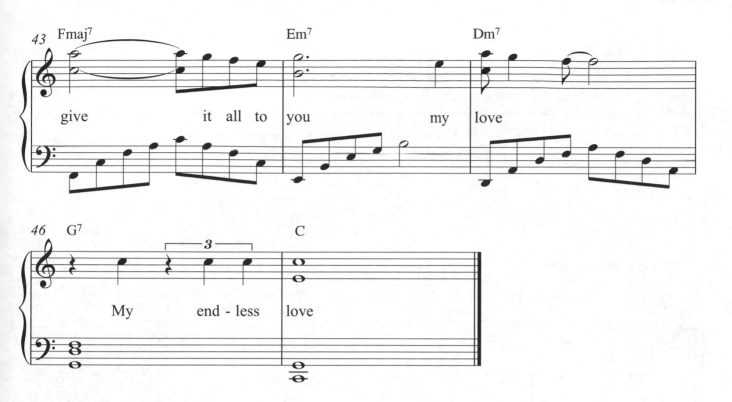

give it all to you my love

My end-less love

Edelweiss

（電影《真善美》插曲）

詞／曲：Richard Rodgers／Oscar Hammerstein　演唱：Ray Conniff

Moderato ♩= 100

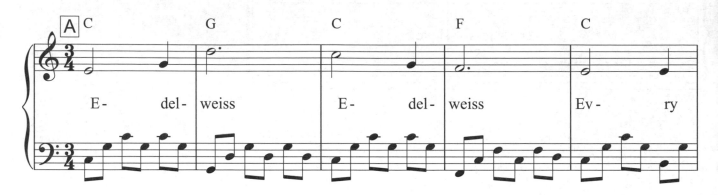

E- del- weiss　E- del- weiss　Ev- ry

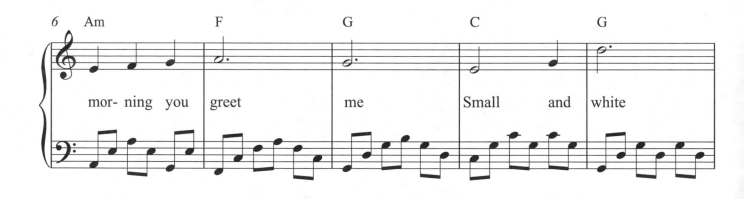

mor- ning you greet　me　Small and white

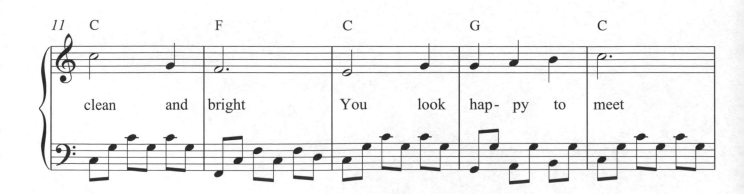

clean and bright　You look hap- py to meet

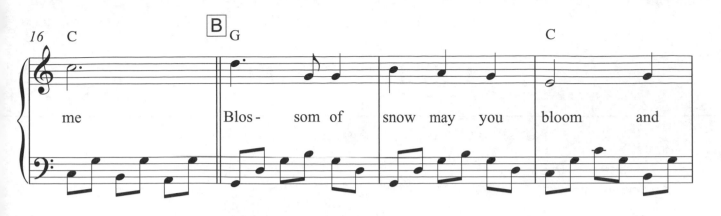

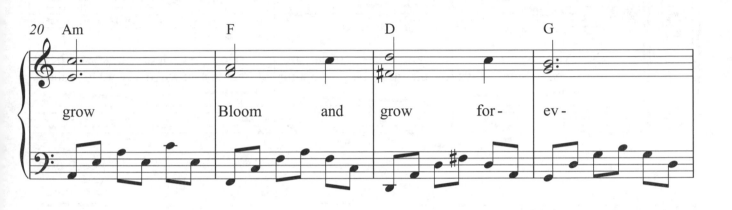

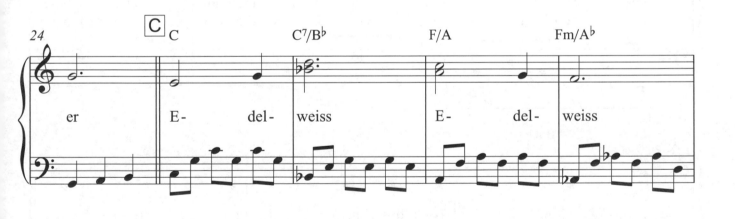

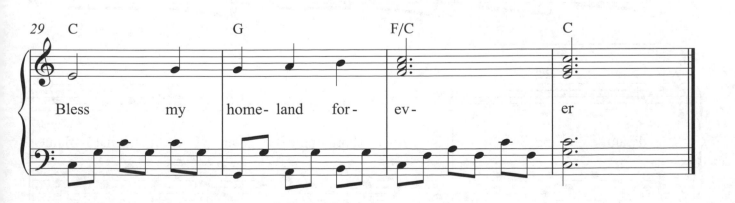

Eternal Flame

詞／曲：Susanna Hoffs / Tom Kelly / Billy Steinberg　演唱：The Bangles

Andantino ♩ = 78

A 𝄋

Close your eyes　　give me your hand dar ling　Do you feel　my heart beat-
I be- lieve　it's meant to be　dar ling　I watch you when　you are sleep-

To Coda

ing　Do you un- der- stand　Do you feel　the same　and am I on- ly
ing　You be- long with me　Do you feel　the same　or am I on- ly

1.

dream- in'?　Is　this　burn- ing　an　e- ter- nal　flame

2.

dream- ing　or is　this　burn- ing　an　e- ter- nal　flame

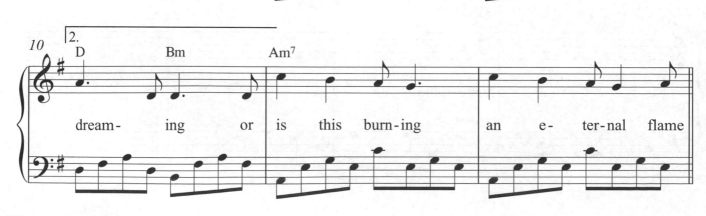

86

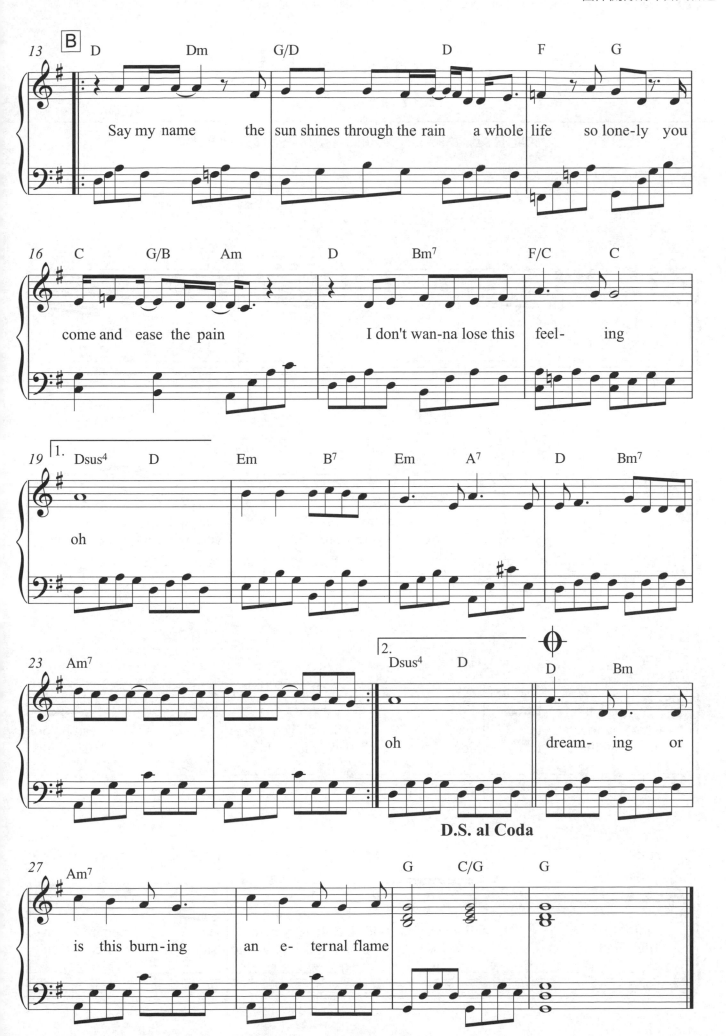

Everything I Do

（電影《羅賓漢俠盜王子》主題曲）

詞 / 曲：Bryan Adams / R.J. Lange / M.Kamen　演唱：Bryan Adams

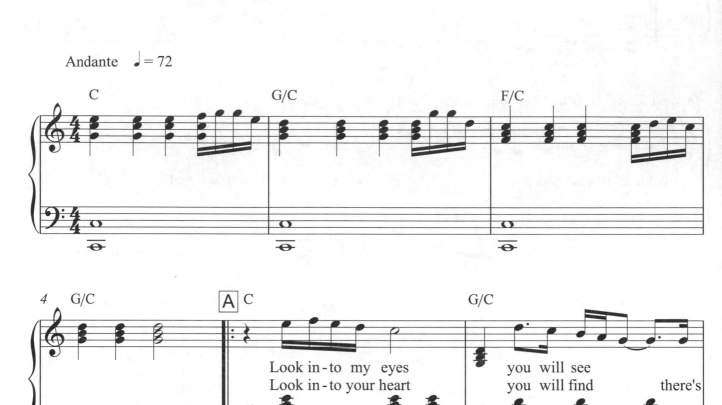

Andante ♩ = 72

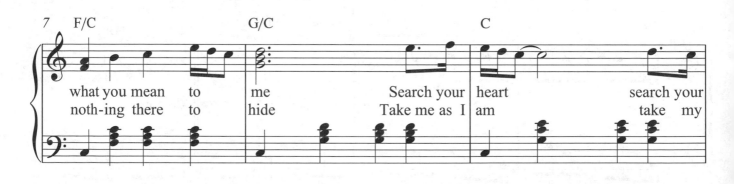

Look in-to my eyes / you will see
Look in-to your heart / you will find　there's

what you mean　to　me / Search your heart / search your
noth-ing there　to hide / Take me as I am / take my

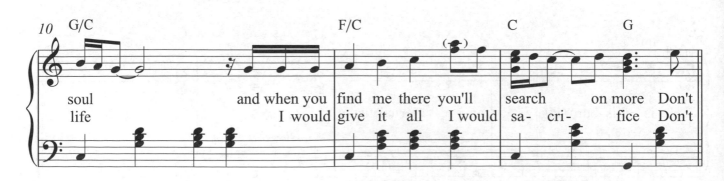

soul / and when you find me there you'll search on more Don't
life / I would give it all I would sa-cri- fice Don't

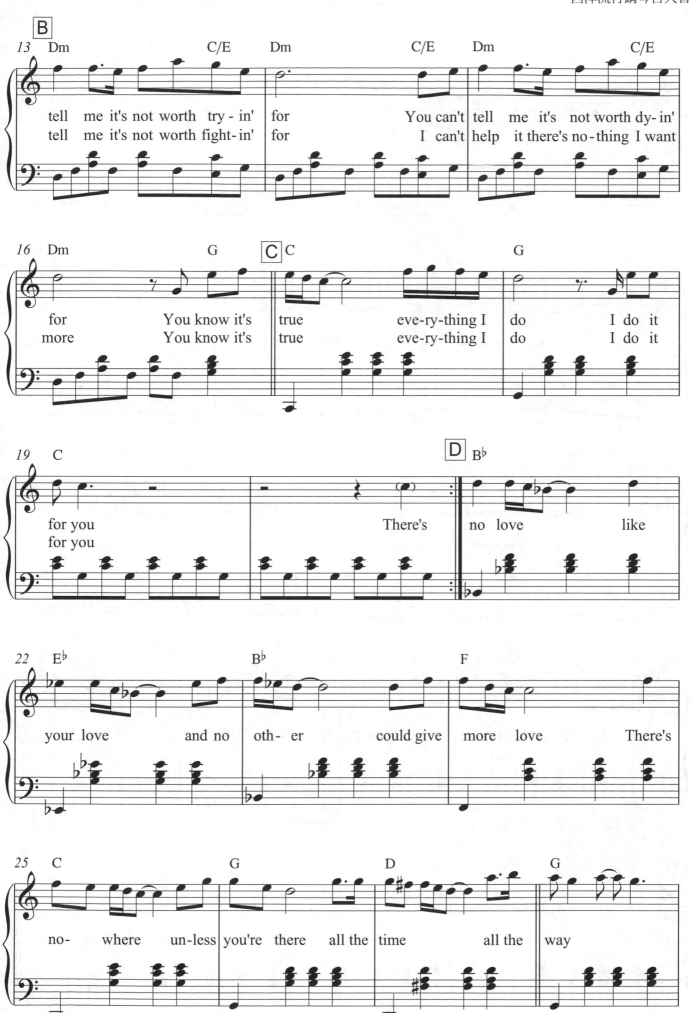

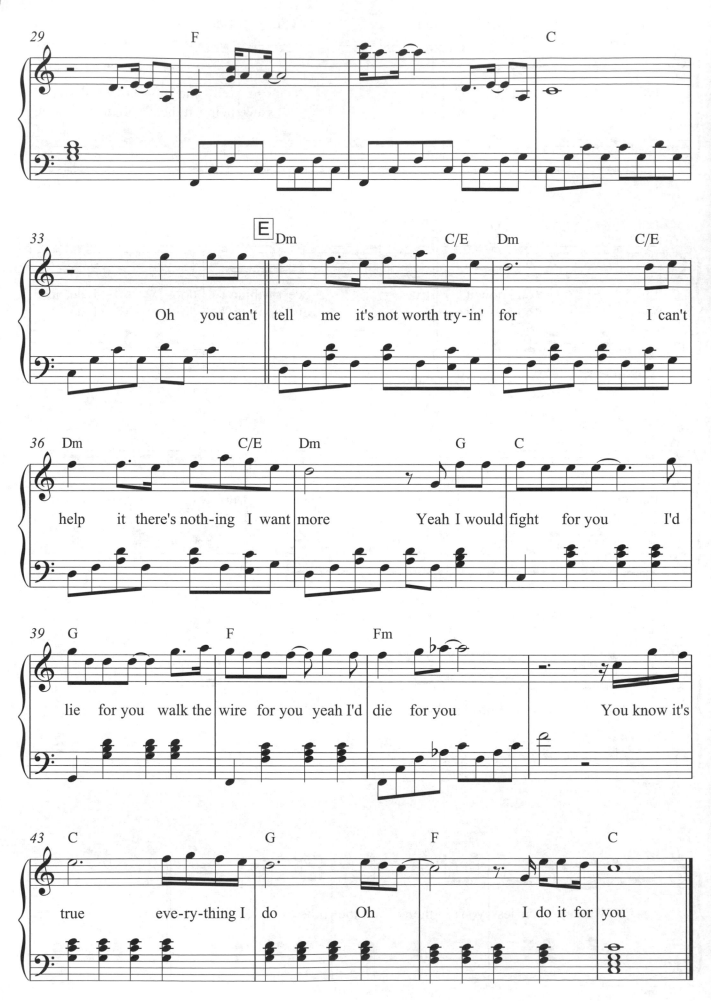

Feeling

詞／曲：Morris Albert　演唱：Morris Albert

Andante ♩= 72

Words & Music by Morris Albert

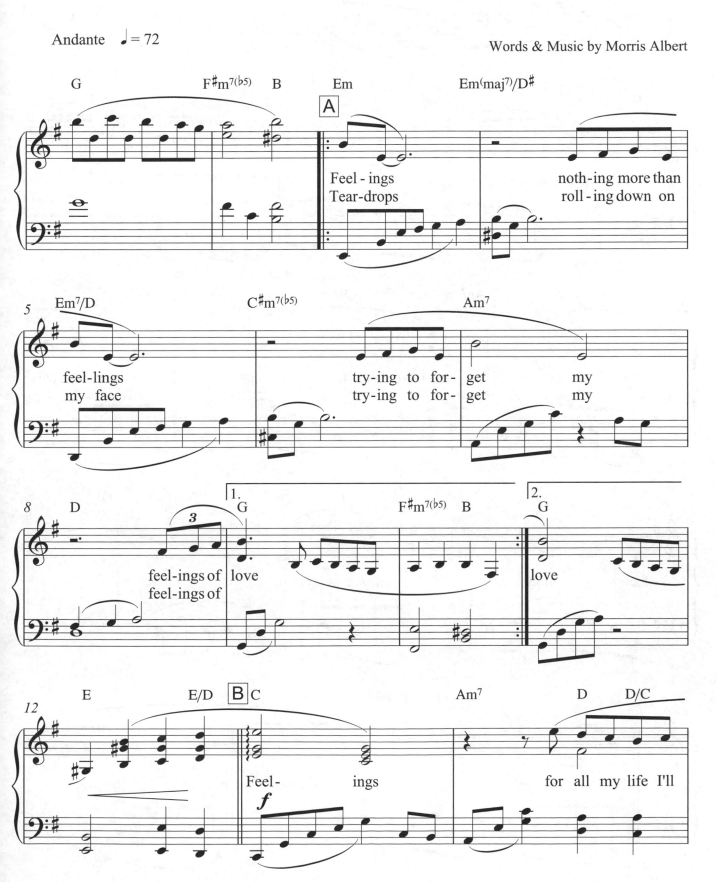

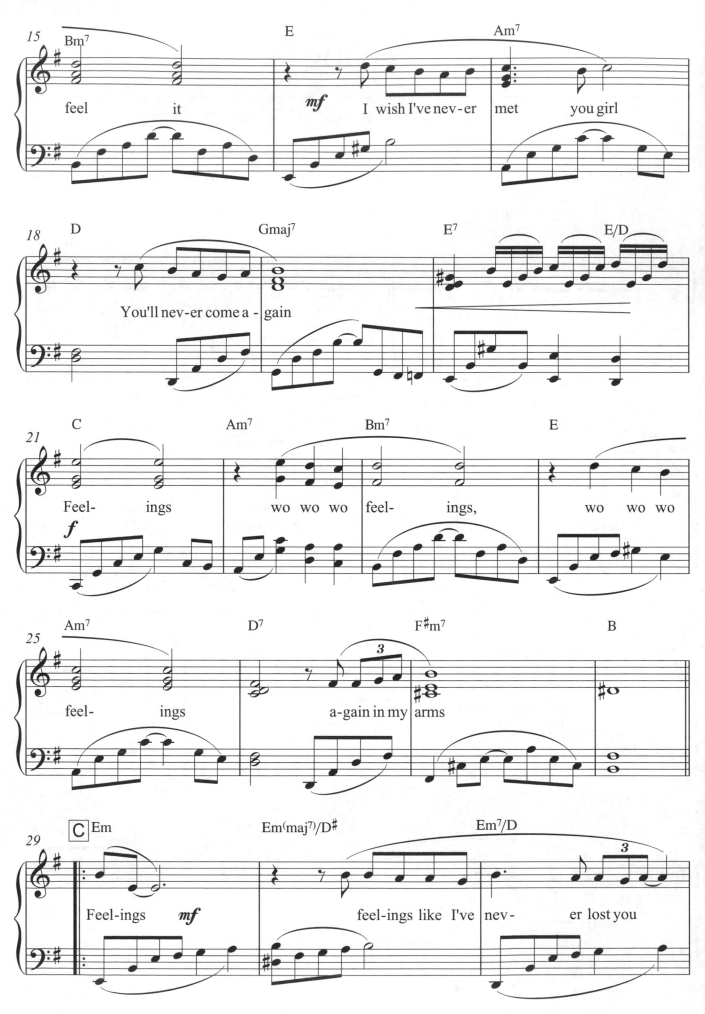

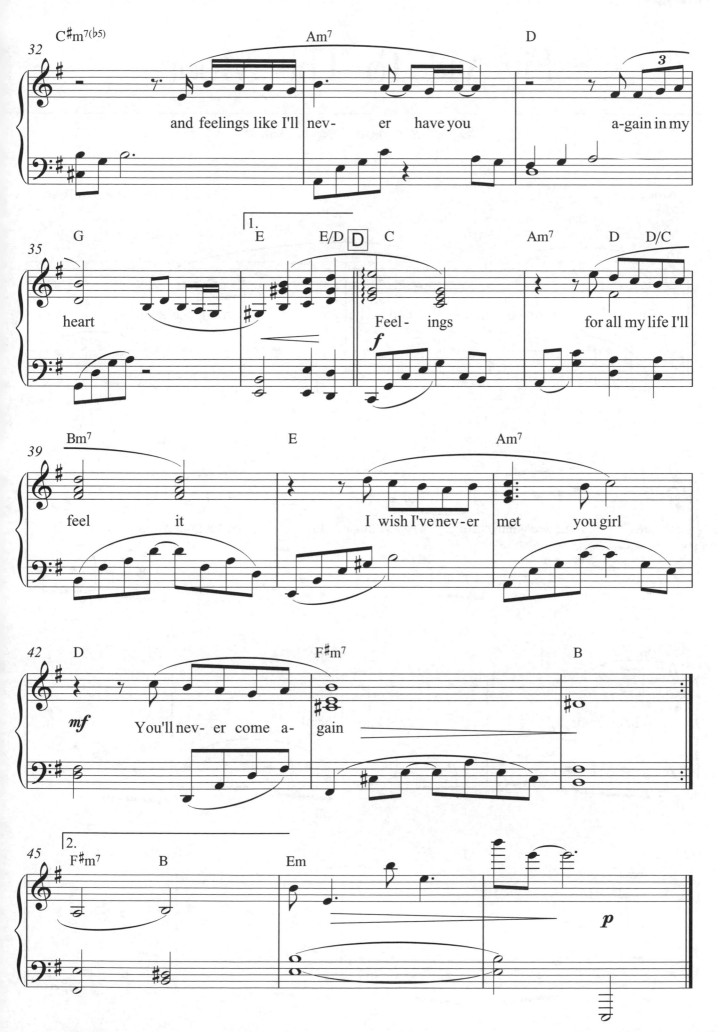

Fly Me To The Moon

詞／曲：Bart Howard　演唱：Diana Krall

Moderato ♩ = 122

Words & Music by Bart Howard

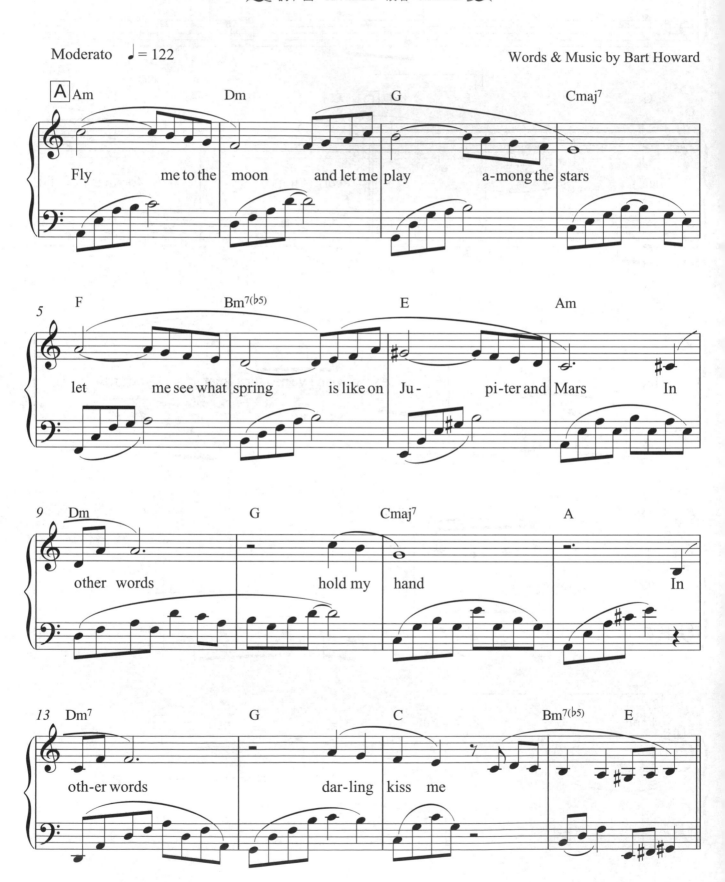

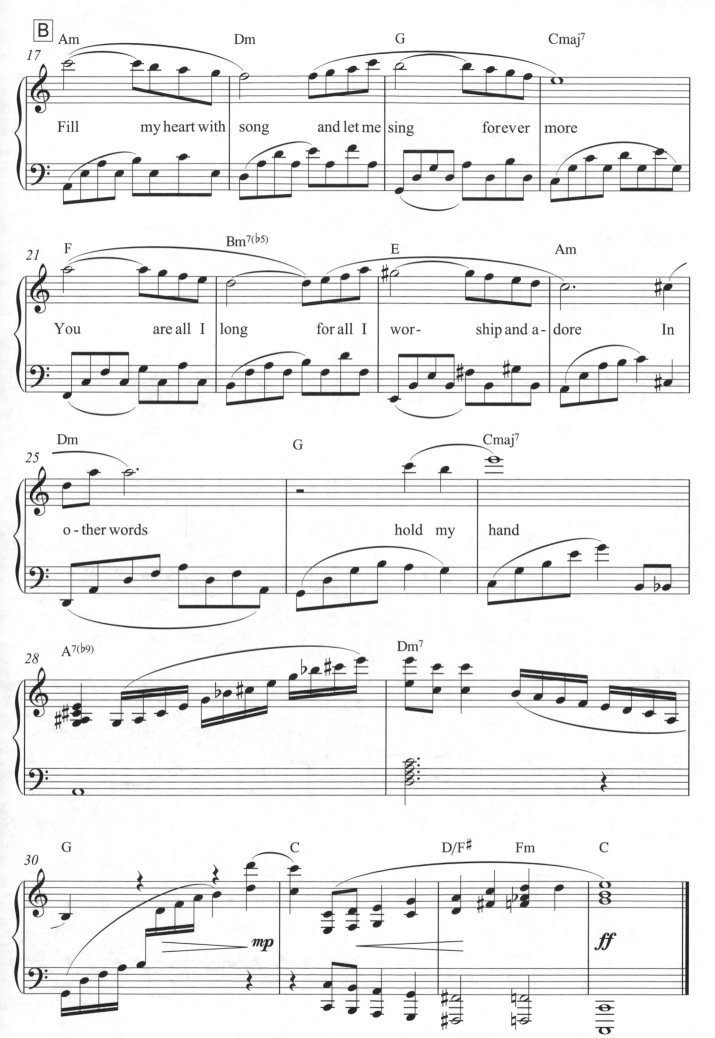

Fill my heart with song and let me sing forever more

You are all I long for all I wor- ship and a- dore In

o - ther words hold my hand

Greensleeves

詞／曲：English Folk Song　演唱：Olivia Newton-John

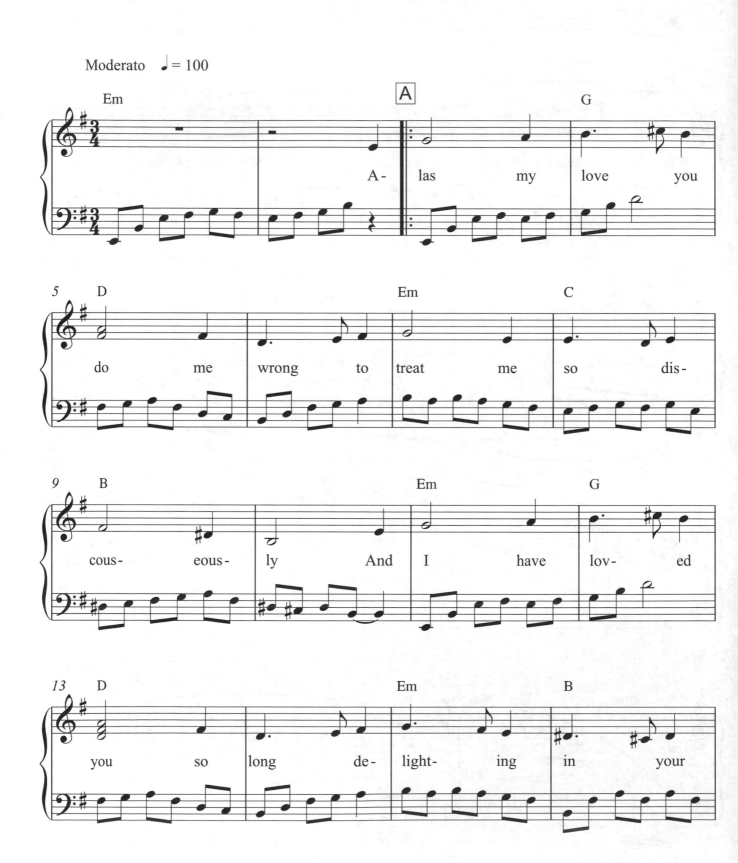

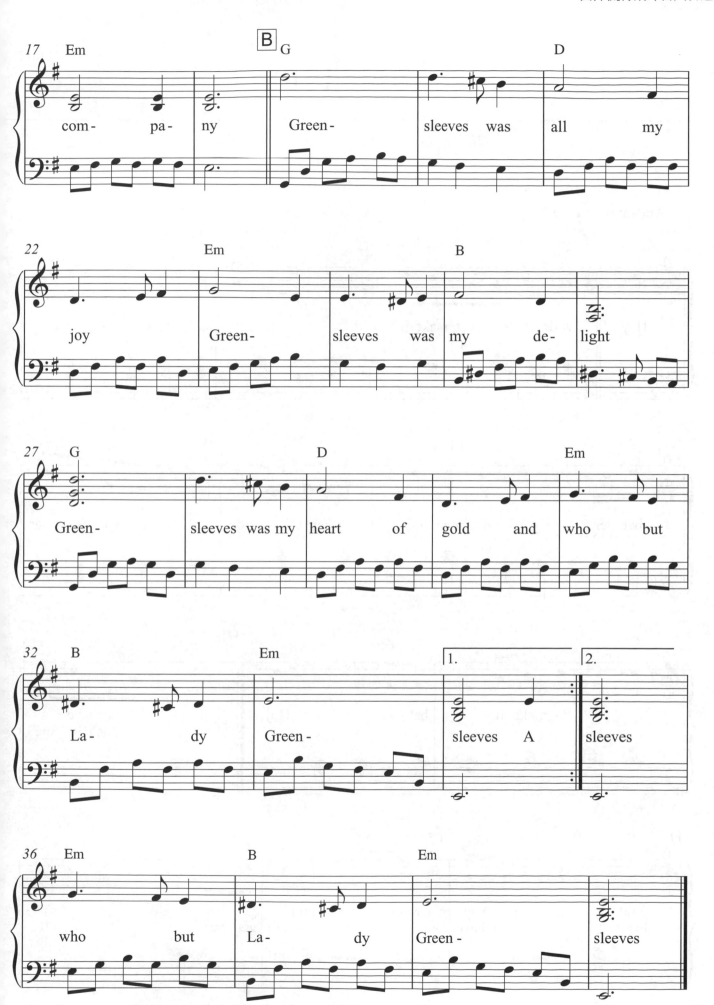

Hey Jude

詞／曲：Lennon / McCartney　演唱：The Beatles

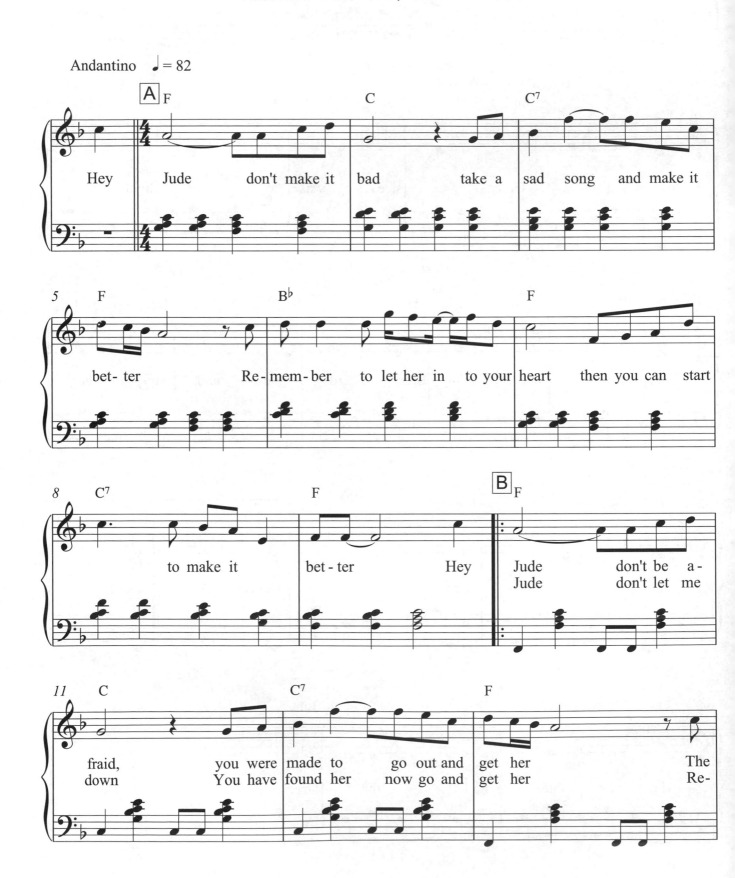

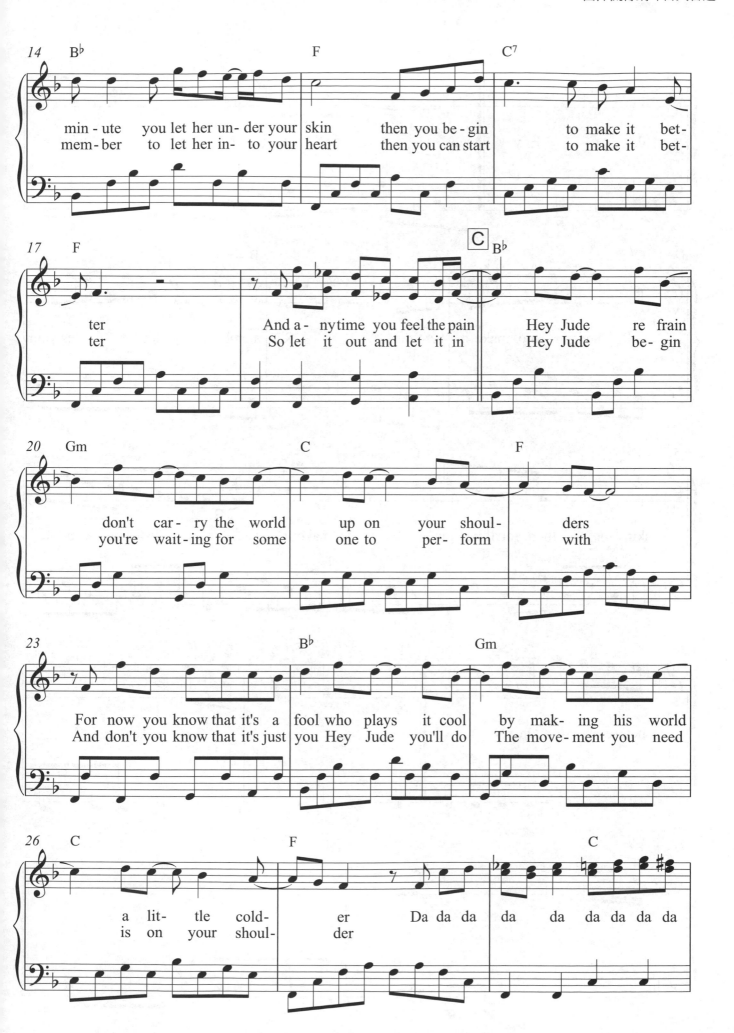

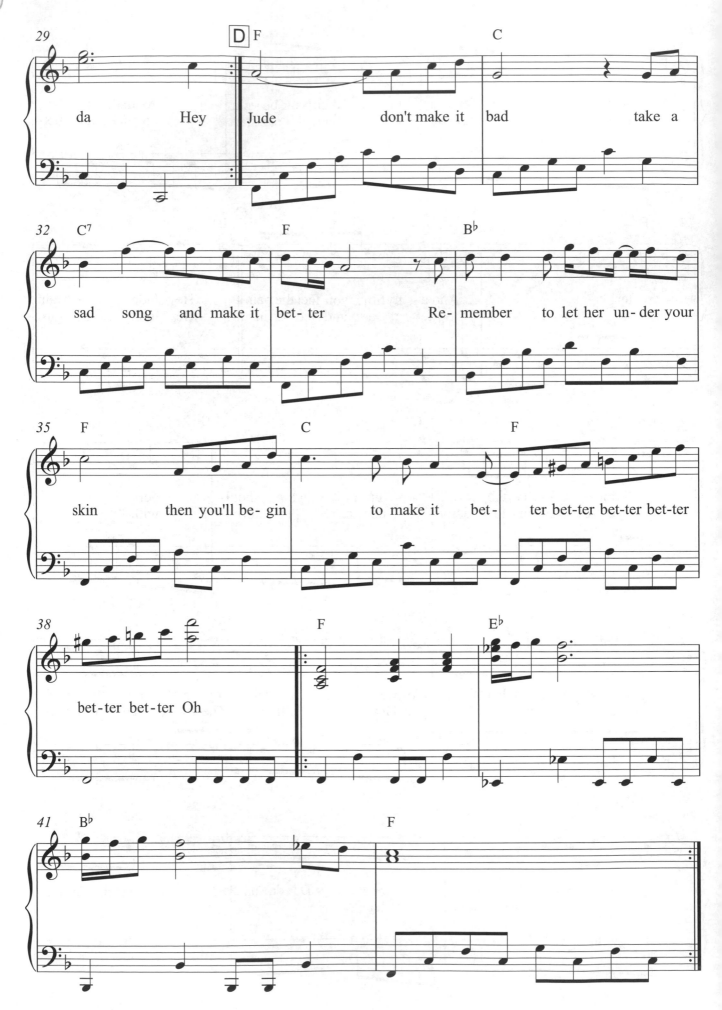

Hero

詞 / 曲：Mariah Carey　演唱：Mariah Carey

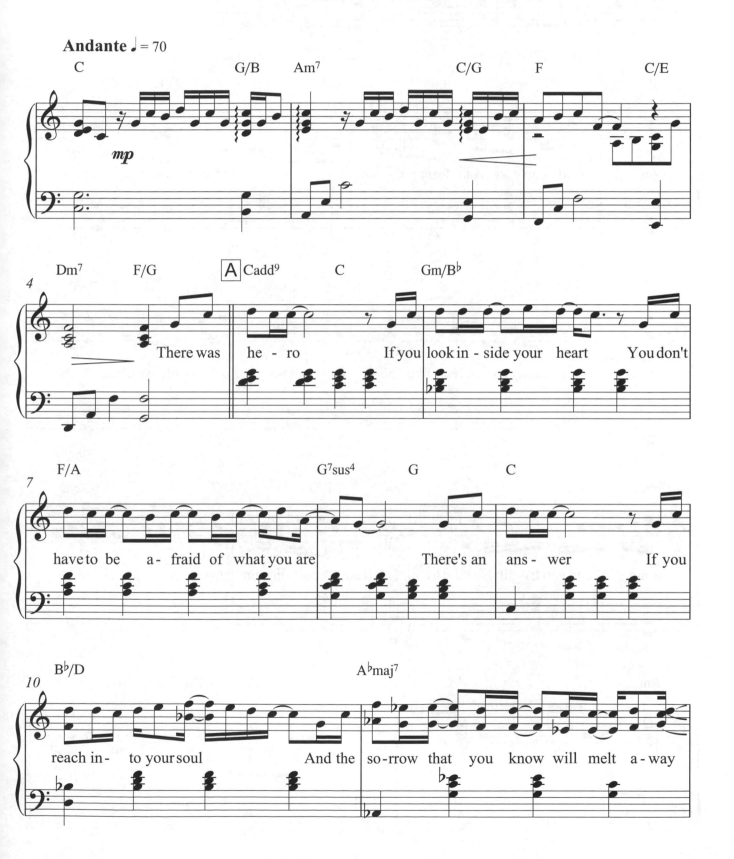

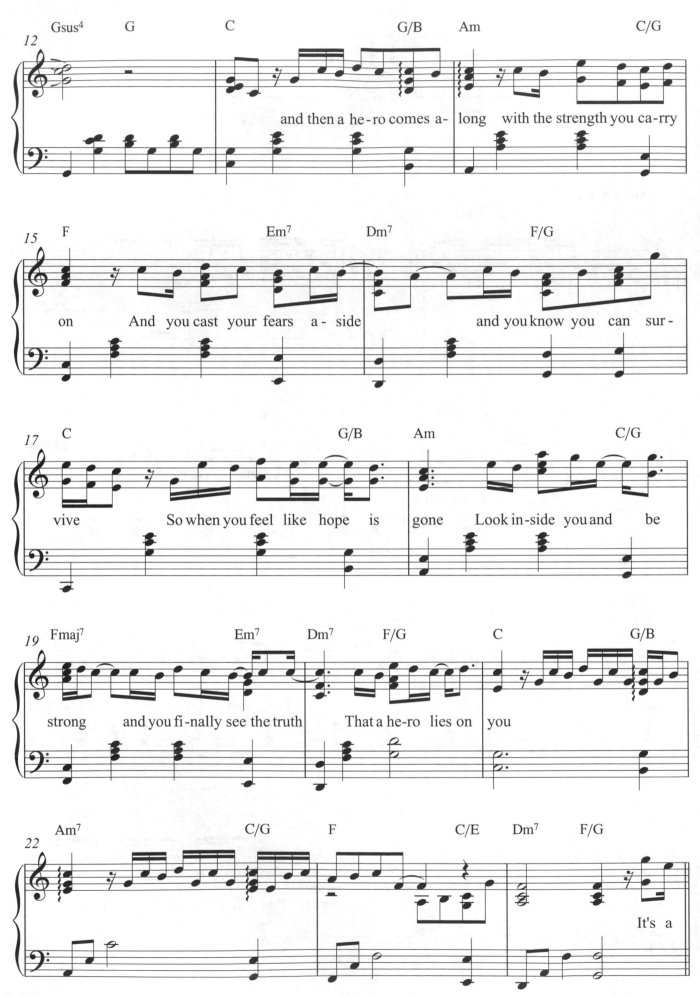

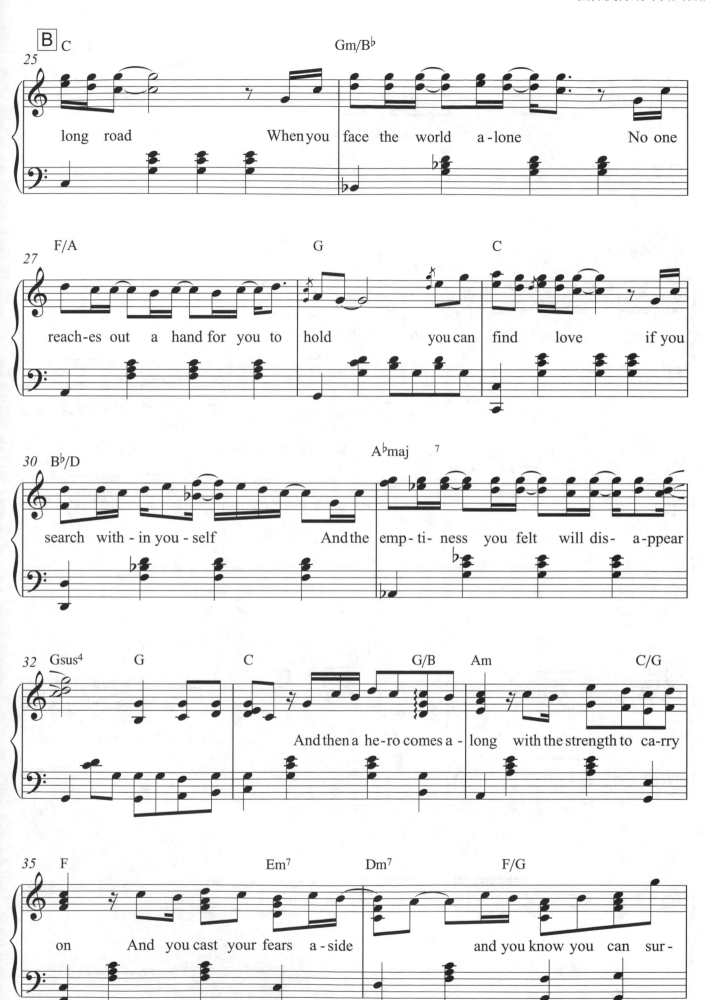

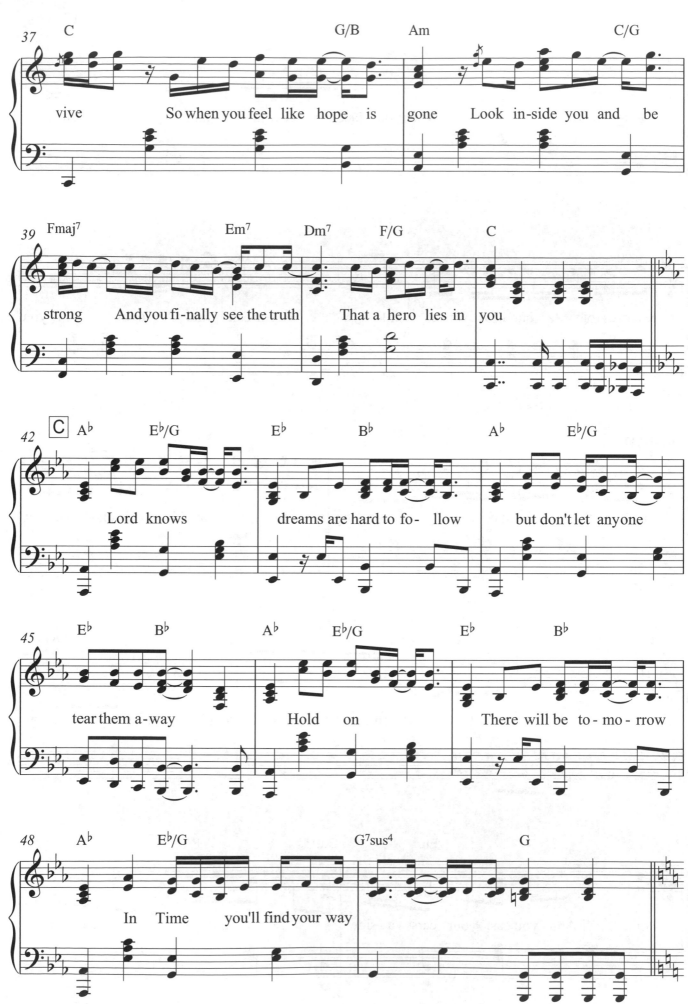

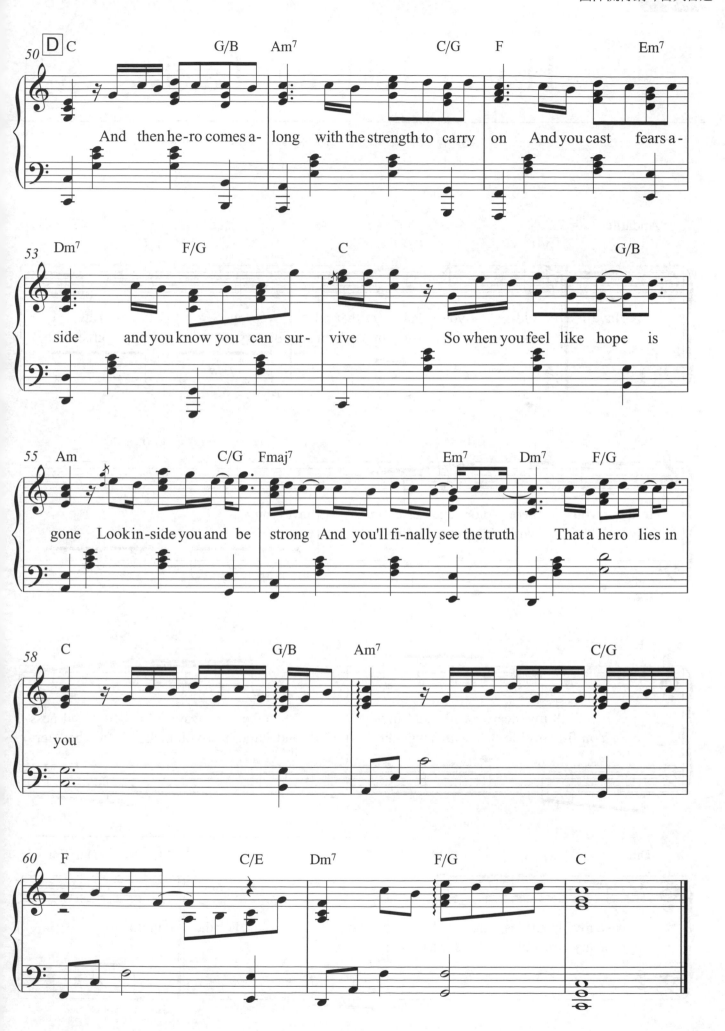

Have I Told You Lately

詞 / 曲：Van Morrison　演唱：Rod Stewart

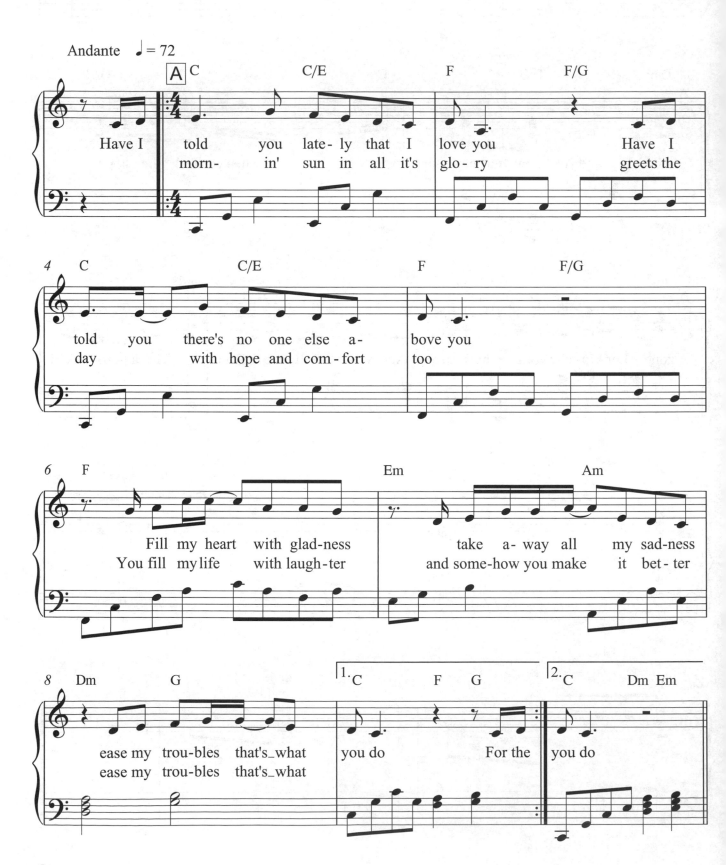

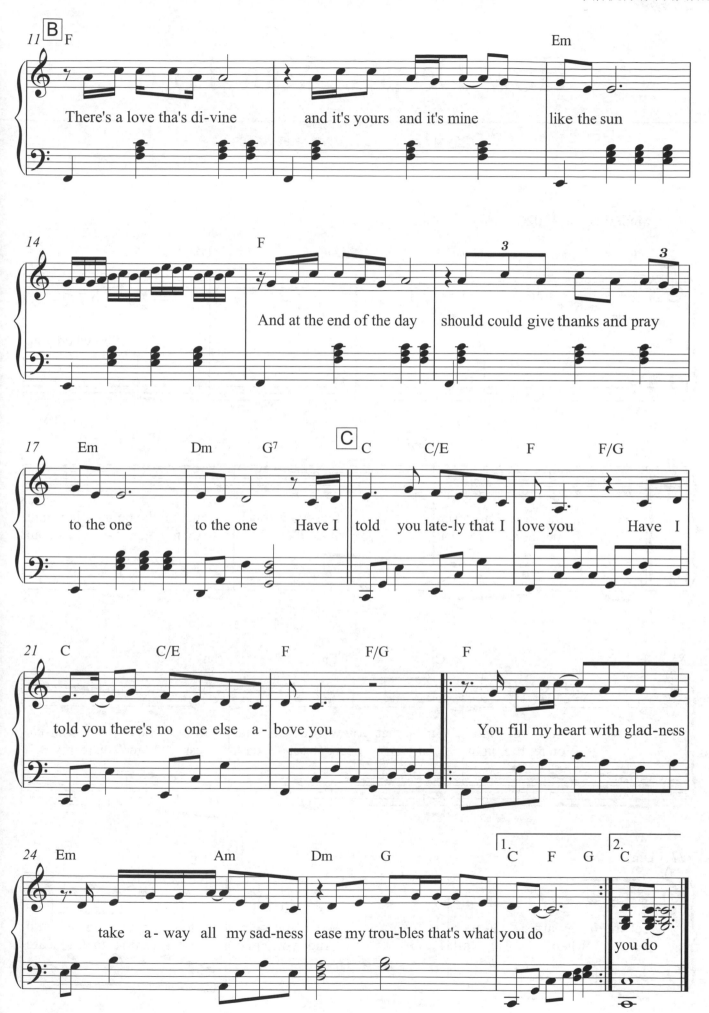

How Deep Is Your Love

詞／曲：Brothers Gibb　演唱：Bee Gees

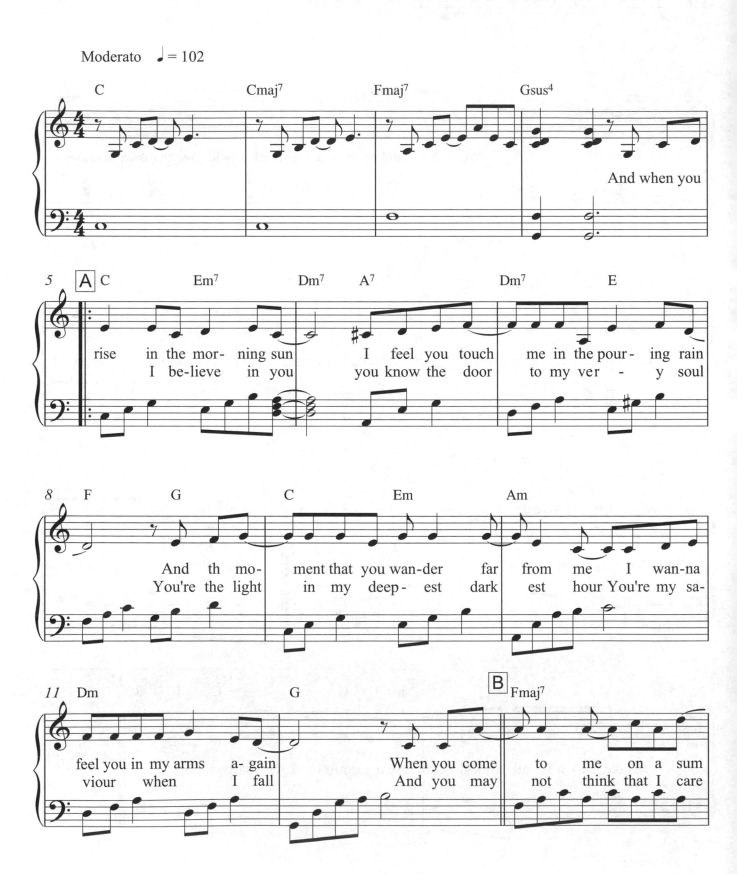

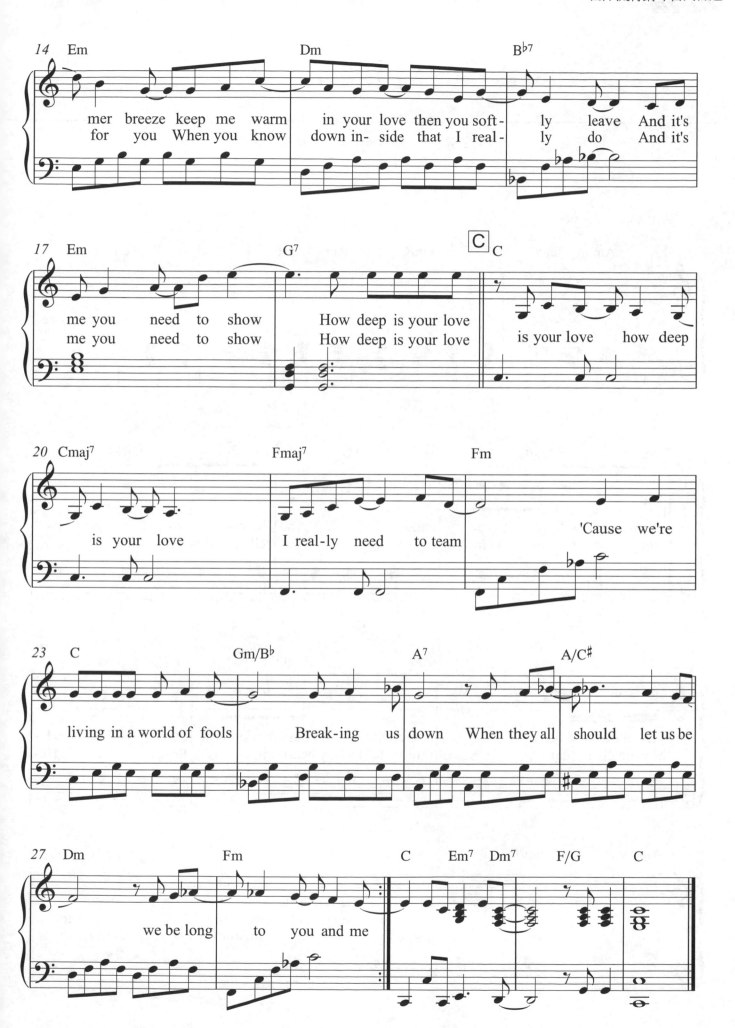

Hello

詞／曲：Lionel Richie　演唱：Lionel Richie

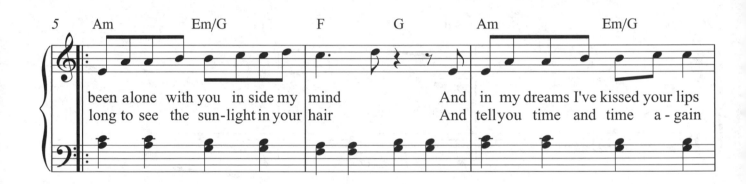

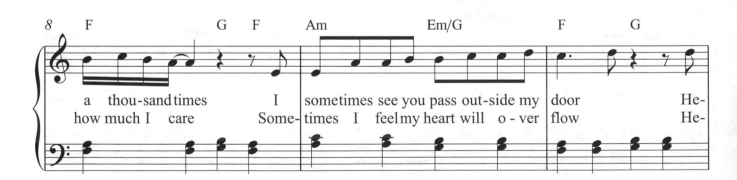

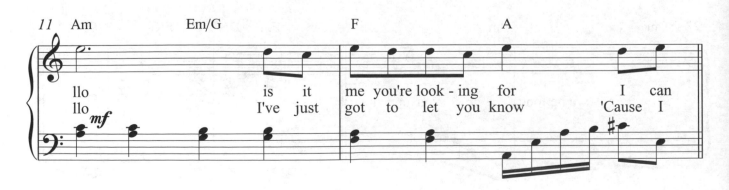

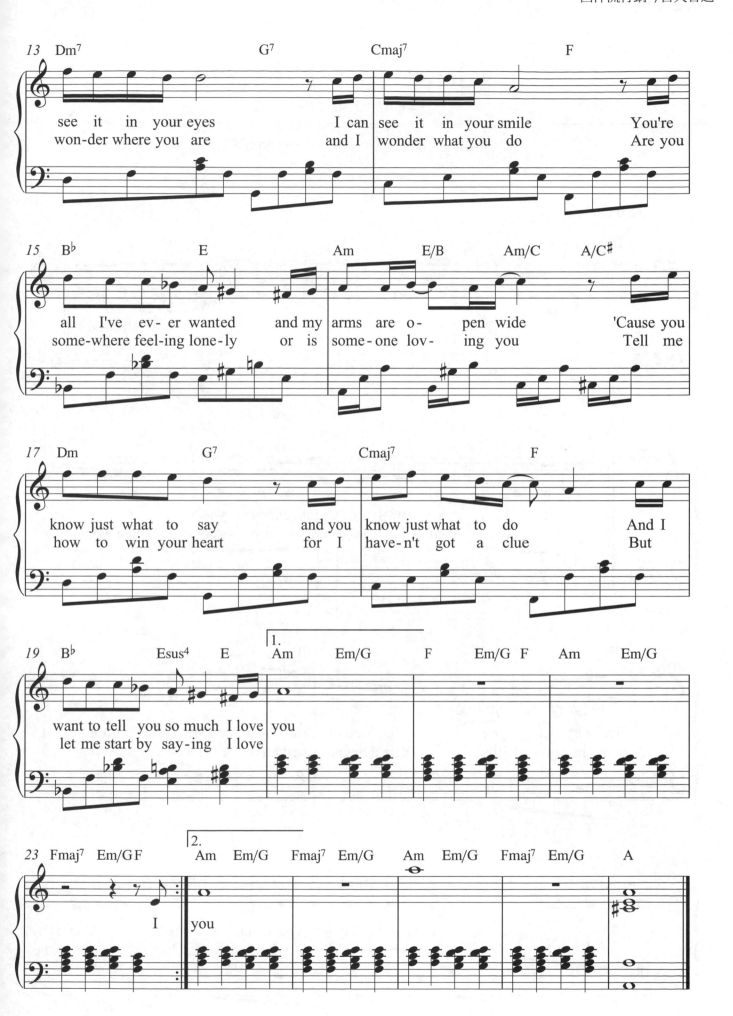

How Do I Live

（電影《空中監獄》主題曲）

詞／曲：Diane Warren　演唱：LeAnn Rimes

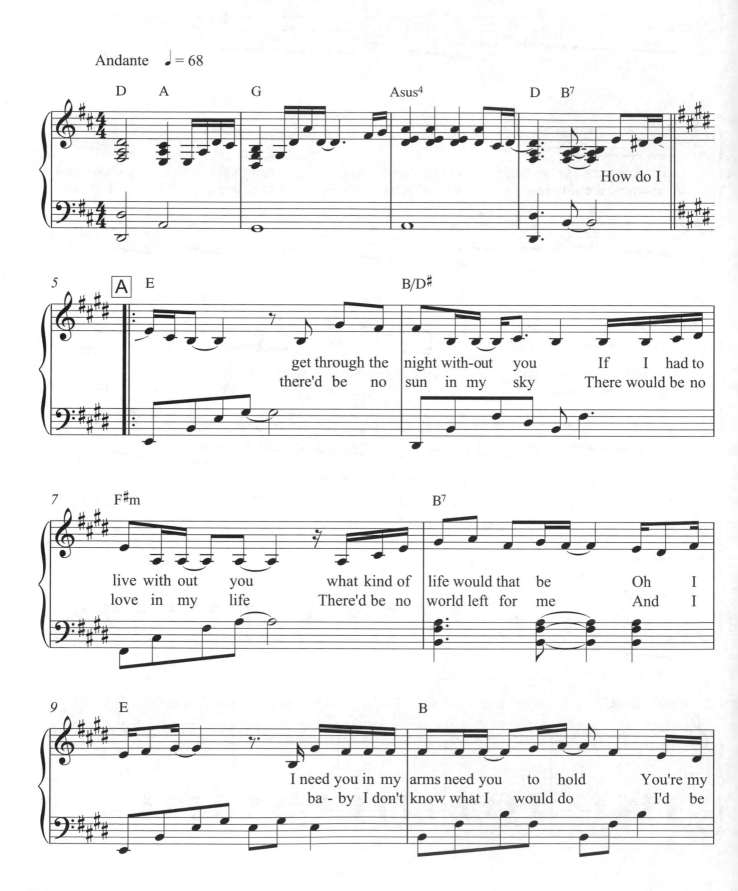

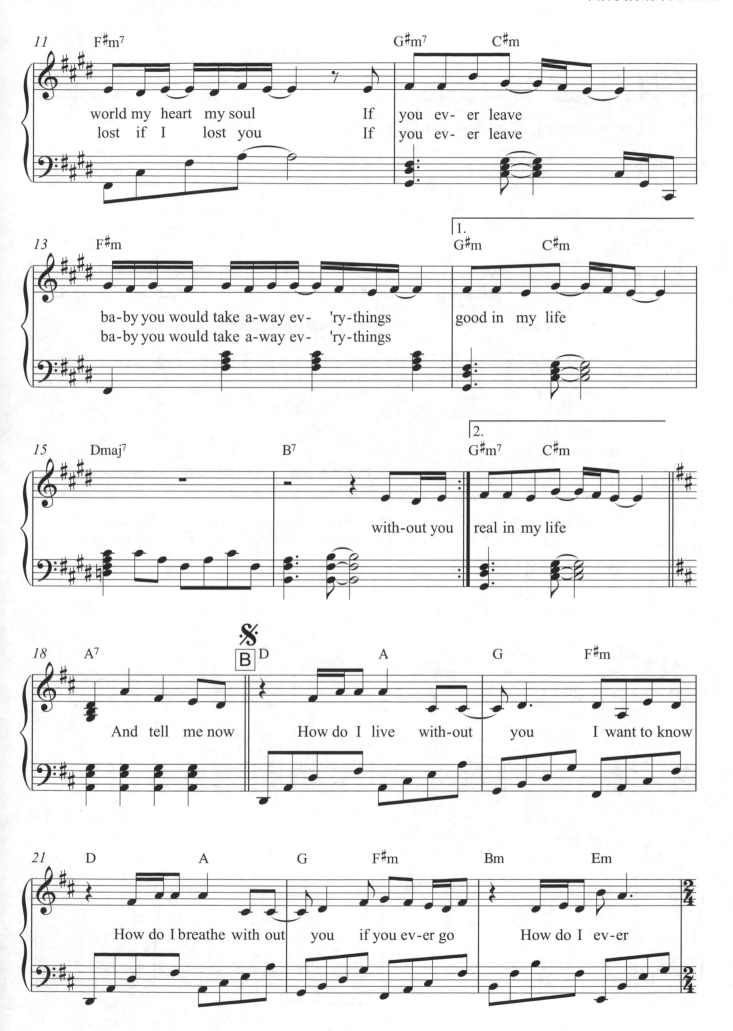

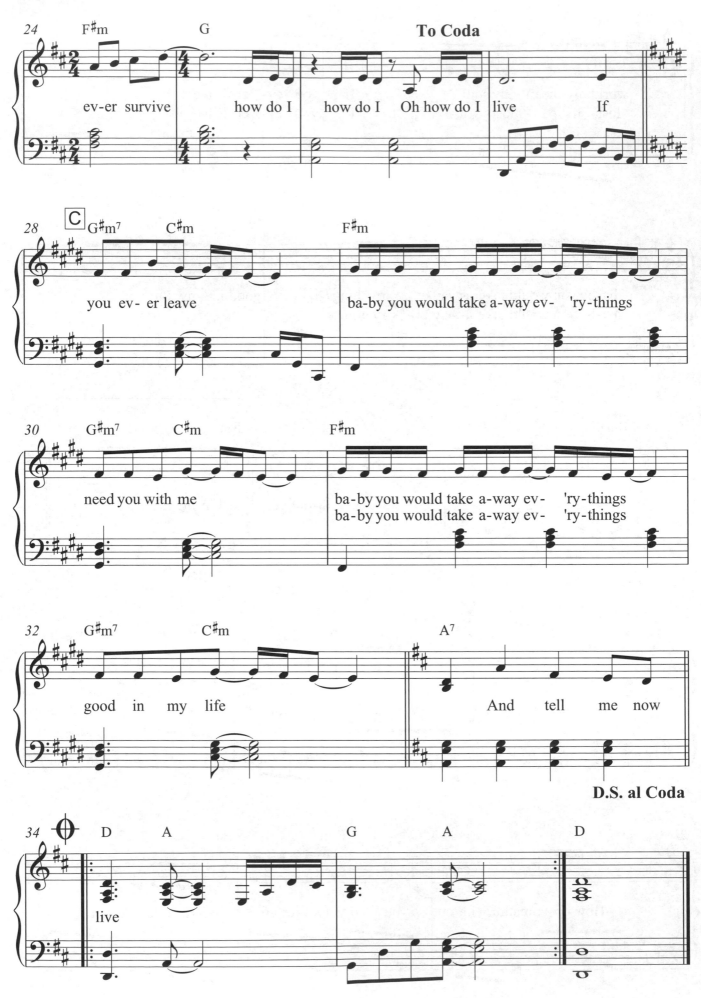

I Just Called To Say I Love You

（電影《紅衣女郎》主題曲）

詞／曲：Stevie Wonder　演唱：Stevie Wonder

Moderato ♩ = 120

No New Year's

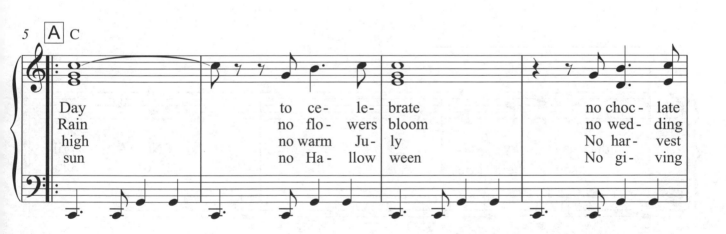

Day	to ce - le -	brate	no choc - late
Rain	no flo - wers	bloom	no wed - ding
high	no warm Ju -	ly	No har - vest
sun	no Ha - llow	ween	No gi - ving

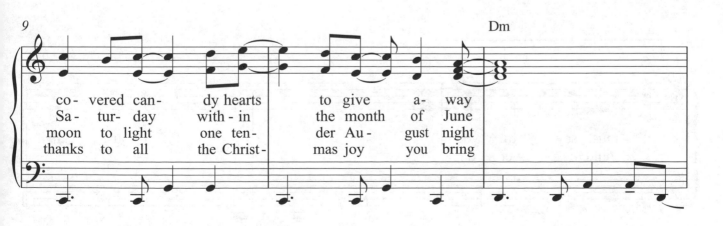

co - vered can -	dy hearts	to give	a - way
Sa - tur - day	with - in	the month	of June
moon to light	one ten -	der Au -	gust night
thanks to all	the Christ -	mas joy	you bring

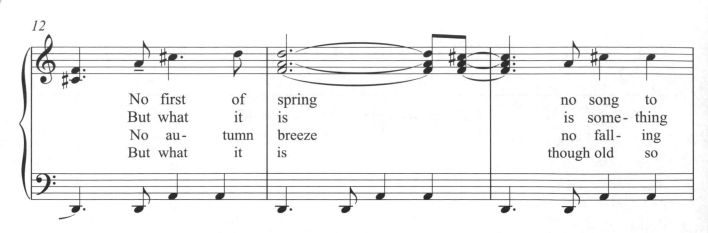

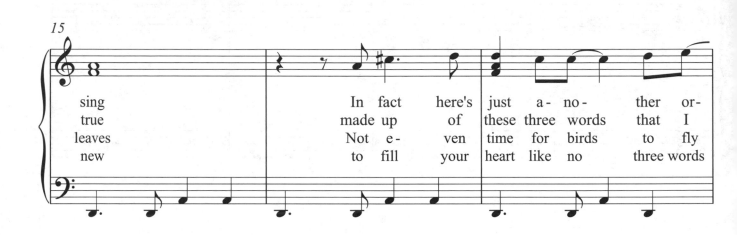

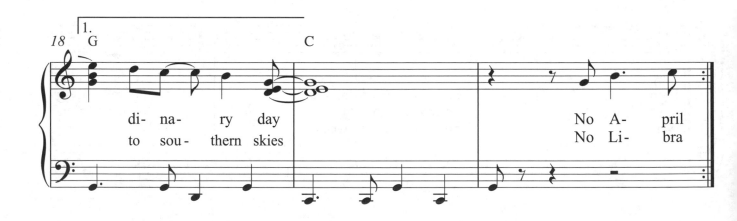

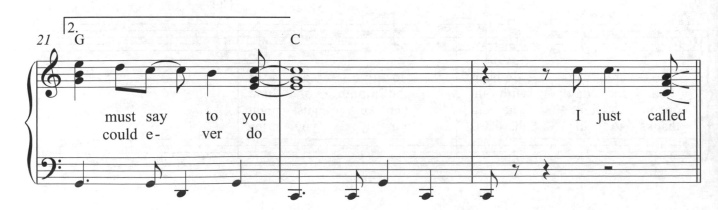

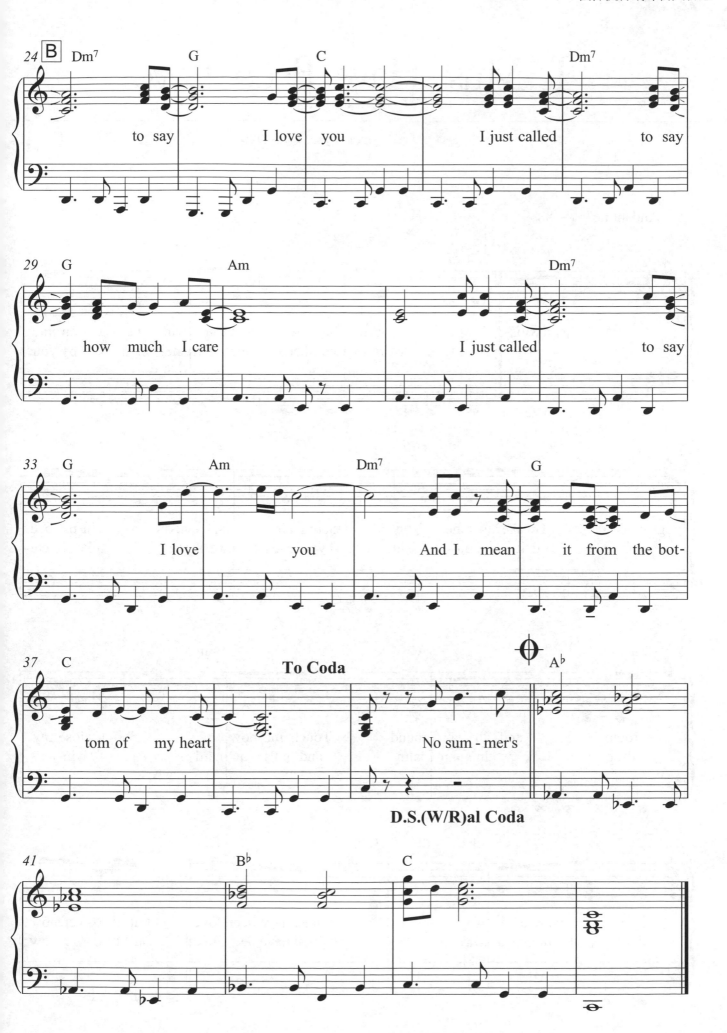

It Must Have Been Love

（電影《麻雀變鳳凰》主題曲）

詞 / 曲：Per Gessle　演唱：Roxette

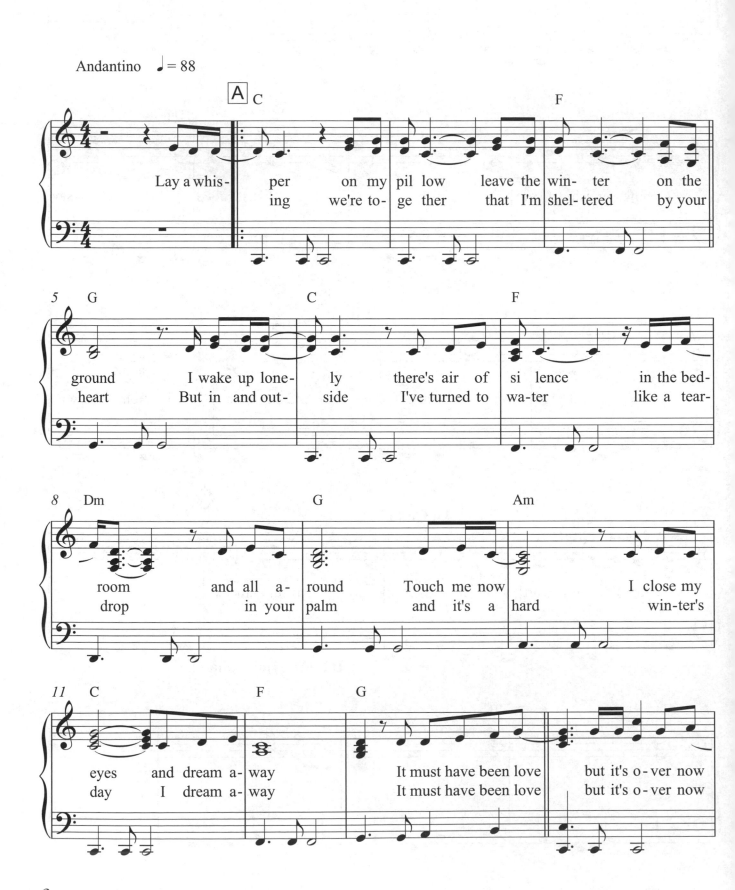

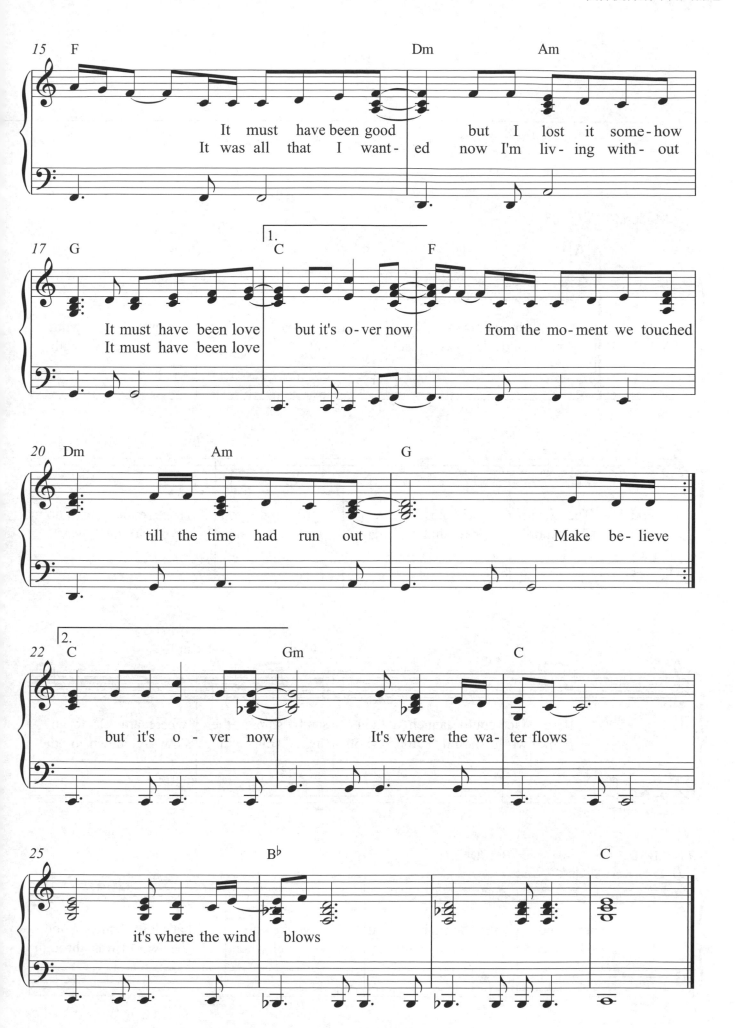

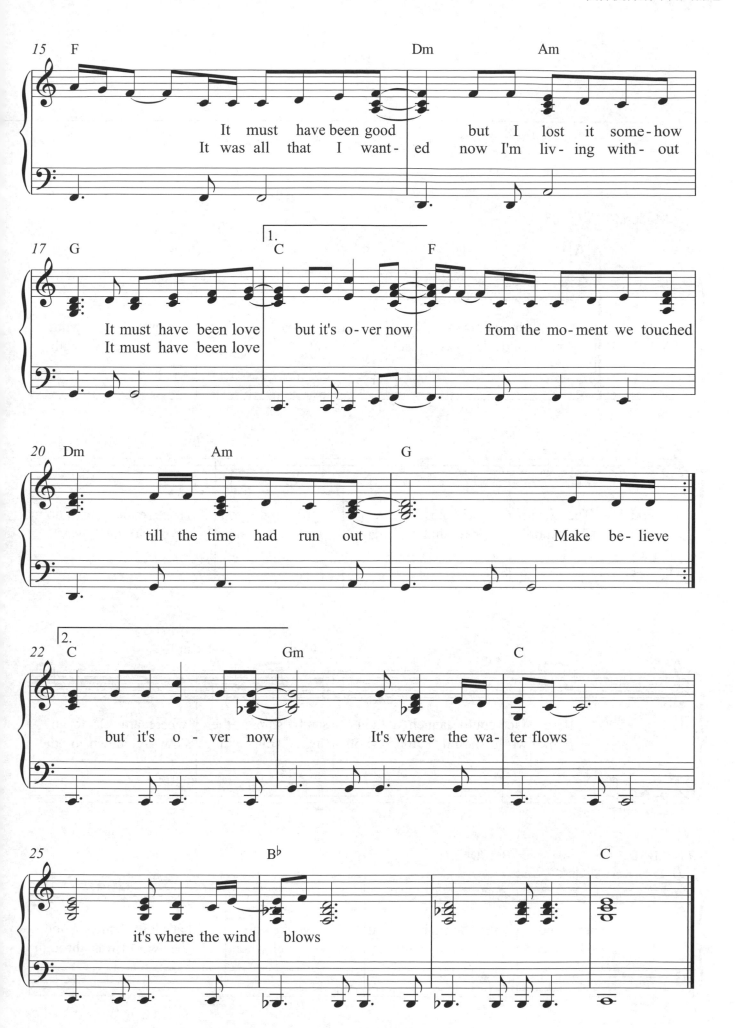

If

詞／曲：David A. Gates　演唱：Westlife

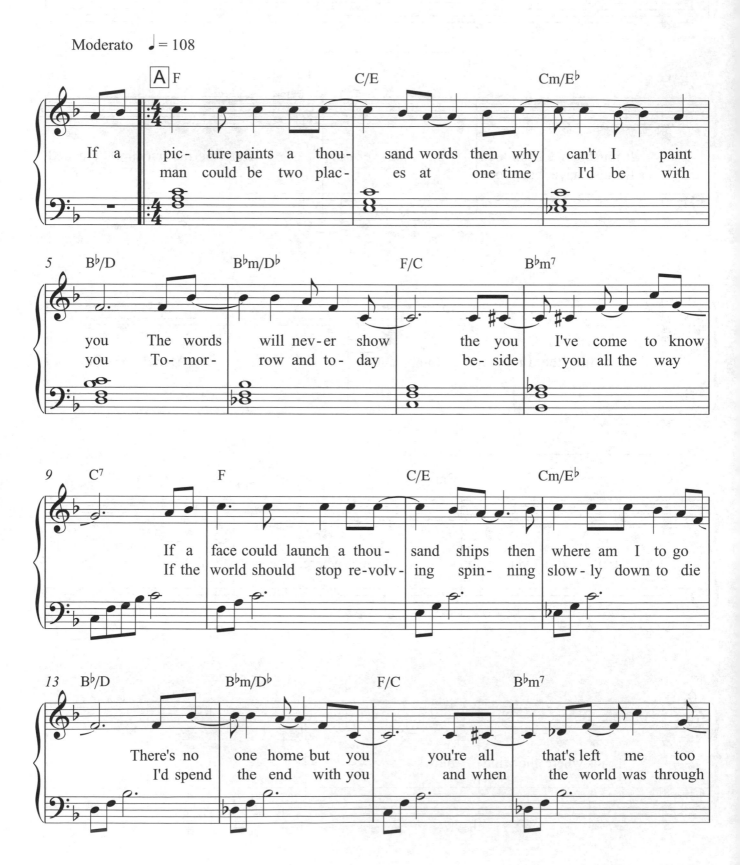

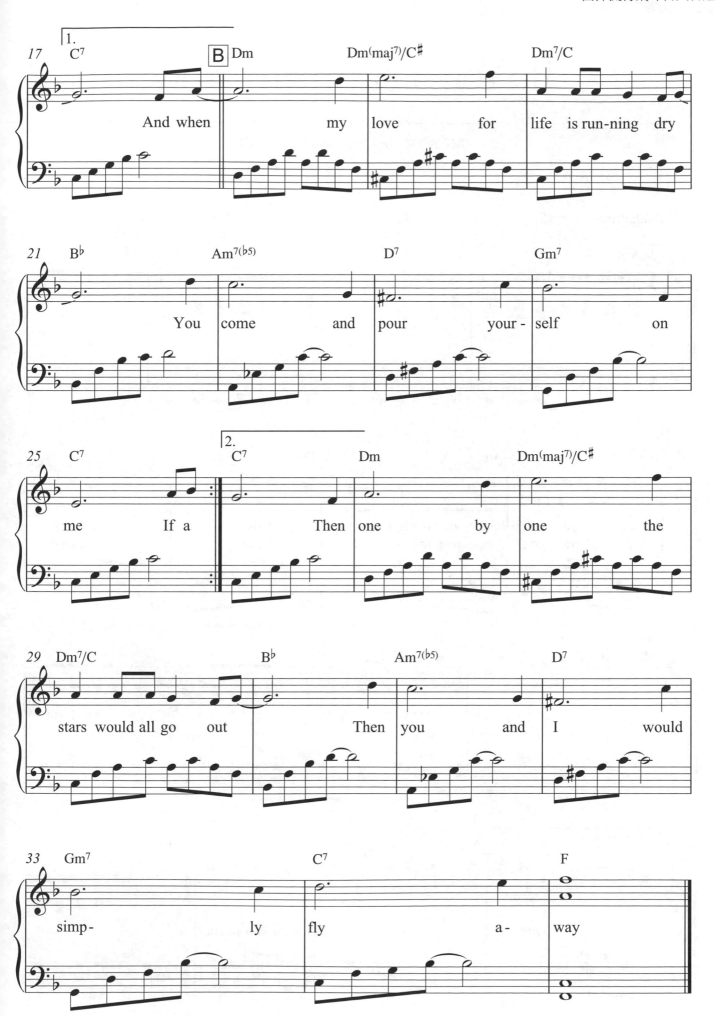

If You Leave Me Now

詞／曲：Peter Cetera　　演唱：Chicago

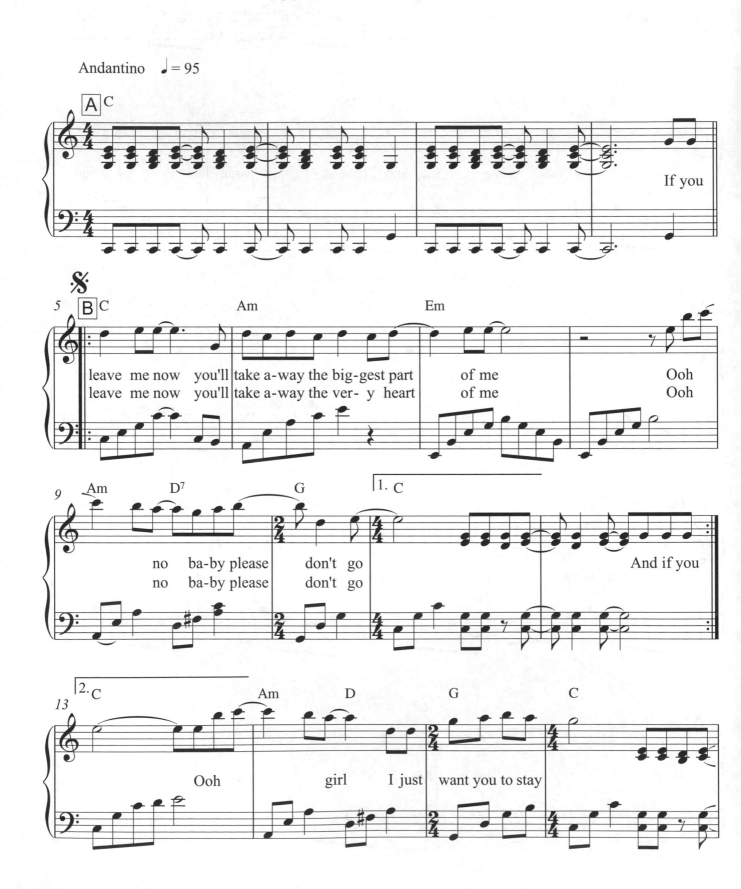

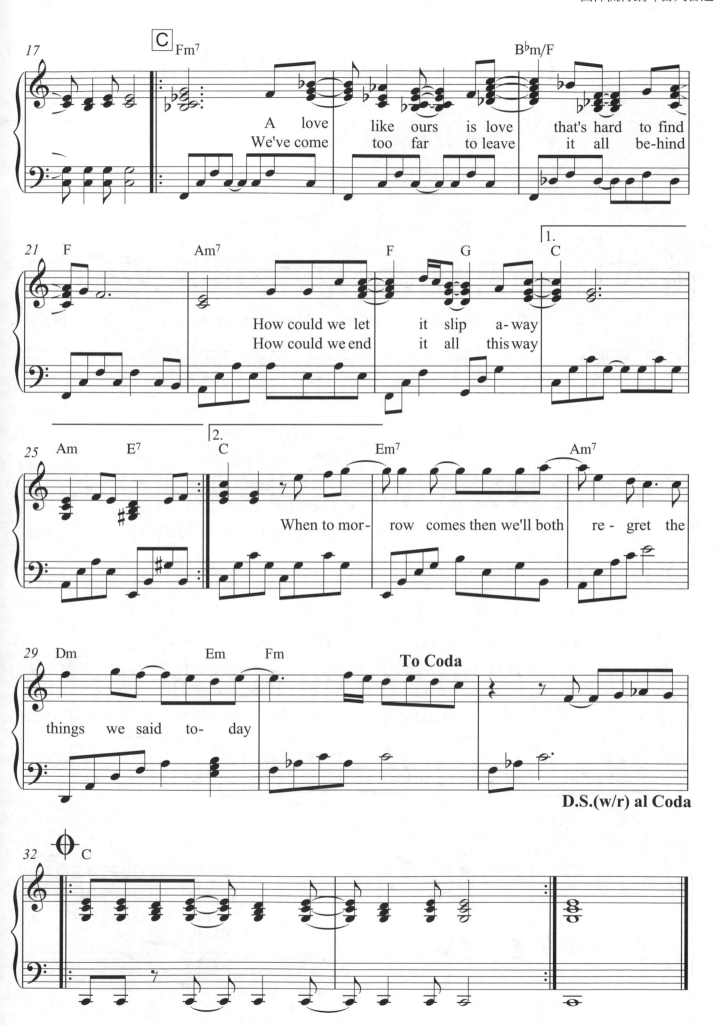

I Will Always Love You

（電影《終極保鑣》主題曲）

詞／曲：Dolly Parton　　演唱：Whitney Houston

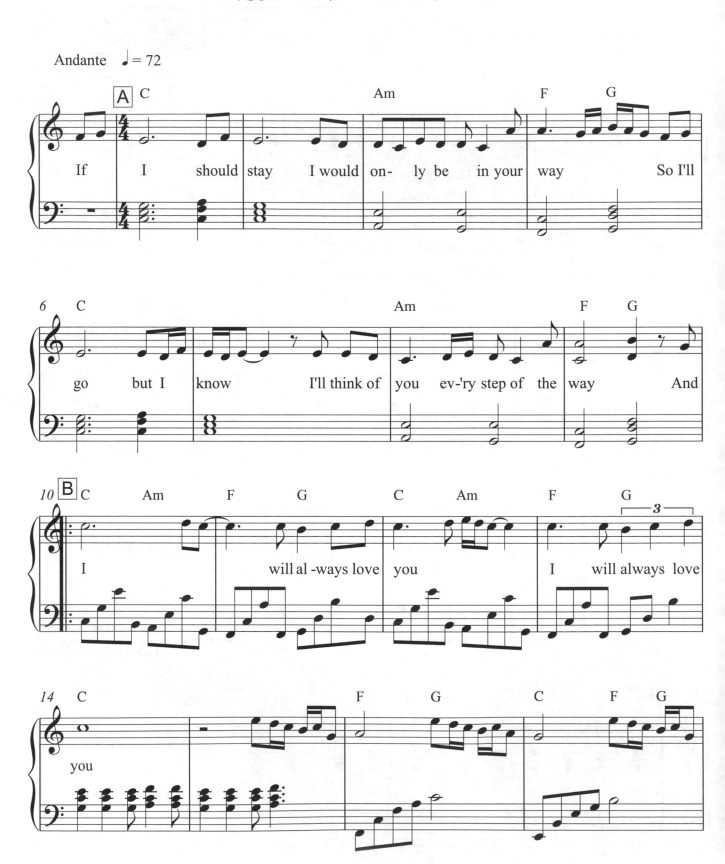

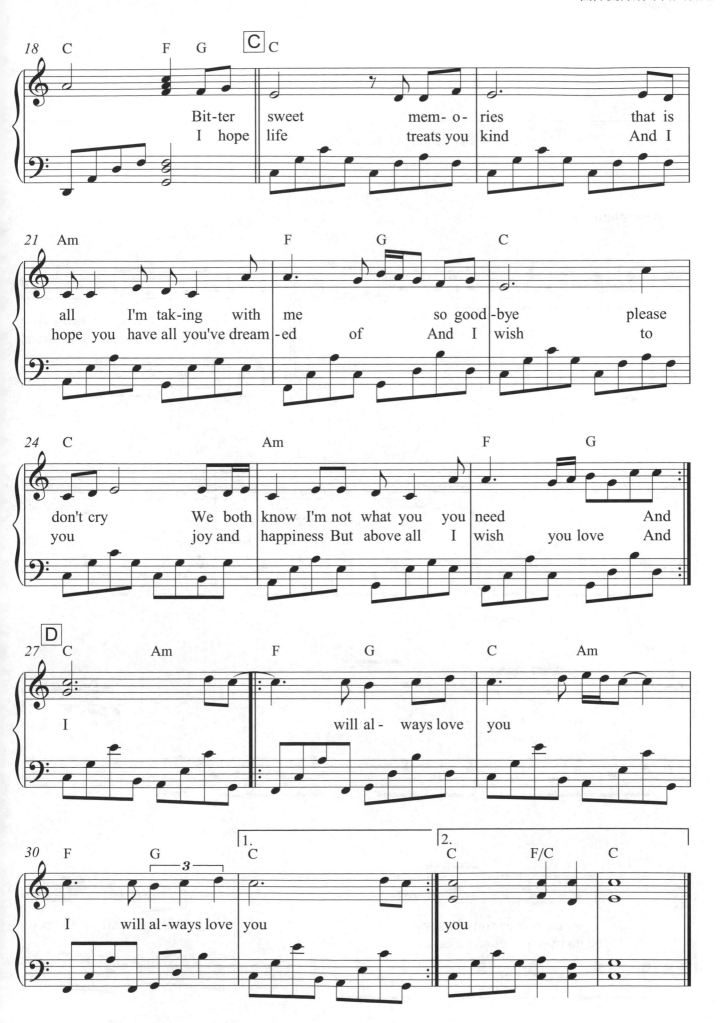

Image

詞／曲：John Lennon　演唱：John Lennon

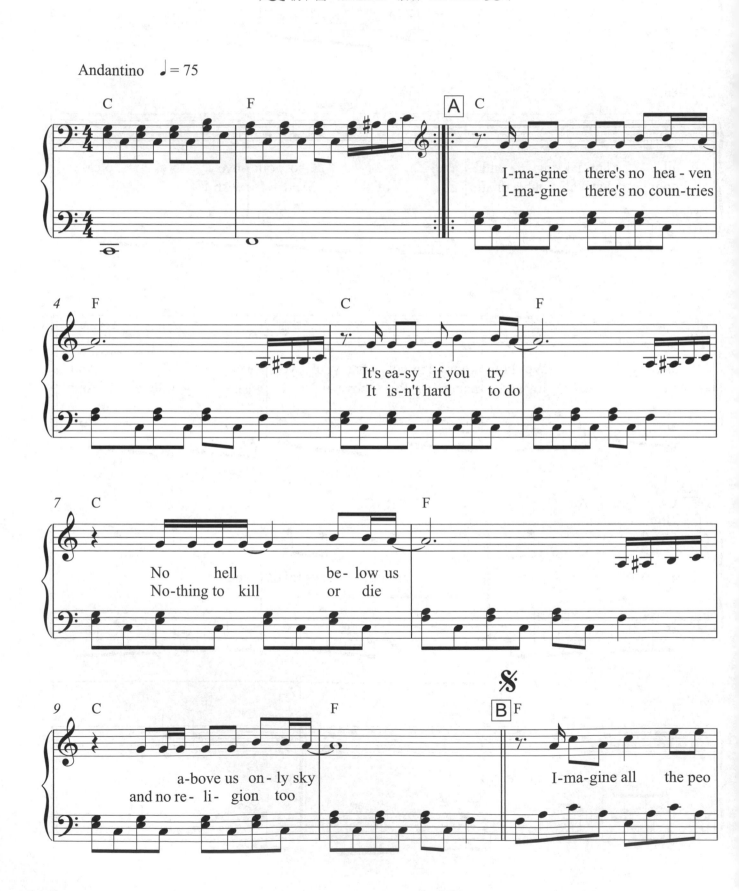

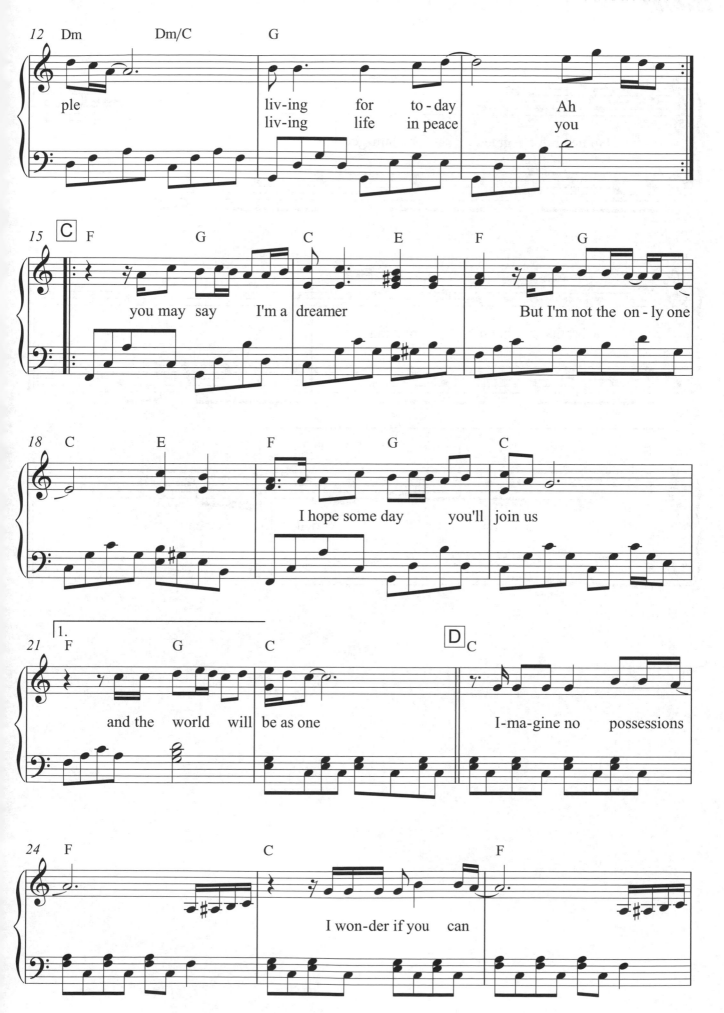

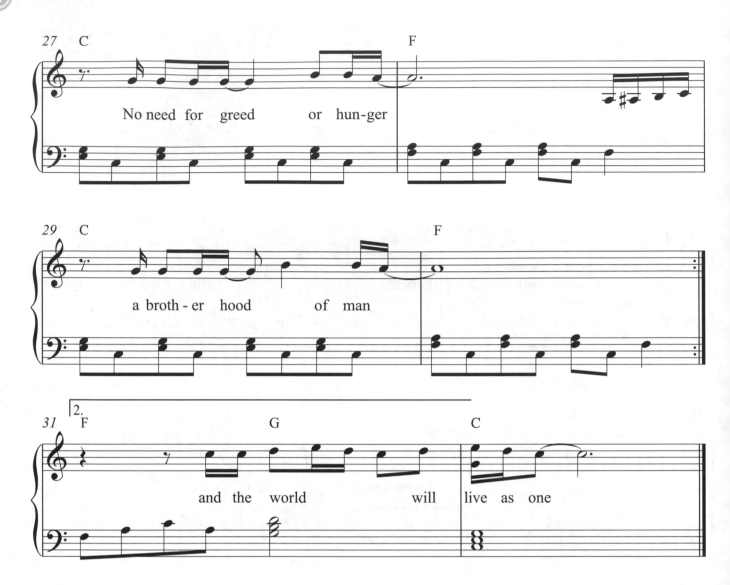

Just The Way You Are

詞／曲：Billy Joel　演唱：Billy Joel

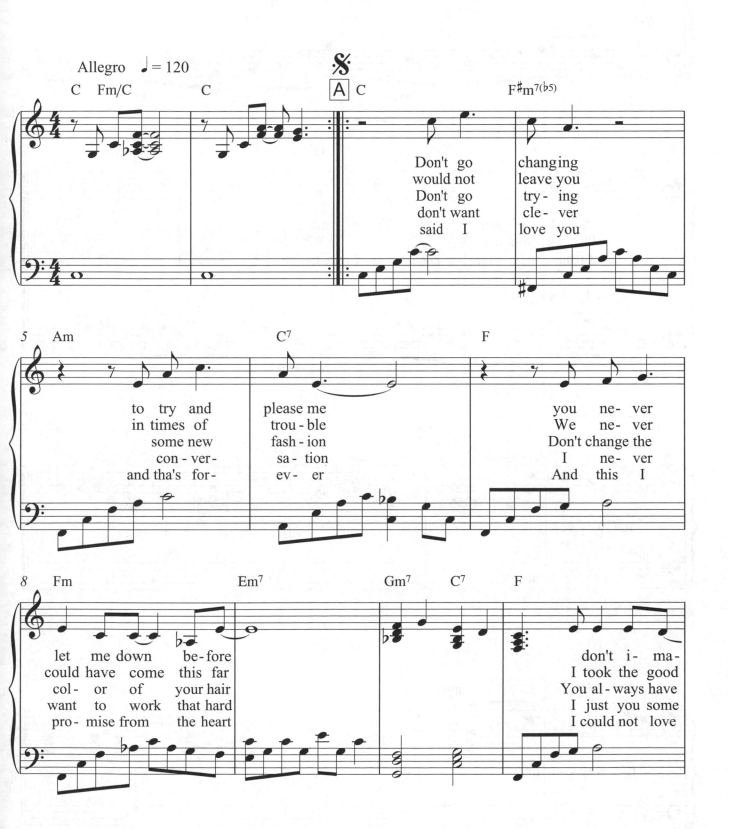

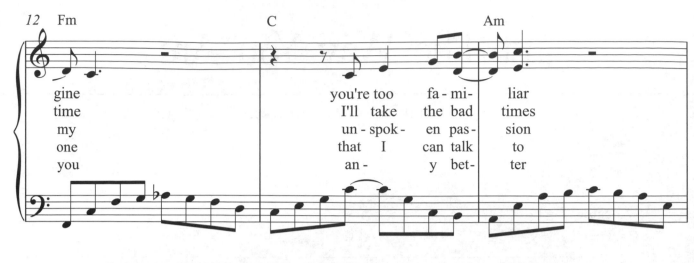

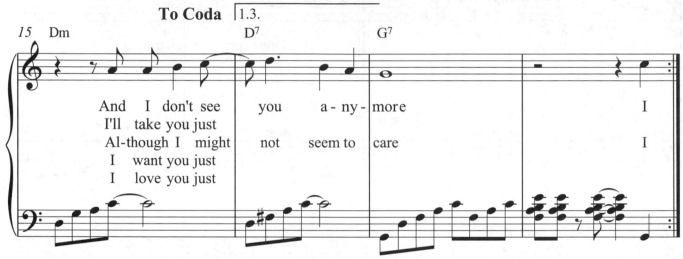

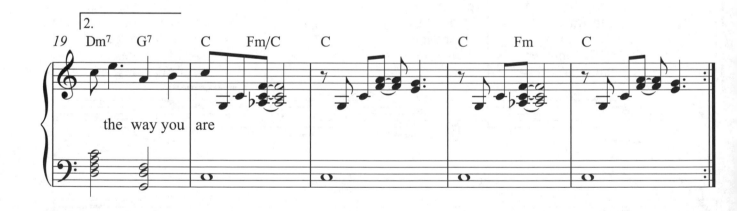

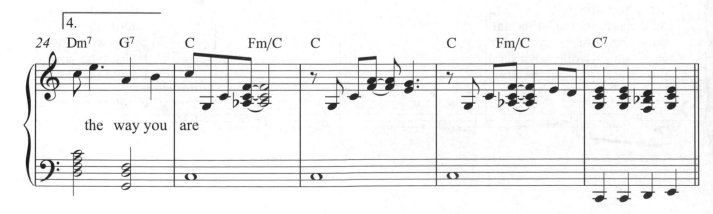

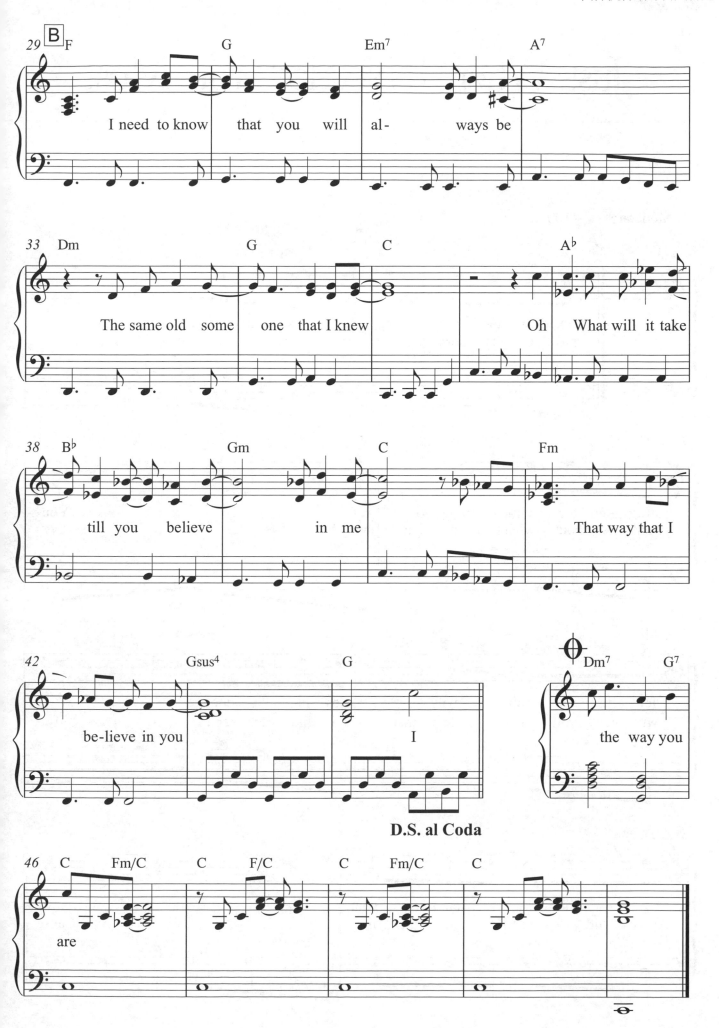

D.S. al Coda

Just When I Needed You Most

詞／曲：Randy Vanwarmer　演唱：品冠

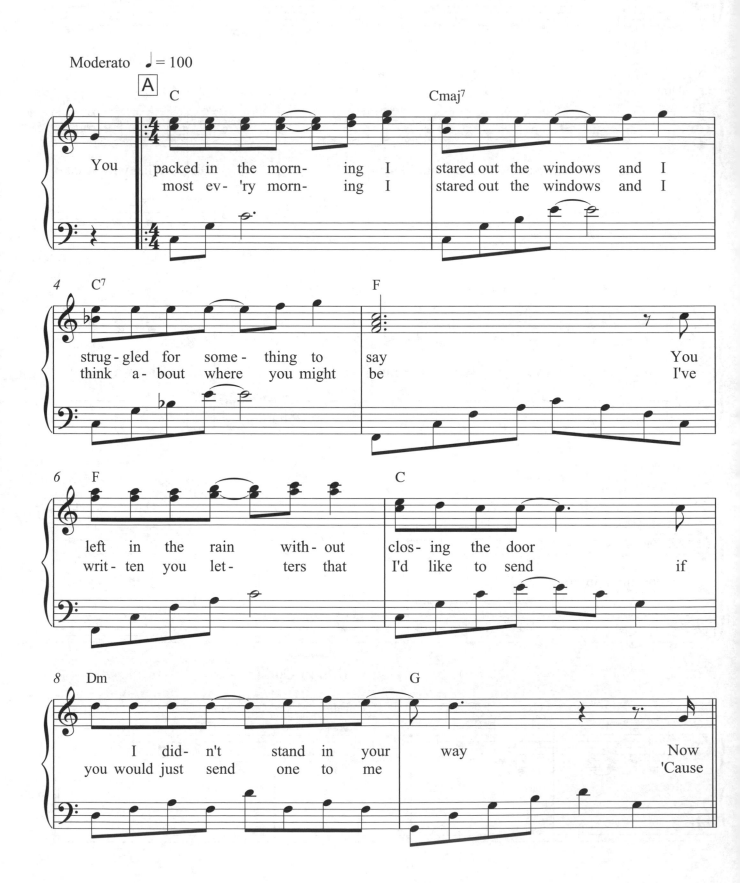

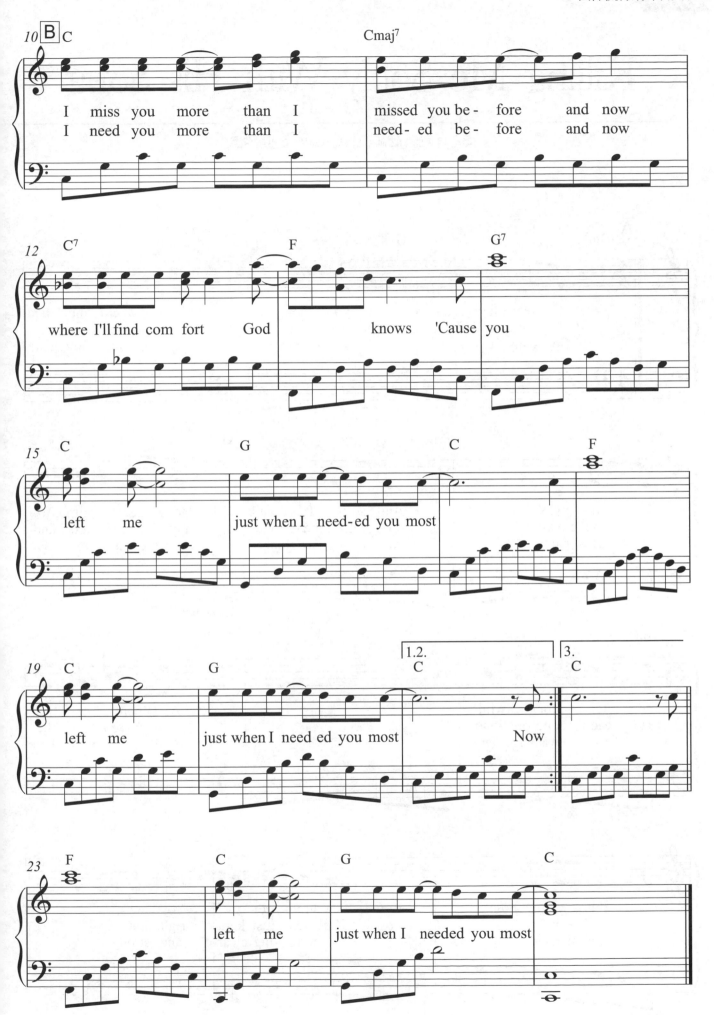

Killing Me Softly With His Song

詞／曲：N.Gimbel／C.Fox　演唱：黃小琥

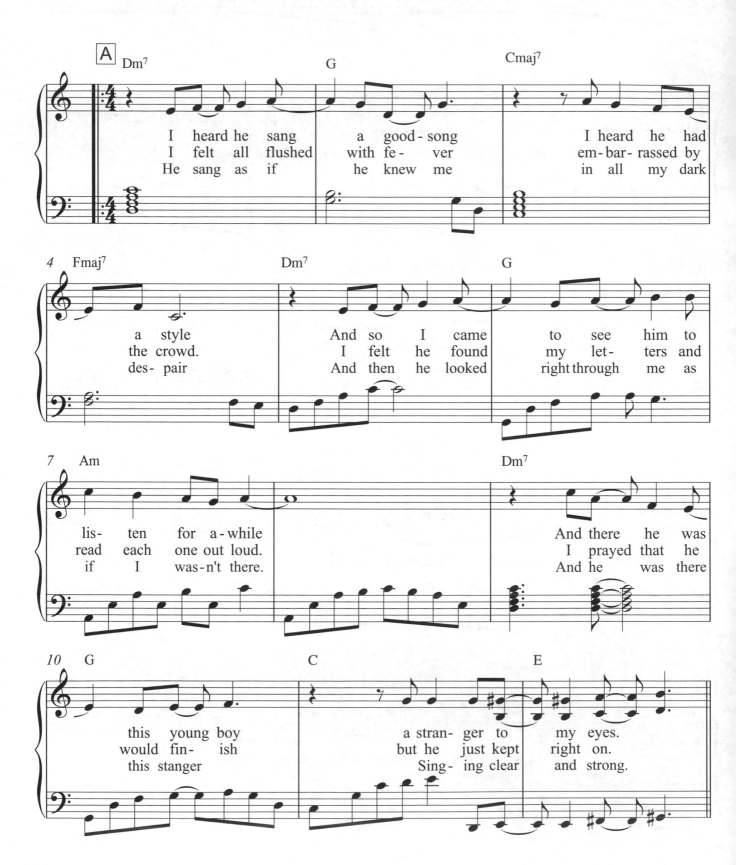

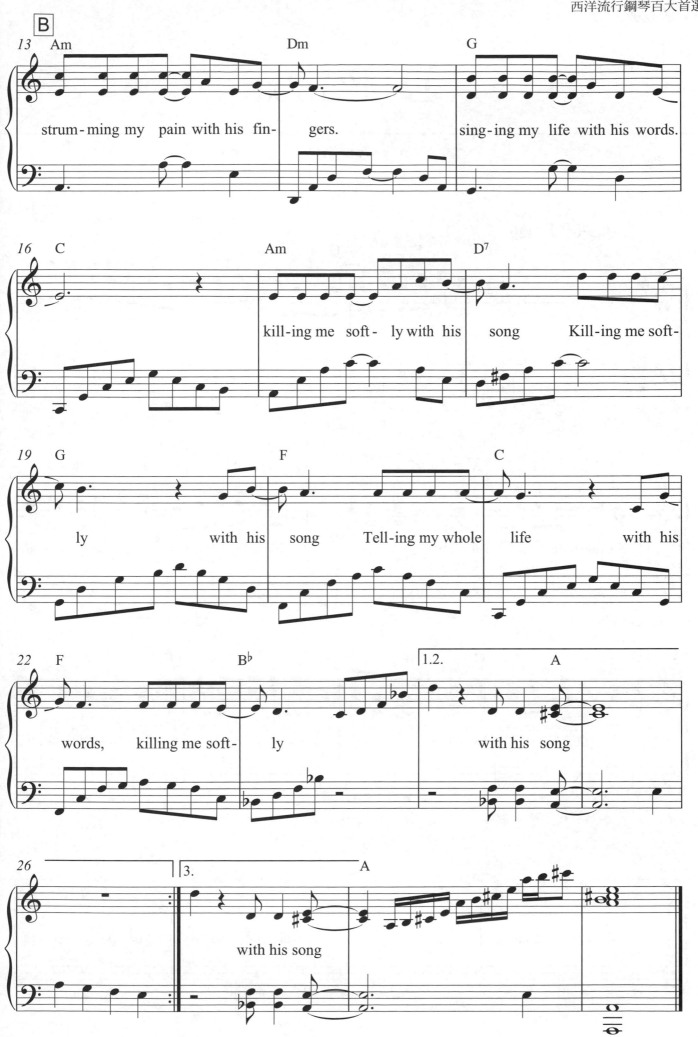

La Bamba

詞／曲：Richie Valens　演唱：Los Lobos

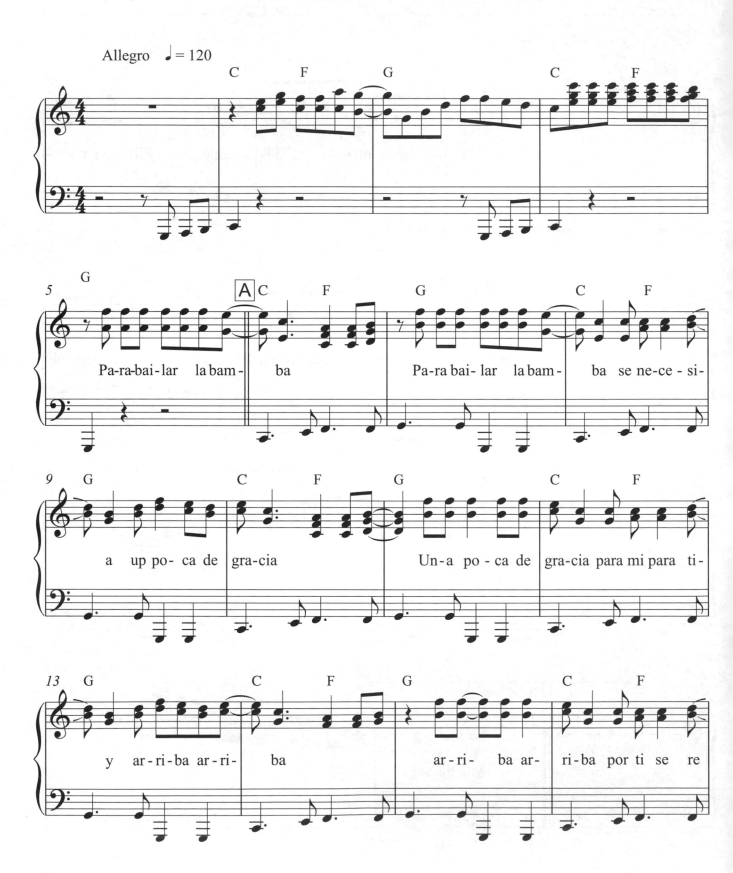

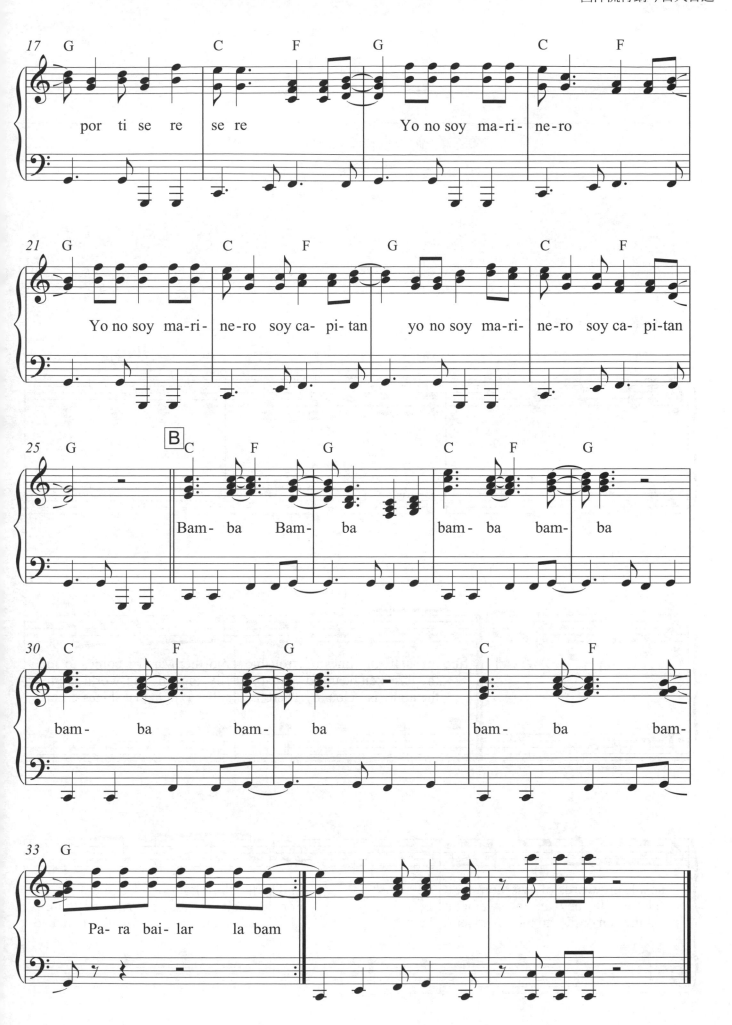

Let It Be

詞／曲：Paul Mccartney　演唱：The Beatles

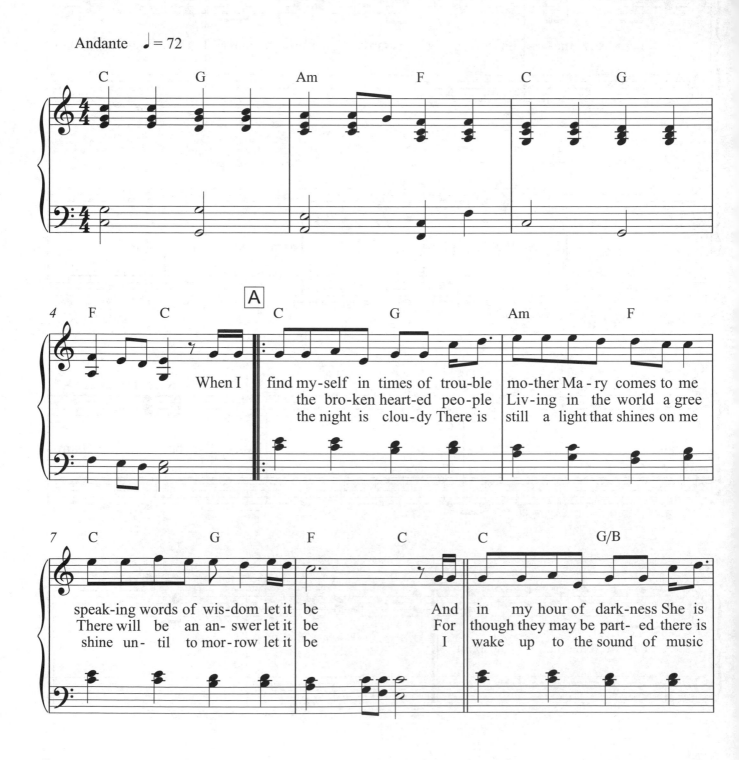

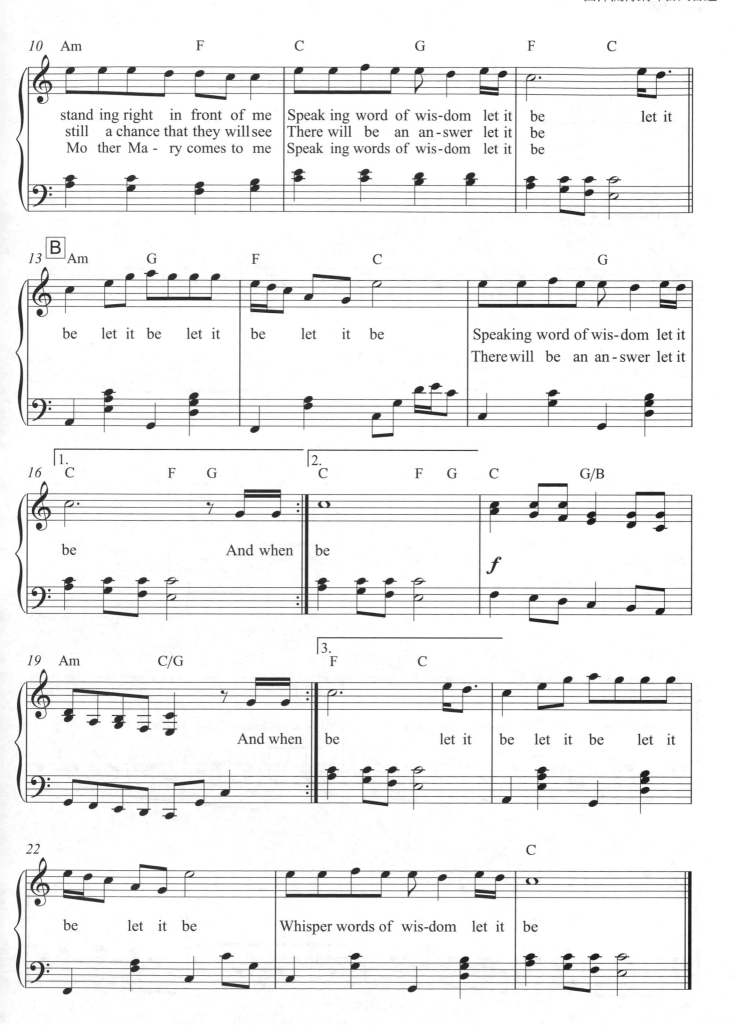

Love Me Tender

詞／曲：Vera Matson / Elvis Presley　演唱：Elvis Presley

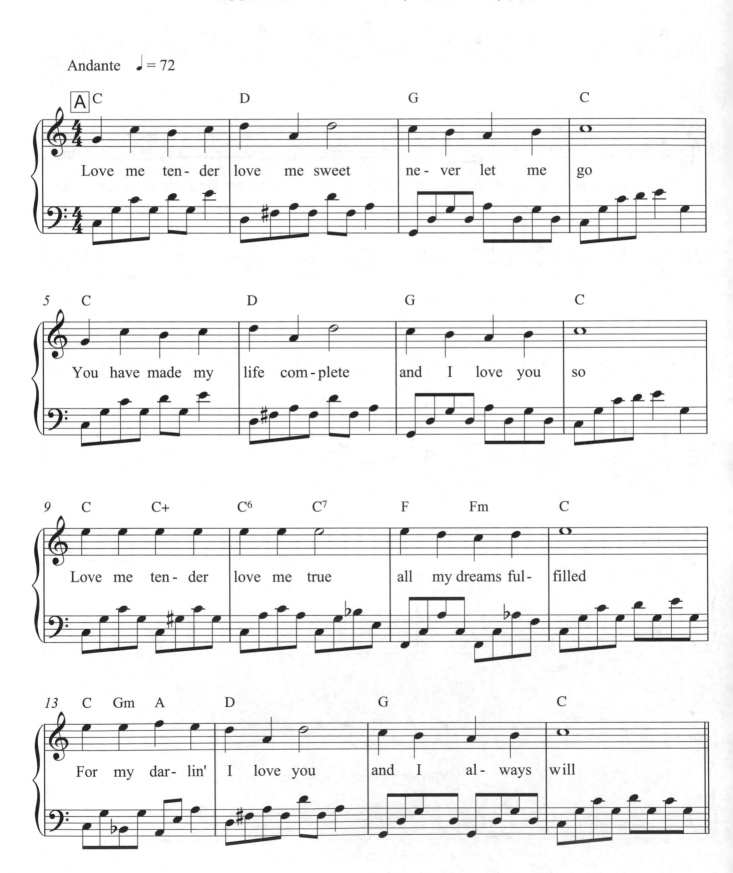

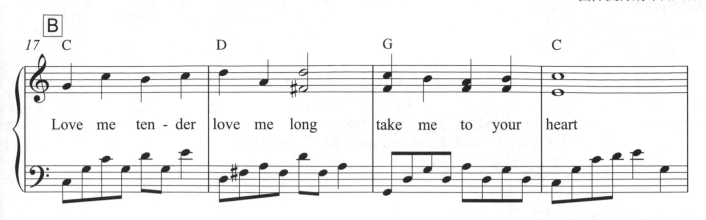

Love me ten-der love me long take me to your heart

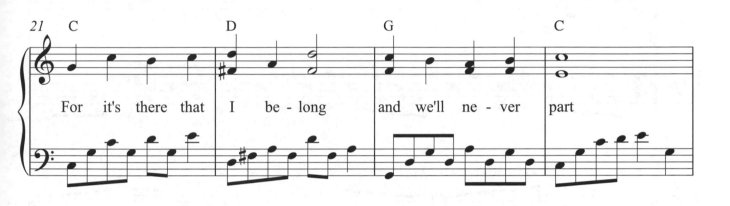

For it's there that I be-long and we'll ne-ver part

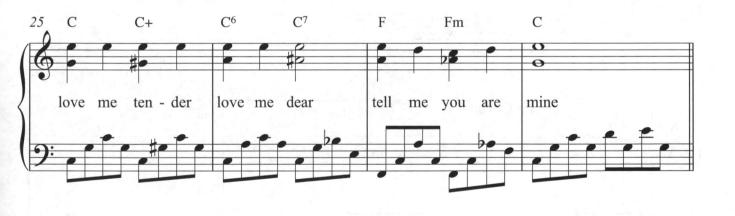

love me ten-der love me dear tell me you are mine

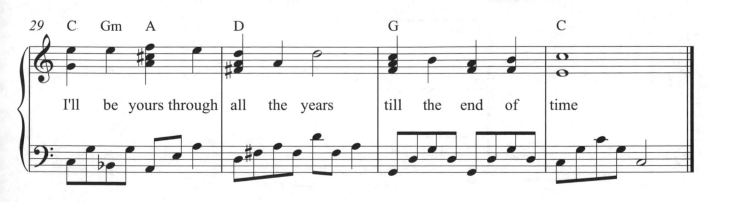

I'll be yours through all the years till the end of time

Love Story

（電影《愛的故事》主題曲）

詞／曲：Erich Segal　演唱：（演奏曲）

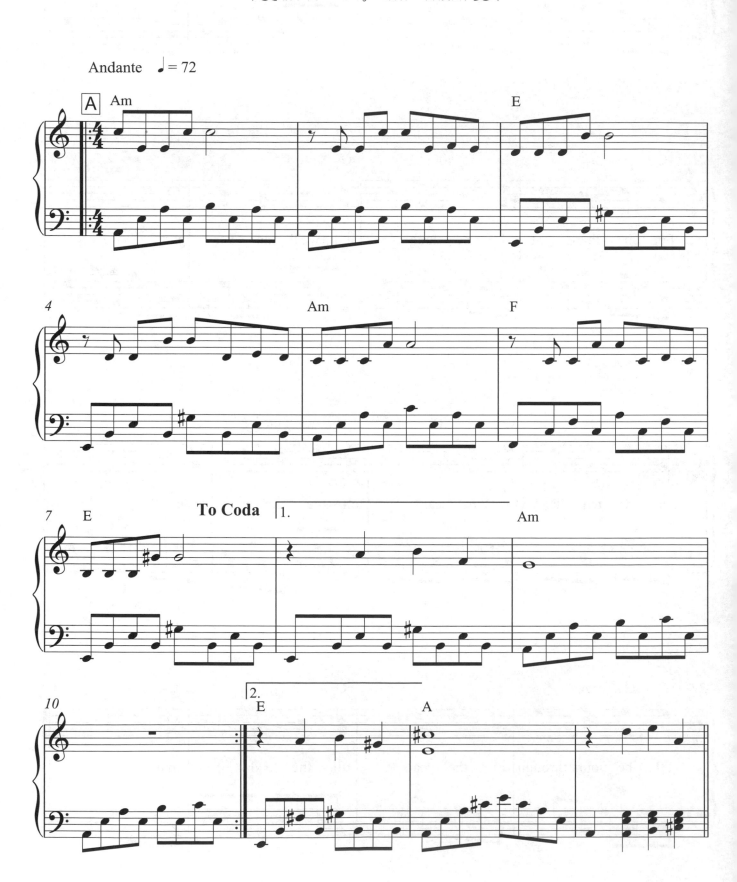

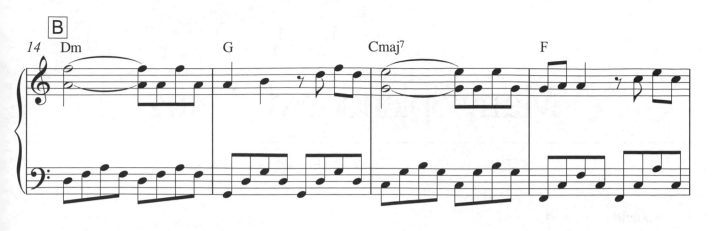
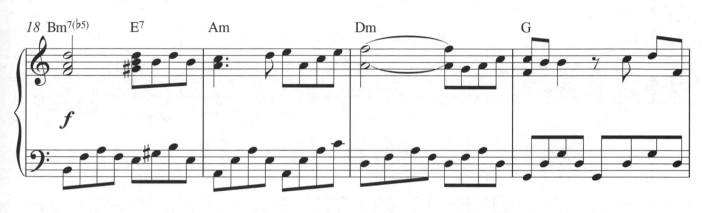
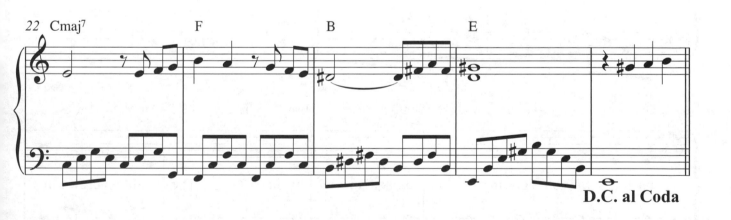
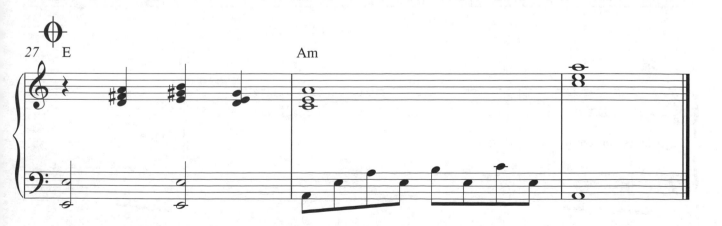

Love Is A
Many Splendored Thing

詞／曲：Sammy Fain / Paul Francis Webster　演唱：Andy Williams

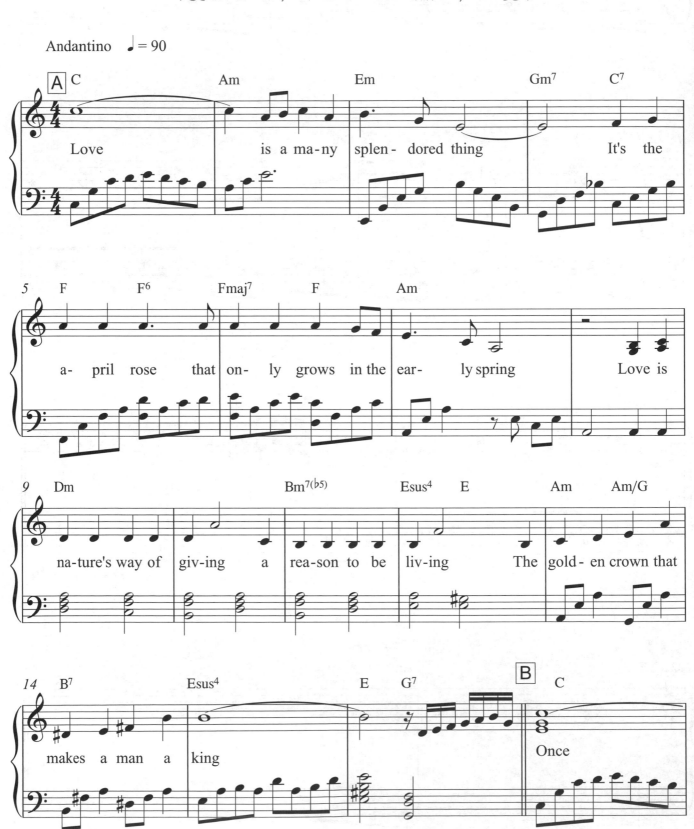

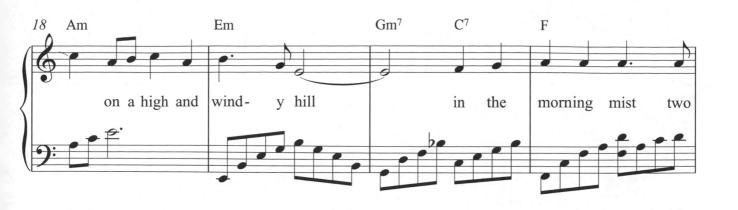

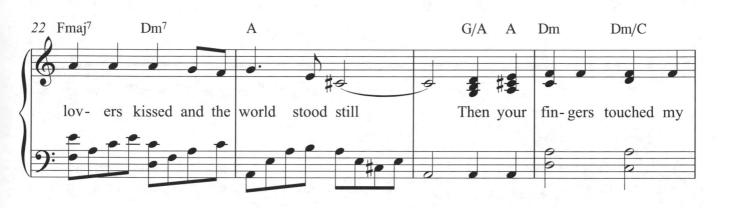

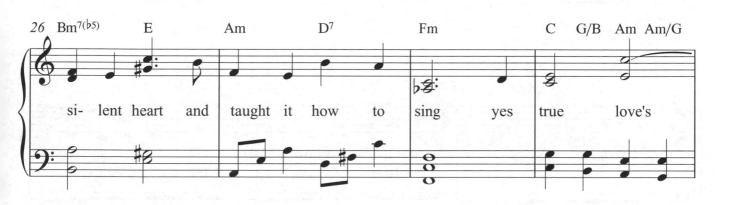

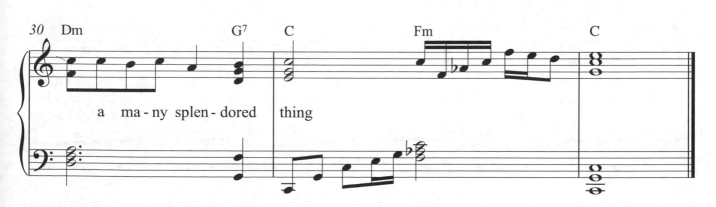

Like A Virgin

詞 / 曲：Billy Steinberg / Tom Kelly 演唱：Madana

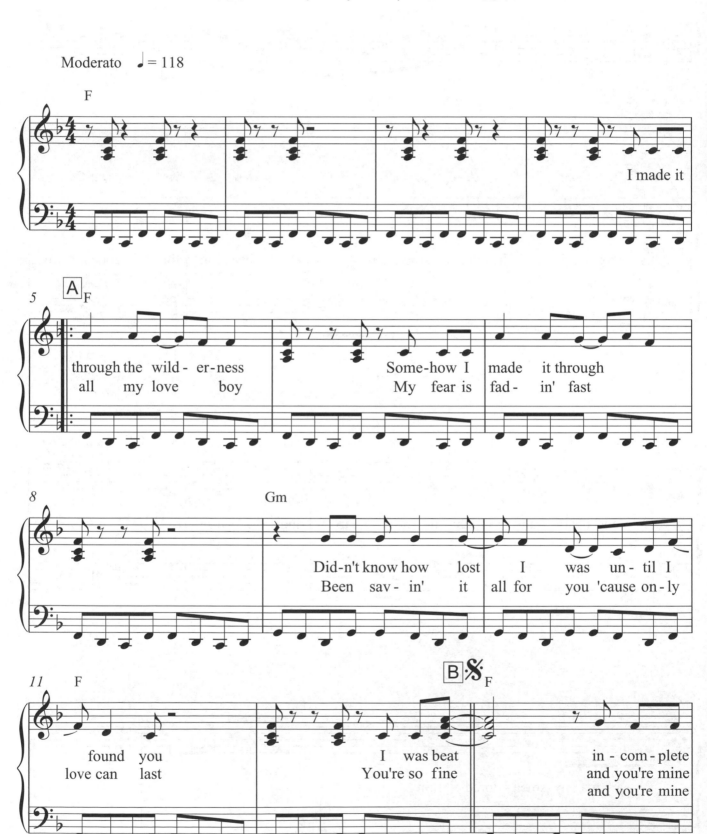

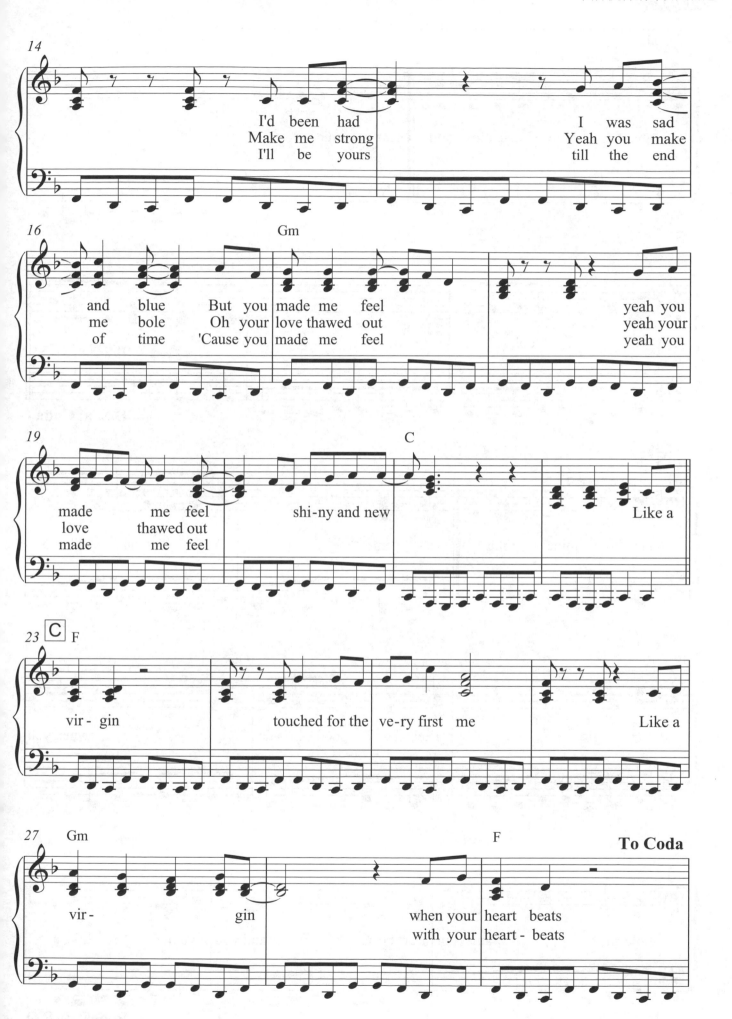

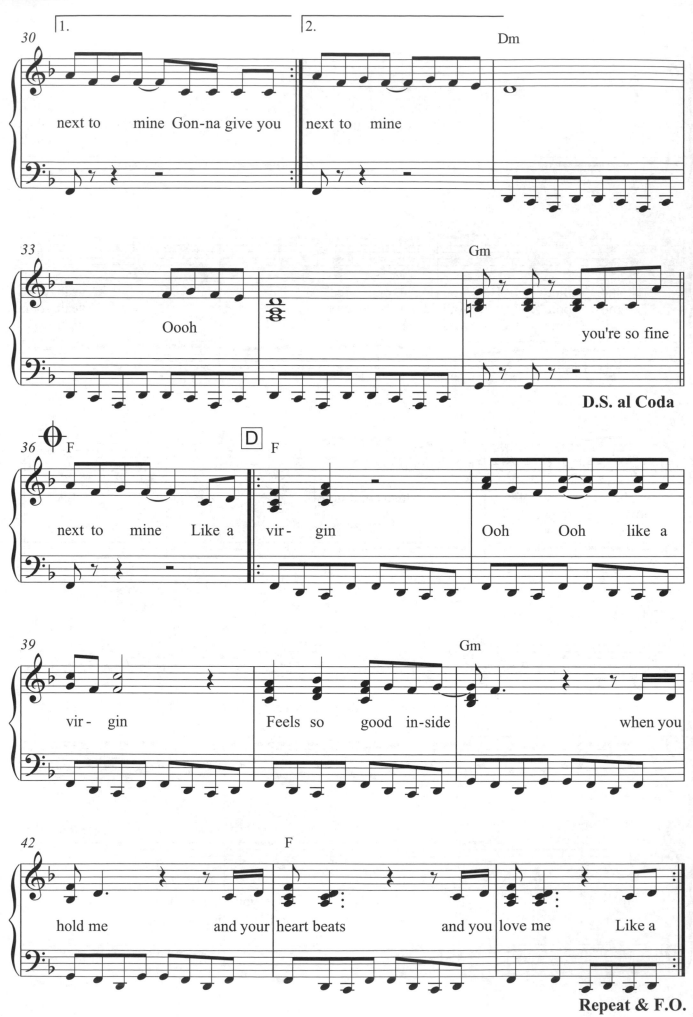

My Way

（電影《奪標》主題曲）

詞／曲：Claude Francois / Jacques Revaux / Paul Anka　　演唱：Paul Anka

Andante ♩=74

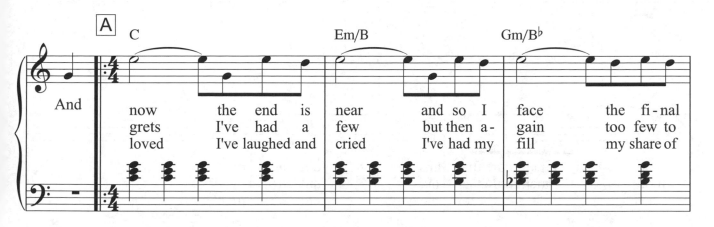

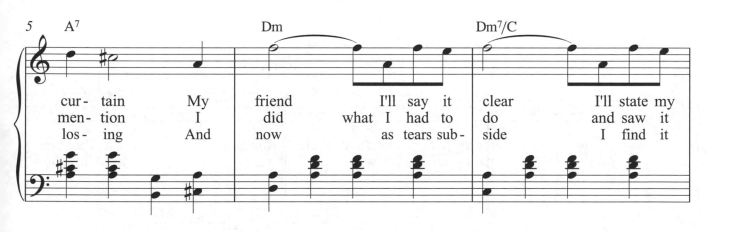

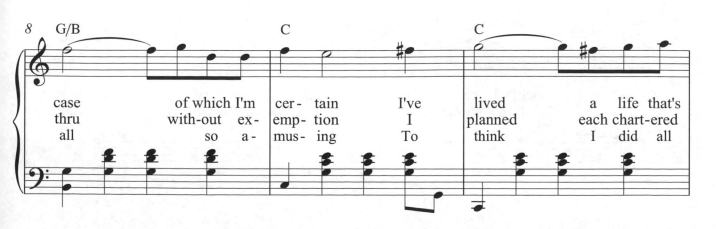

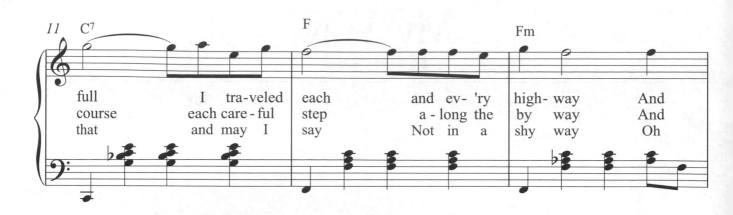

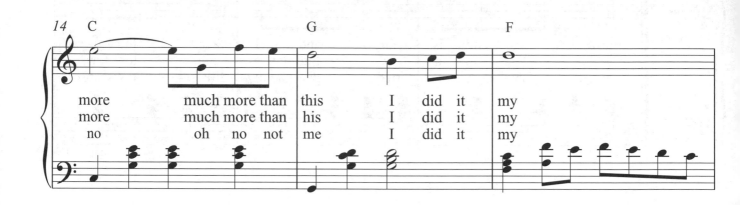

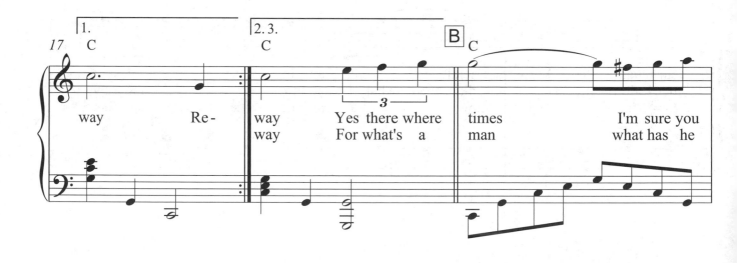

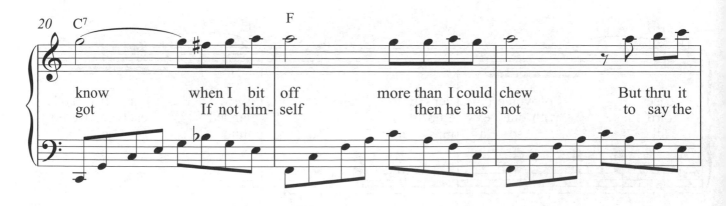

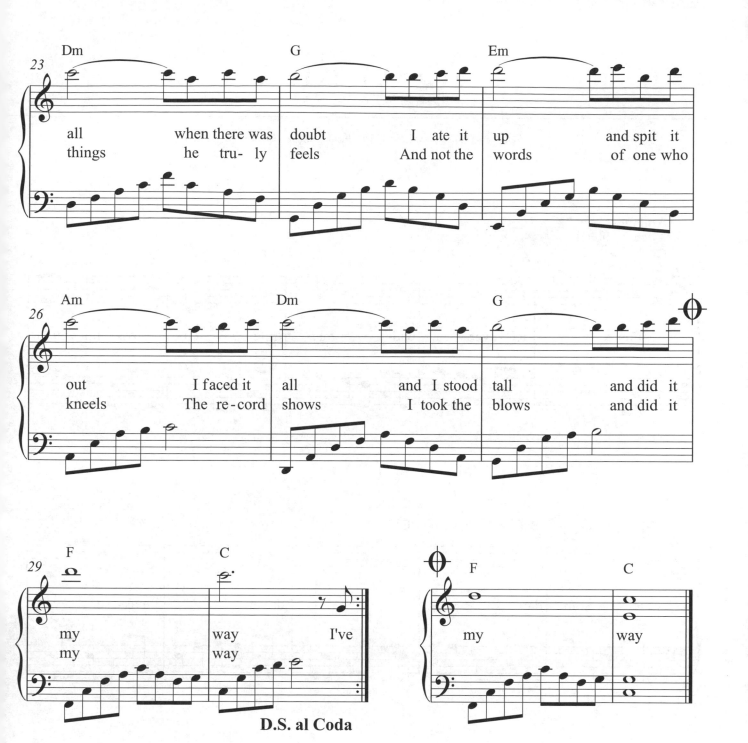

Moon River

（電影《第凡內早餐》主題曲）

詞／曲：Johnny Mercer / Herry Mancini　演唱：Andy Williams

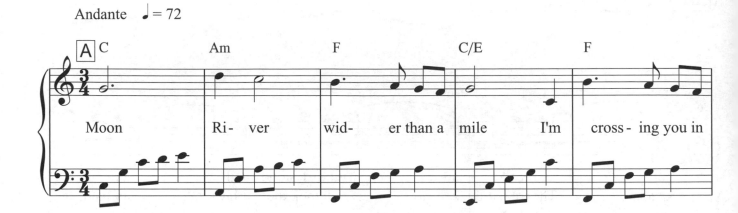

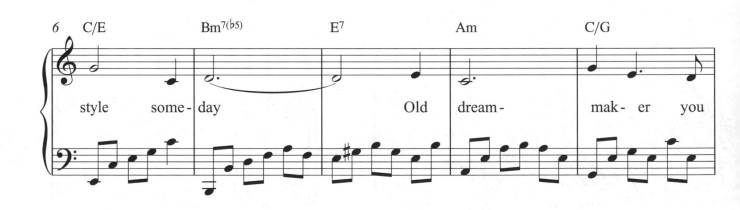

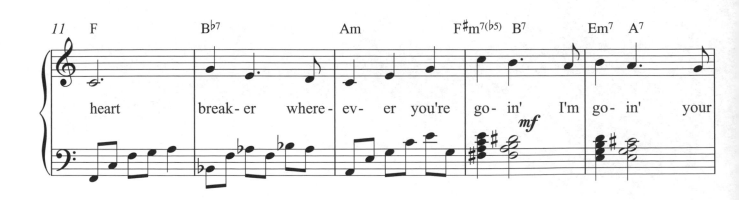

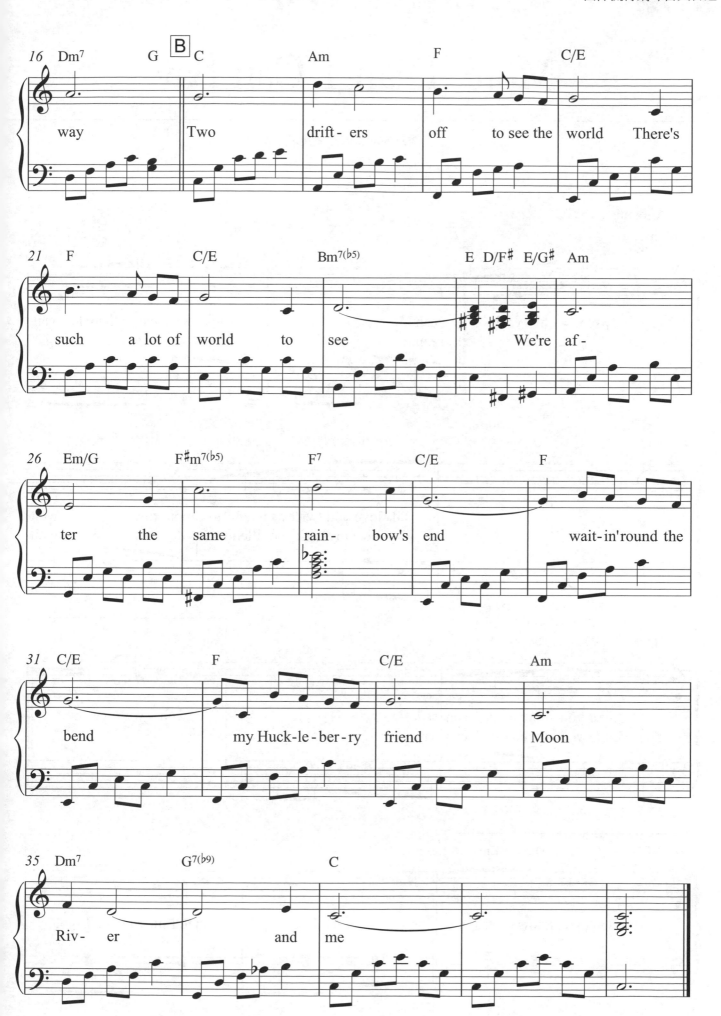

More Than I Can Say

演唱：Bobby Vee

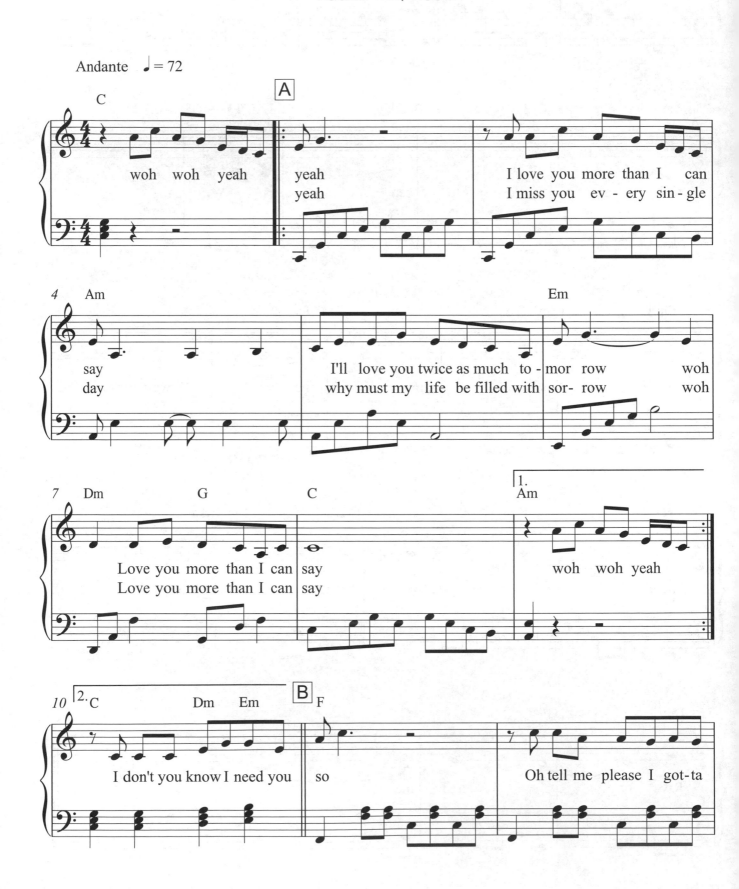

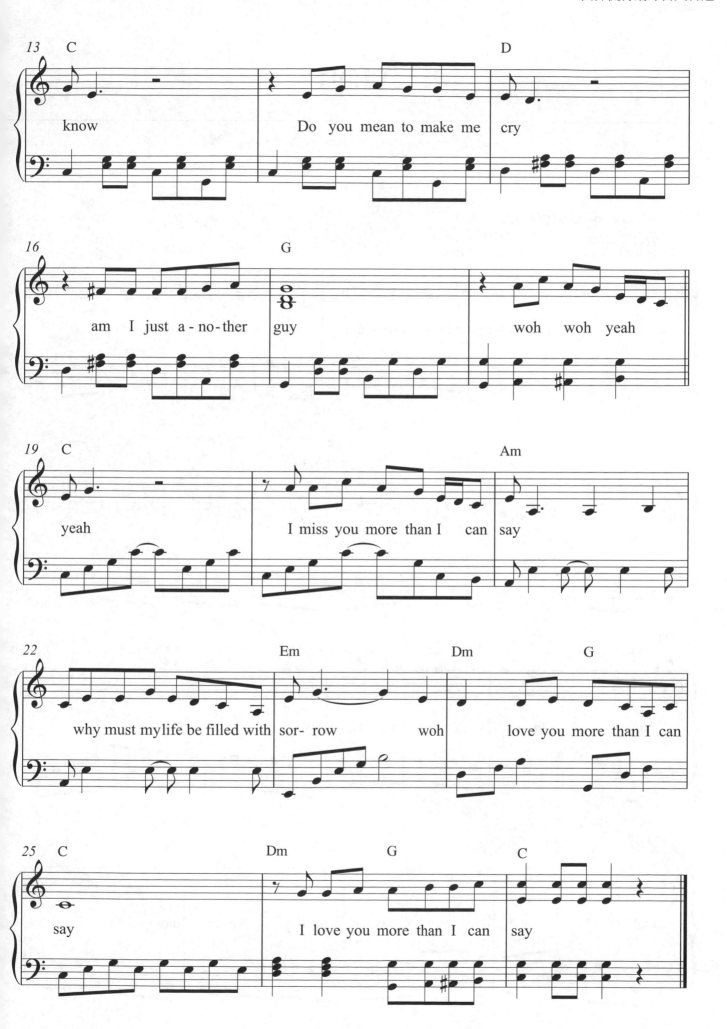

More

詞 / 曲：Alex Alstone / Tom Glazer　演唱：Perry Como

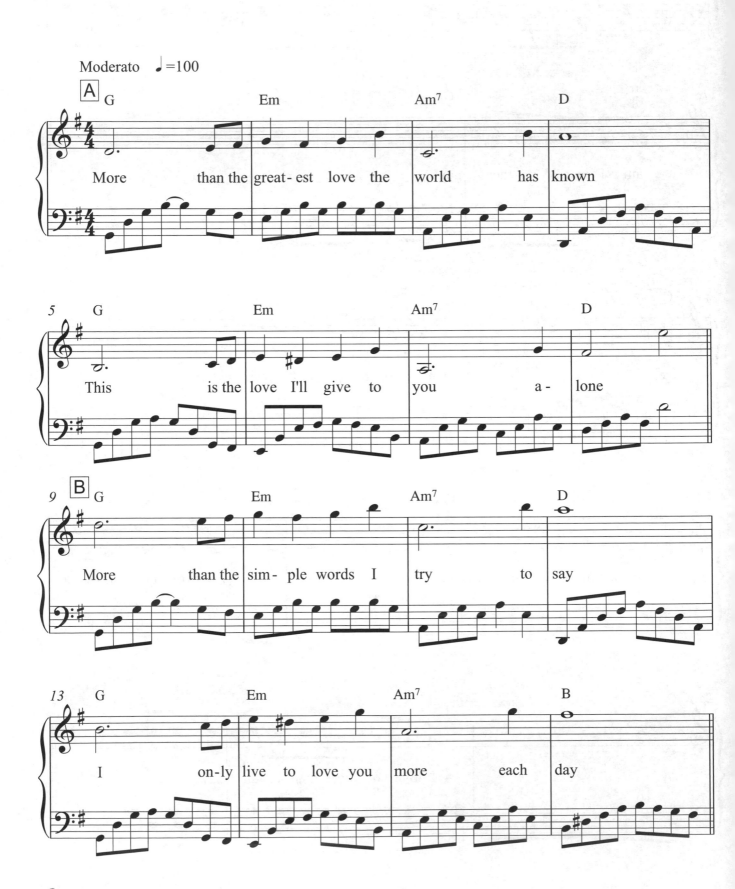

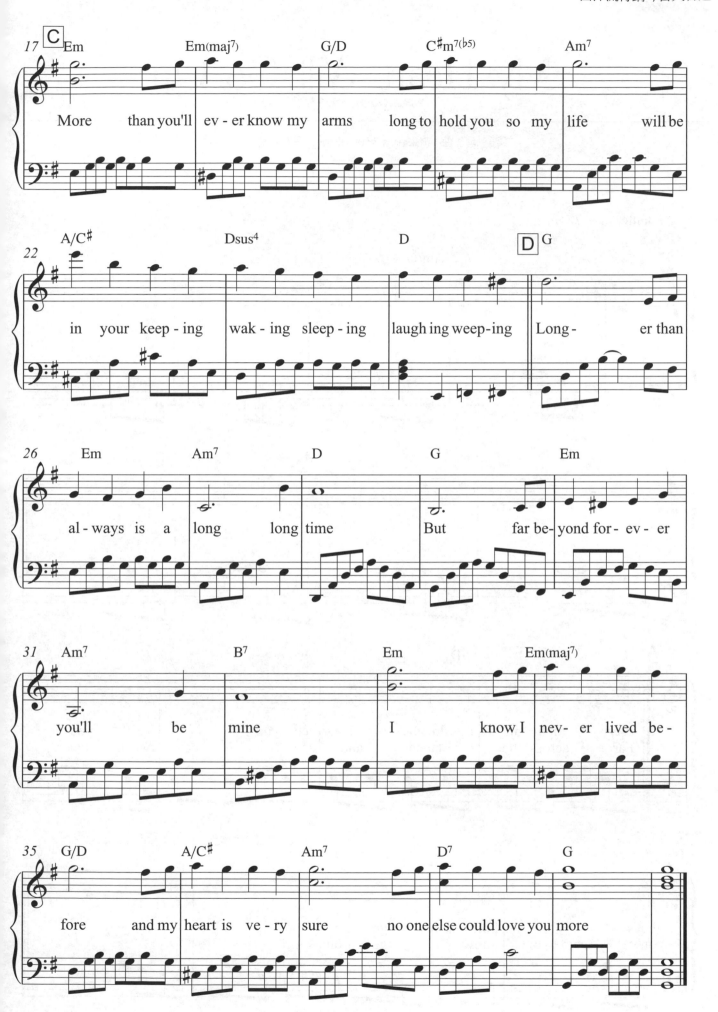

My Heart Will Go On

（電影《鐵達尼號》主題曲）

詞／曲：Will Jennings／James Horner　演唱：Celine Dion

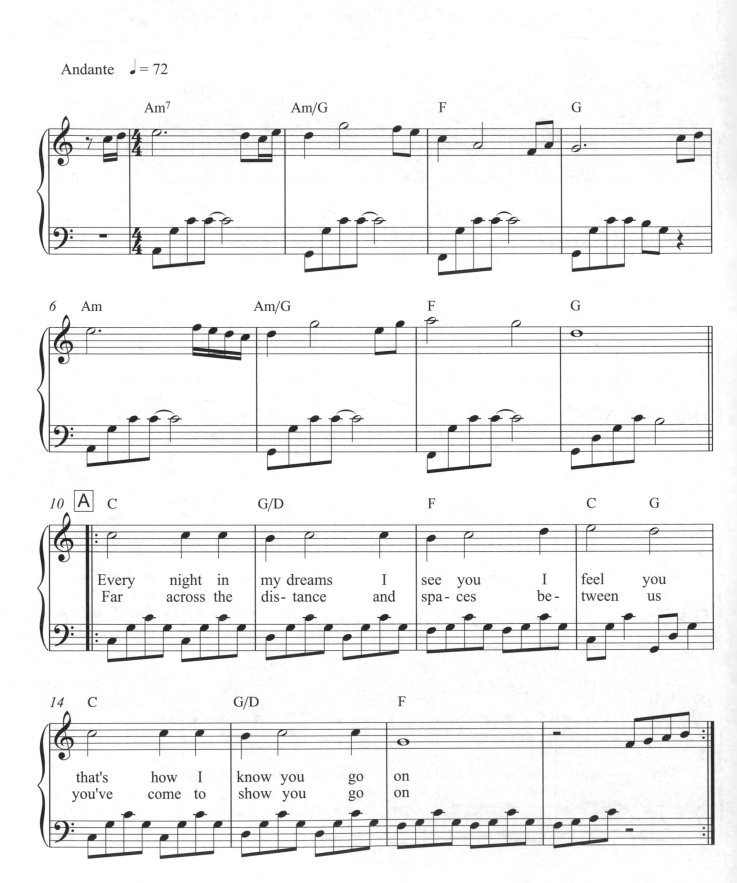

Andante ♩ = 72

Every night in my dreams I see you I feel you
Far across the dis- tance and spa- ces be- tween us

that's how I know you go on
you've come to show you go on

158

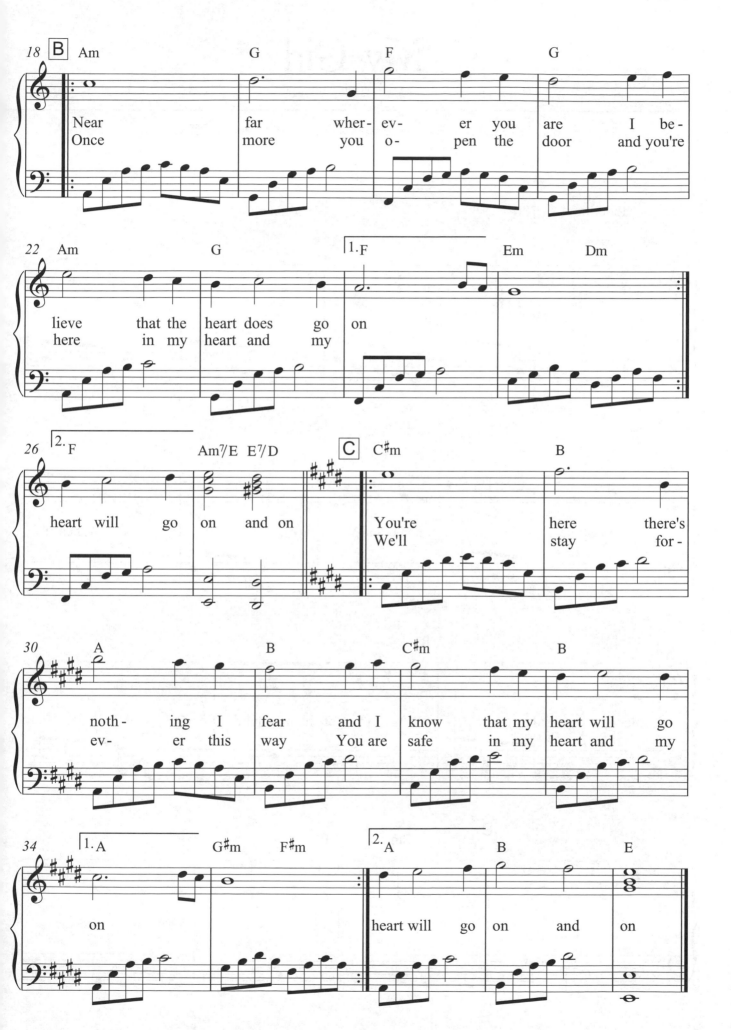

My Girl

（電影《小鬼初戀》主題曲）

詞／曲：Ronal A.White / William Robinson / Jr　演唱：Alabama

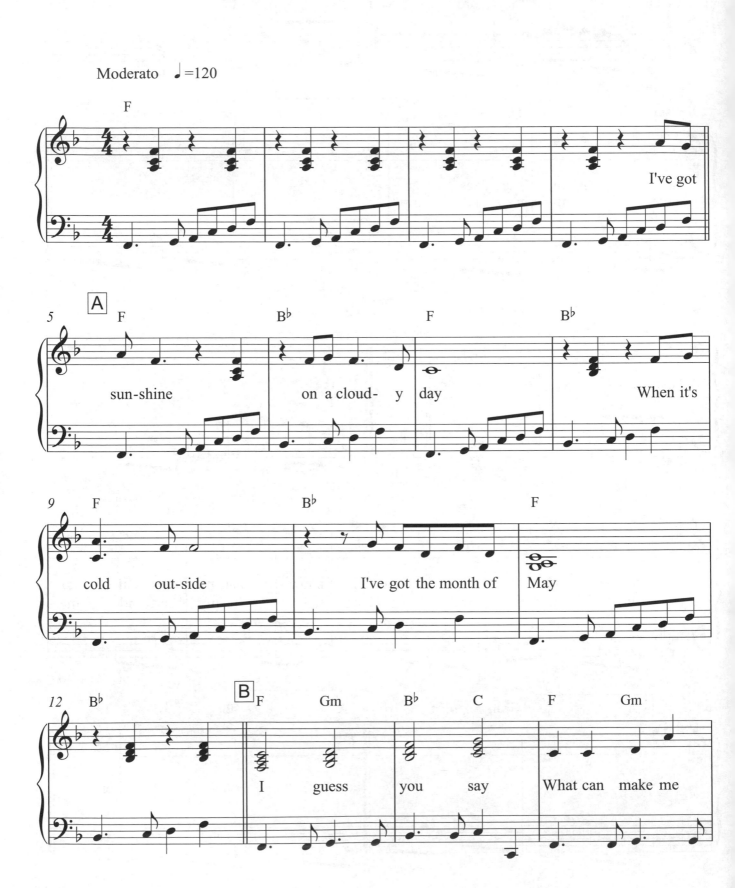

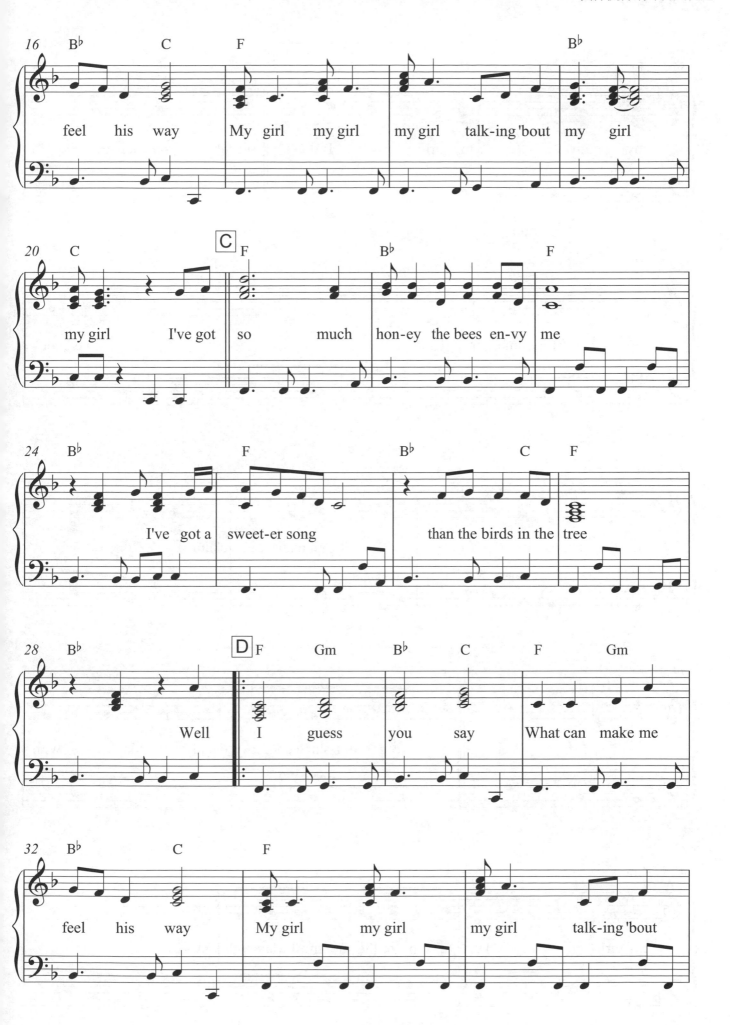

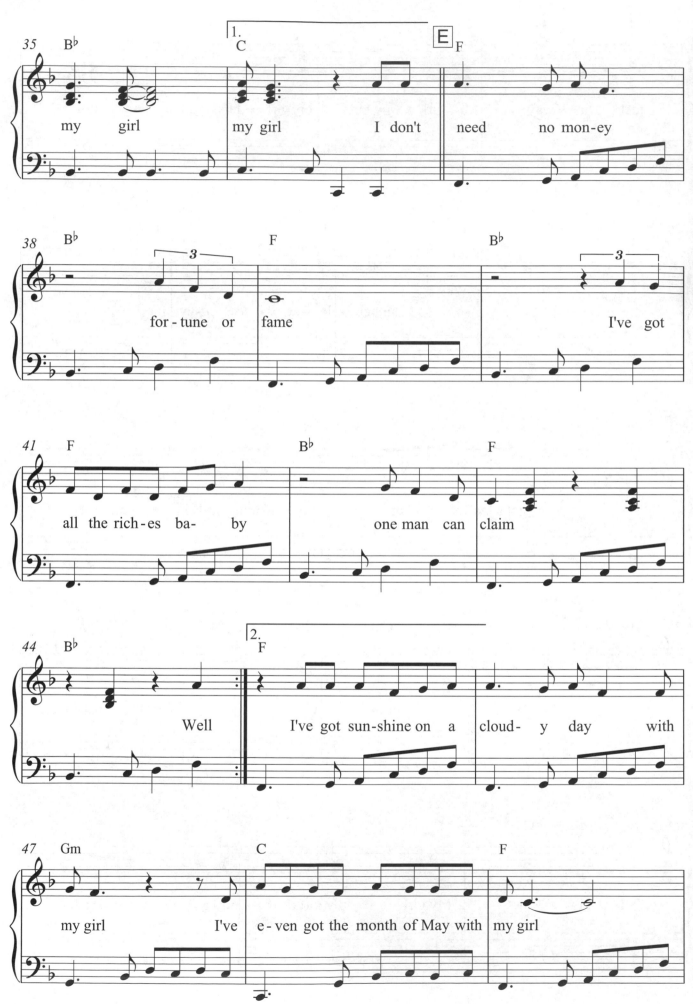

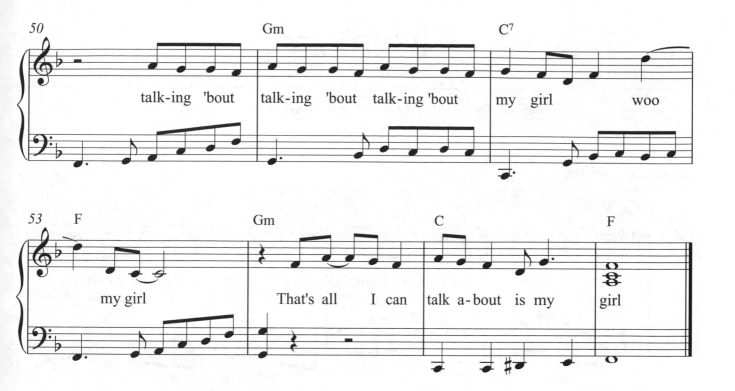

Memory

（音樂劇《貓》主題曲）

詞／曲：Trevor Nunn / Andrew Lloyd Webber　演唱：Barbra Streisand

Moderato ♩ = 100

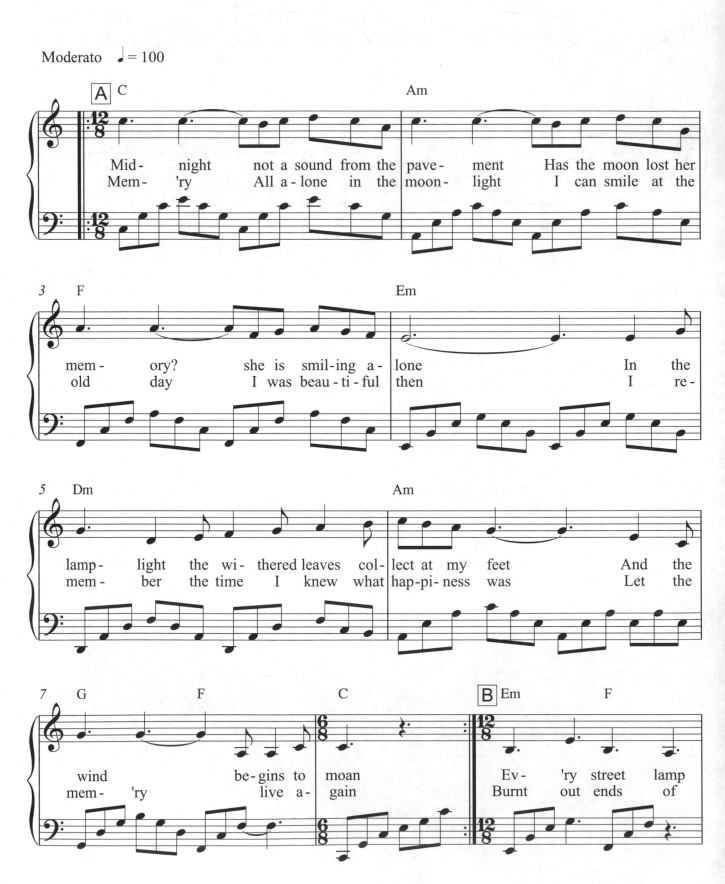

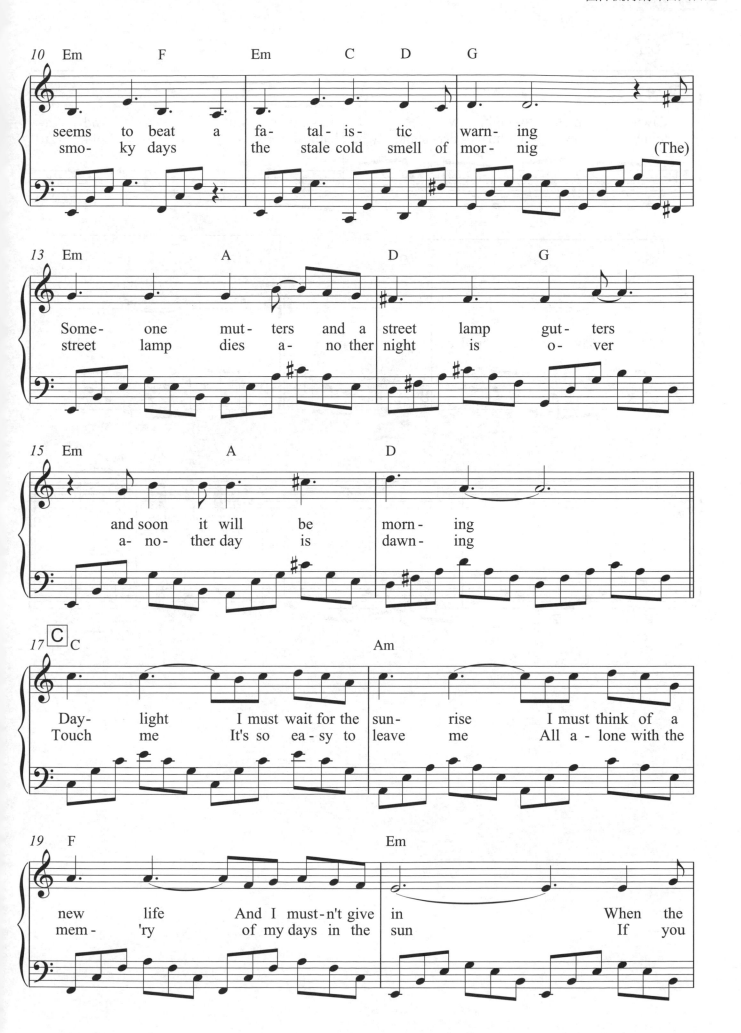

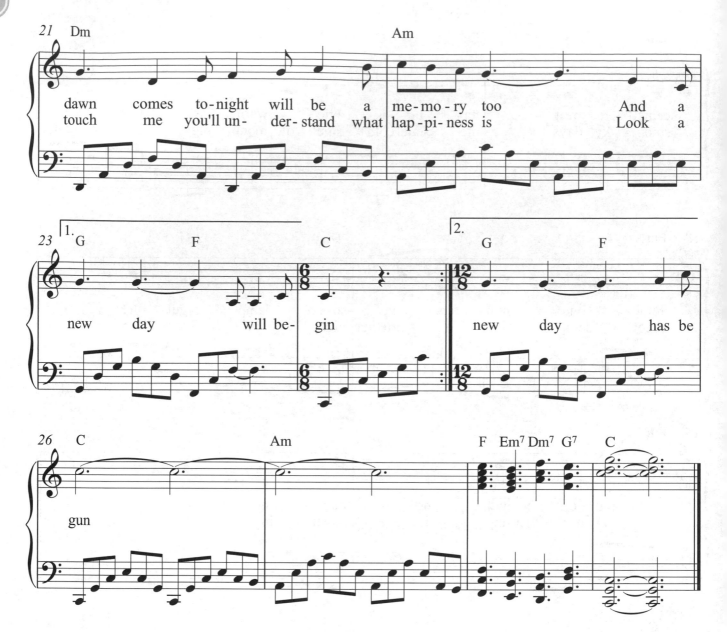

Music Box Dancer

詞／曲：Frank Mills　演唱：（演奏曲）

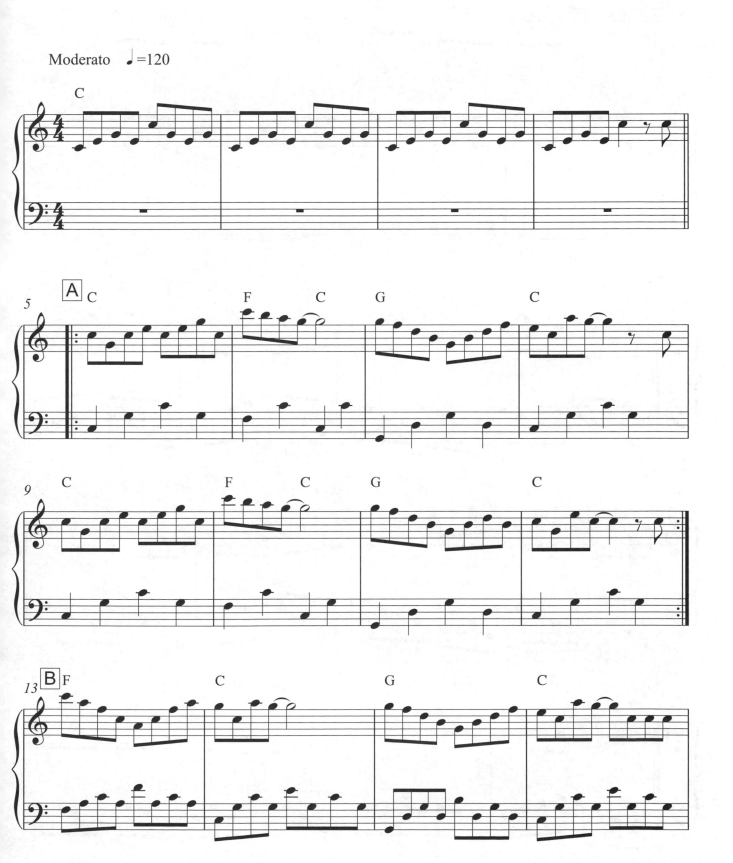

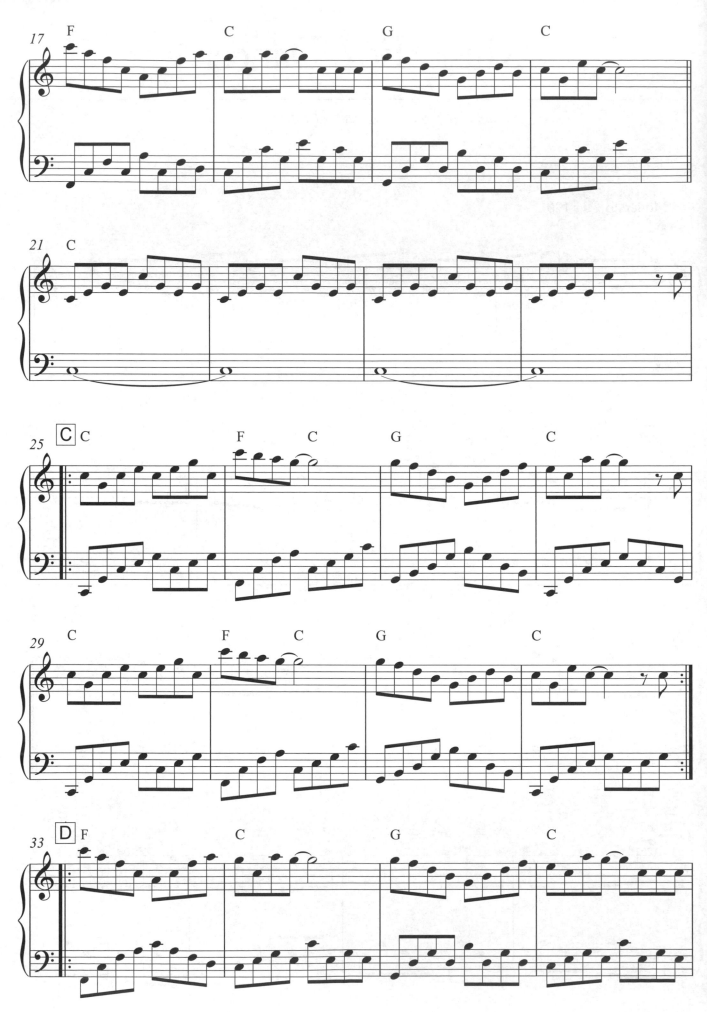

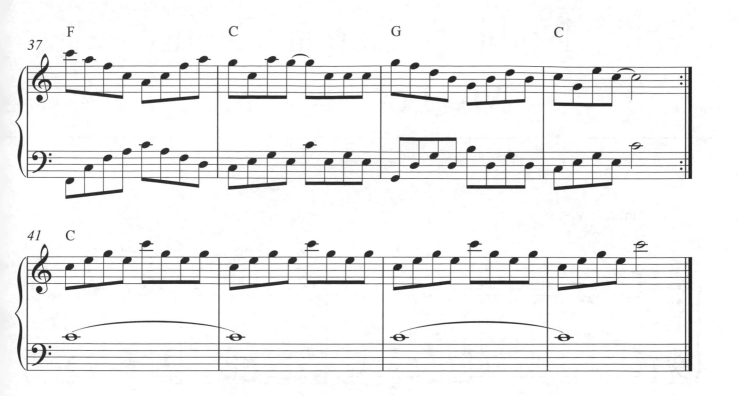

Nothing's Gonna Change
My Love For You

詞 / 曲：Gerry Goffin / Michael Masser　演唱：George Benson

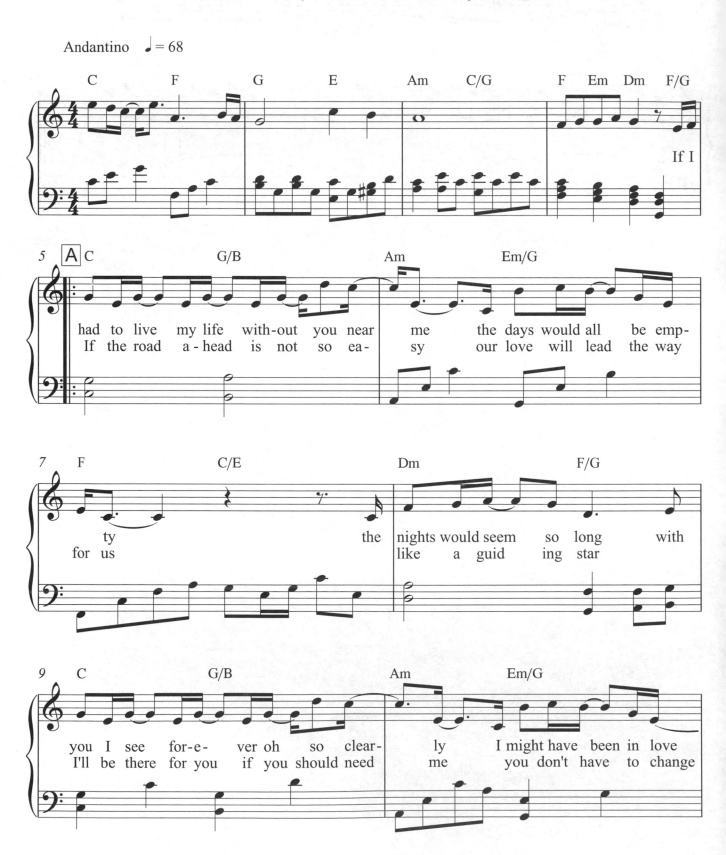



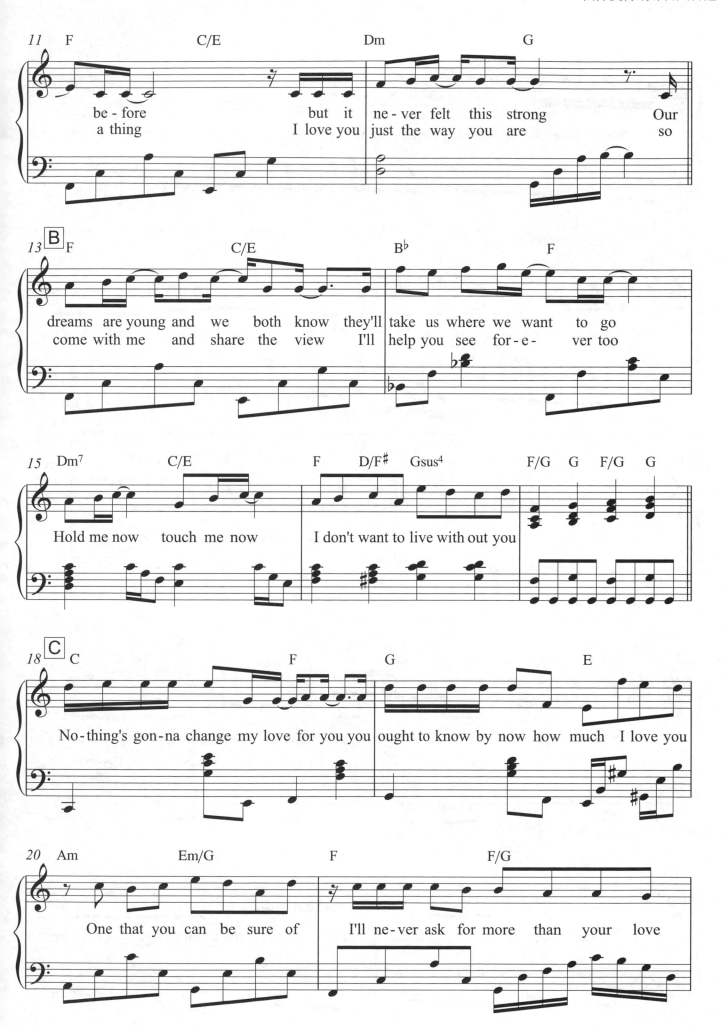

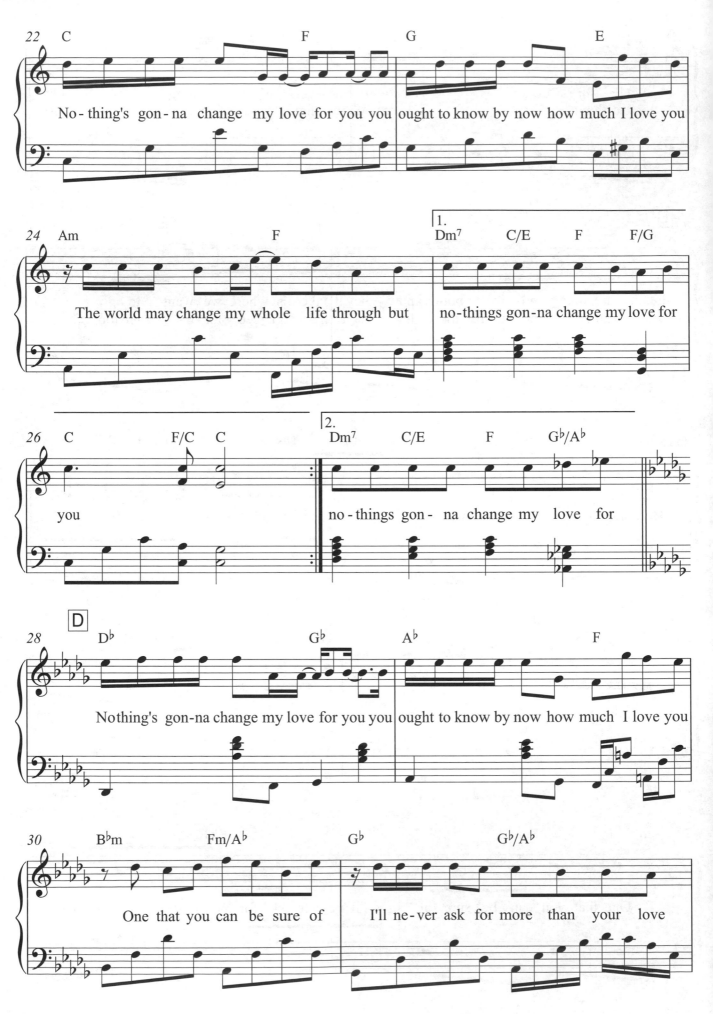

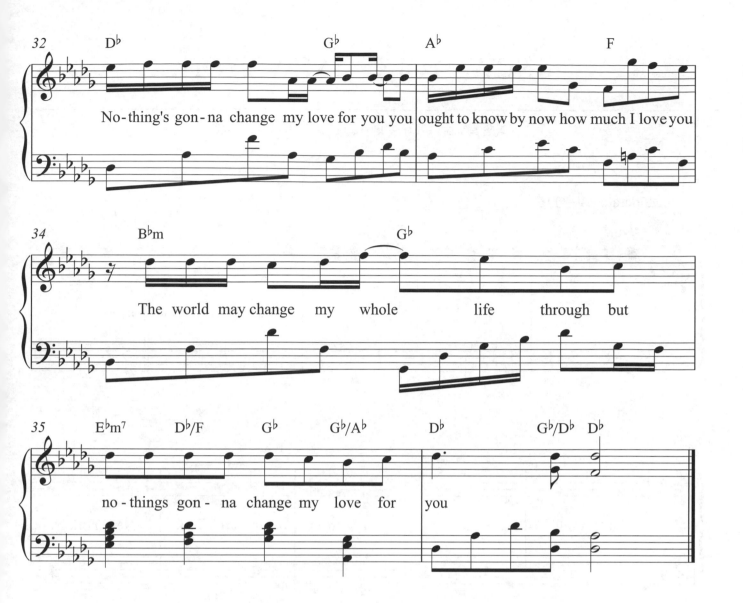

New York, New York

詞／曲：Fred Ebb／John Kander　演唱：Frank Sinatra

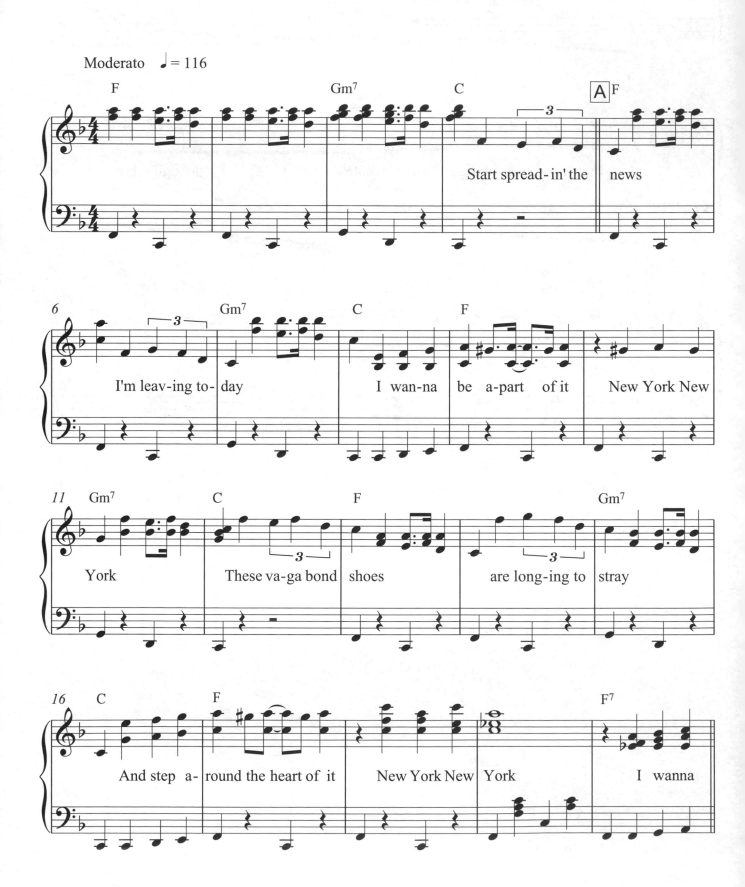

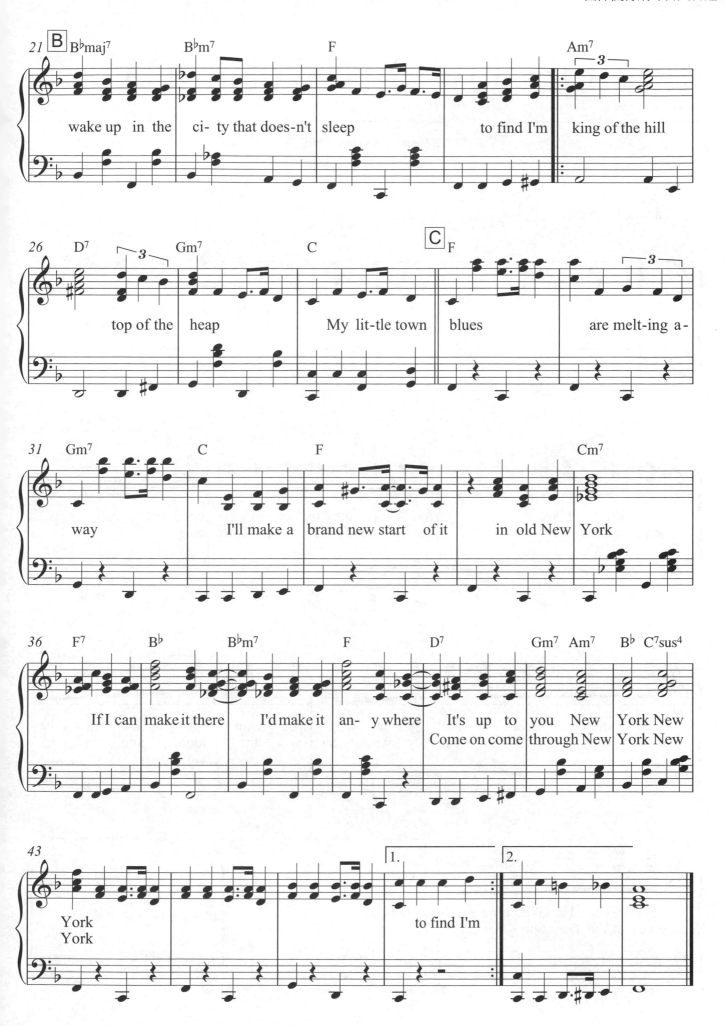

OB-LA-DI, OB-LA-DA

詞／曲：Lennon / McCartney　演唱：The Beatles

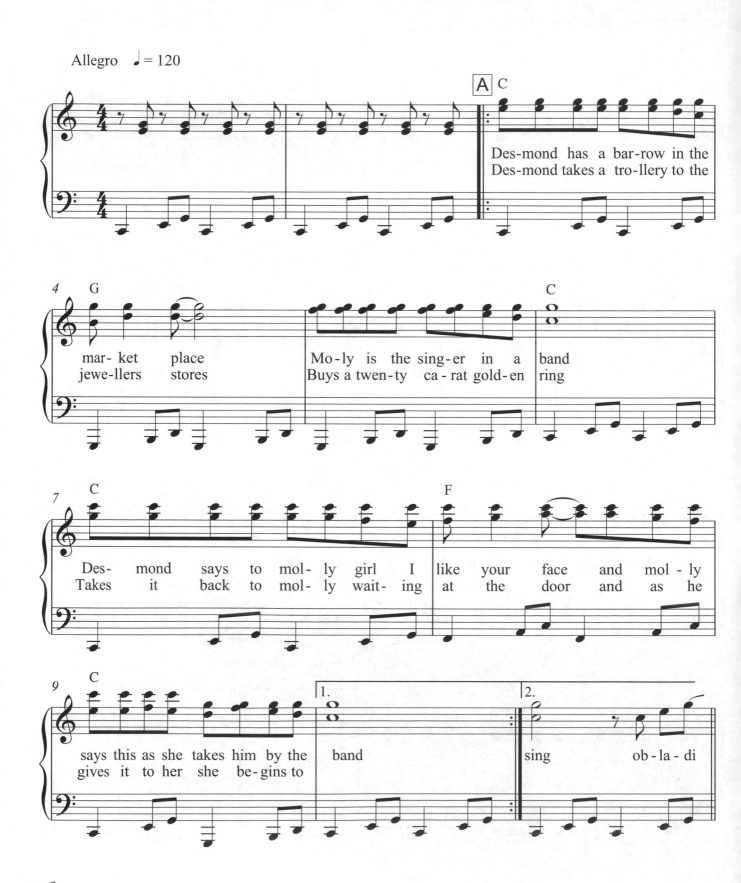

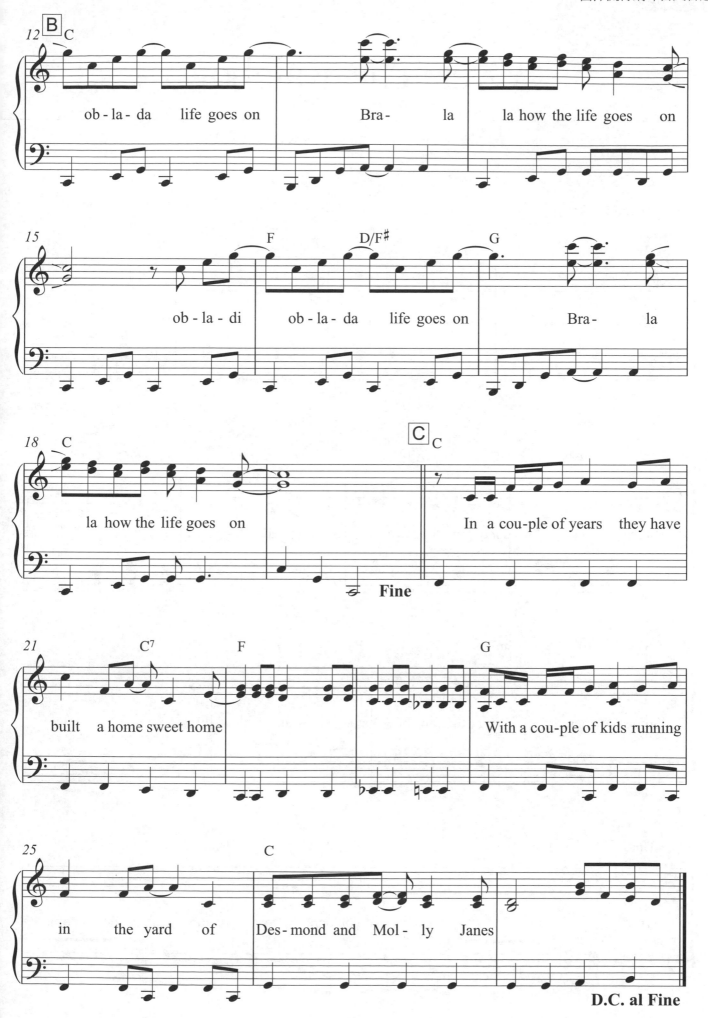

Over The Rainbow

（電影《綠野仙蹤》主題曲）

詞／曲：Harold Arlen / E.Y.Harburg　演唱：Ray Charles

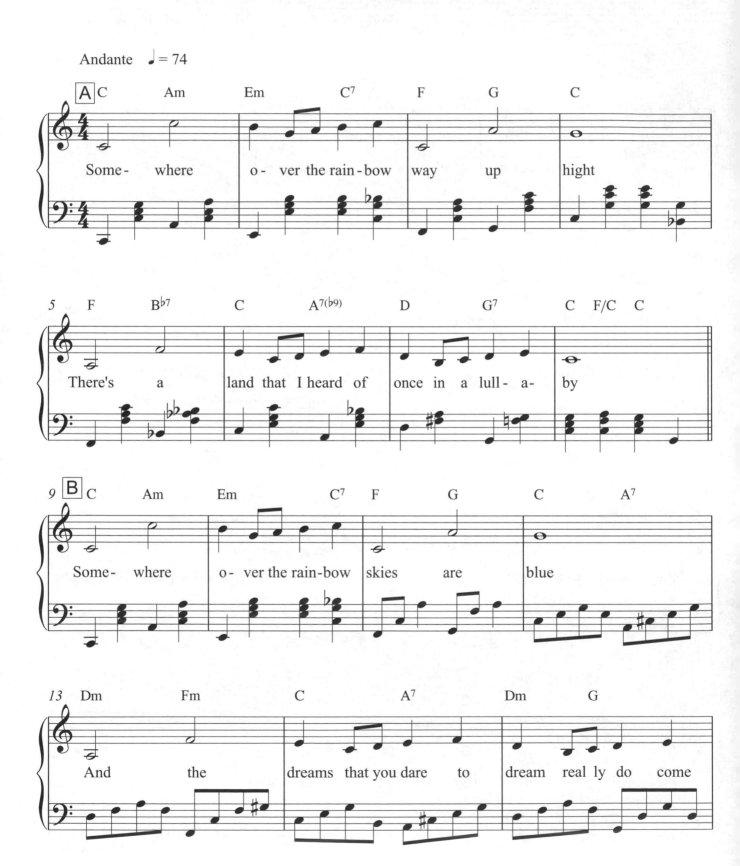

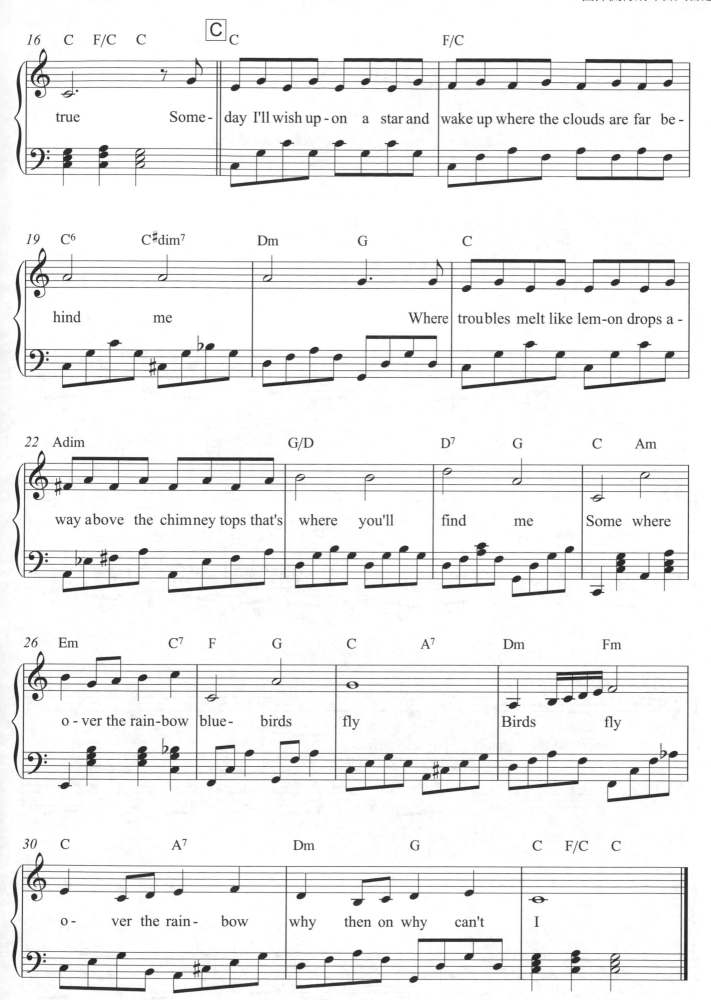

Only You

詞／曲：Buck Ram / Andre Rand　演唱：Diana Ross

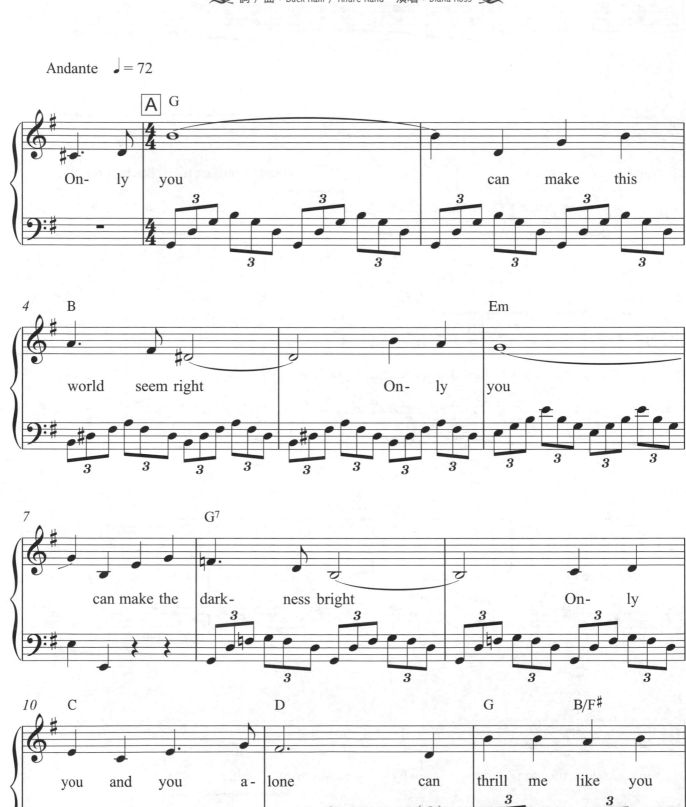

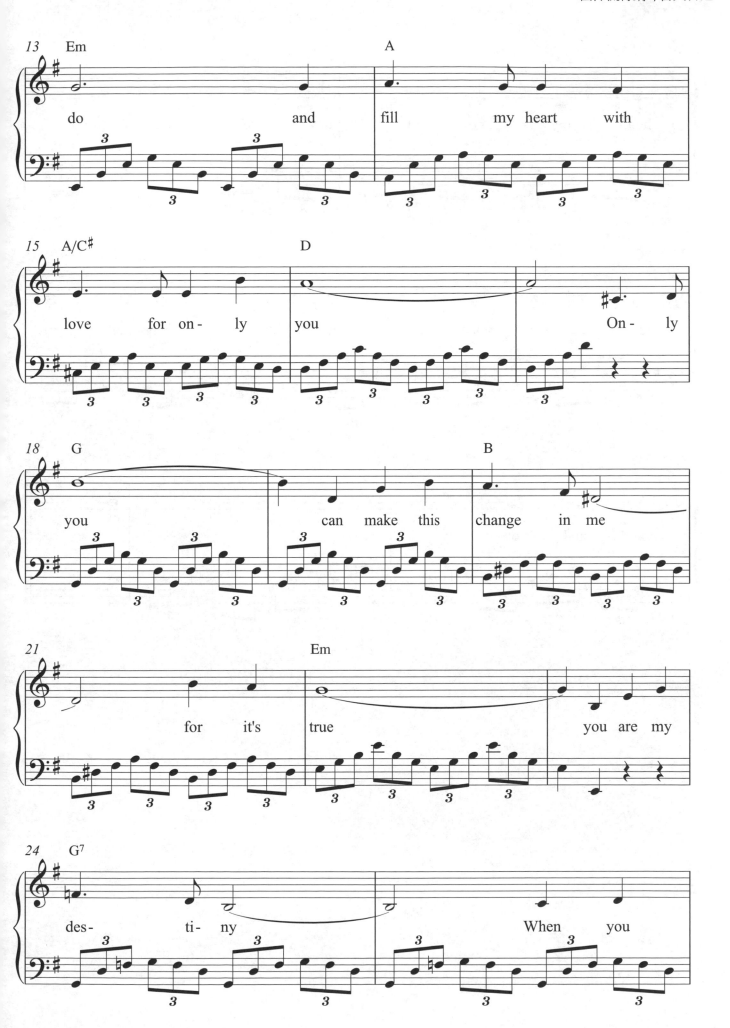

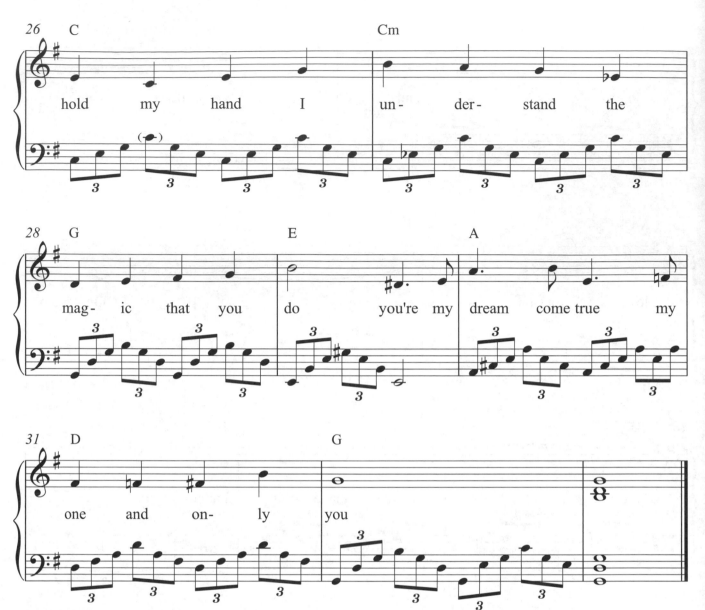

Rhythm Of The Rain

詞／曲：John Claude Gummoe　演唱：The Cascades

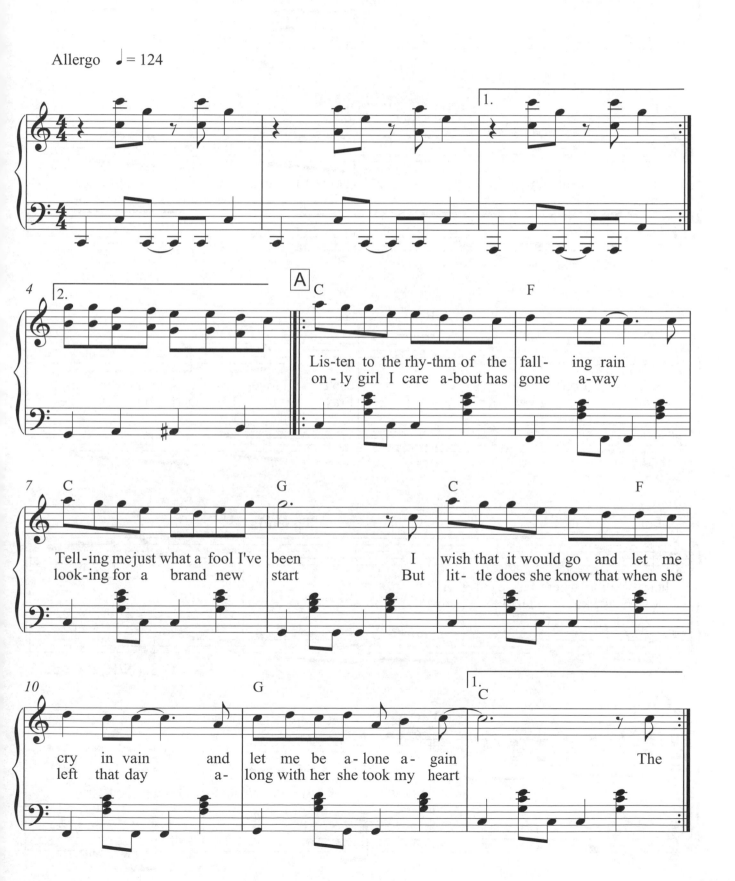

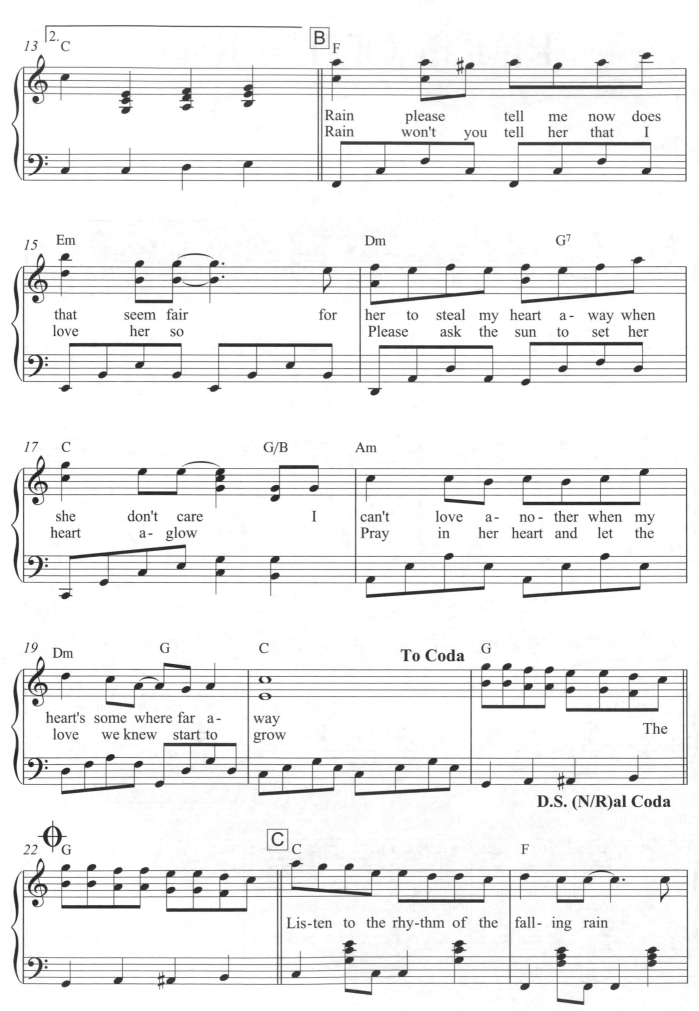

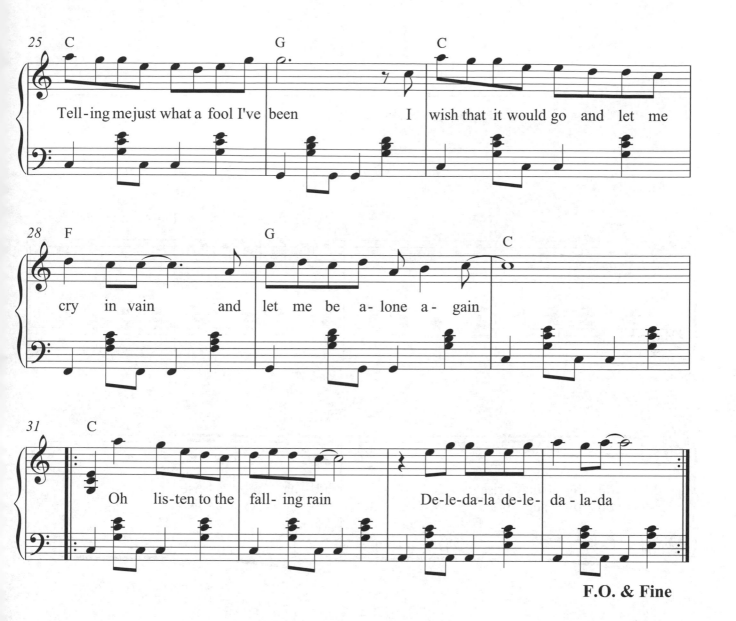

F.O. & Fine

Reality

（電影《第一次接觸》主題曲）

詞／曲：Vladimir Cosma　演唱：Richard Sanderson

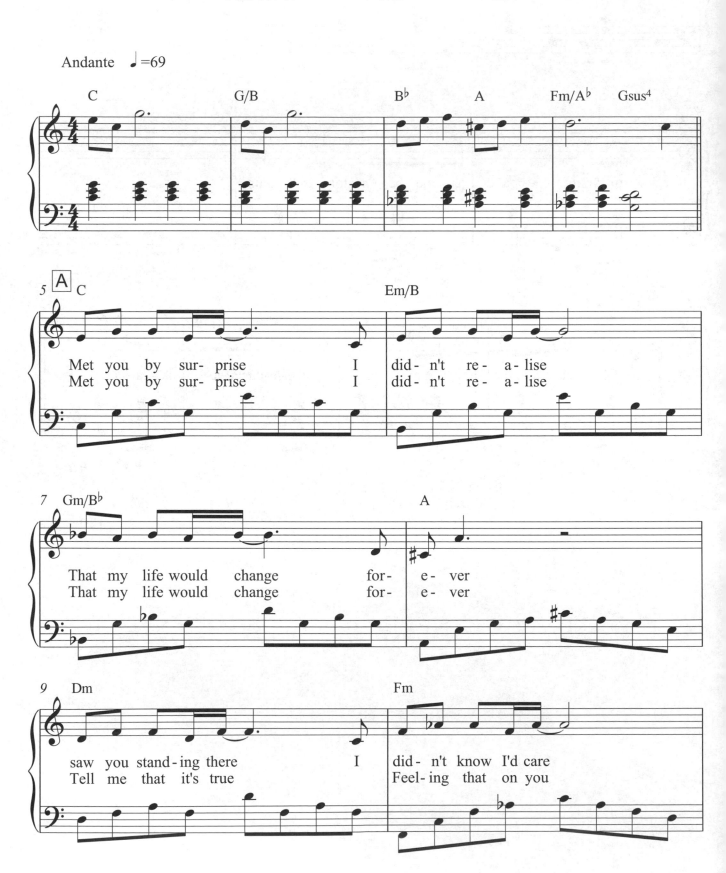

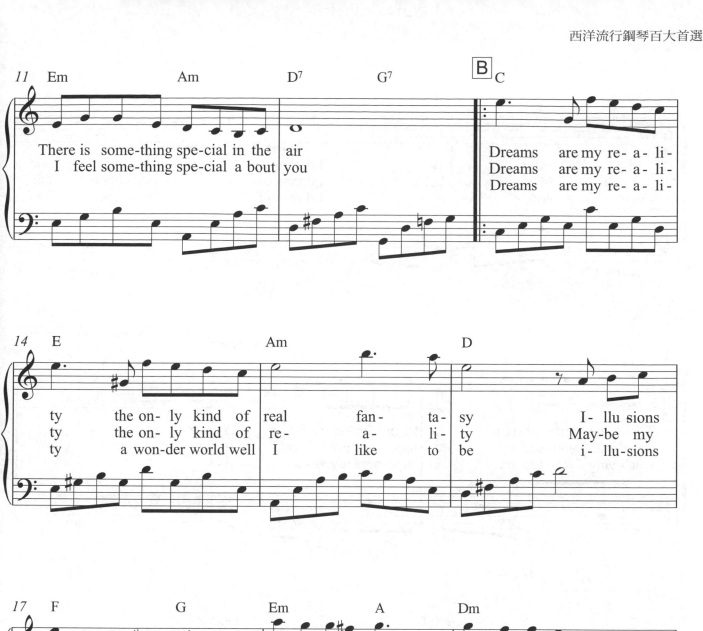

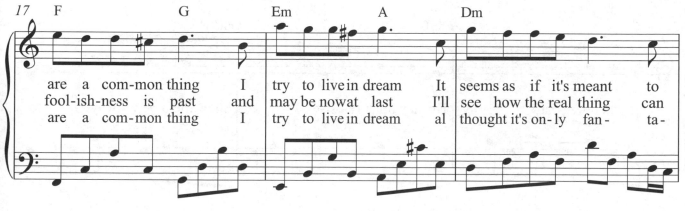

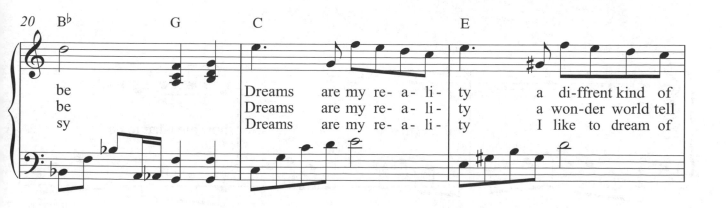

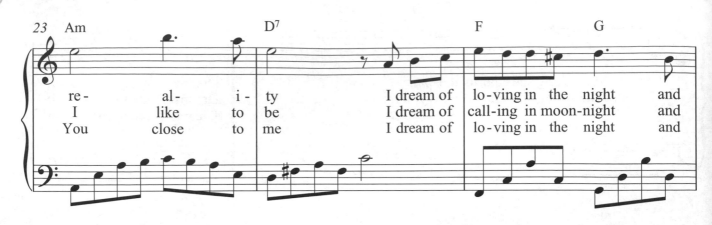

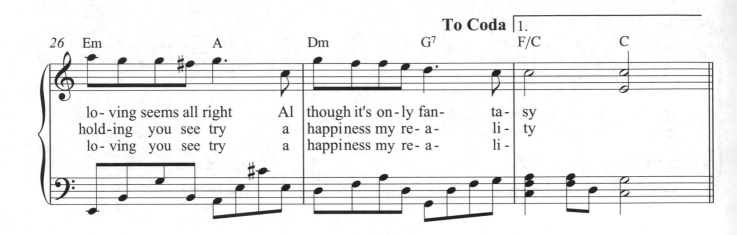

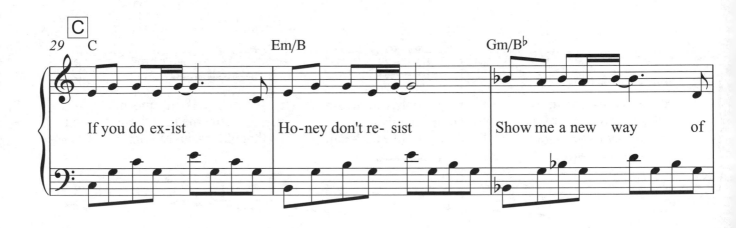

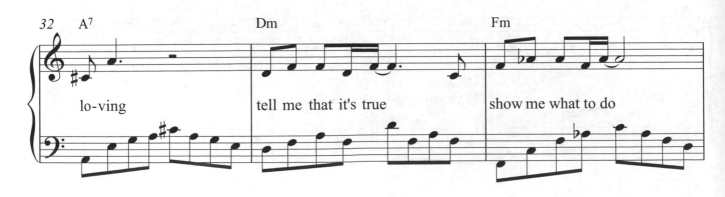

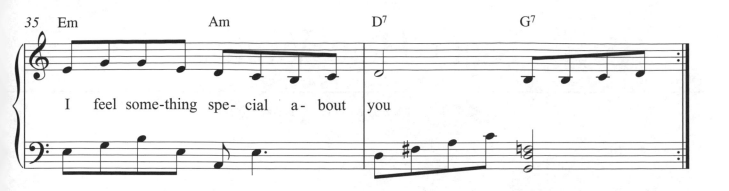

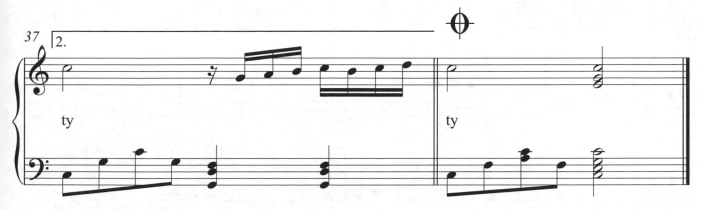

D.S. al Coda

Right Here Waiting

詞／曲：Richard Marx　　演唱：Richard Marx

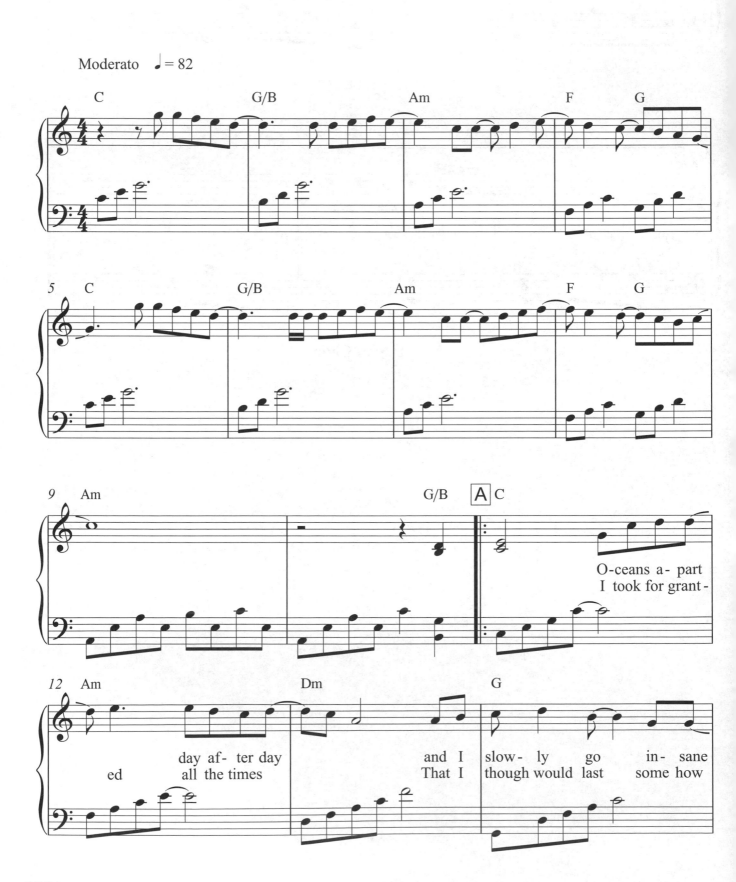

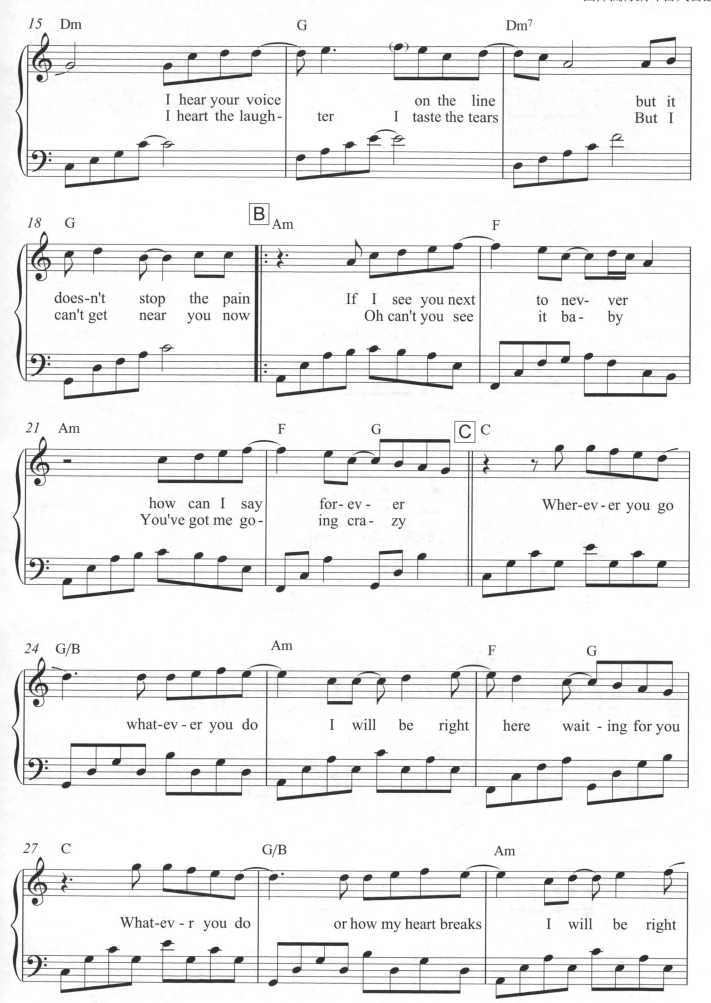

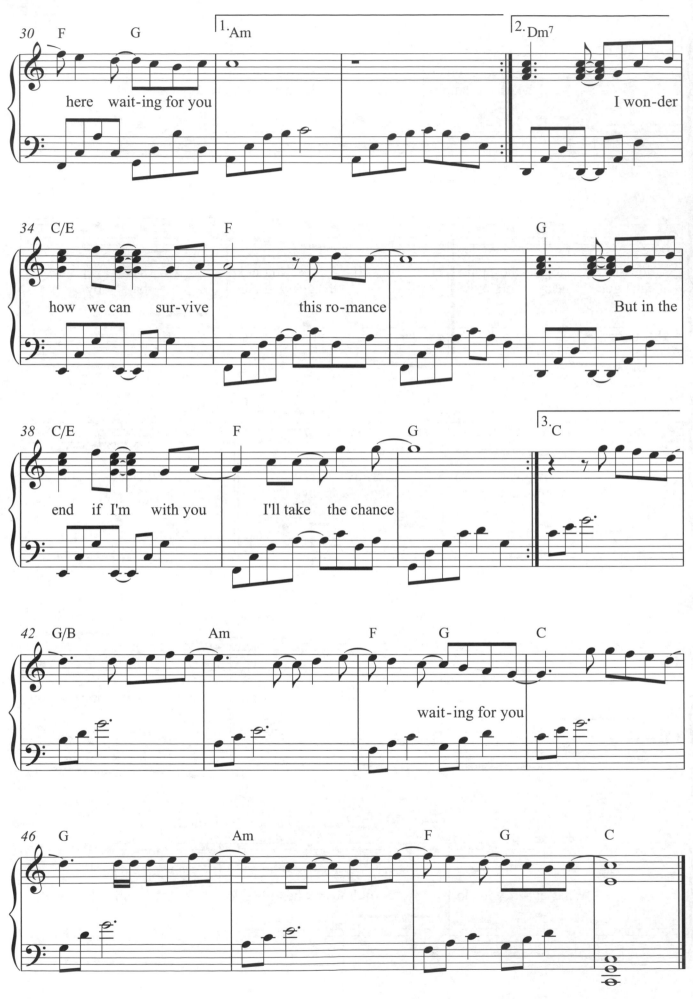

Raindrop Falling On My Head

（電影《虎豹小霸王》主題曲）

詞／曲：Hal David / Burt Bacharach　演唱：B.J. Thomas

Moderato ♩=100

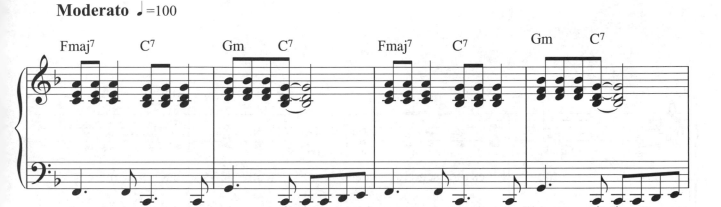

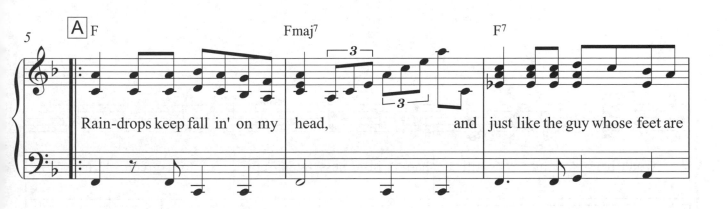

Rain-drops keep fall in' on my head, and just like the guy whose feet are

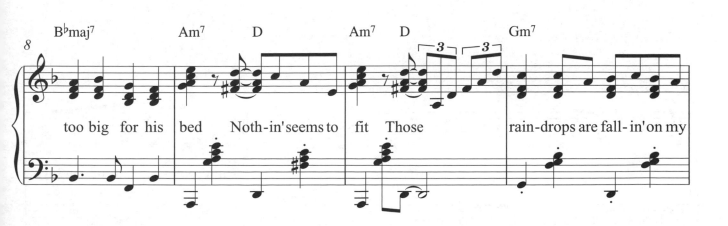

too big for his bed Noth-in' seems to fit Those rain-drops are fall-in' on my

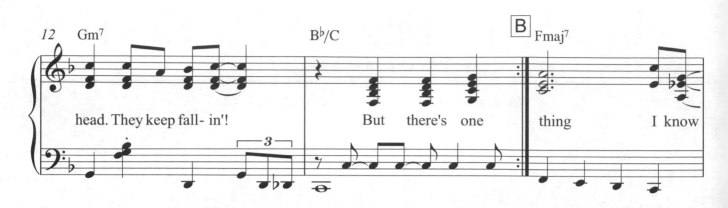

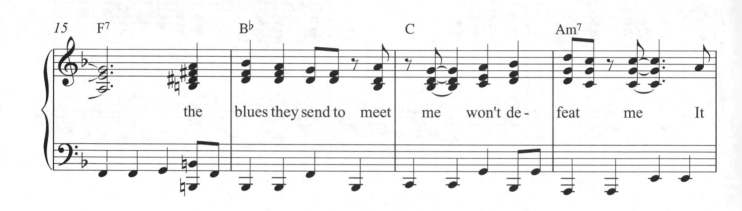

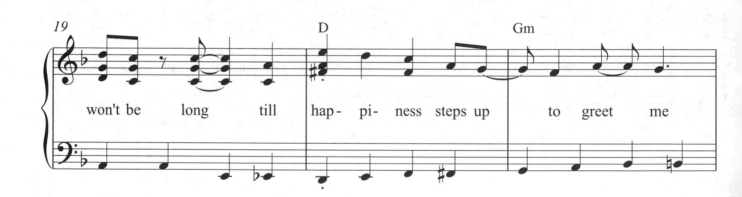

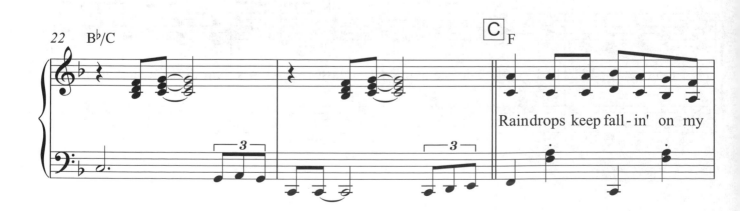

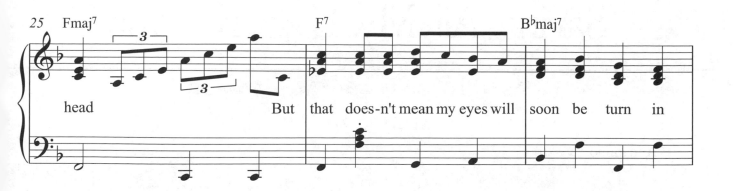

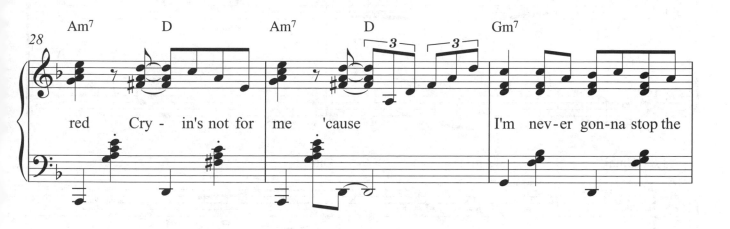

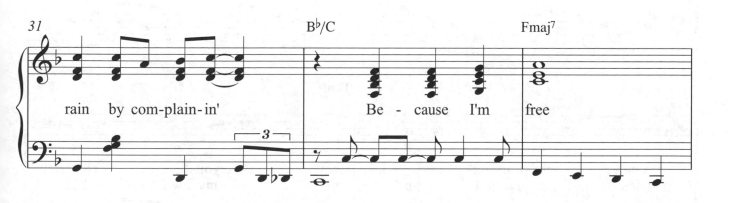

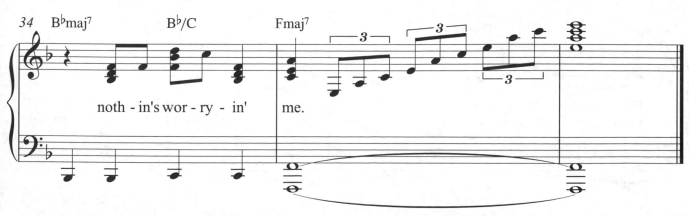

Saving All My Love For You

詞／曲：Gerry Goffin／Michael Masser　演唱：Whitney Houston

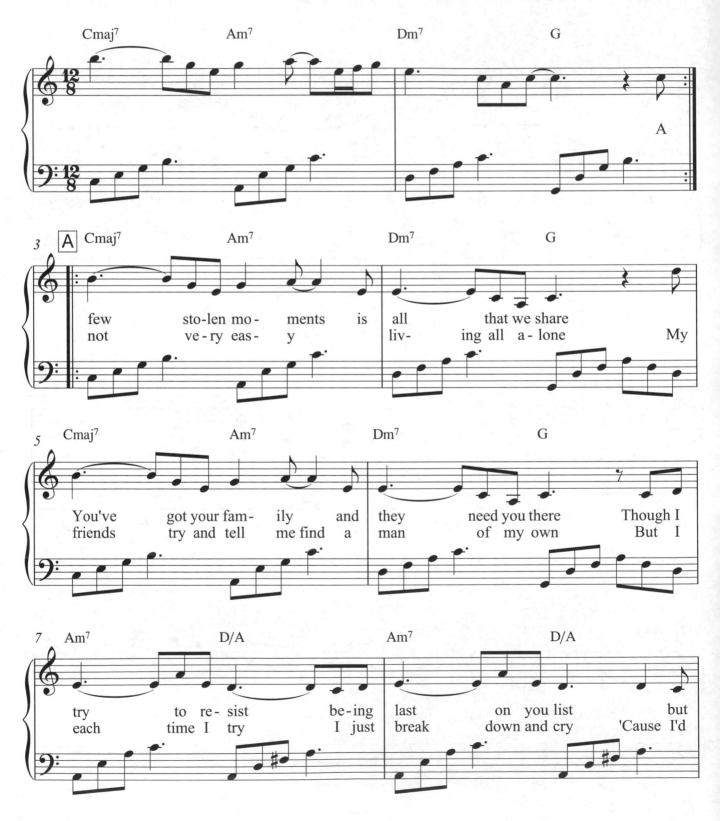

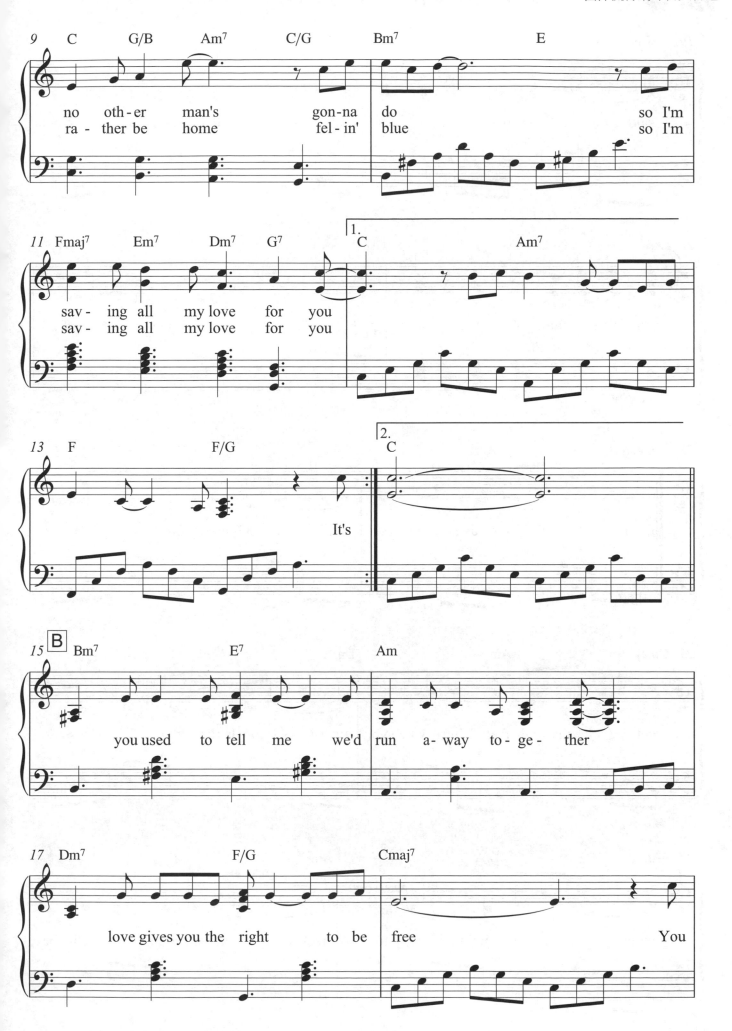

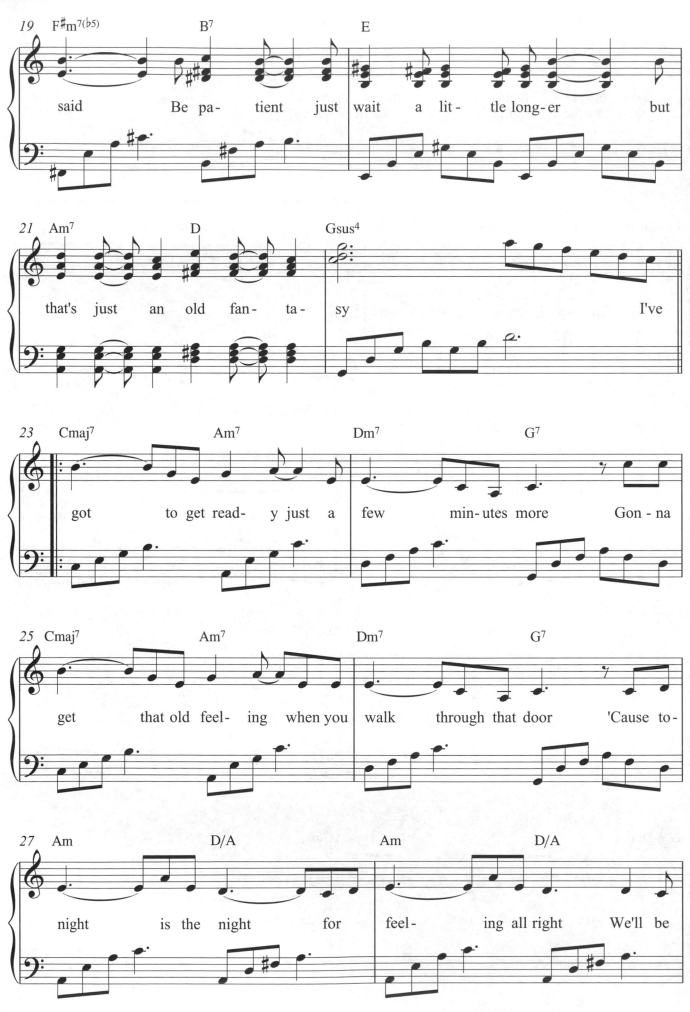

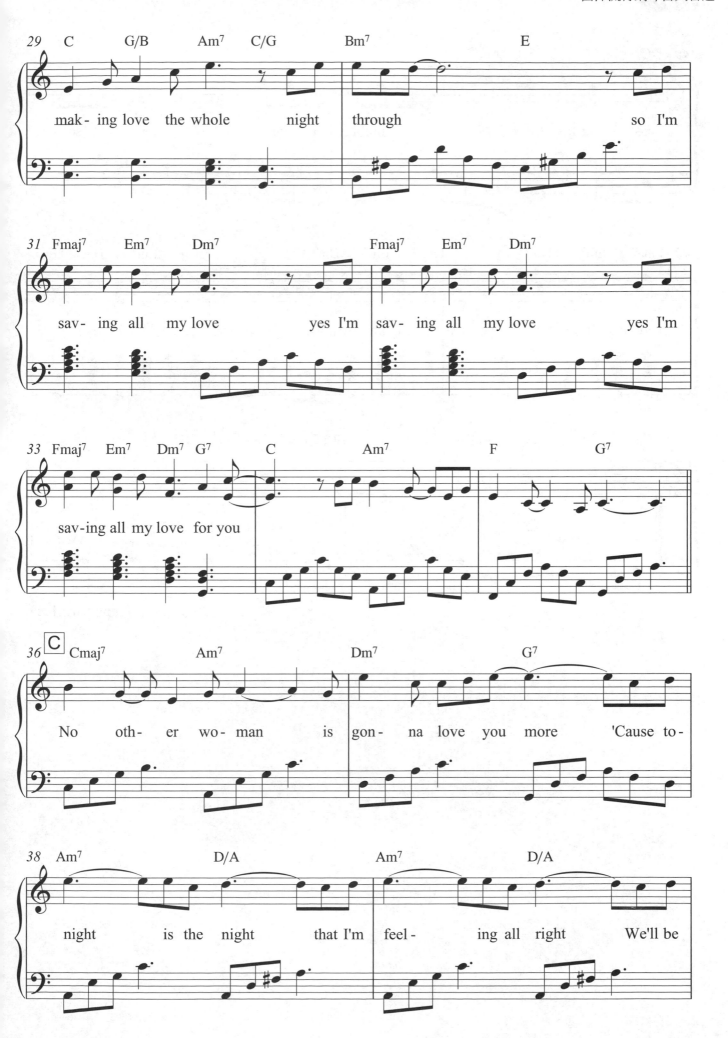

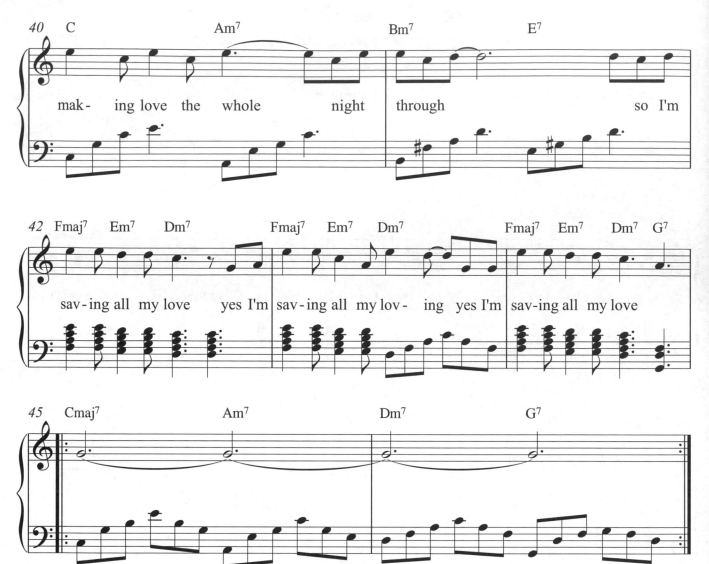

Repeat & F.O.

Something In Your Eyes

詞 / 曲：Pamela Philips Oland / Richard Carpenter　演唱：The Carpenters

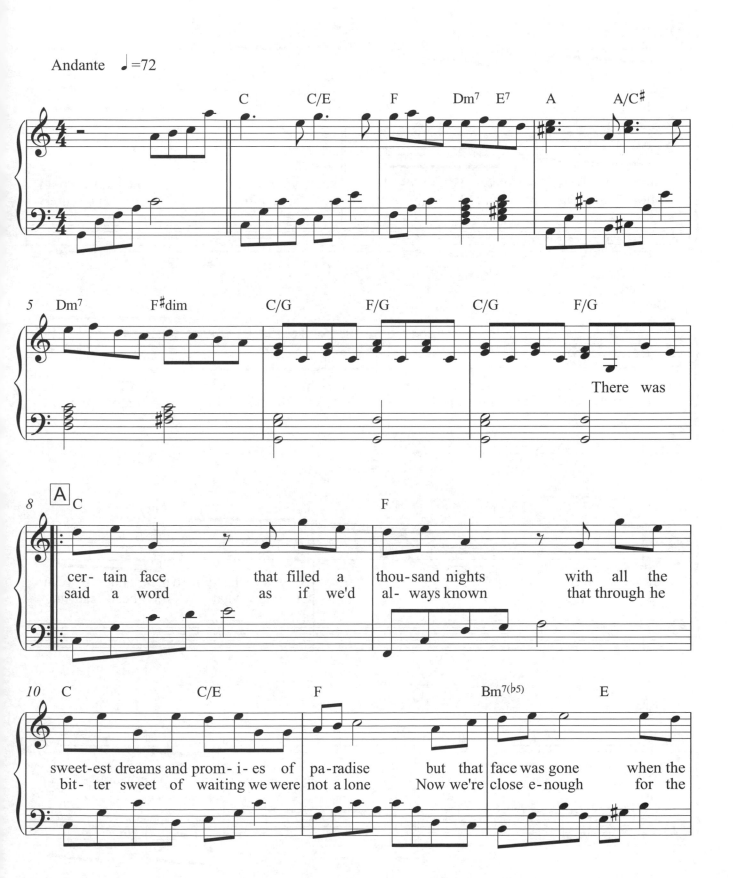

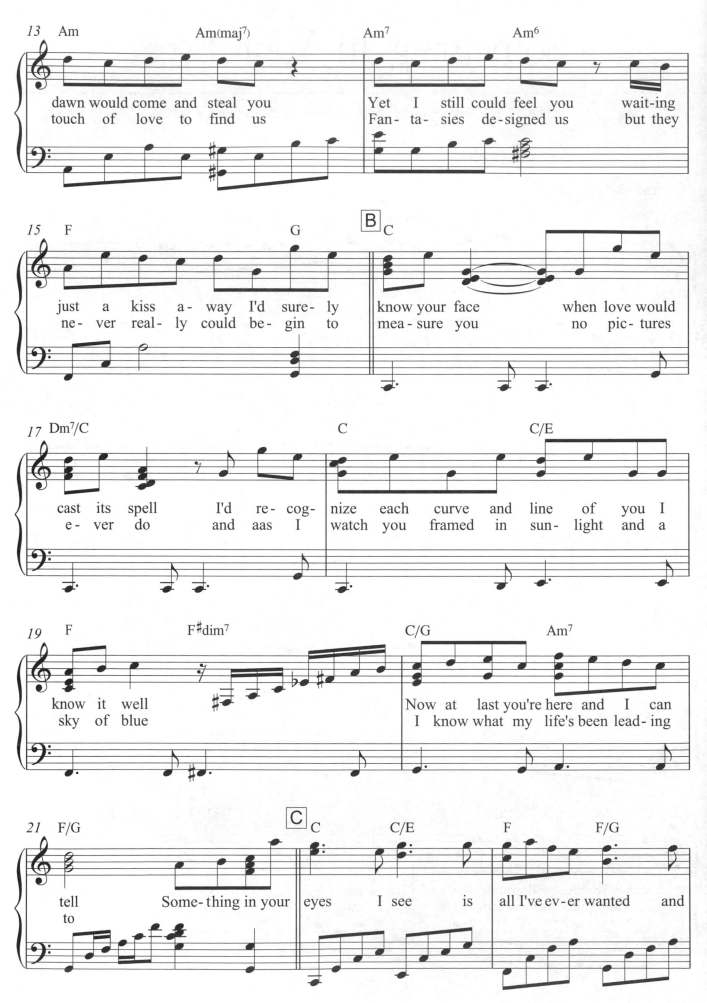

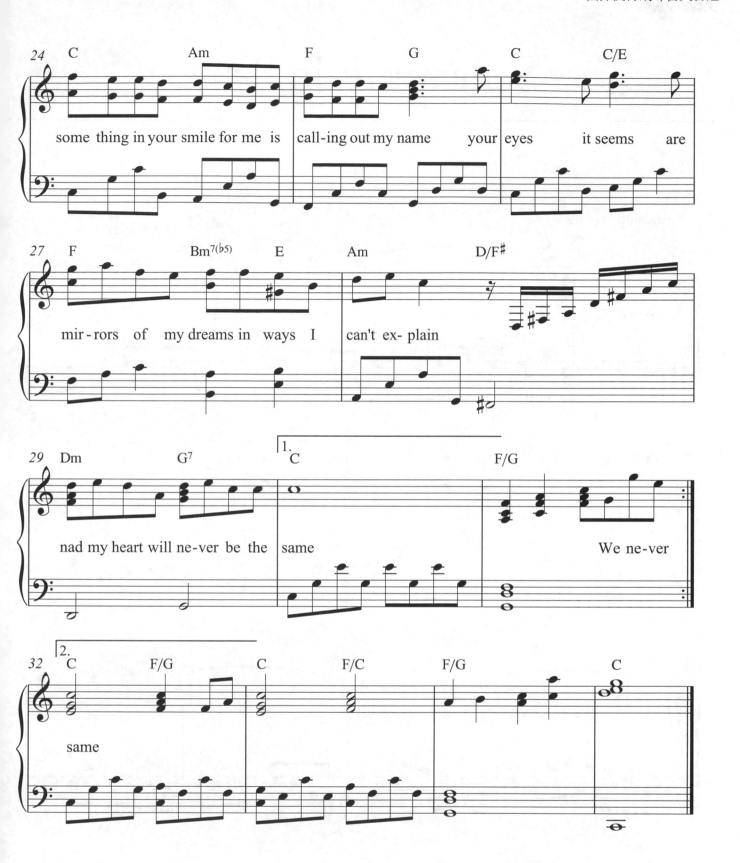

Somewhere In Time

（電影《似曾相識》主題音樂）

詞／曲：John Barry　演唱：（演奏曲）

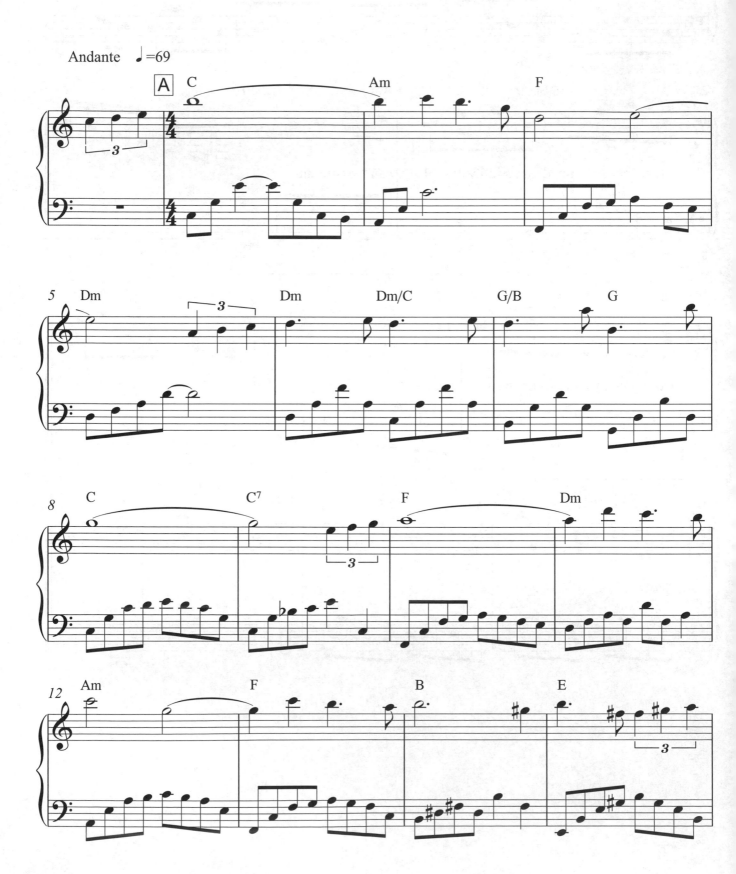

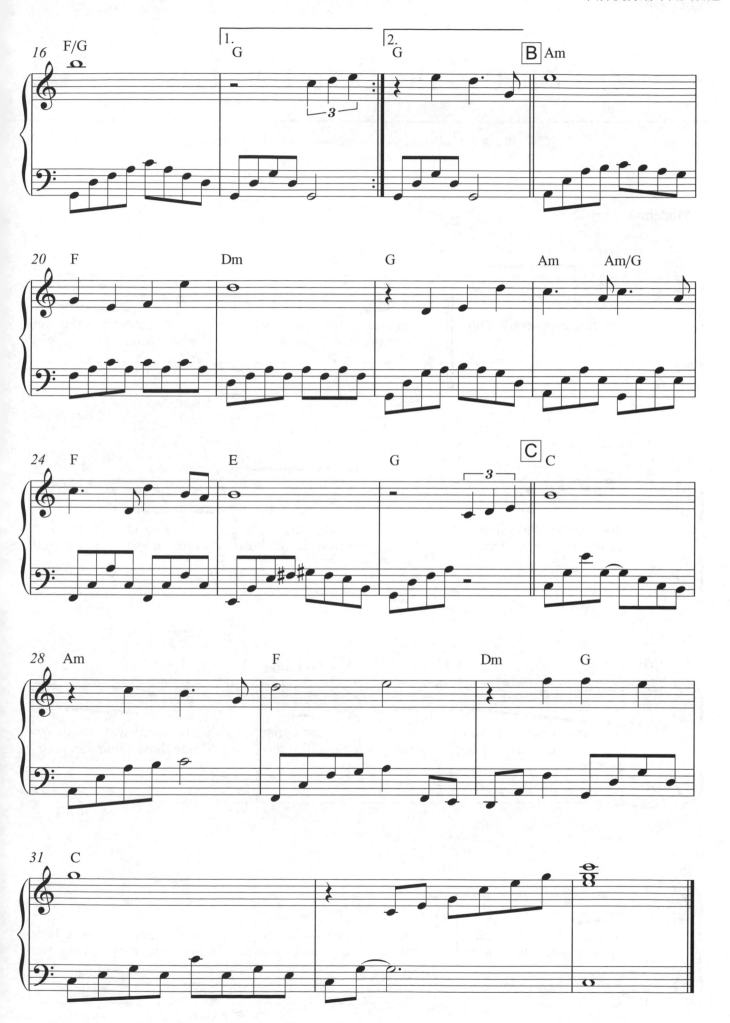

Save The Best For Last

詞／曲：Phil Galdston.Jon Lind／Wendy Waldman　演唱：Vanessa Williams

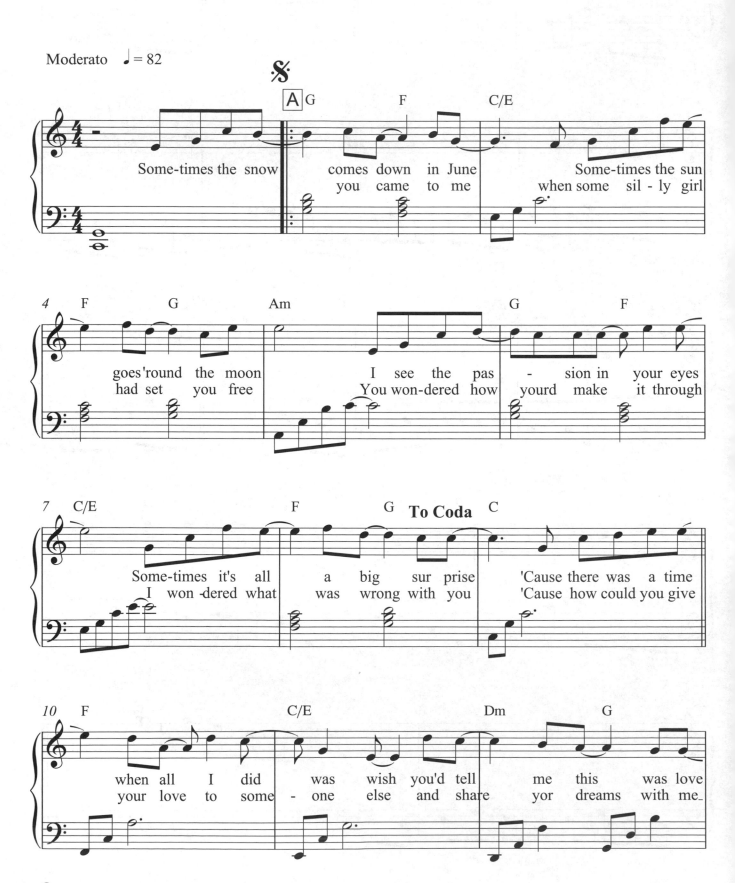

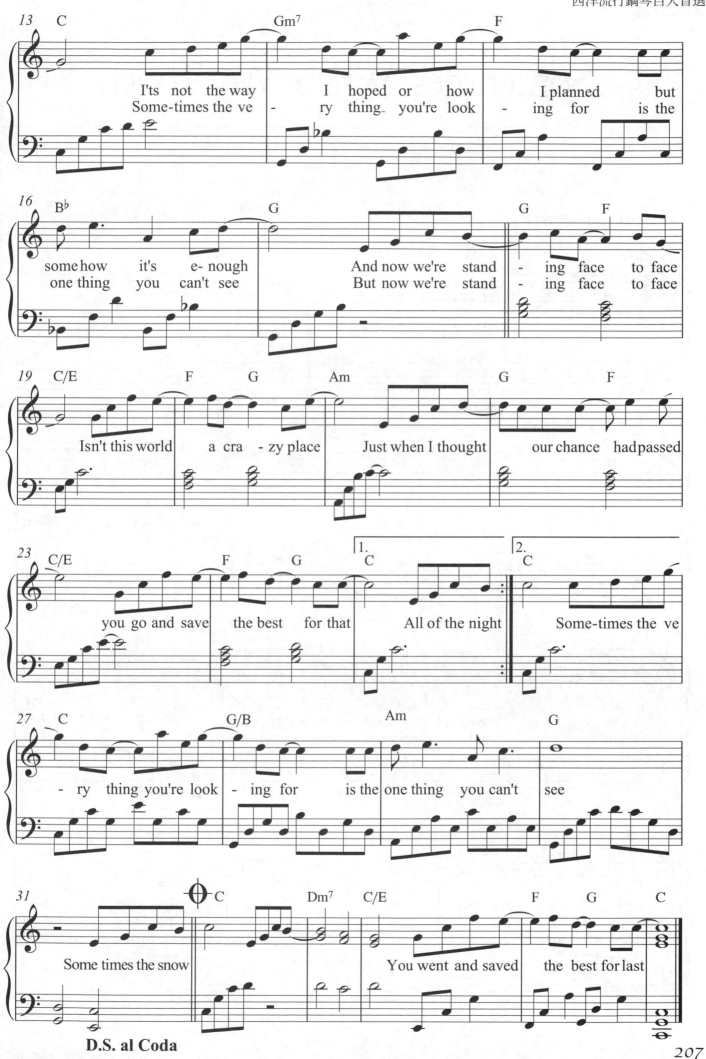

D.S. al Coda

Sometimes When We Touch

詞／曲：Dan Hill / Barry Mann　演唱：Rod Stewart

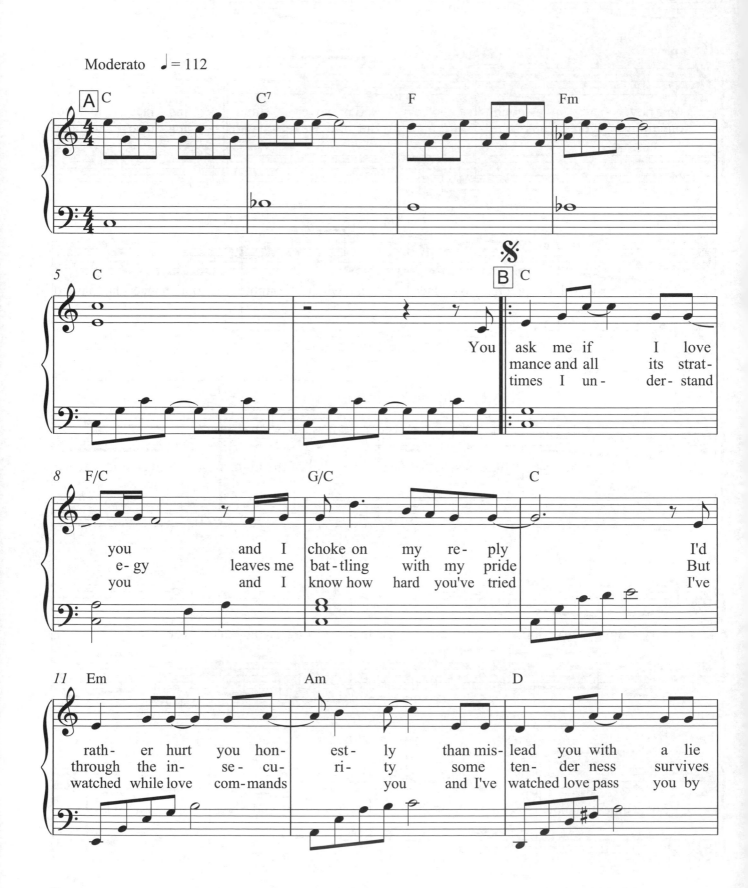

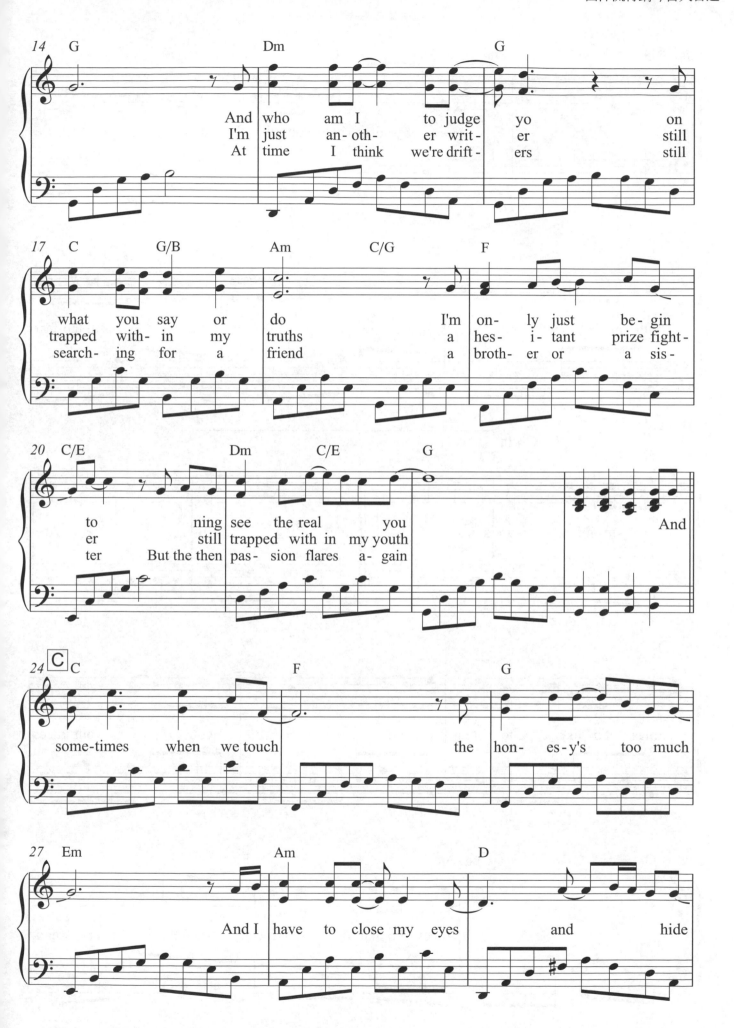

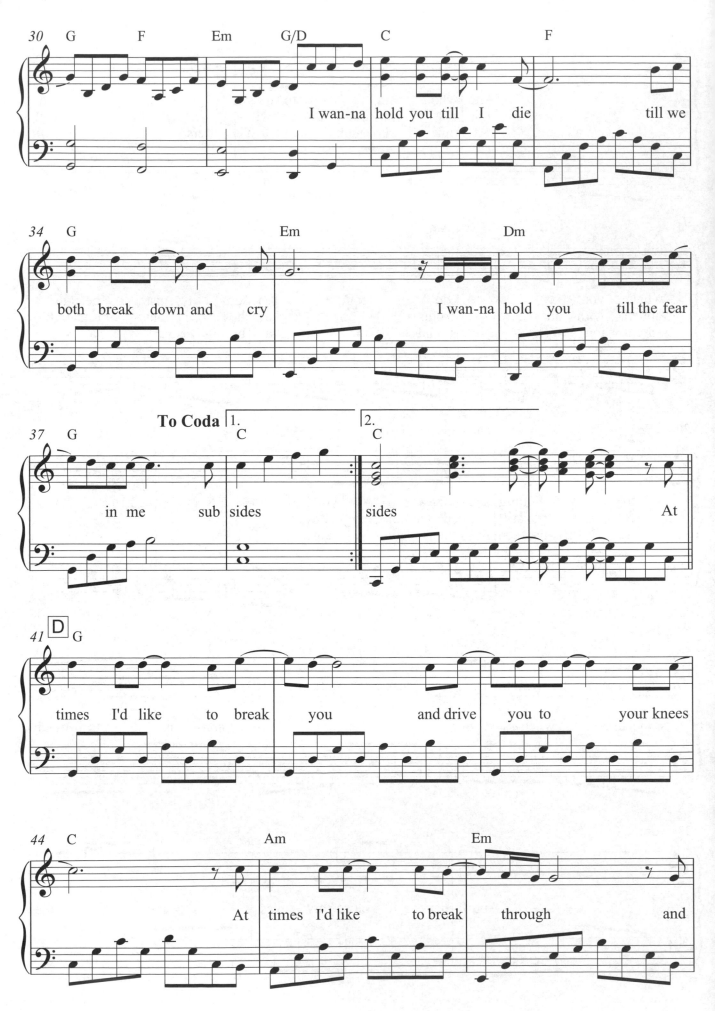

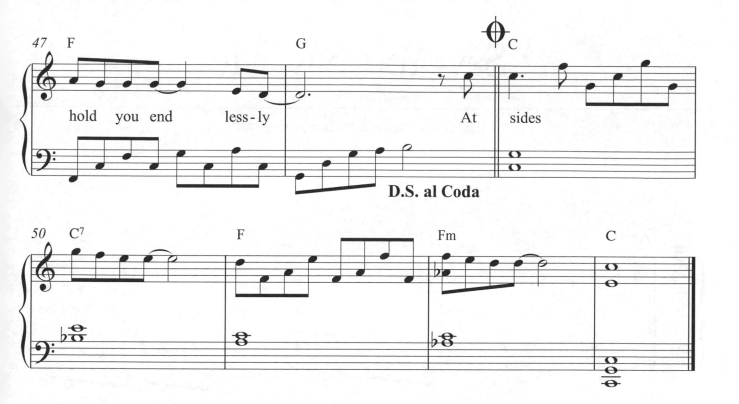

hold you end less-ly

At sides

D.S. al Coda

Say You Say Me

（電影《飛越蘇聯》主題曲）

詞／曲：Lionel Richie　演唱：Lionel Richie

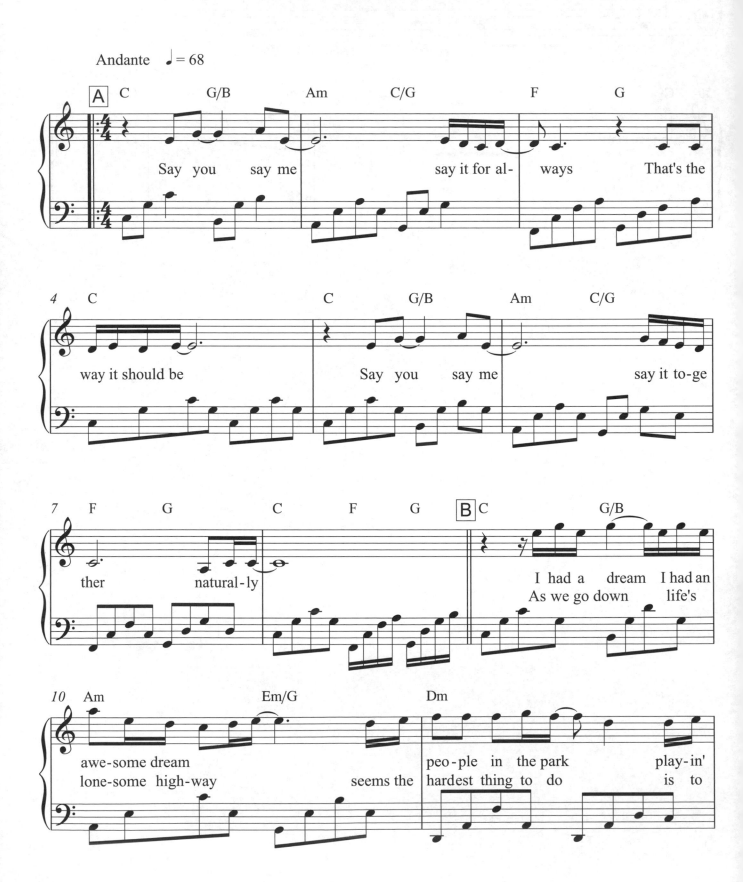

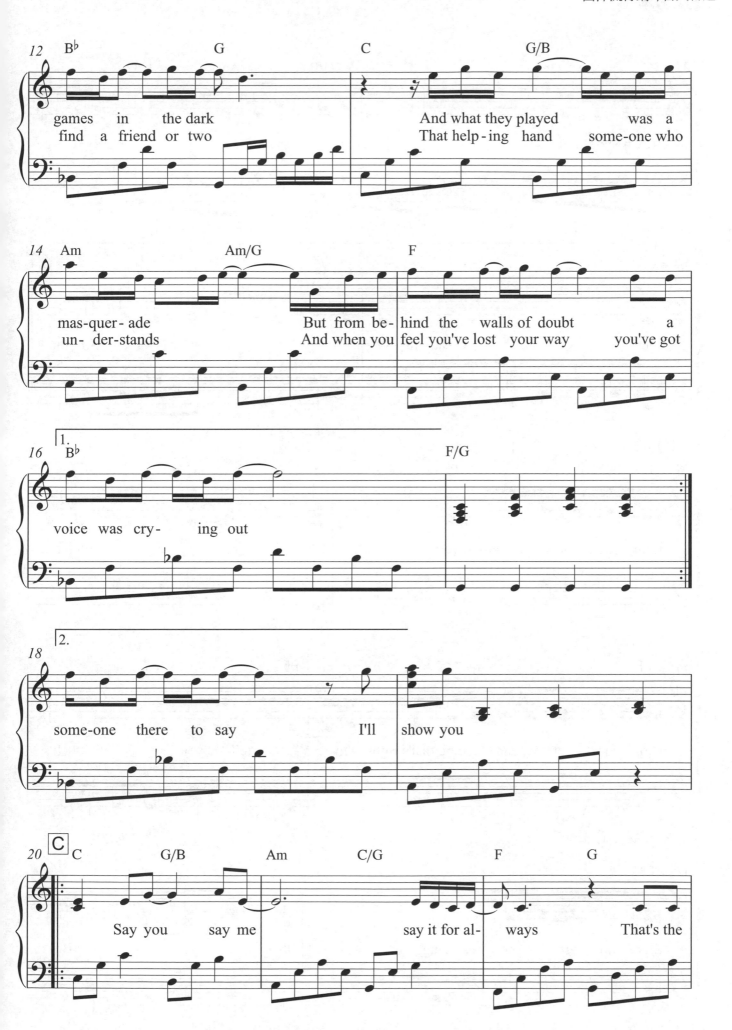

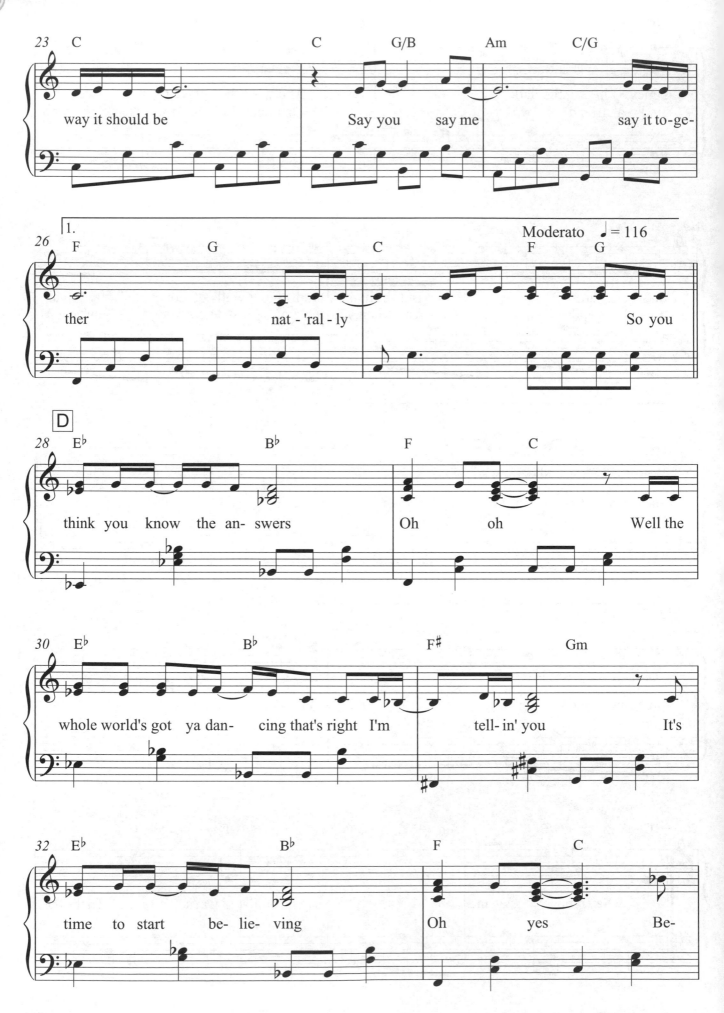

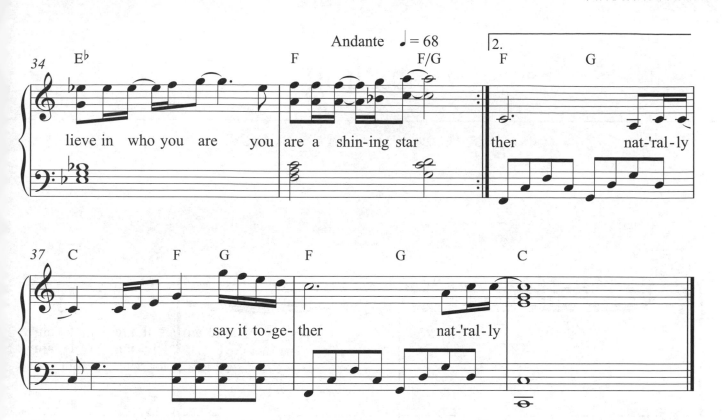

Sailing

詞 / 曲：Gavin Sutherland　演唱：Rod Stewart

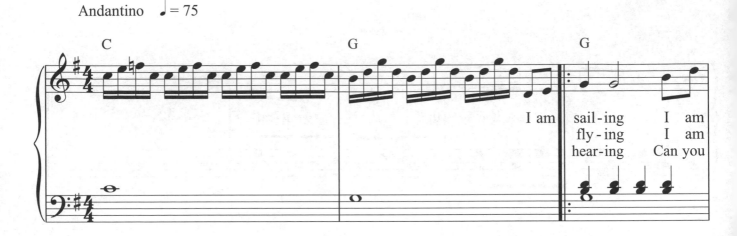

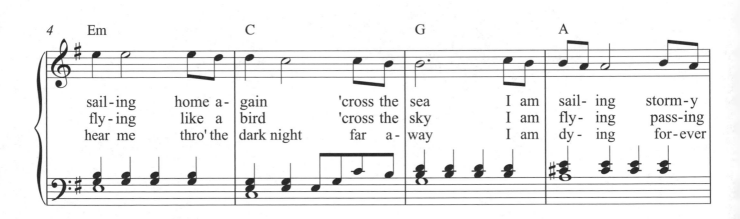

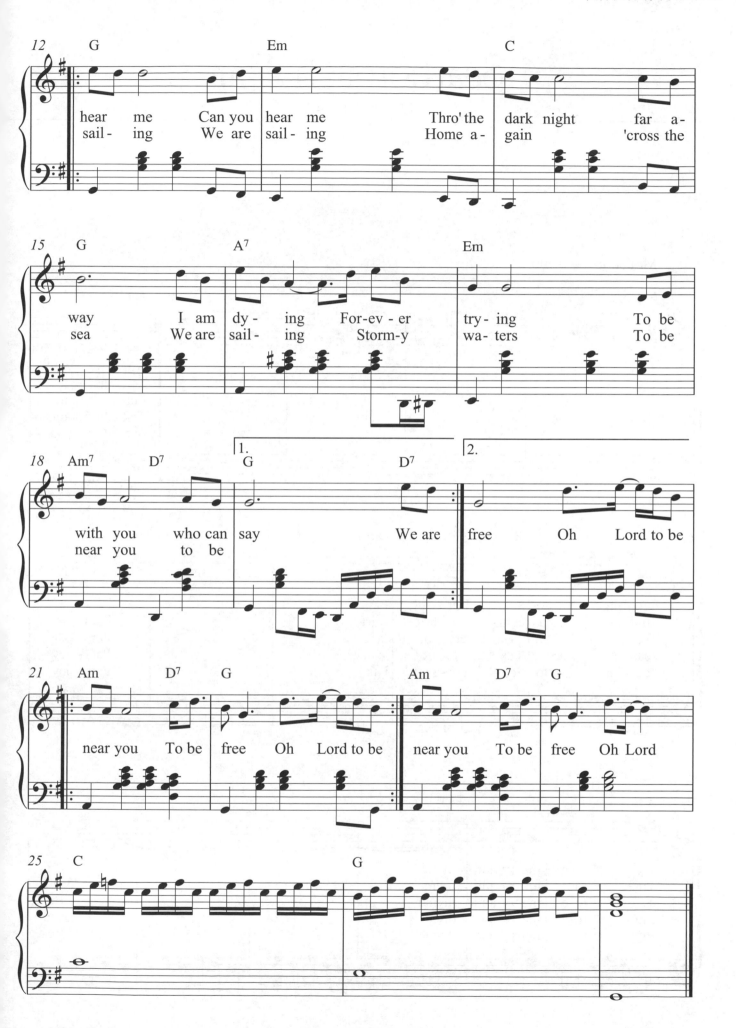

Scarborough Fair

（電影《畢業生》主題曲）

詞／曲：Paul Simon　演唱：Simon & Garfunkel

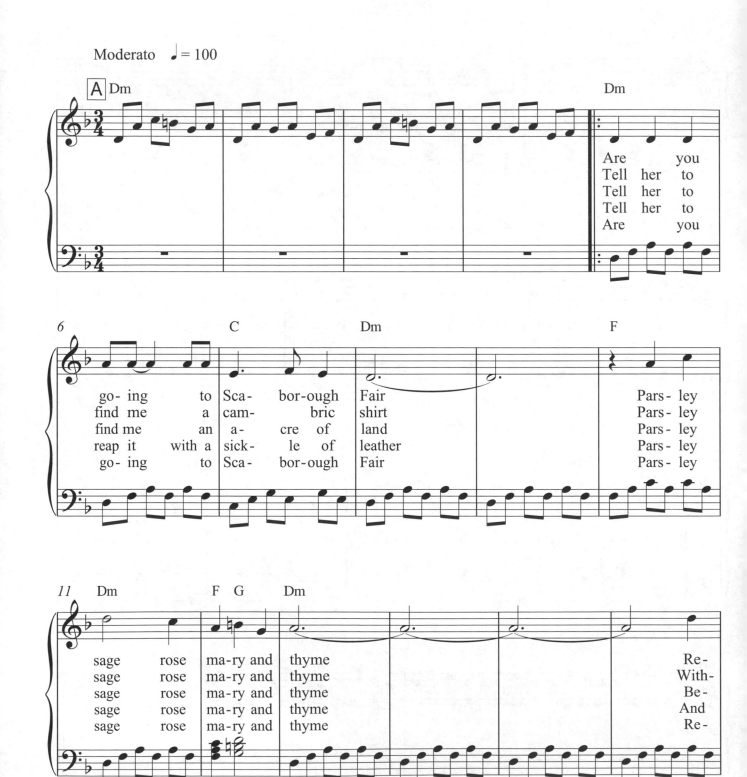

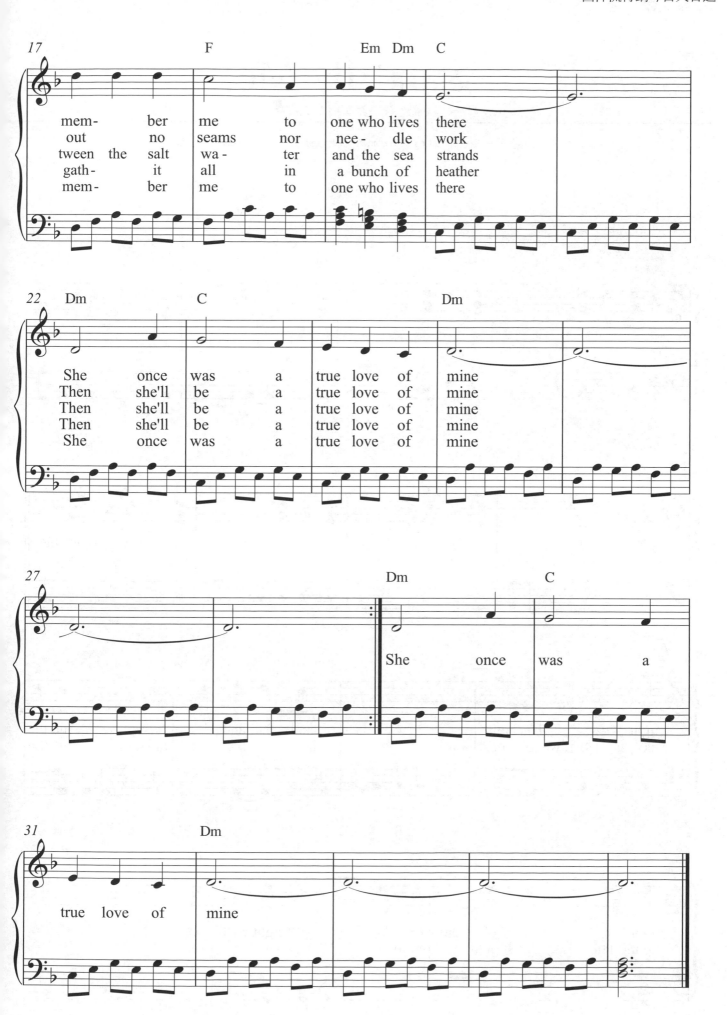

Stand By Me

（電影《站在我這邊》主題曲）

詞／曲：Ben E. King / Mike Stoller / Jerry Leiber　　演唱：John Lennon

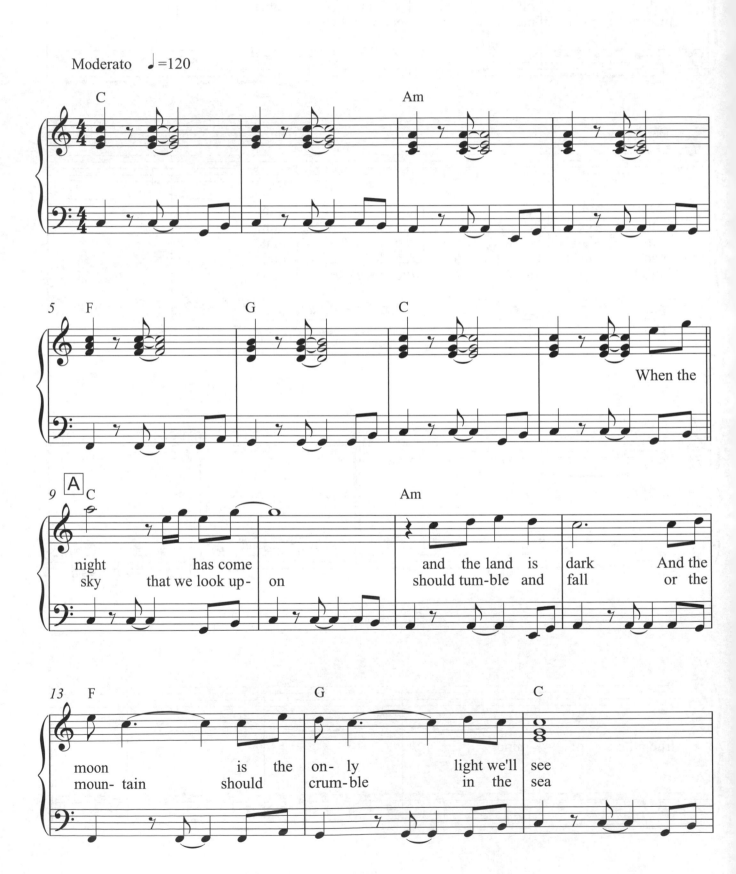

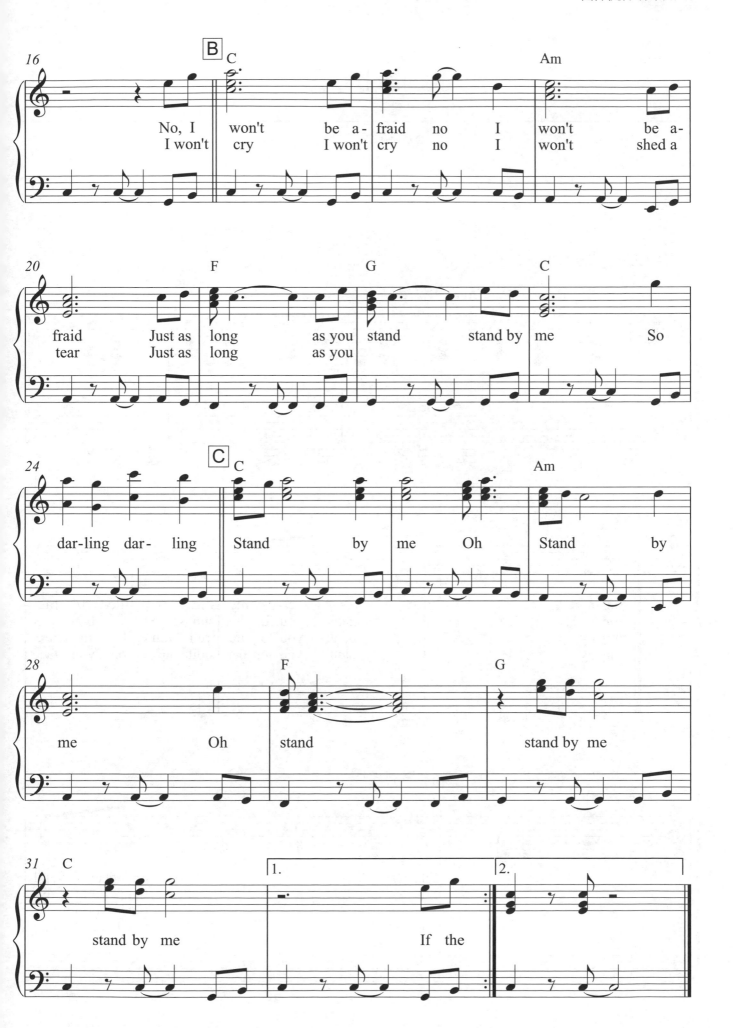

Sunny

演唱：Frank Sinatra

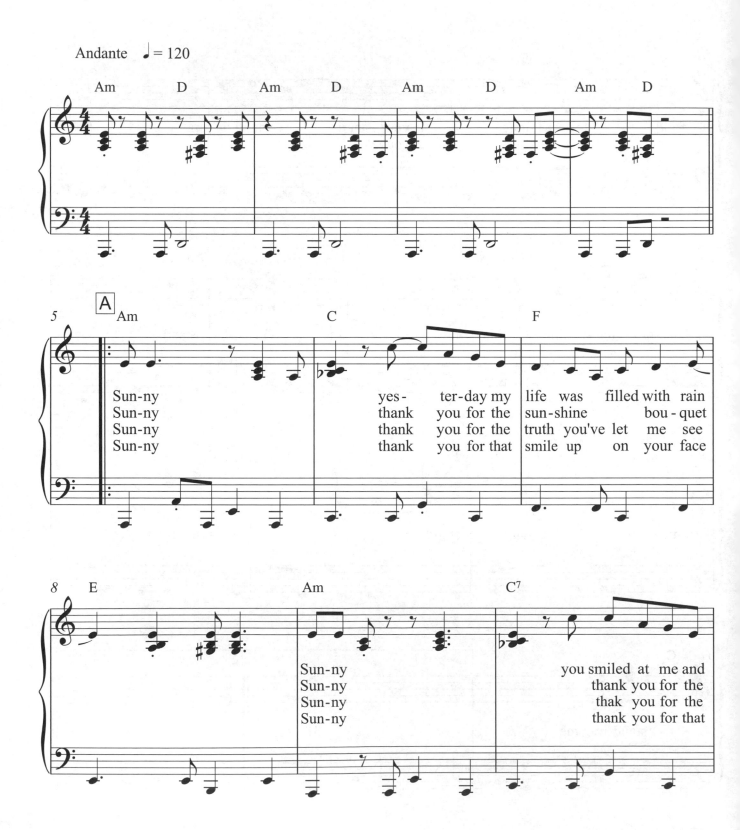

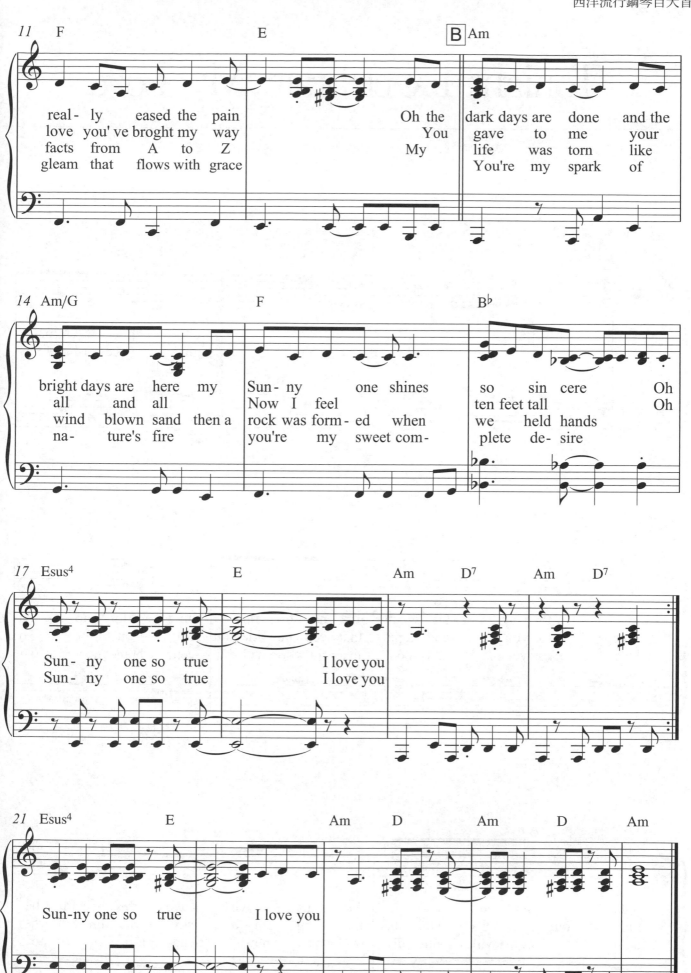

Tonight I Celebrate My Love

詞／曲：Gerry Goffin　　演唱：Peabo Bryson / Roberta Flack

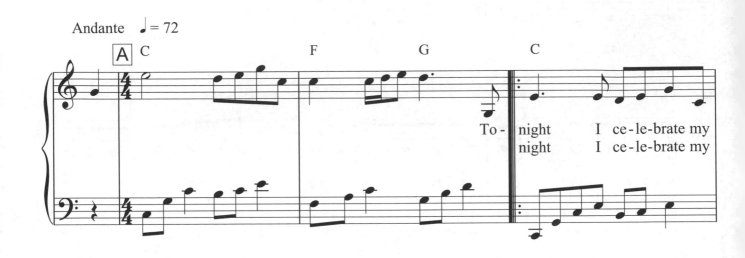

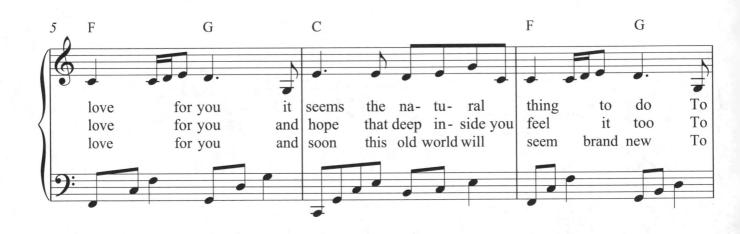

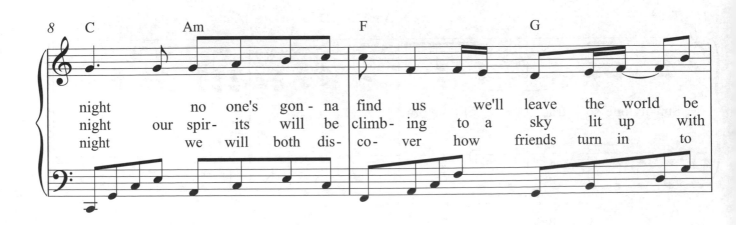

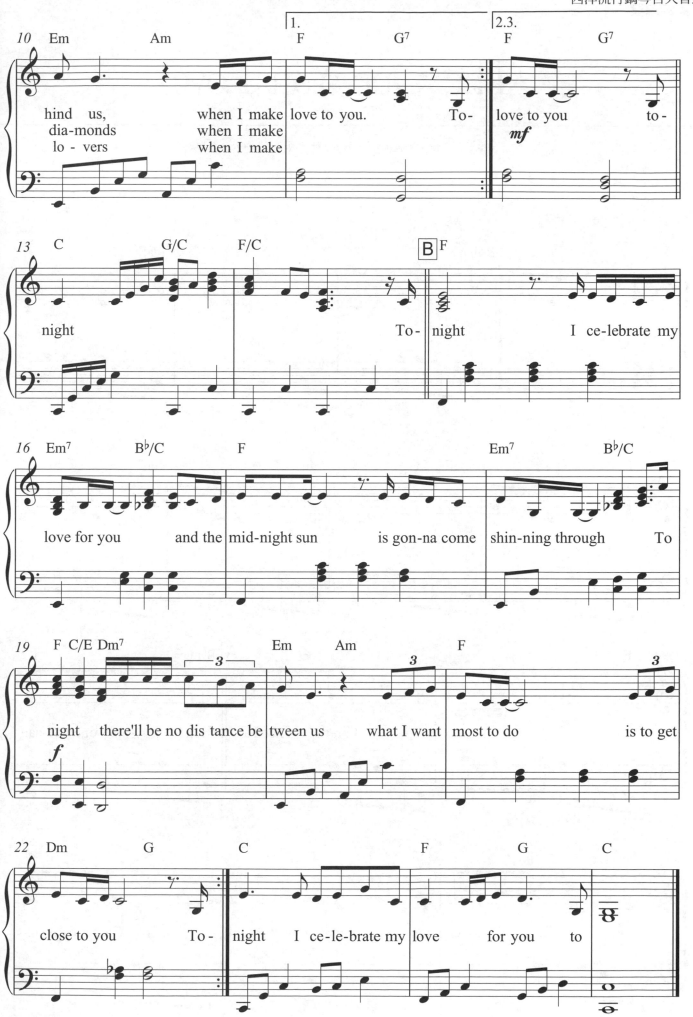

The One You Love

詞／曲：Glenn Frey / Jack Tempchin　演唱：Glenn Frey

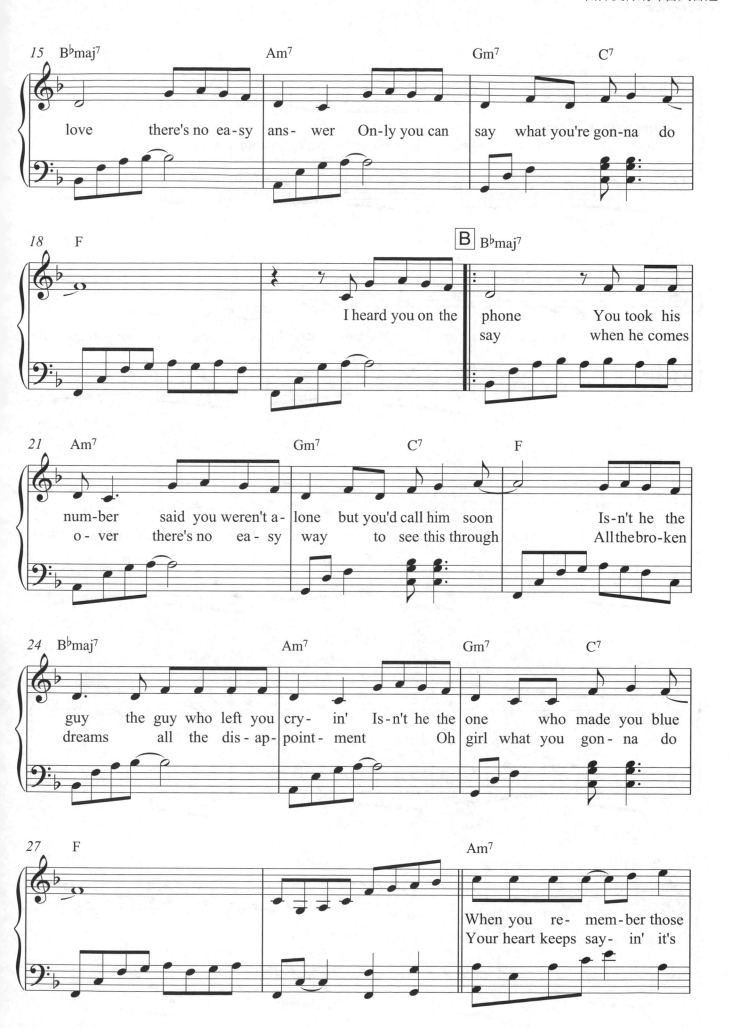

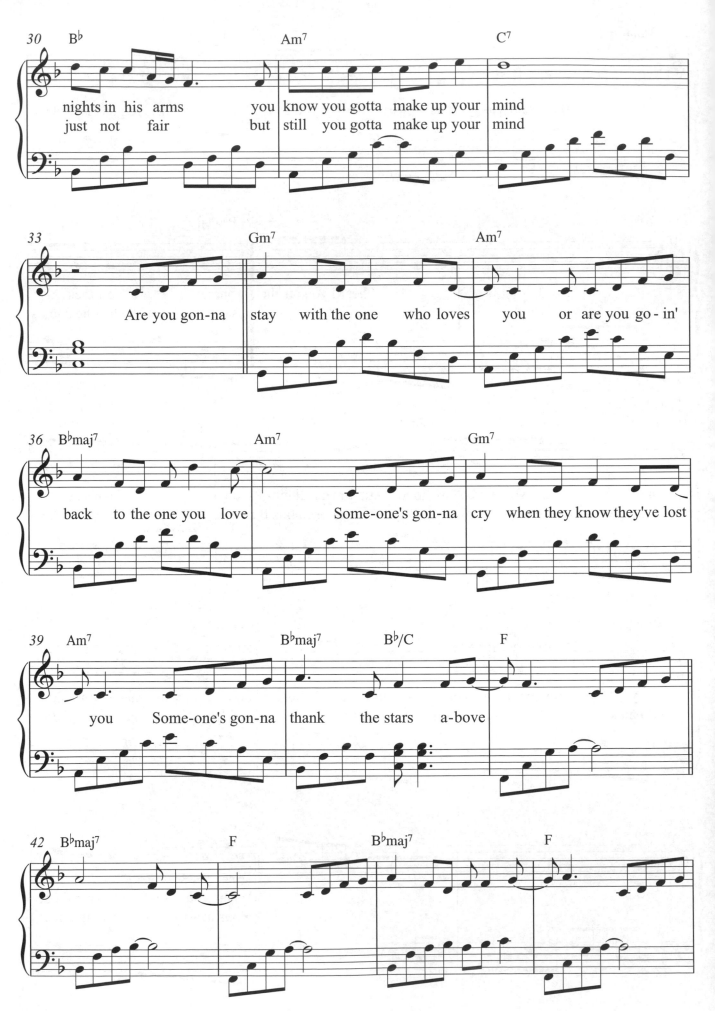

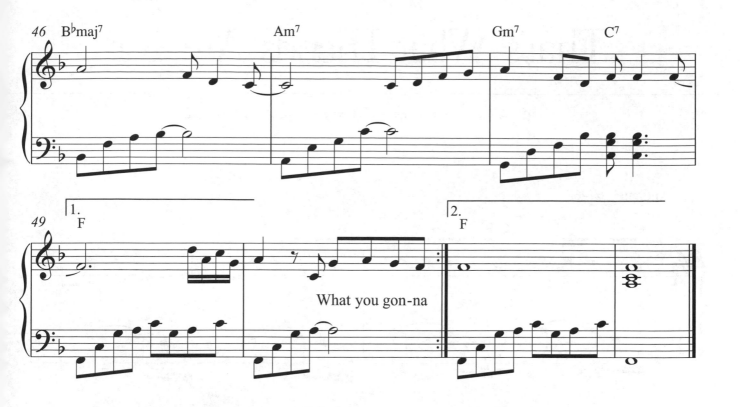

What you gon-na

That's What Friends Are For

詞／曲：Carole Bayer Sager／Burt Bacharach　演唱：Dionne Warwick

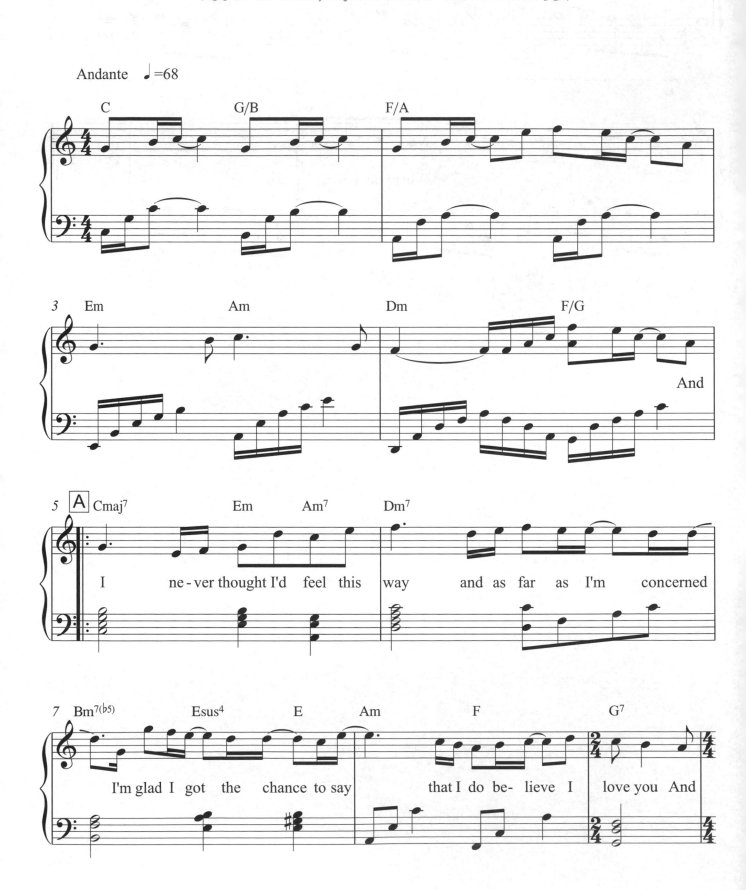

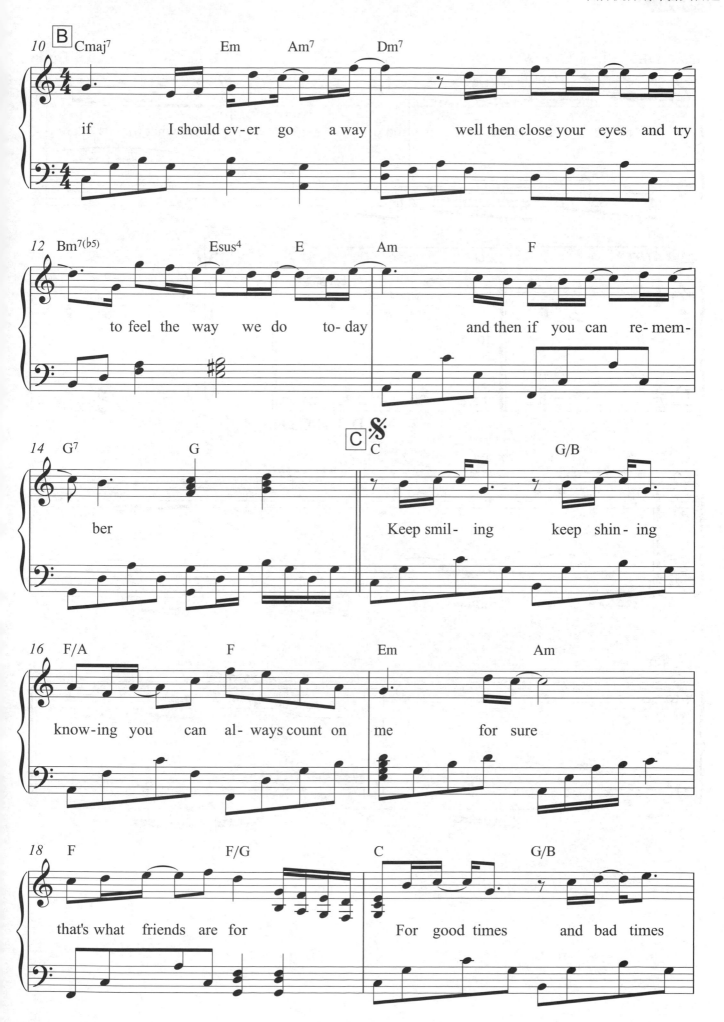

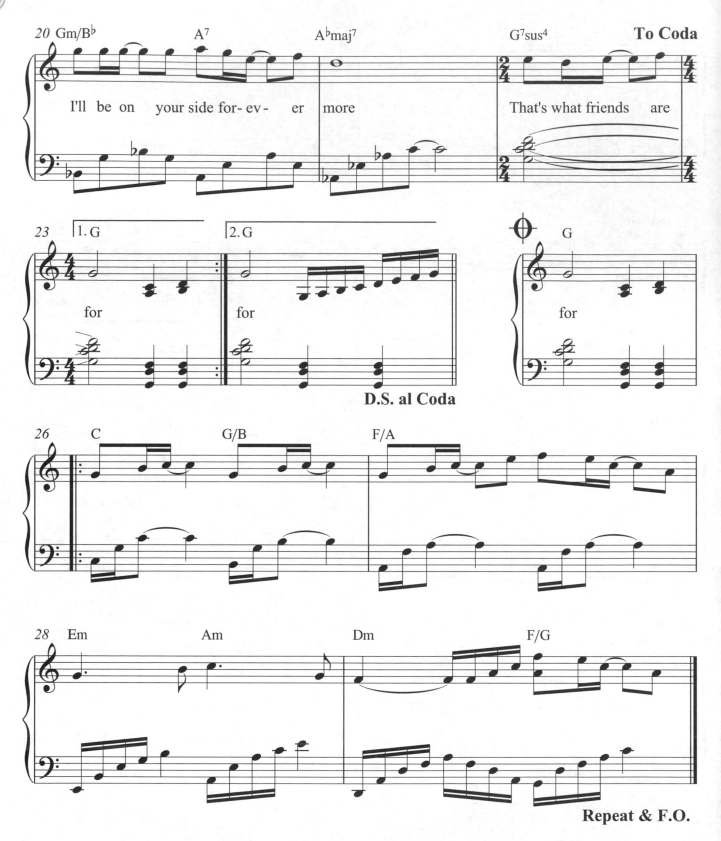

Time After Time

詞 / 曲：Cyndi Lauper / Rob Hyman　　演唱：Cyndi Lauper

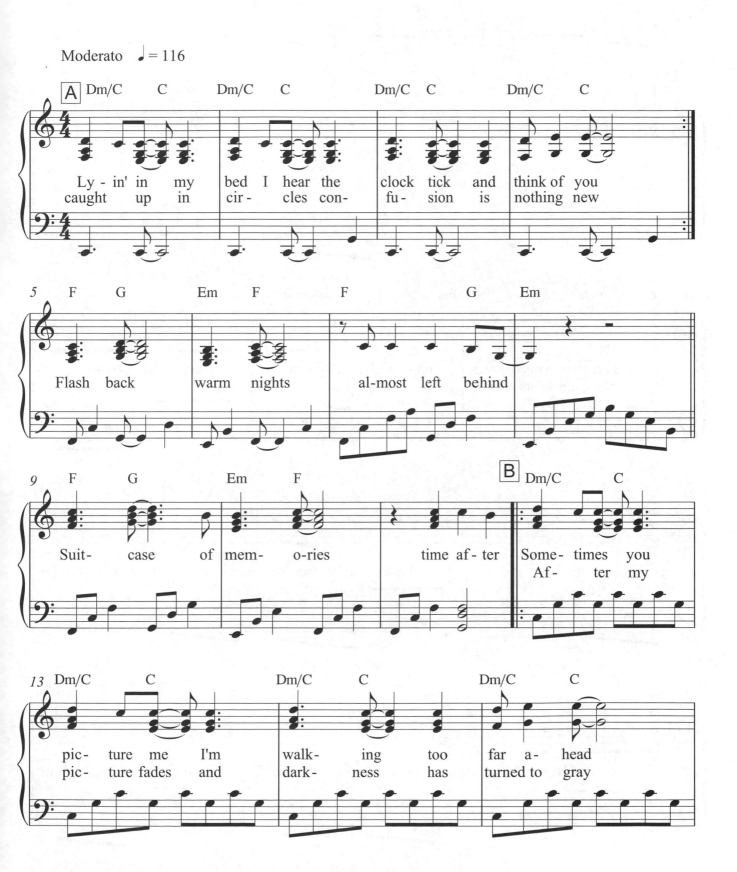

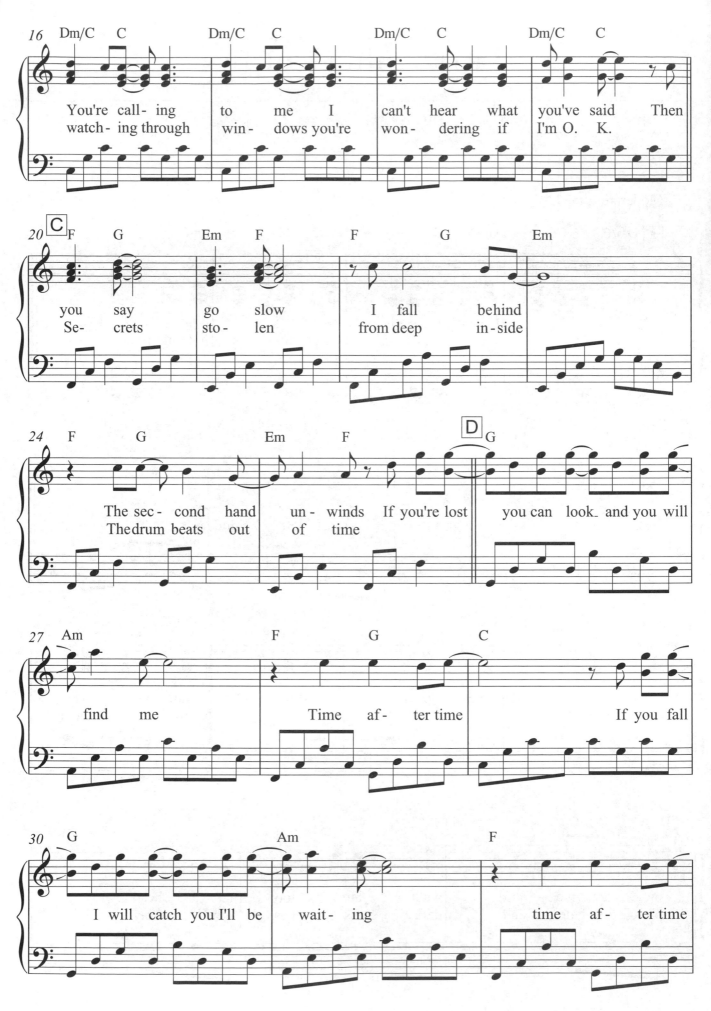

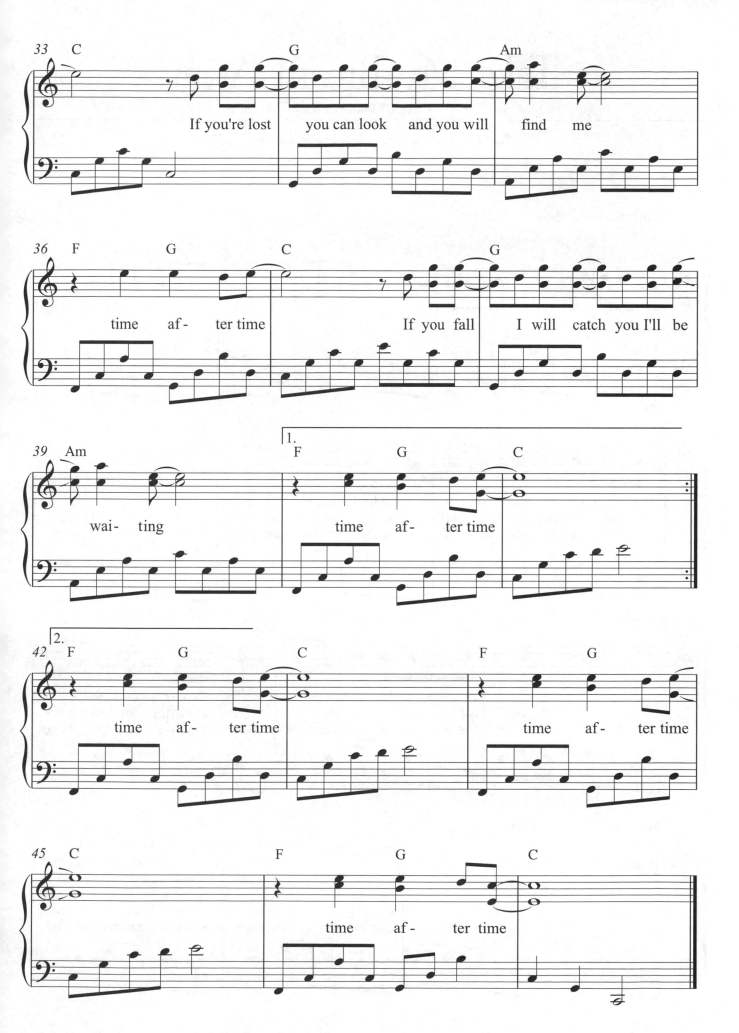

Take My Breath Away

(電影《捍衛戰士》主題曲)

詞 / 曲：Whitlack Tom / Moroder Giorgio　演唱：Berlin

Andantino　♩=96

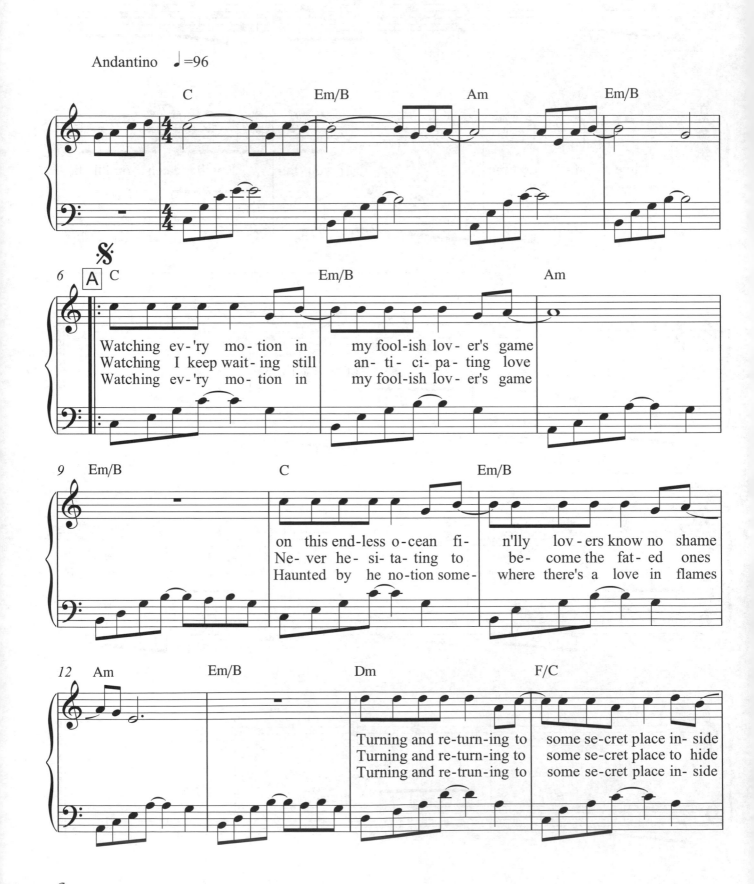

Watching ev-'ry mo-tion in　my fool-ish lov-er's game
Watching I keep wait-ing still　an-ti-ci-pa-ting love
Watching ev-'ry mo-tion in　my fool-ish lov-er's game

on this end-less o-cean fi-　n'lly lov-ers know no shame
Ne-ver he-si-ta-ting to　be-come the fat-ed ones
Haunted by he no-tion some-　where there's a love in flames

Turning and re-turn-ing to　some se-cret place in-side
Turning and re-turn-ing to　some se-cret place to hide
Turning and re-trun-ing to　some se-cret place in-side

236

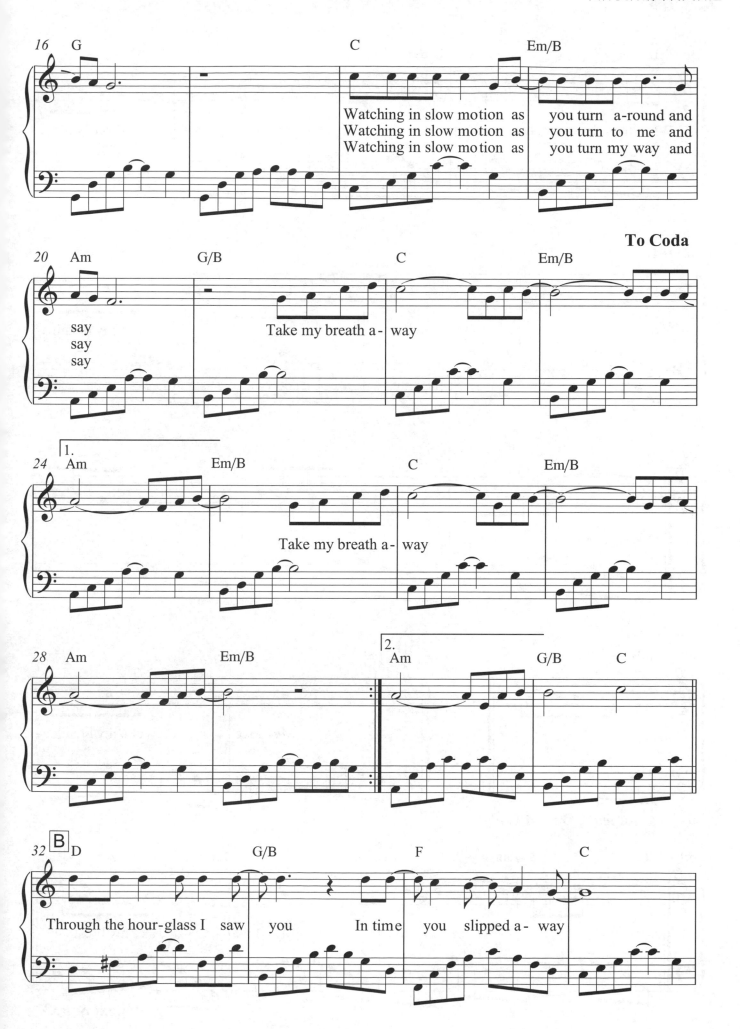

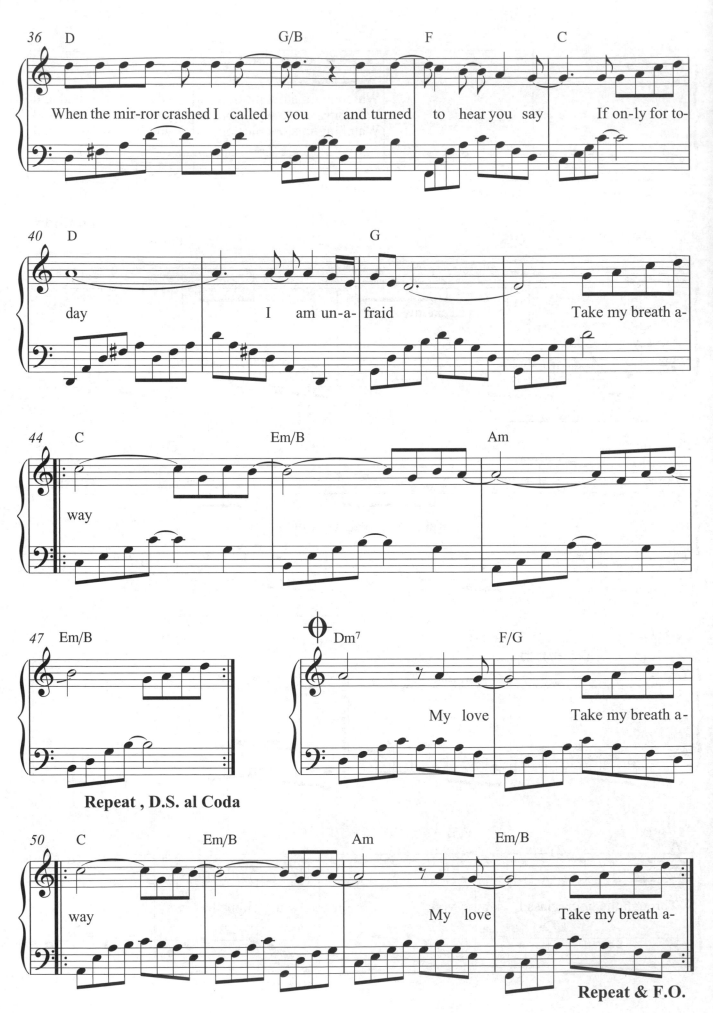

Repeat , D.S. al Coda

Repeat & F.O.

Tears In Heaven

（電影《Rush》主題曲）

詞／曲：Eric Clapton　演唱：Eric Clapton

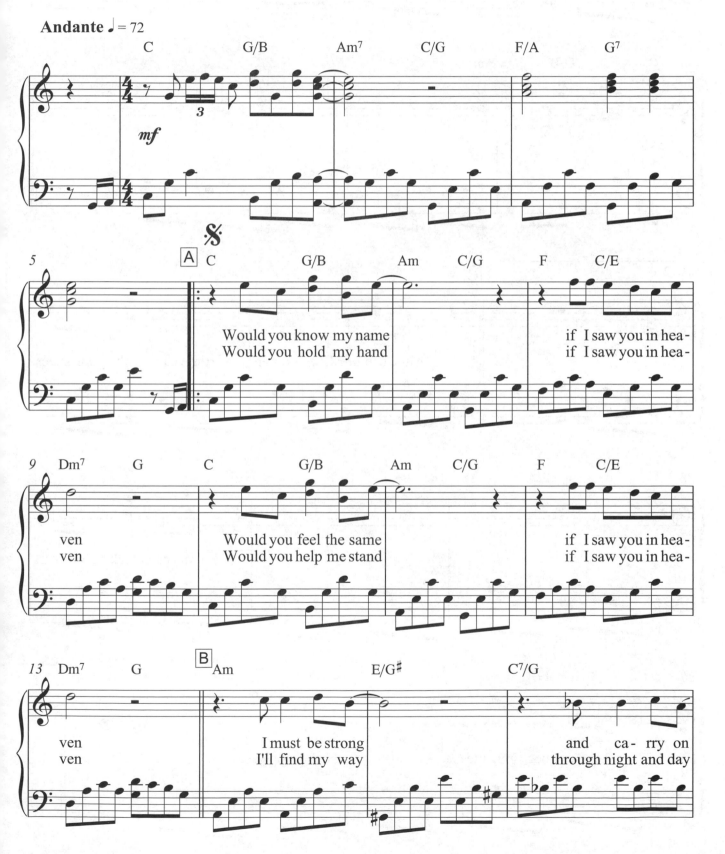

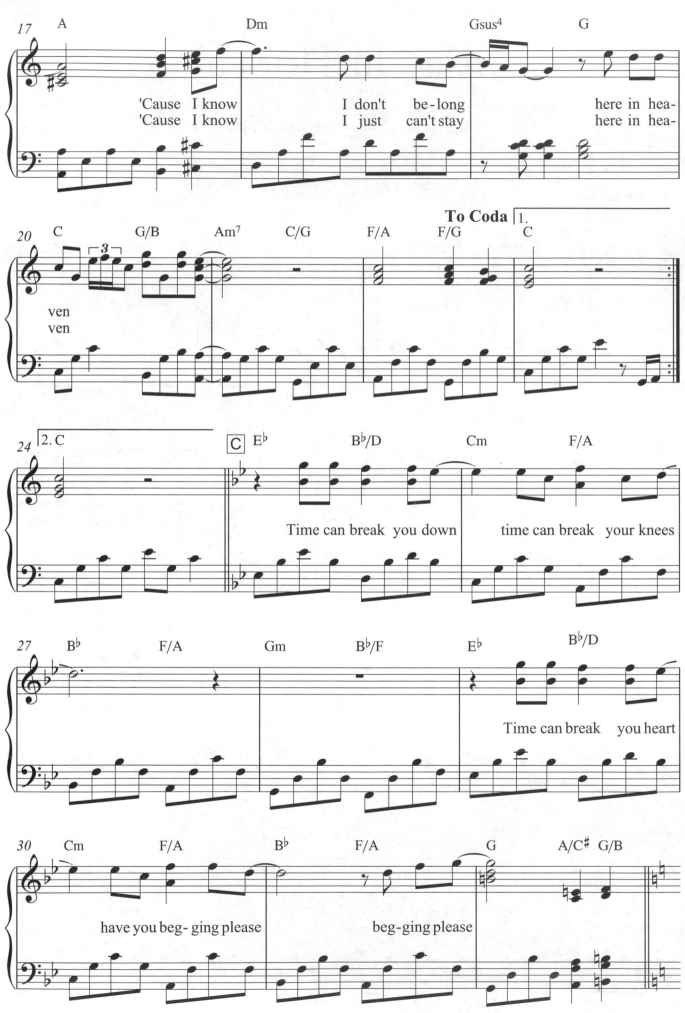

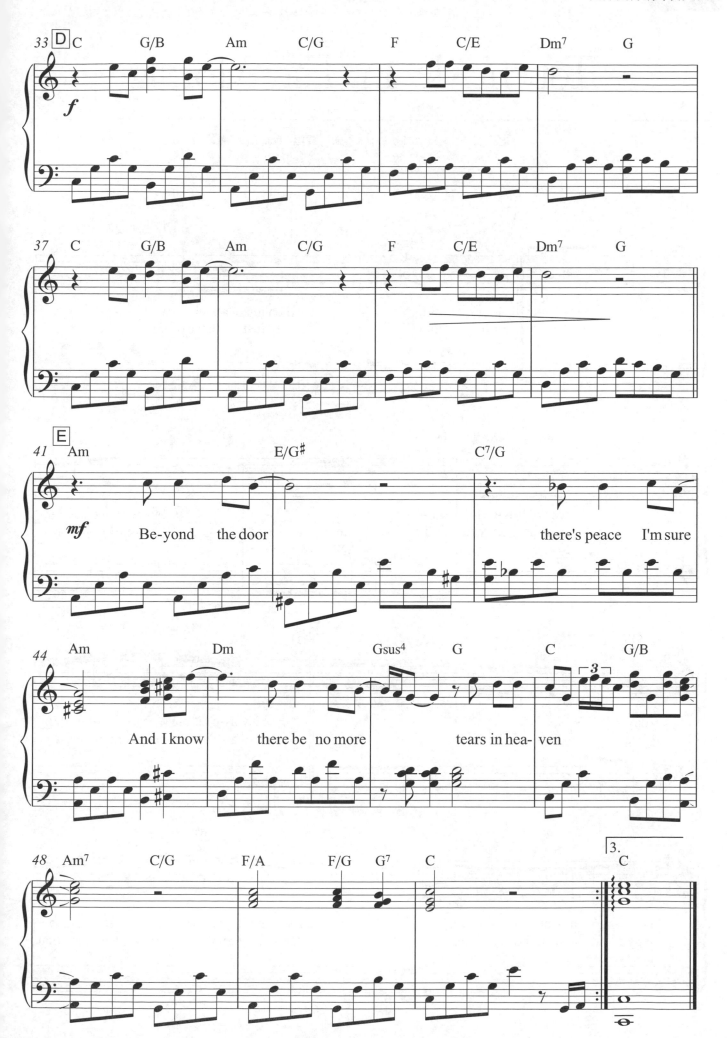

Touch Me In The Mornig

詞／曲：Ron Miller / Michael Masser　演唱：Diana Ross

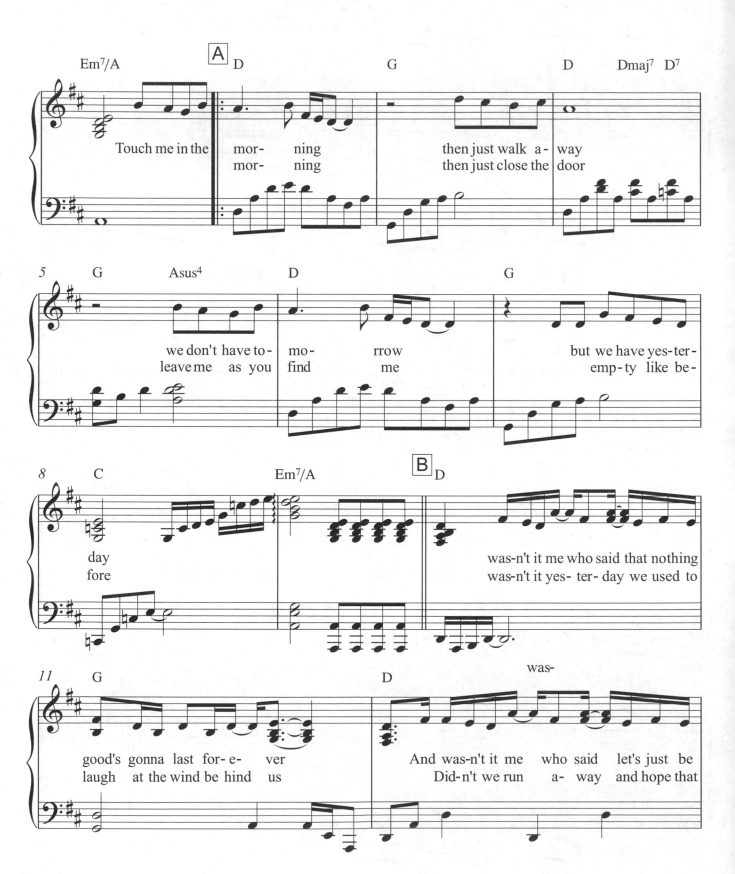

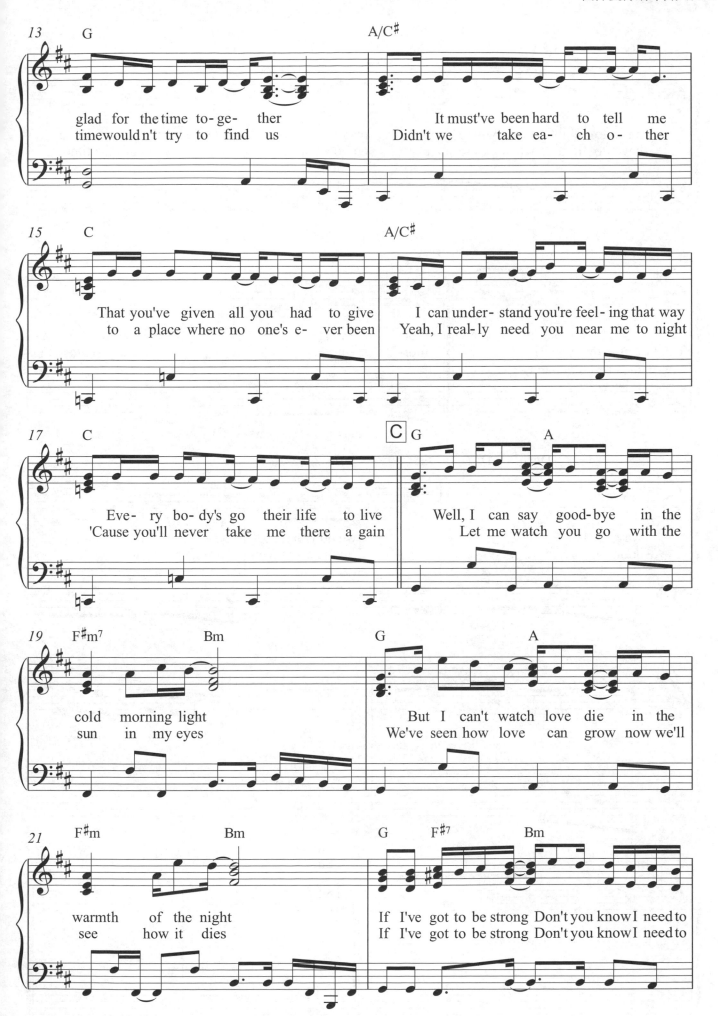

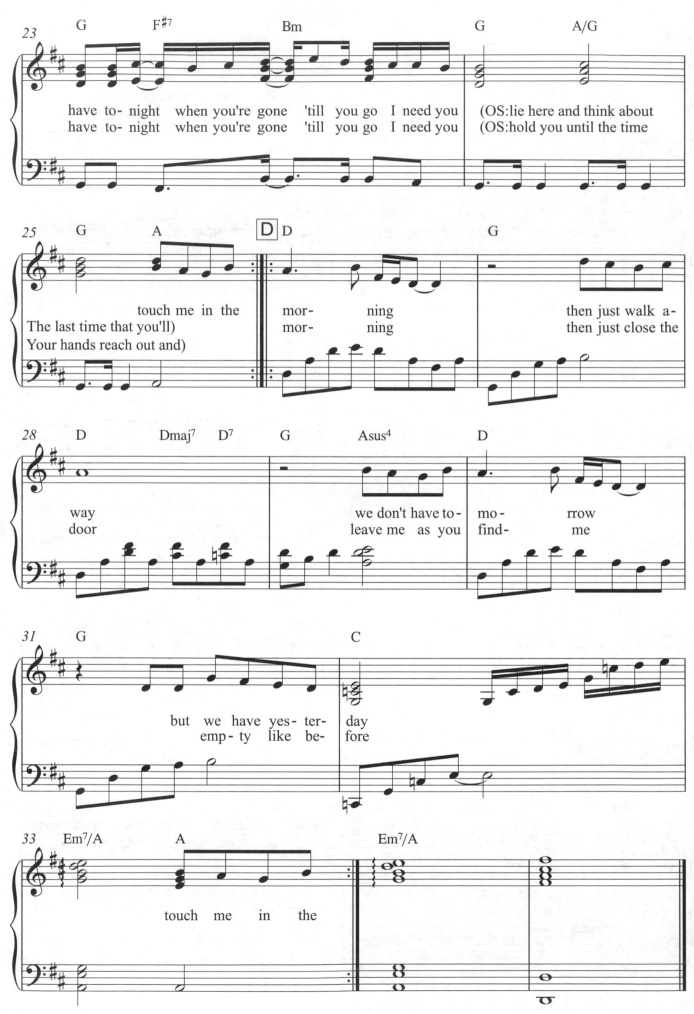

The Way We Were

（電影《往日情懷》主題曲）

詞／曲：A.Bergman / M.Bergman / M.Hamlish　演唱：Barbra Streisand

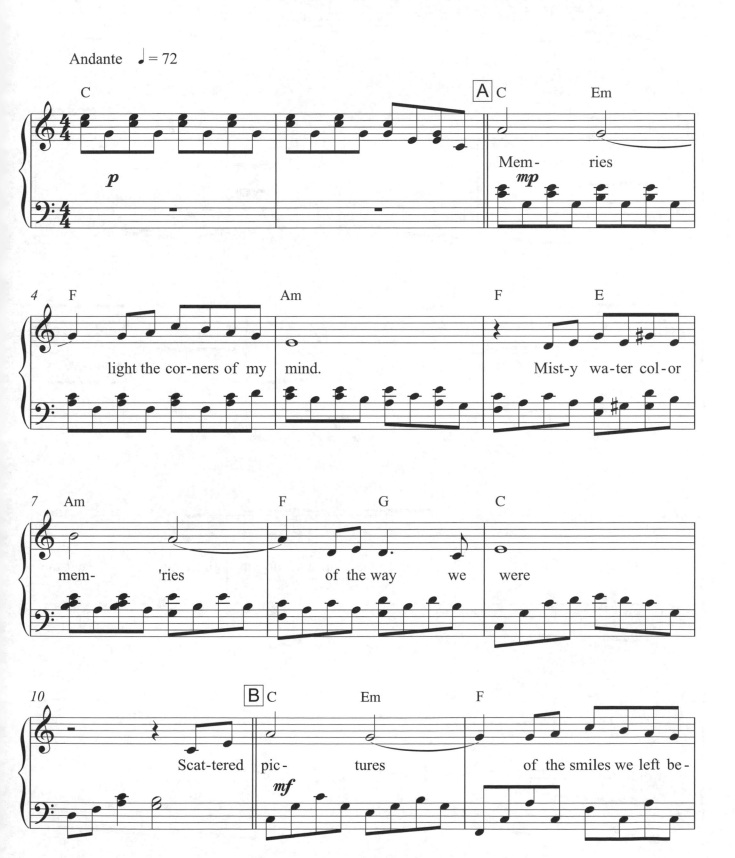

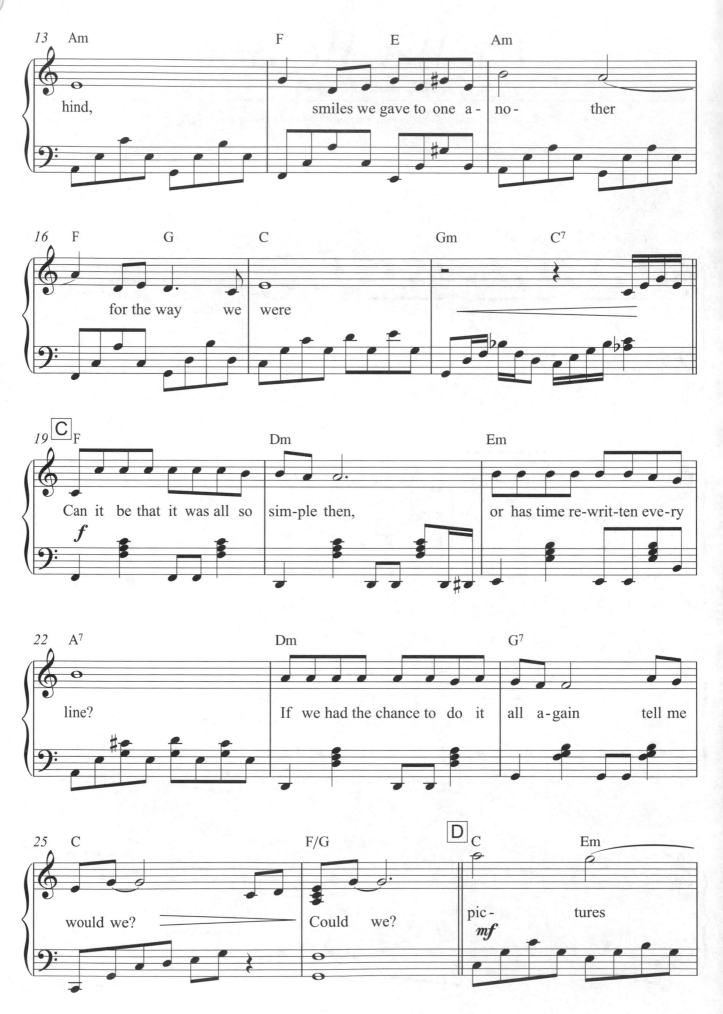

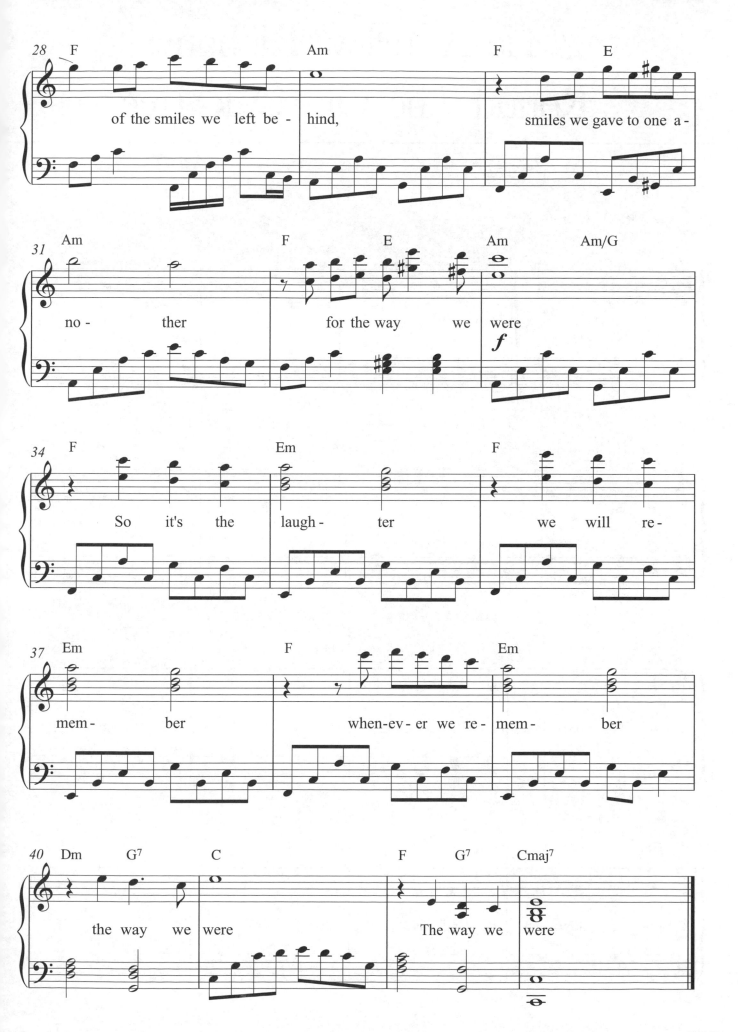

Tie A Yellow Ribbon
Round The Old Oak Tree

詞／曲：L.Russell Brown / Irwin Levine　演唱：Tony Orlando & Dawn

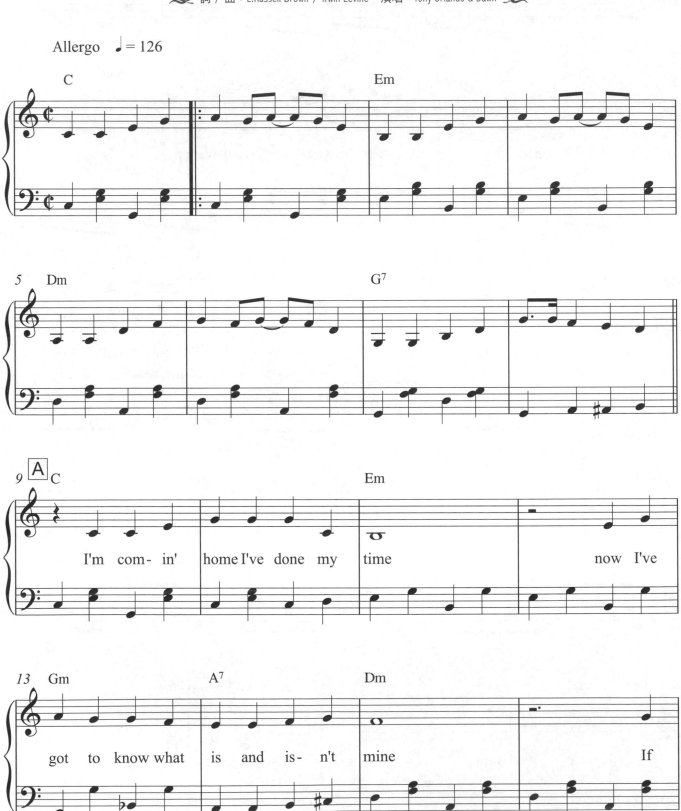

I'm com- in' home I've done my time　　　　now I've

got to know what is and is- n't mine　　　If

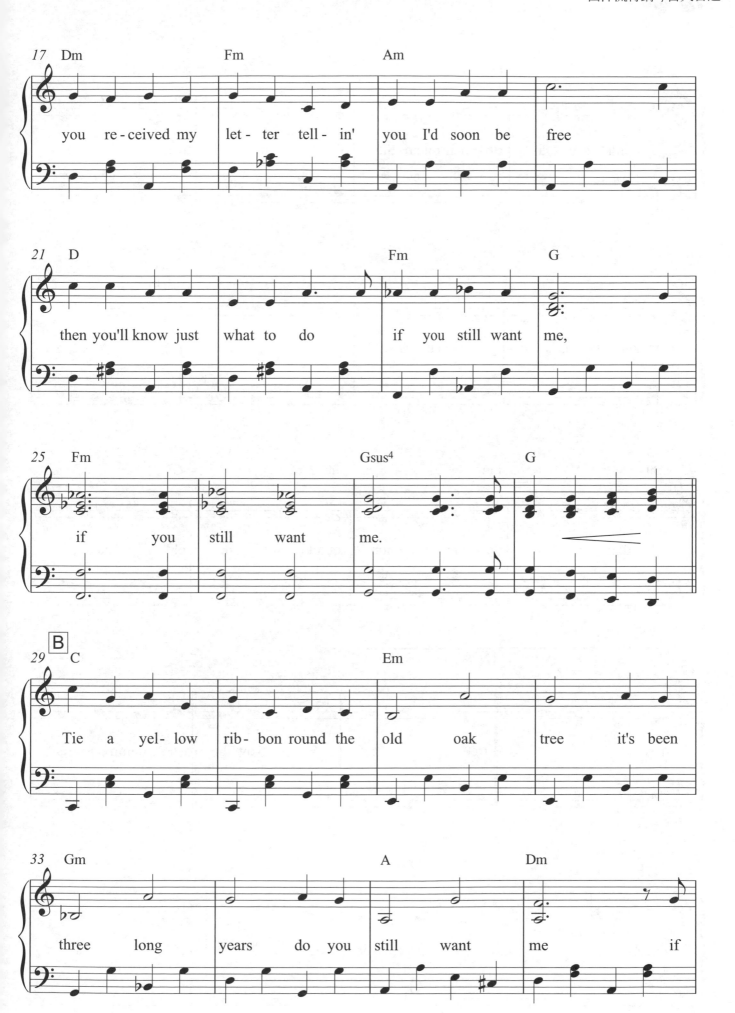

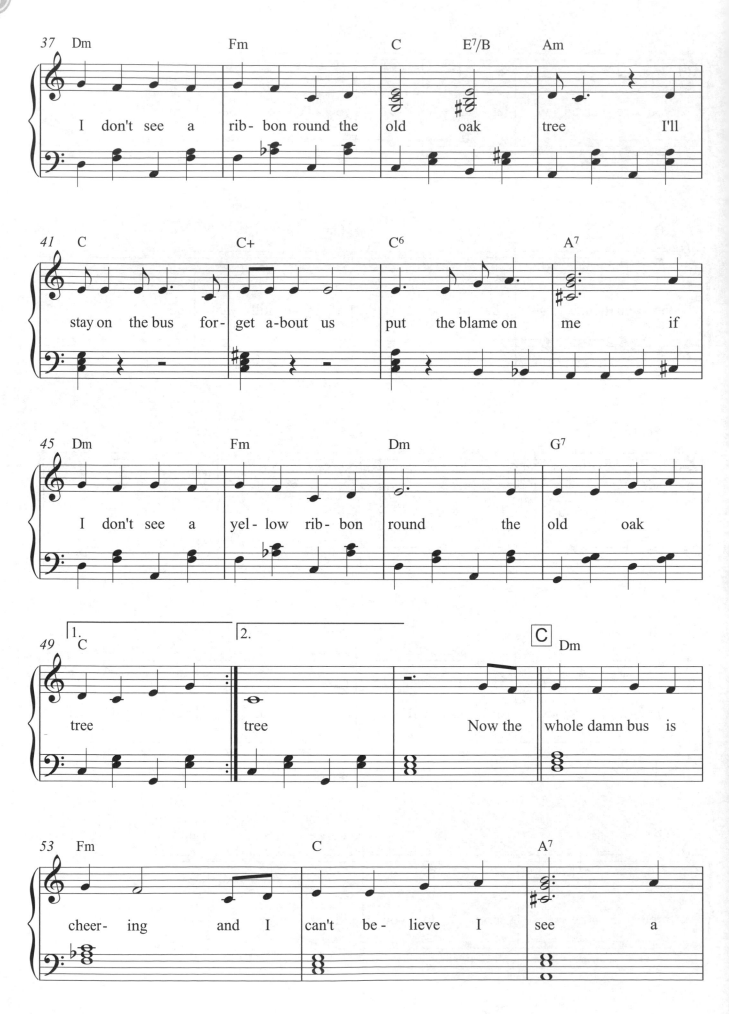

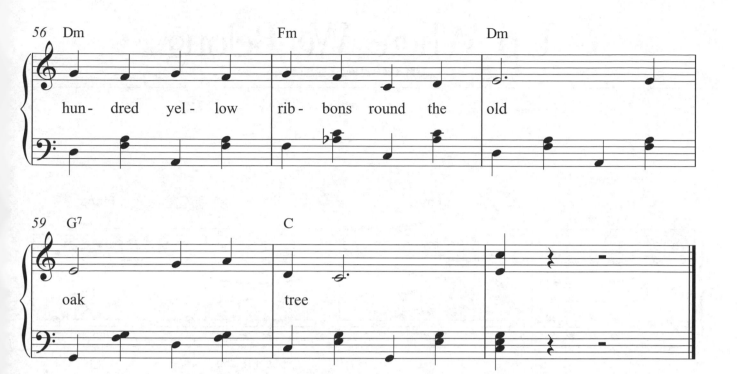

Up Where We Belong

（電影《軍官與紳士》主題曲）

詞 / 曲：Alex North / Hy Zaret　演唱：Joe Cocker / Jennifer Warnes

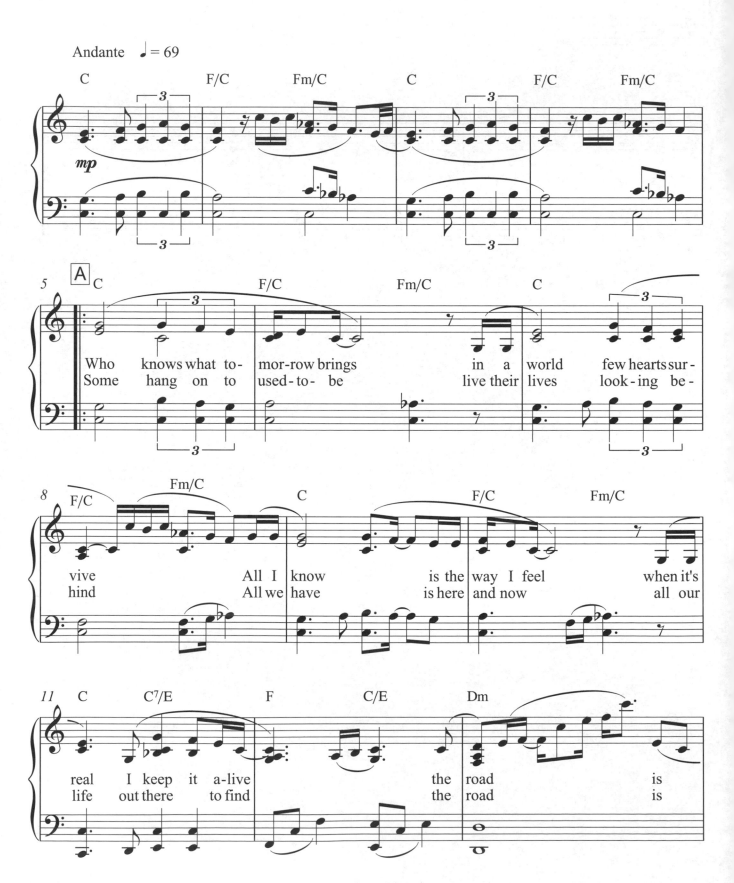

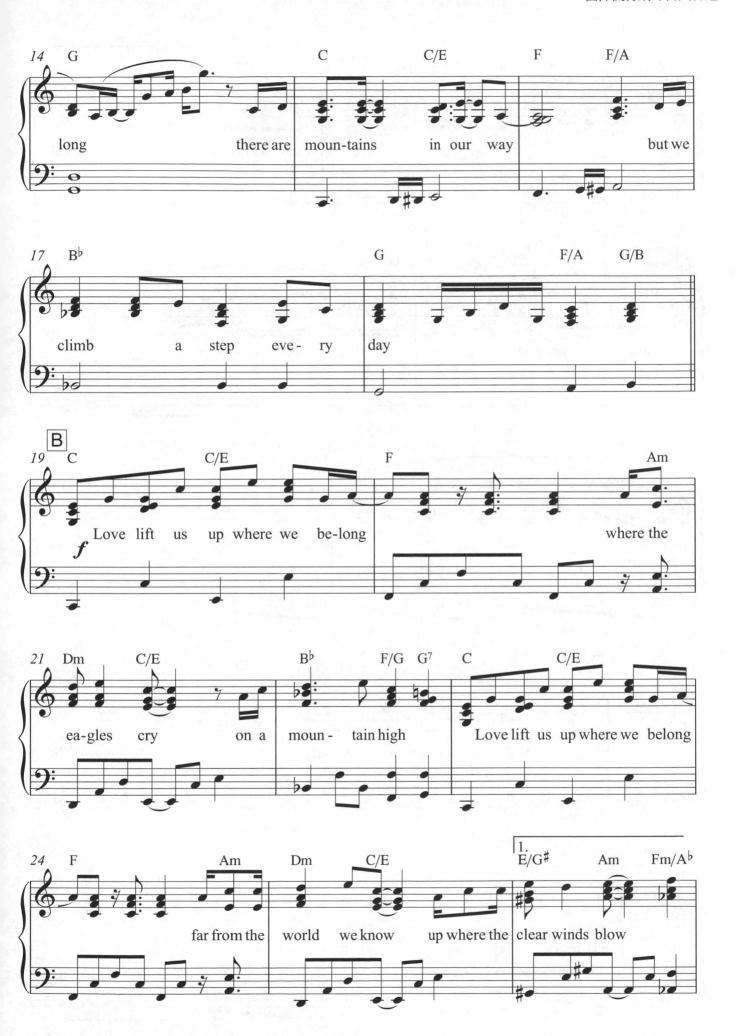

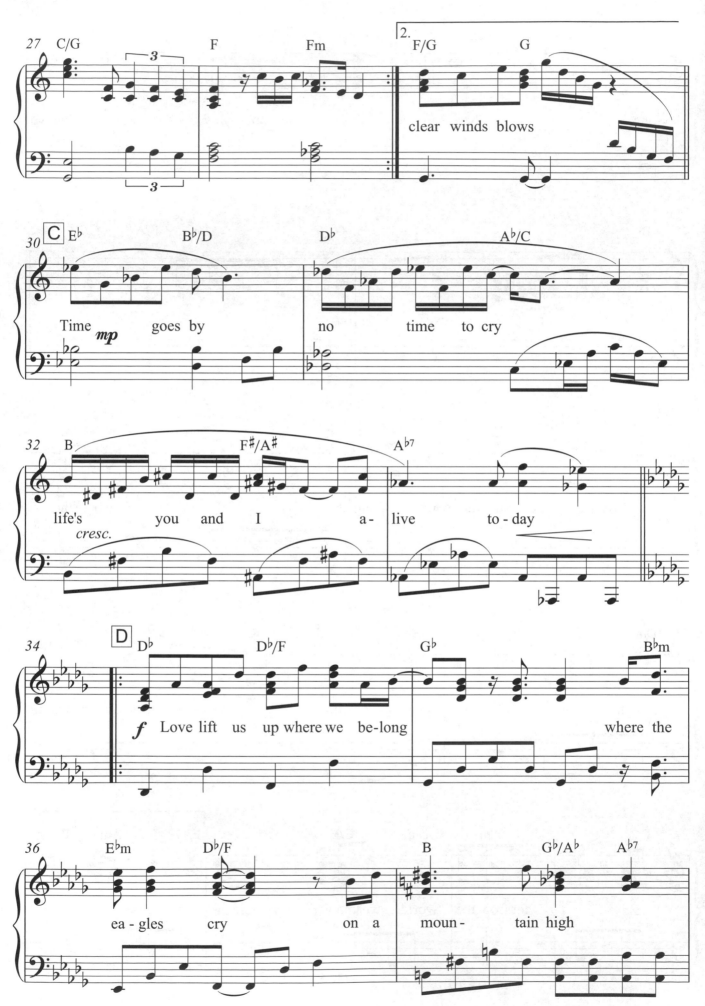

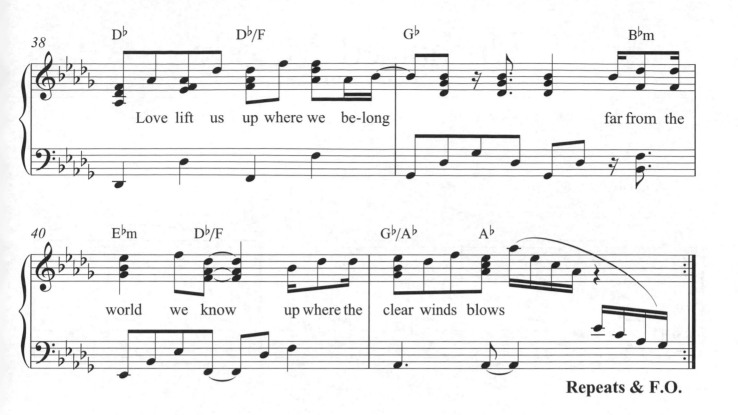

Love lift us up where we be-long far from the

world we know up where the clear winds blows

Repeats & F.O.

Unchained Melody

（電影《第六感生死戀》主題曲）

詞／曲：Will Jennings / Buffy Sainte - Marie / Jack Nitzsche　演唱：Righteous Brothers

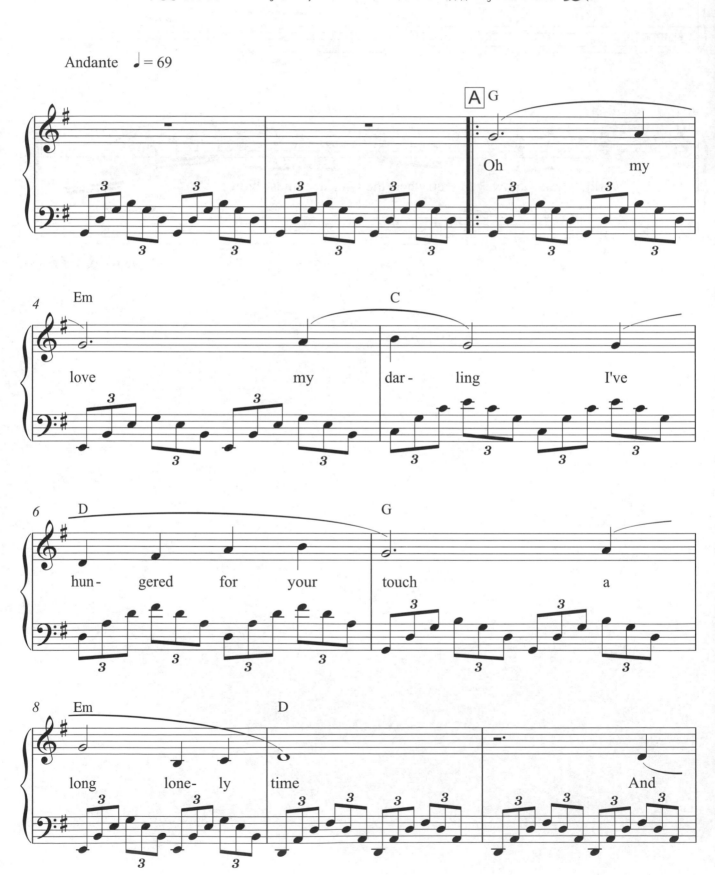

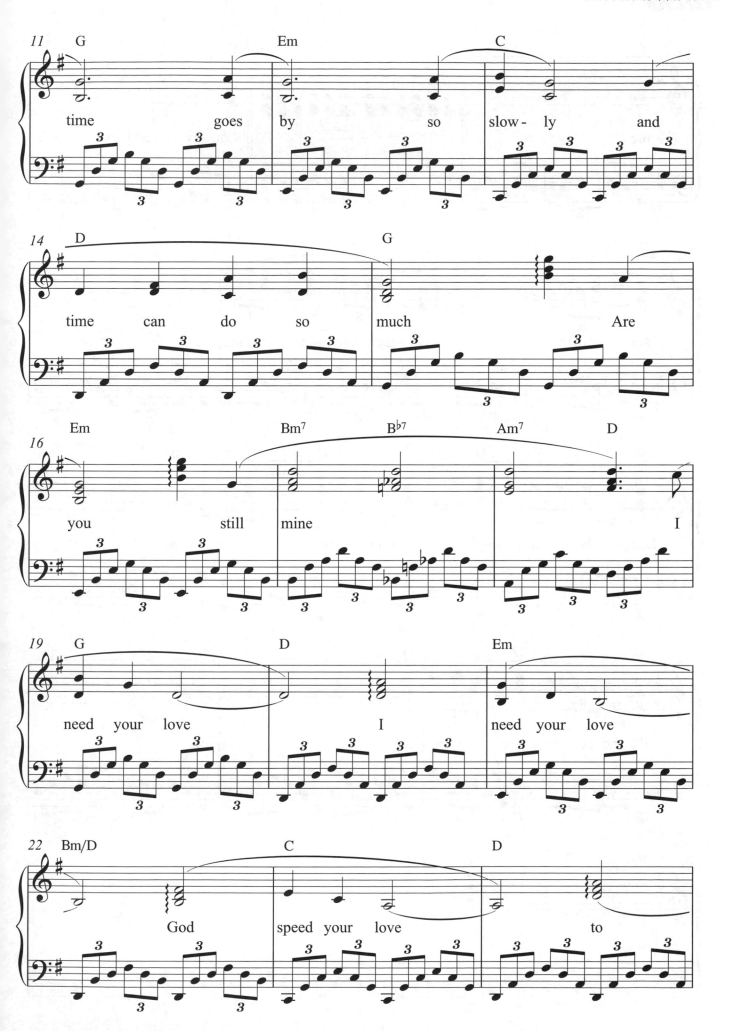

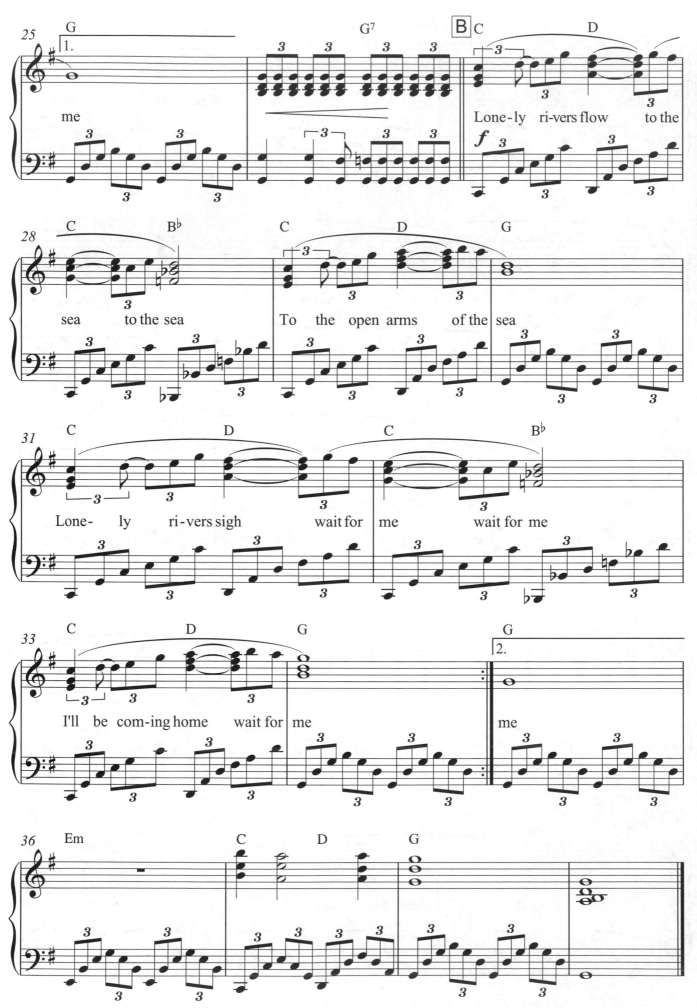

When A Man Love A Woman

詞 / 曲：Calvin Lewis / Andrew Wright　演唱：Michael Bolton

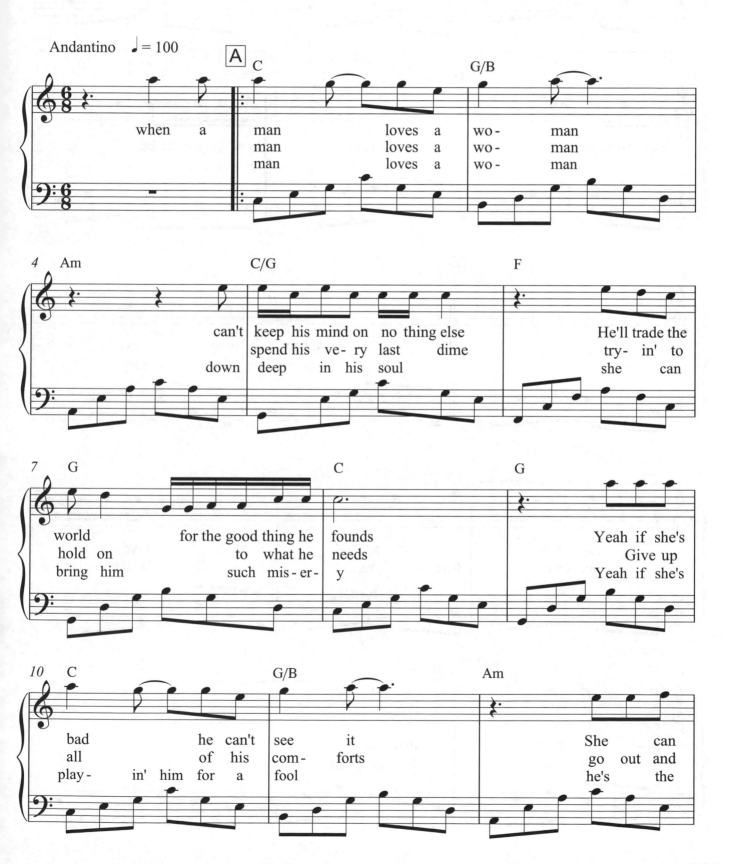

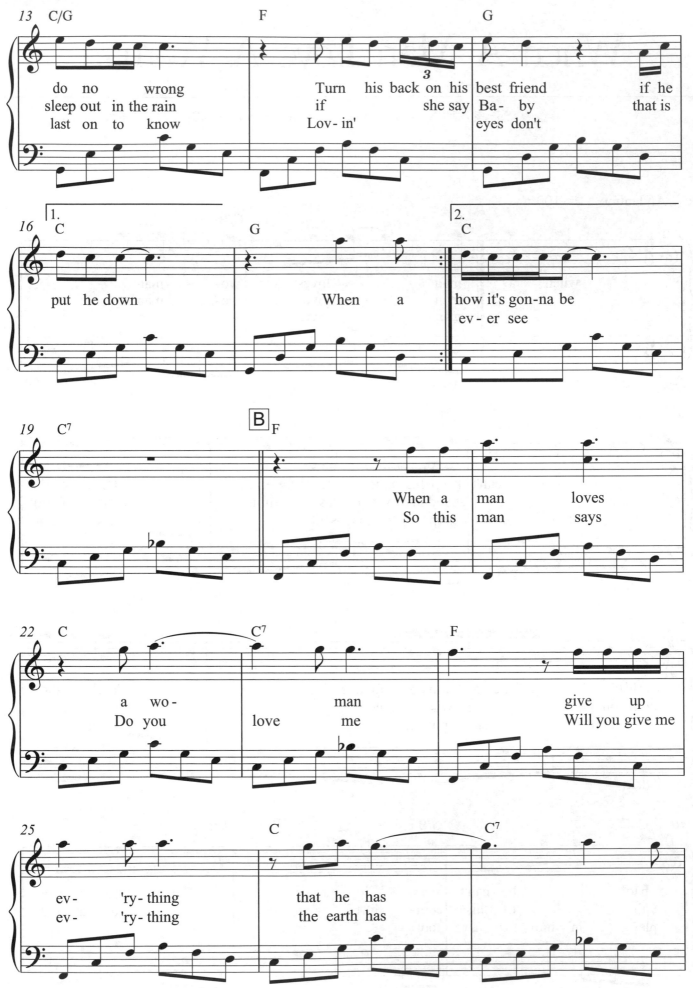

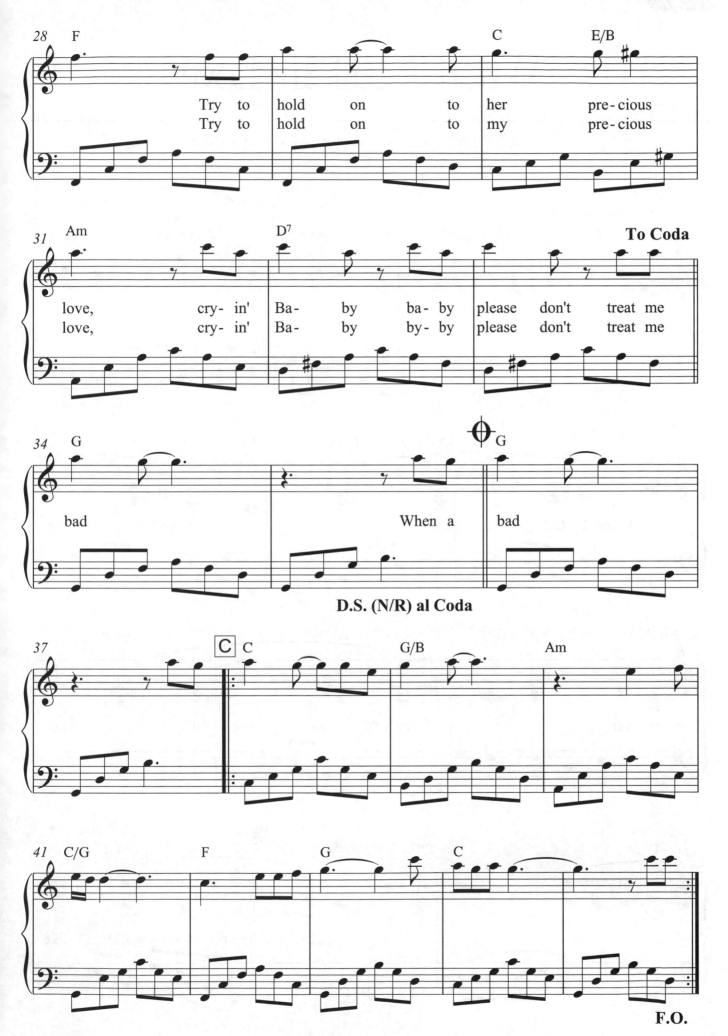

When I Fall In Love

詞 / 曲：Edward Heyman / Victor Young　演唱：Natalie Cole

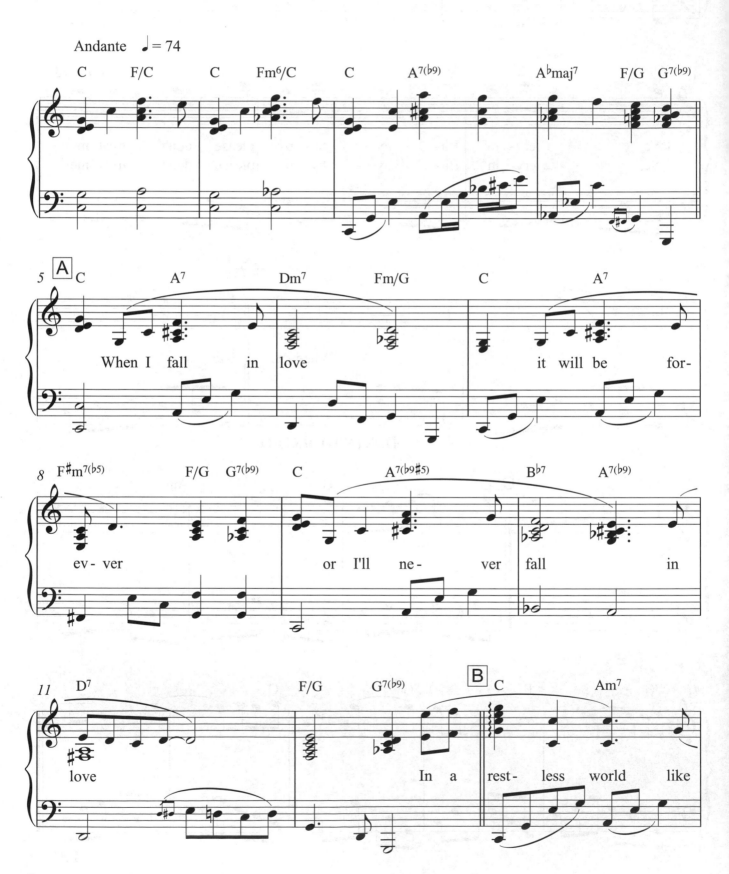

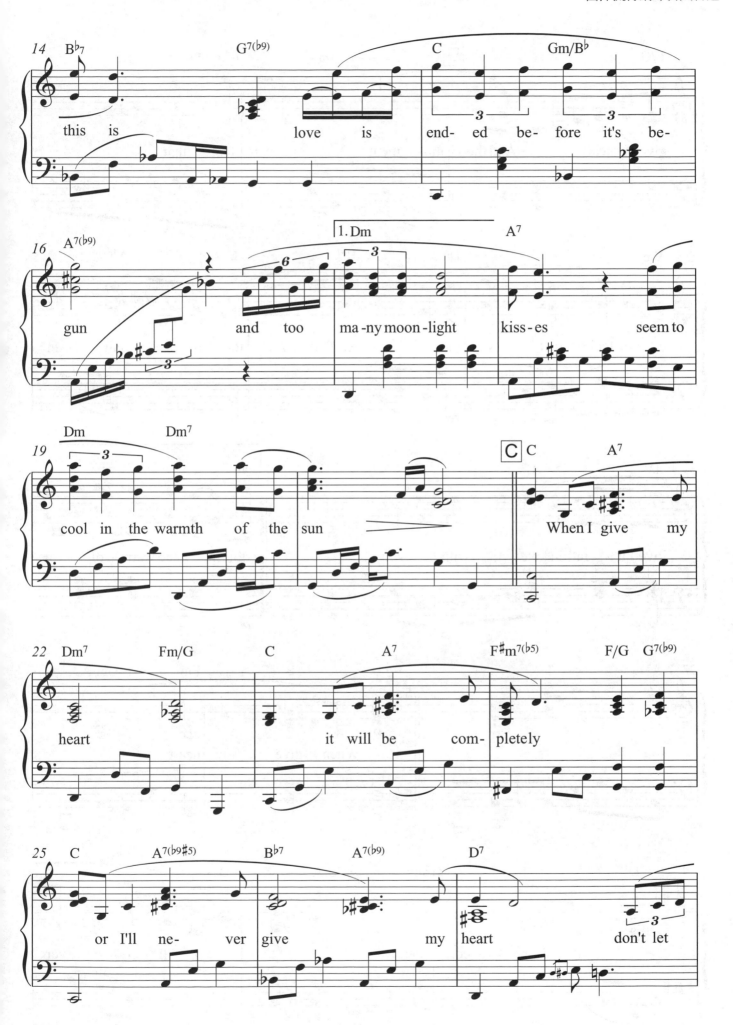

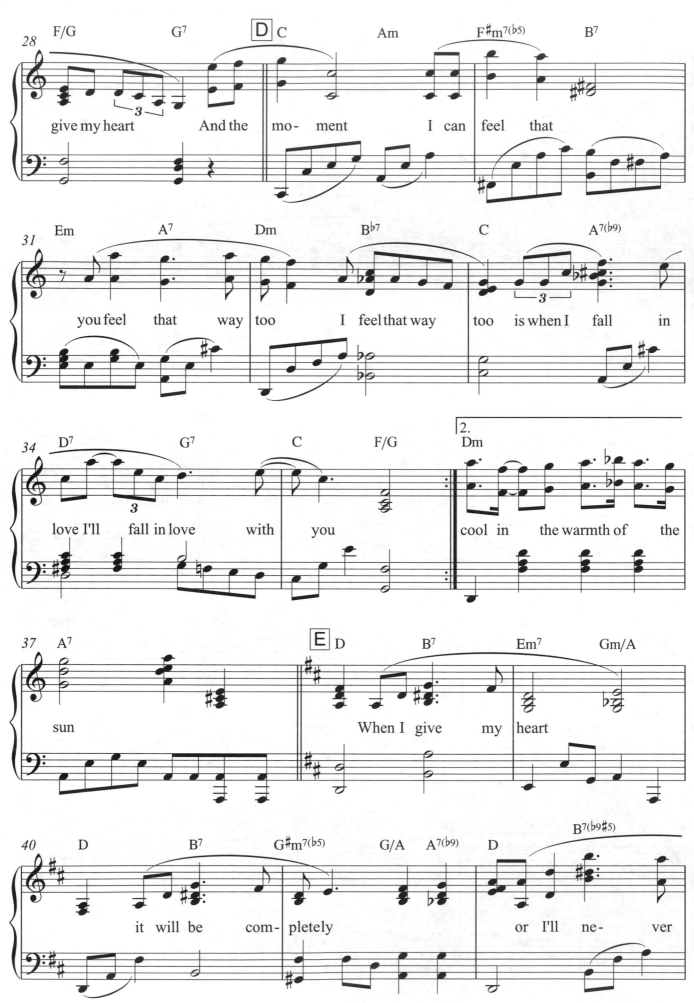

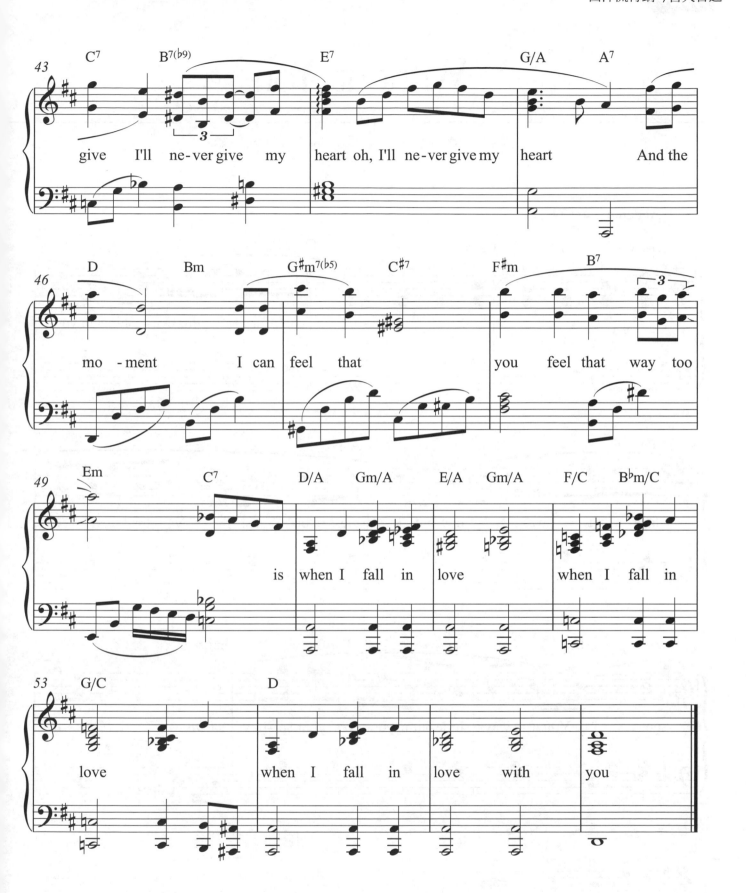

Without You

詞／曲：William Ham／Tom Evans　演唱：Mariah Carey

Andante ♩= 74

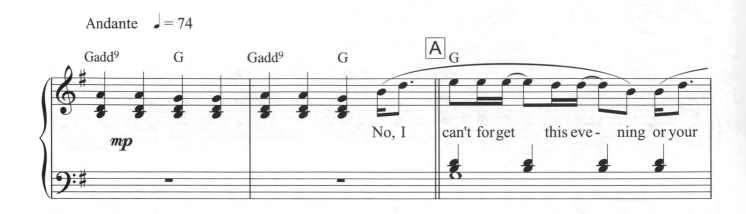

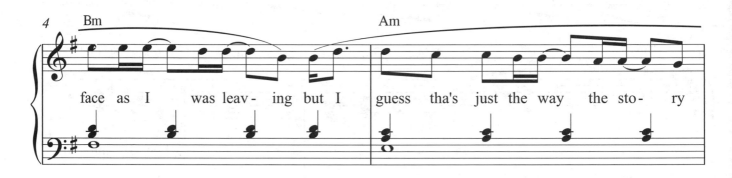

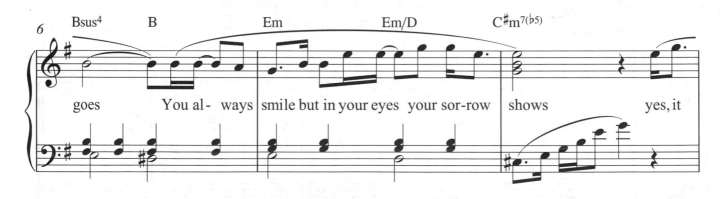

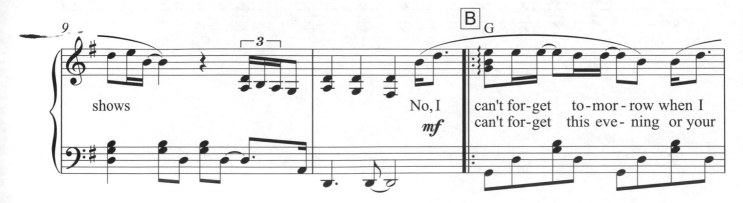

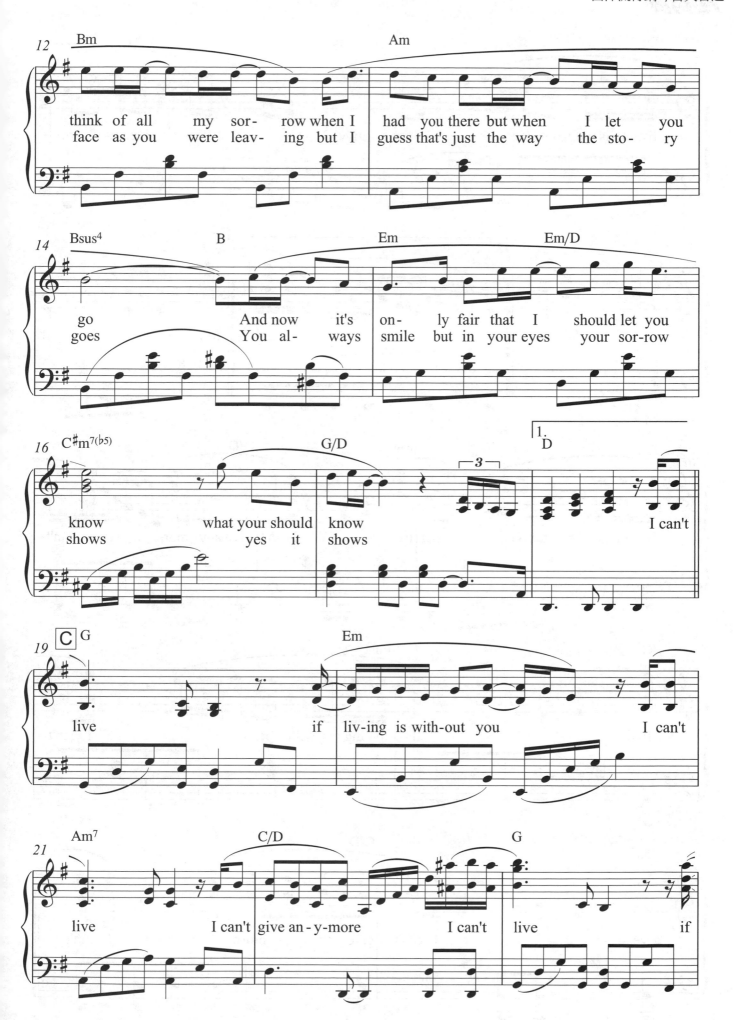

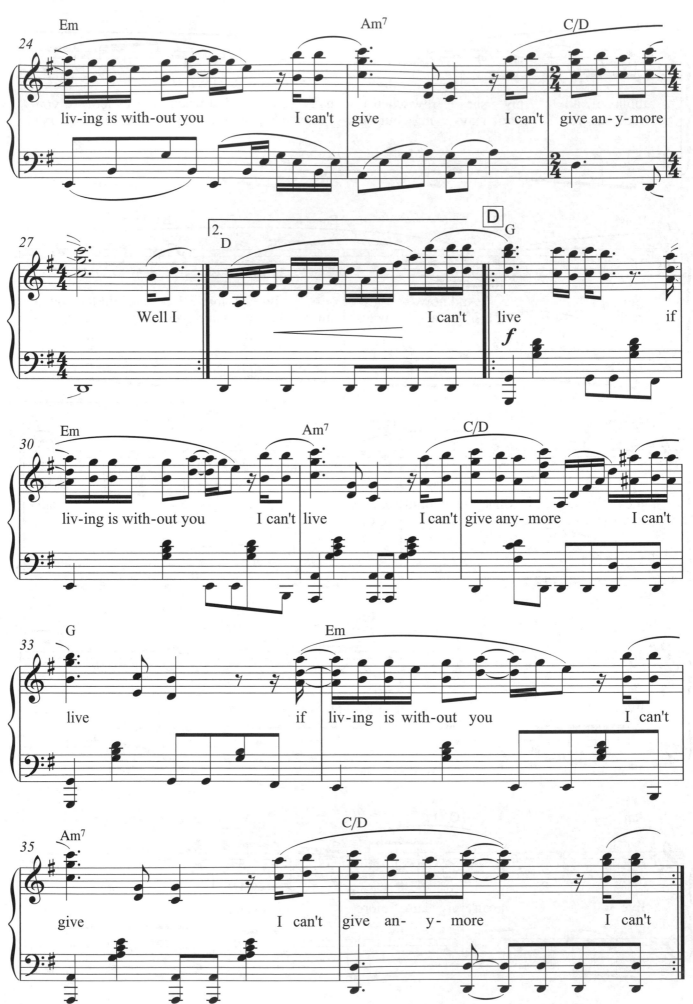

You're Are Everything

詞／曲：Mobillon / Skorsky / Gomes　演唱：Santa Esmeralda

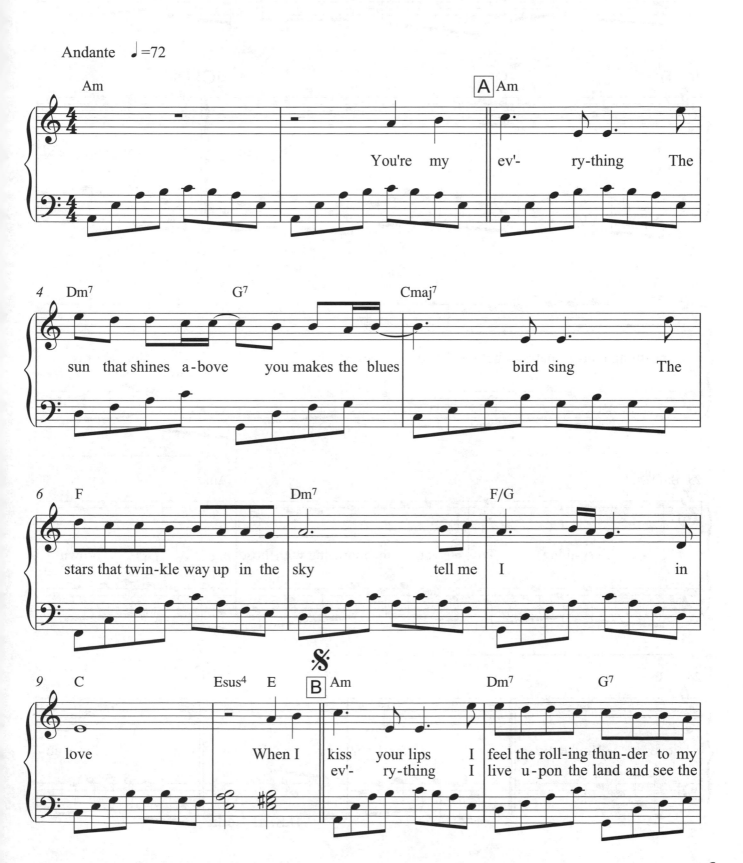

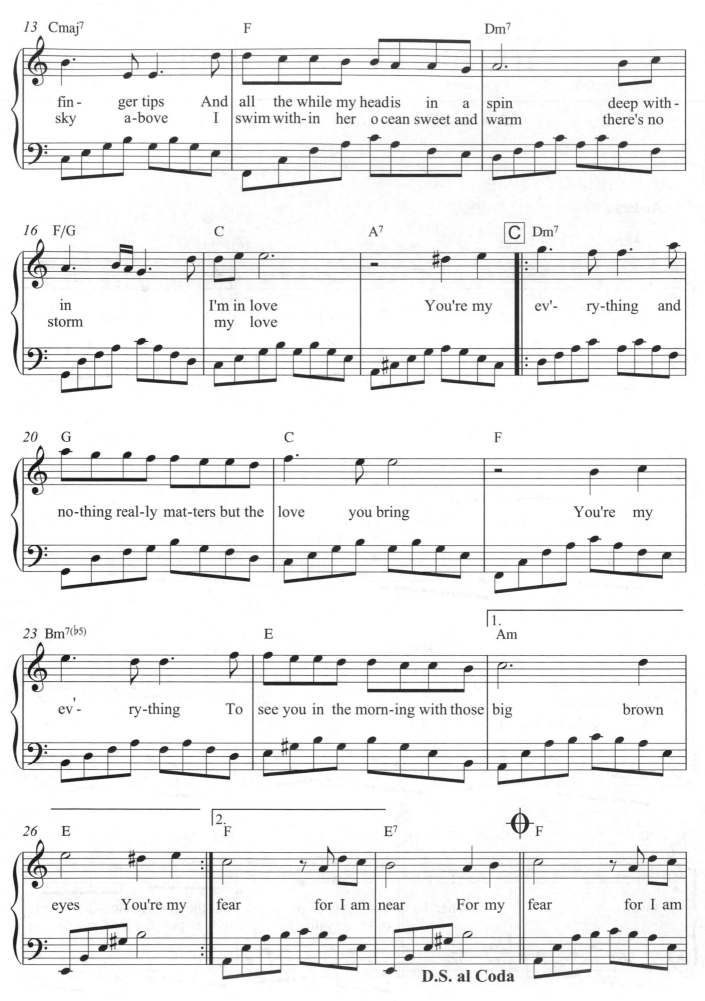

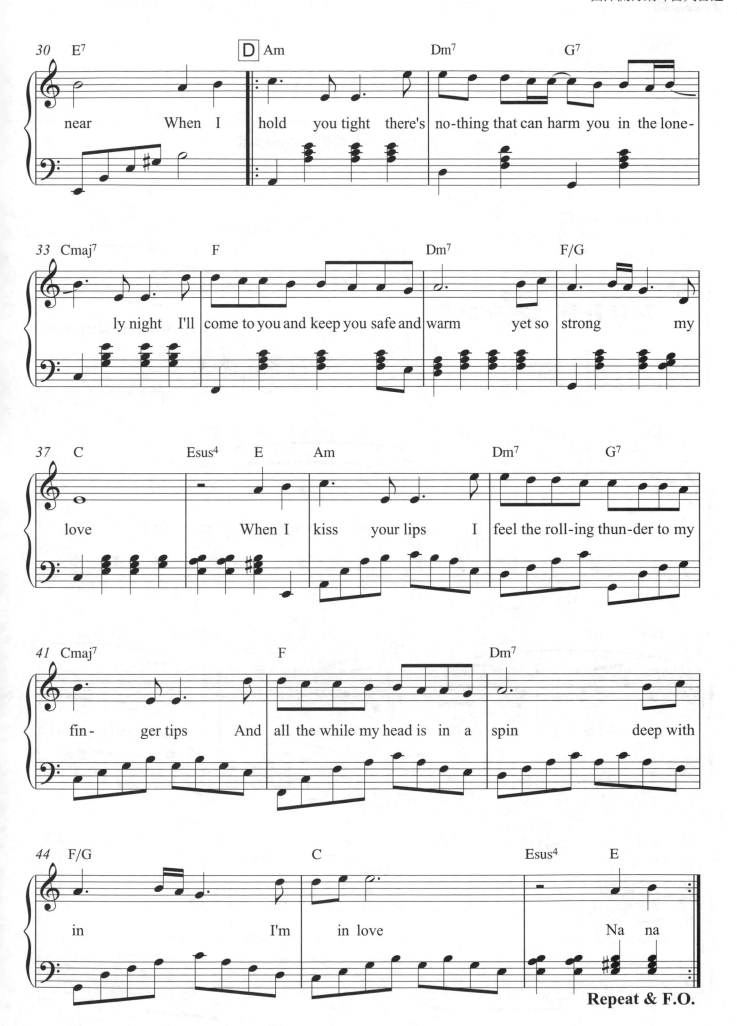

Yesterday

詞／曲：Paul Mccartney　演唱：The Beatles

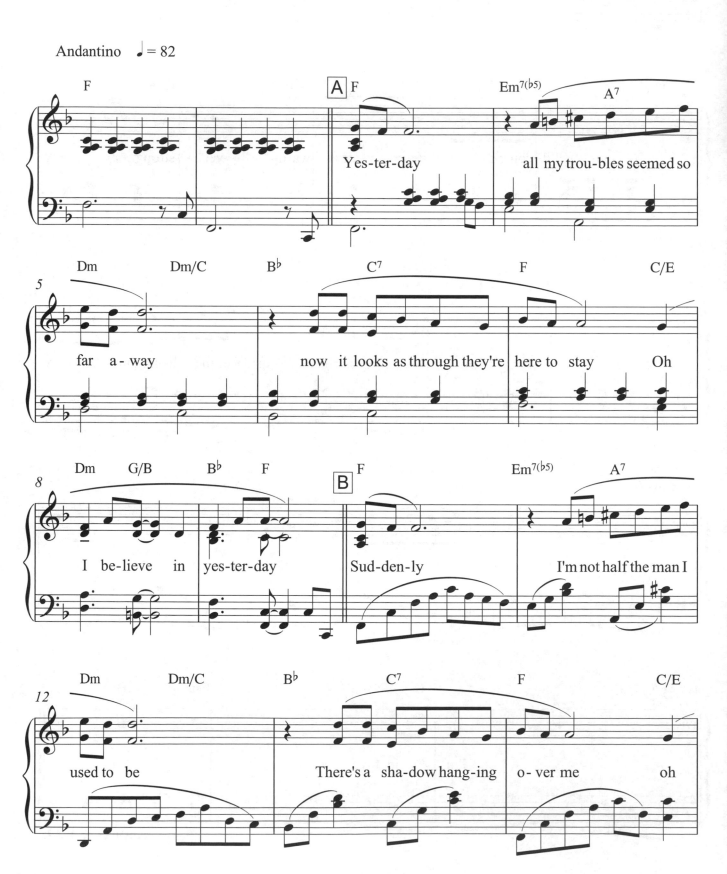

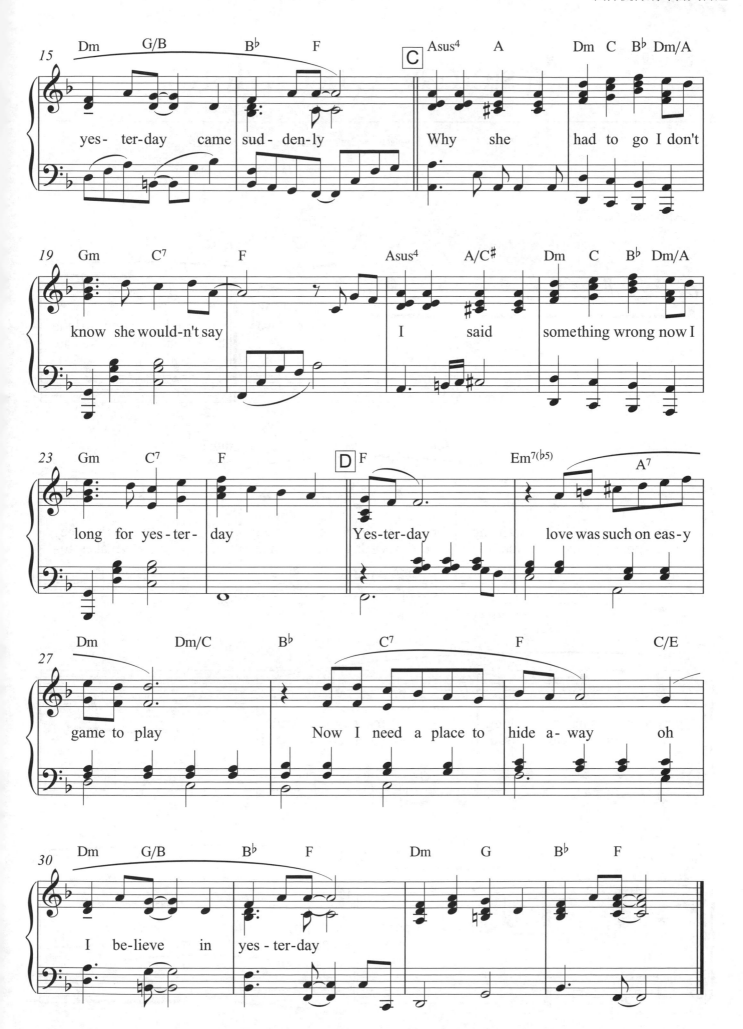

Yesterday Once More

詞／曲：Richard Carpenter / ohn Bettis　演唱：The Carpenters

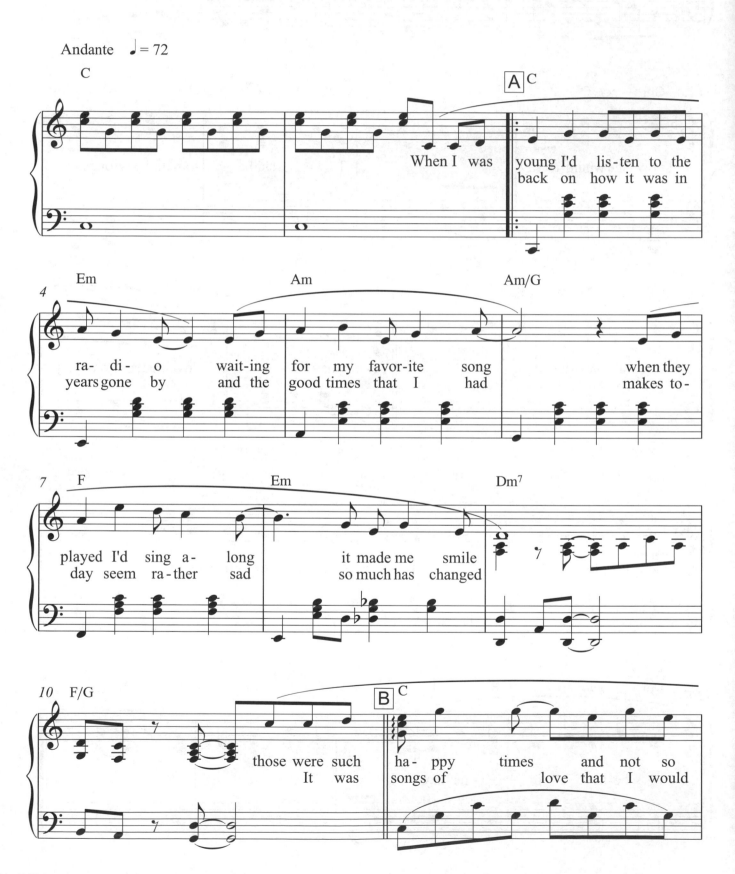

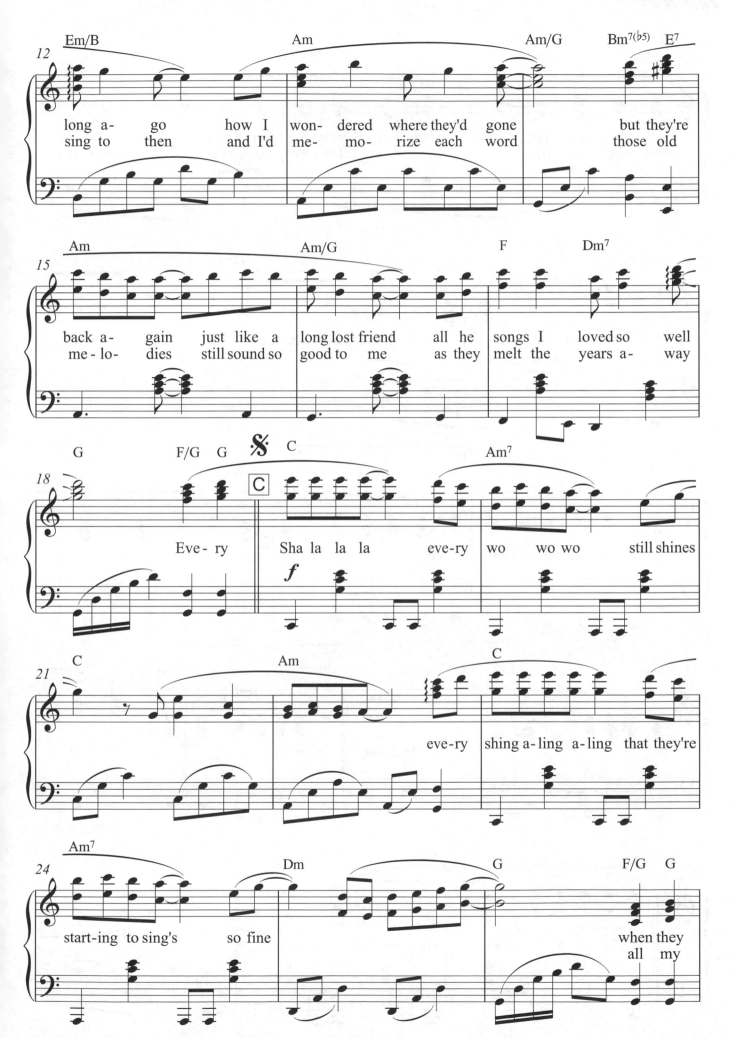

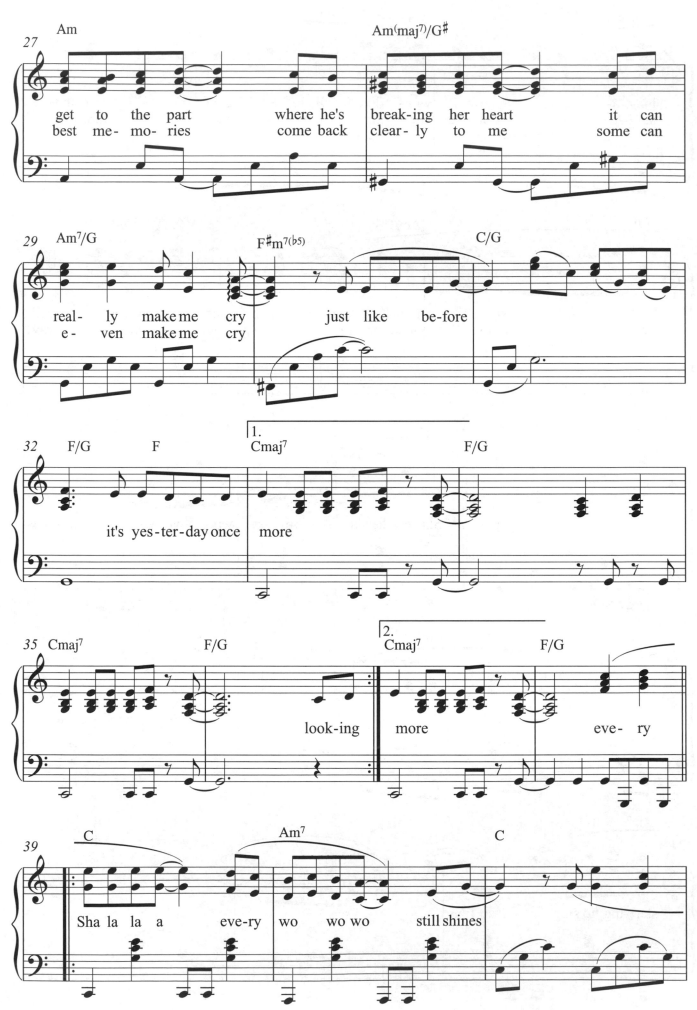

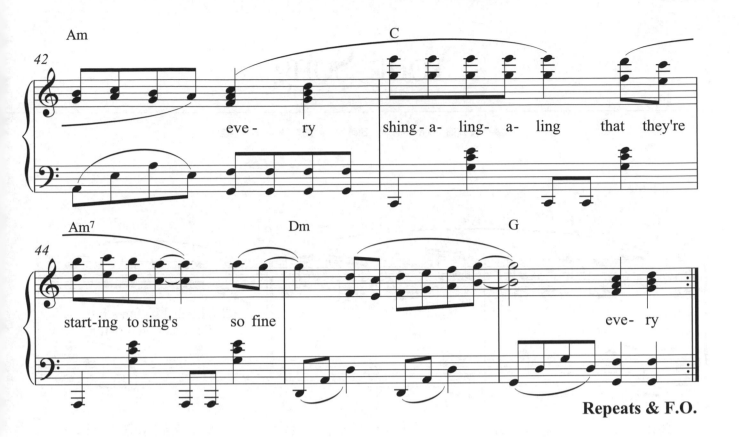

Repeats & F.O.

Your Song

詞／曲：Bernie Taupin / Elton John　演唱：Elton John

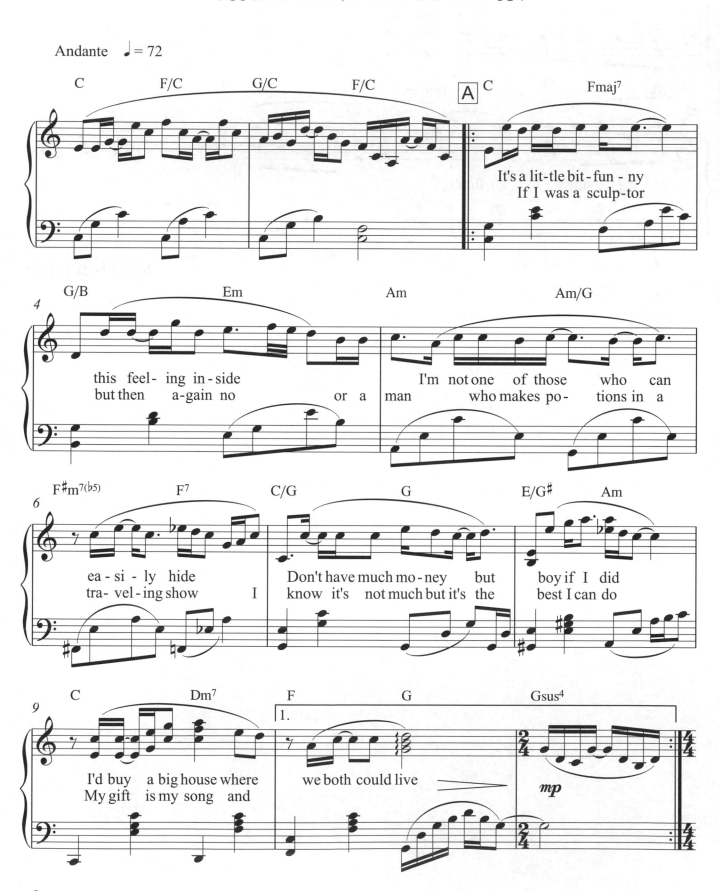

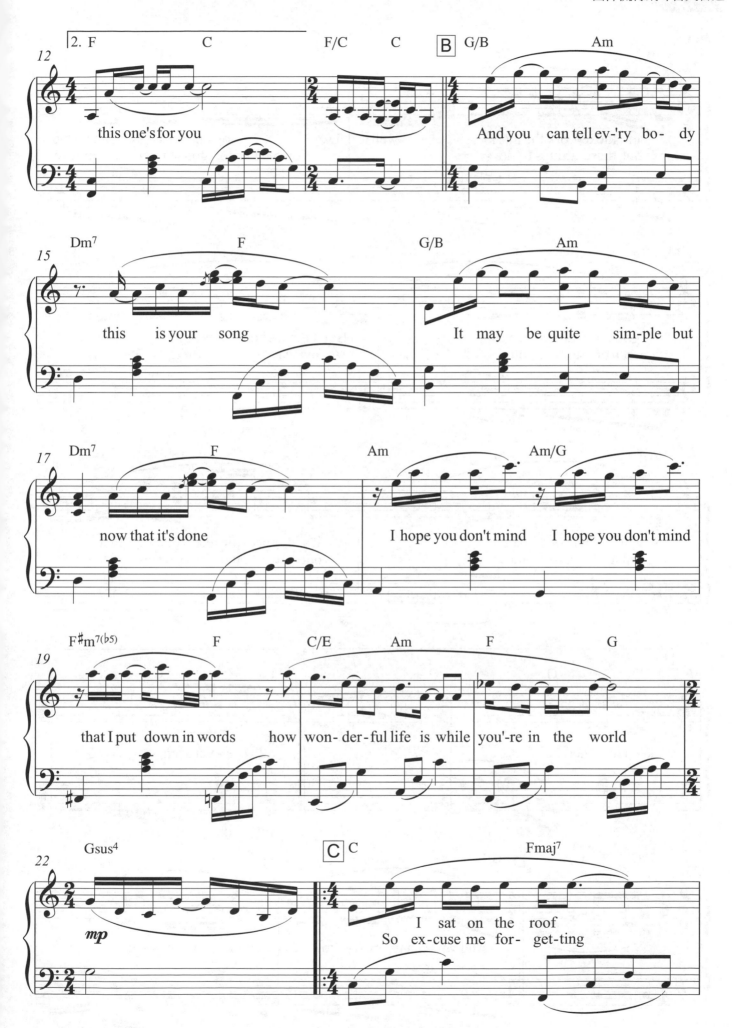

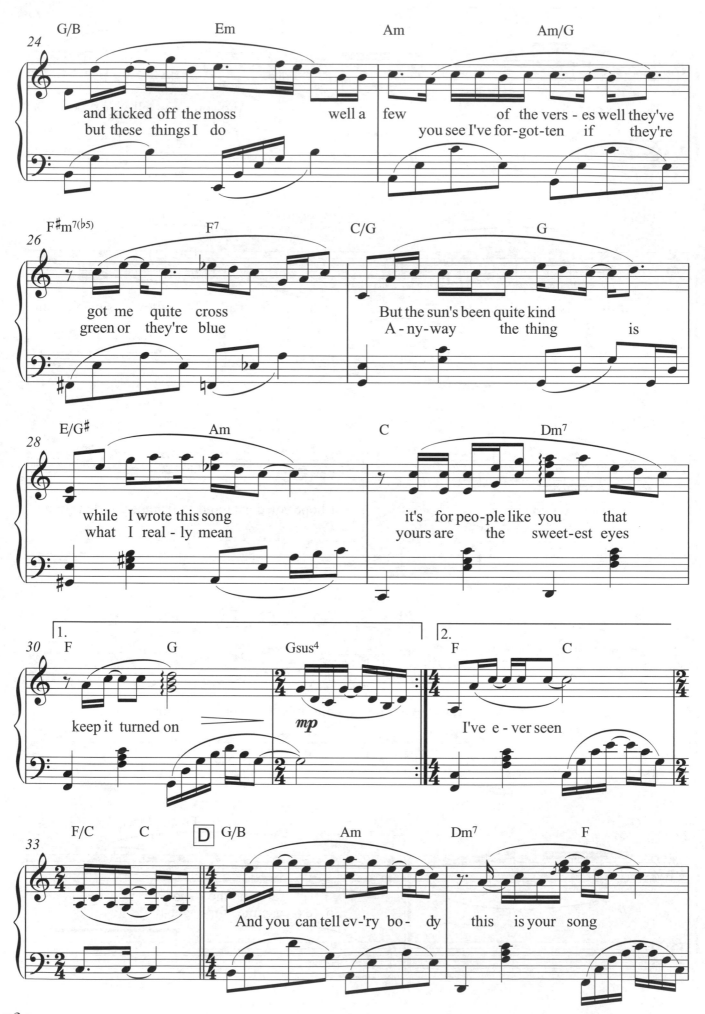

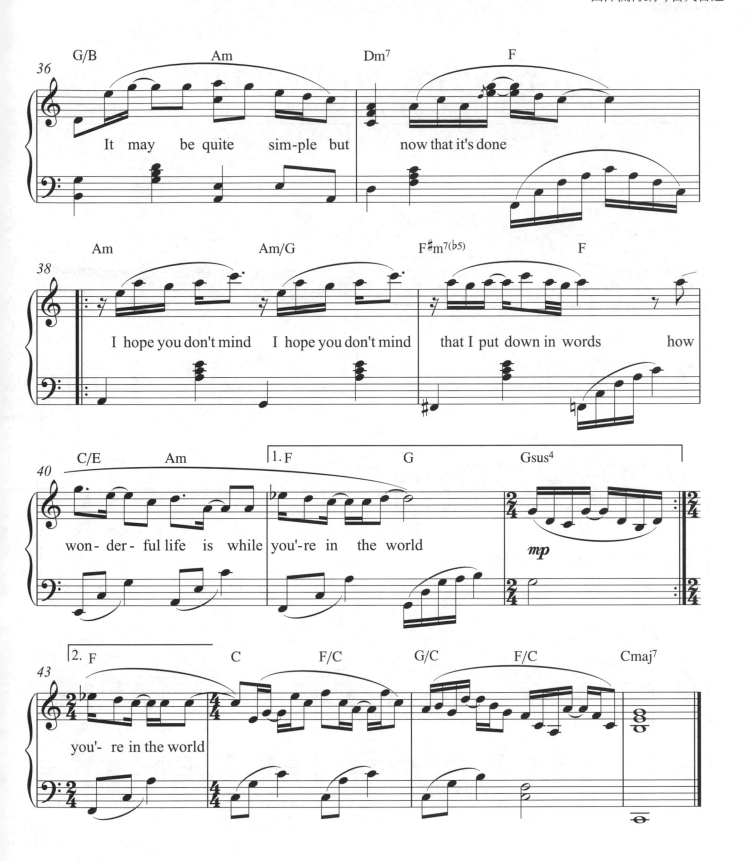

You Are So Beautiful

詞／曲：Tilly Preston / Bruce Fisher　演唱：Joe Cocker

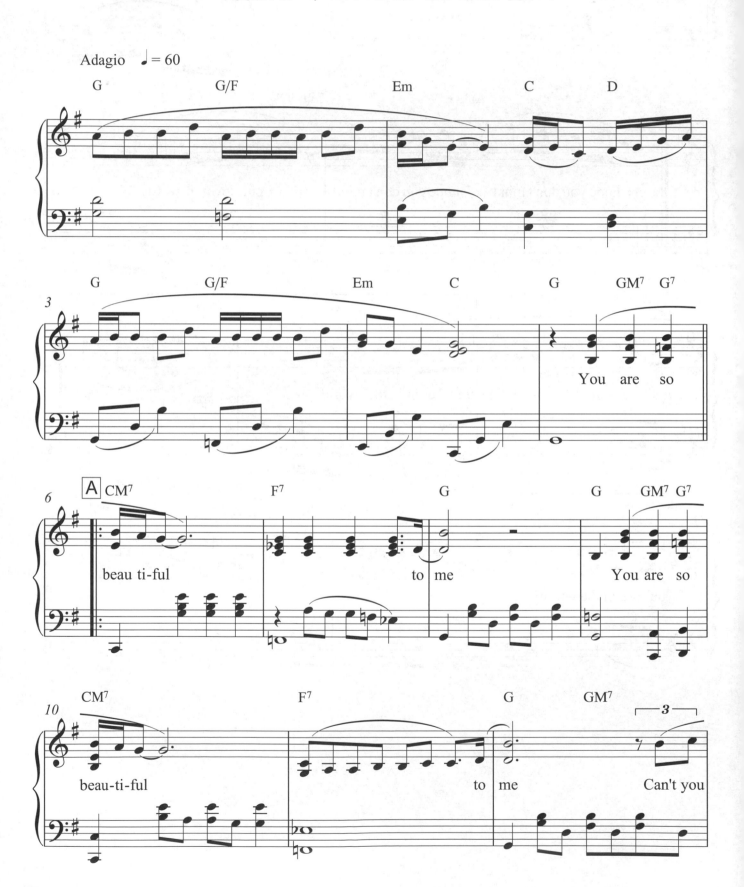

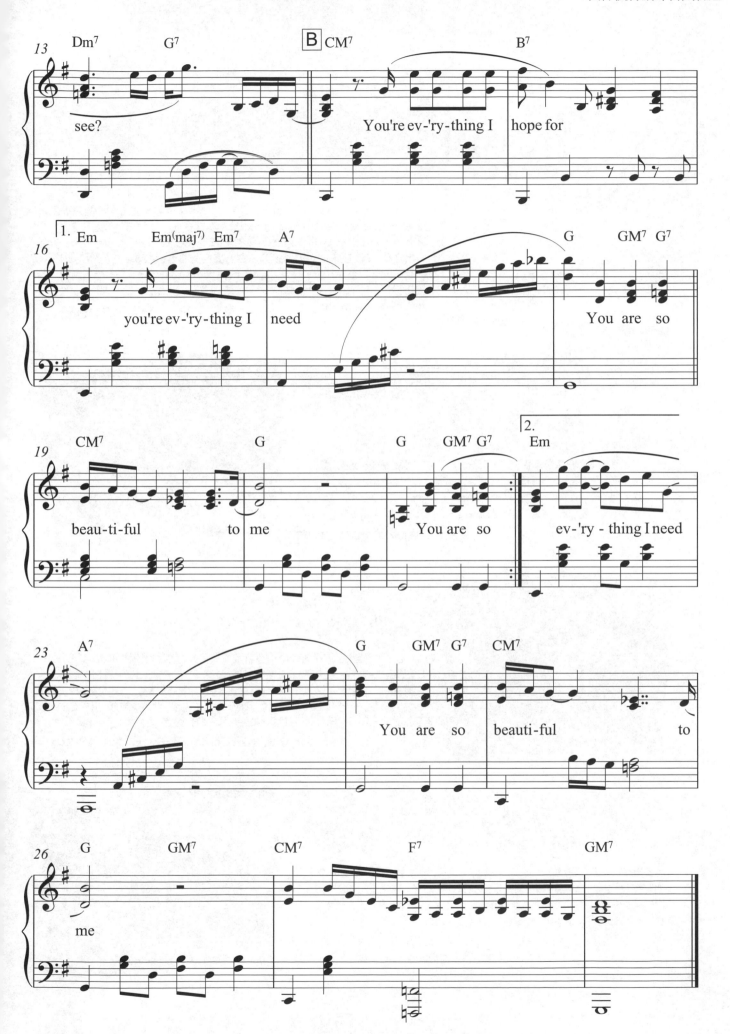

婚禮主題曲 PIANO 30選 Wedding 五線譜版

Comme au premier jour、三吋日光、Everything、聖母頌、愛之喜、愛的禮讚、
Now, on Land and Sea Descending、威風凜凜進行曲、輪旋曲、愛這首歌、
Someday My Prince Will Come、等愛的女人、席巴女王的進場、My Destiny、
婚禮合唱、D大調卡農、人海中遇見你、終生美麗、So Close、今天你要嫁給我、
Theme from Love Affair、Love Theme from While You Were Sleeping、因為愛情、
時間都去哪兒了、The Prayer、You Raise Me Up、婚禮進行曲、Jalousie、
You Are My Everything

朱怡潔 編著 定價：**320**元

經典電影主題曲 PIANO 30選 Movie 五線譜版 簡譜版

1895、B.J.單身日記、不可能的任務、不能說的秘密、北非諜影、
在世界的中心呼喊愛、色‧戒、辛德勒的名單、臥虎藏龍、金枝玉葉、
阿凡達、阿甘正傳、哈利波特、珍珠港、美麗人生、英倫情人、修女也瘋狂、
海上鋼琴師、真善美、神話、納尼亞傳奇、送行者、崖上的波妞、教父、
清秀佳人、淚光閃閃、新天堂樂園、新娘百分百、戰地琴人、魔戒三部曲

朱怡潔 編著 每本定價：**320**元

新世紀鋼琴古典名曲 30選 New Age 五線譜版 簡譜版

G弦之歌、郭德堡變奏曲舒情調、郭德堡變奏曲第1號、郭德堡變奏曲第3號、
降E大調夜曲、公主徹夜未眠、我親愛的爸爸、愛之夢、吉諾佩第1號、吉諾佩第2號、
韃靼舞曲、阿德麗塔、紀念冊、柯貝利亞之圓舞曲、即興曲、慢板、西西里舞曲、天鵝、
鄉村騎士間奏曲、卡門間奏曲、西西里舞曲、卡門二重唱、女人皆如此、孔雀之舞、
死公主之孔雀舞、第一號匈牙利舞曲、帕格尼尼主題狂想曲、天鵝湖、Am小調圓舞曲

何真真 劉怡君 著 每本定價**360**元 內附有聲**2CDs**

新世紀鋼琴台灣民謠 30選 New Age 五線譜版 簡譜版

一隻鳥仔哮啾啾、五更鼓、卜卦調、貧彈仙、病子歌、乞食調、走路調、都馬調、
西北雨、勸世歌、思想起、採茶歌、天黑黑、青蚵嫂、六月茉莉、農村酒歌、牛犁歌、
草螟弄雞公、丟丟銅仔、桃花過渡、舊情綿綿、望春風、雨夜花、安平追想曲、
白牡丹、補破網、河邊春夢、燒肉粽、思慕的人、四季紅

何真真 著 每本定價**360**元
五線譜版附演奏示範**QR Code**、簡譜版附有聲**2CDs**

麥書國際文化事業有限公司 http://www.musicmusic.com.tw
全省書店、樂器行均售‧洽詢專線：（02）2363-6166

西洋流行鋼琴百大首選

【企劃製作】麥書國際文化事業有限公司

【監　製】潘尚文

【編　著】邱哲豐

【封面設計】陳姿穎

【美術編輯】陳姿穎

【製譜校對】邱哲豐

【譜面輸出】李國華

【發　行】麥書國際文化事業有限公司

Vision Quest Publishing International Co., Ltd.

【地　址】10647台北市羅斯福路三段325號4F-2

4F-2, No. 325, Sec. 3, Roosevelt Rd.,

Da'an Dist., Taipei City 106, Taiwan(R.O.C)

【電　話】886-2-23636166，886-2-23659859

【傳　真】886-2-23627353

【郵政劃撥】17694713

【戶　名】麥書國際文化事業有限公司

http://www.musicmusic.com.tw

E-mail:vision.quest@msa.hinet.net

中華民國101年11月 三版